Prendergast in Italy

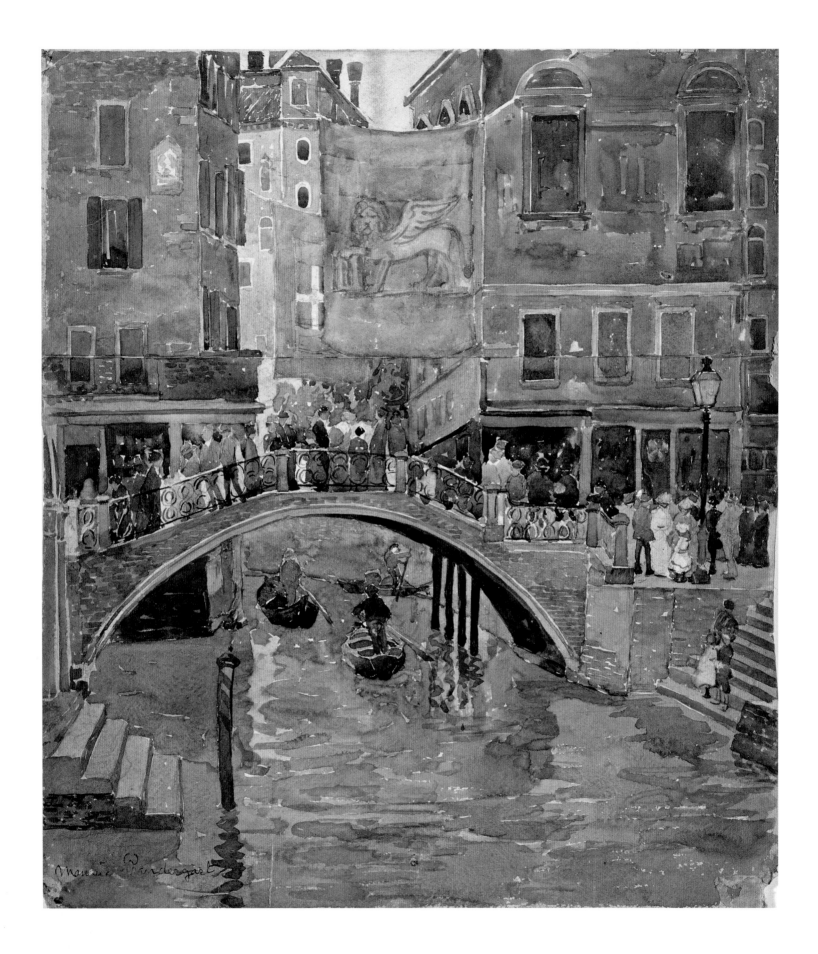

Maurice Prendergast

Prendergast in Italy

Nancy Mowll Mathews
with Elizabeth Kennedy

MERRELL
LONDON · NEW YORK

in association with
Williams College Museum of Art
and Terra Foundation for American Art

First published 2009 by

Merrell Publishers Limited
81 Southwark Street
London SE1 0HX

merrellpublishers.com

in association with

Williams College Museum of Art
15 Lawrence Hall Drive, Suite 2
Williamstown, MA 01267

wcma.org

and

Terra Foundation for American Art
980 North Michigan Avenue, Suite 1315
Chicago, IL 60611

terraamericanart.org

Published on the occasion of the exhibition *Prendergast in Italy*
Williams College Museum of Art, Williamstown, Massachusetts
July–September 2009
Peggy Guggenheim Collection, Venice
October 2009–January 2010
The Museum of Fine Arts, Houston, Texas
February–May 2010

A catalogue record for this book is available
from the Library of Congress

British Library Cataloguing-in-Publication data:
Prendergast, Maurice Brazil, 1858–1924
Prendergast in Italy
1. Prendergast, Maurice Brazil, 1858–1924 – Exhibitions
2. Modernism (Art) – Exhibitions 3. Italy – In art – Exhibitions
I. Title II. Mathews, Nancy Mowll III. Kennedy, Elizabeth, 1949–
IV. Williams College. Museum of Art
759.1

ISBN 978-1-8589-4483-8 (hardcover edition)
ISBN 978-1-8589-4484-5 (softcover edition)

Printed and bound in Italy

Produced by Merrell Publishers Limited
Designed by Maggi Smith
Copy-edited by Matthew Taylor
Proof-read by Philippa Baker
Indexed by Vicki Robinson

Note on captions
The dimensions in the captions indicate height followed by width.
The numbers given at the end of captions for works by Prendergast
refer to the catalogue raisonné (see note on page 170).

Jacket/cover
Festa del Redentore, ca. 1899 (see page 119)

Page 2
Venice, ca. 1898–99 (see page 39)

Page 9
Venetian Canal, ca. 1898–99 (see page 55)

Pages 10–11
Procession, Venice, 1899 (see page 175)

Page 13
Afternoon Pincian Hill, ca. 1898–99 (see page 123)

Contents

Forewords

The Williams College Museum of Art is the home of the Prendergast Archive and Study Center, which, in addition to producing the ongoing catalogue raisonné of Maurice and Charles Prendergast, is the repository of the largest collection of works by these artists (comprising approximately 400 items). For over twenty-five years, the museum has shared this collection and associated research with scholars, faculty, students, and the public through a variety of exhibitions and publications. The museum has been discussing the possibility of mounting an exhibition of Maurice Prendergast's Italian works for many years. It was the watercolors and monotypes from his trip to Italy of 1898–99 that catapulted Maurice Prendergast to national attention in 1900, and they have remained the most admired of his œuvre ever since. The watercolors from the second trip, in 1911, show how the concepts of Modernism that had emerged in the work of 1898–99 came to fruition during the crucial first decade of the twentieth century. Taken as a whole, Prendergast's Italian works are, arguably, the most visually sumptuous and aesthetically challenging pieces he ever produced.

Organizing this exhibition has required the cooperation of approximately one hundred lenders, as well as the mobilization of considerable resources. We simply could not have done it without the generosity, international perspective, and innovative approach to supporting such an undertaking of the Terra Foundation for American Art. In 2008, the Williams College Museum of Art and the Terra Foundation entered into a partnership that would serve our mutual interest in Prendergast and in placing American art in a broader transatlantic context. The Terra Foundation has enabled the exhibition to have international significance by underwriting several special features: its installation at the Peggy Guggenheim Collection in Venice, the Italian translation of the catalogue, and the catalogue's international range of essayists, allowing Prendergast's work to be considered within the broadest cultural frame. Working together,

curators Nancy Mowll Mathews from Williams College and Elizabeth Kennedy from the Terra Foundation have studied the artistic and cultural milieu that gave rise to this seminal body of work. They reached out to scholars working in the United States and in Europe to produce an exhibition and catalogue with multiple perspectives on this material. I wish to congratulate Nancy and Betsy for the significant new contributions they have made to this pivotal period in the development of American Modernism.

Such an opportunity to carry out in-depth research on a single artist and on a focused historical period has perfectly suited the mission of the Prendergast Archive and Study Center. Furthermore, *Prendergast in Italy*, both the exhibition and the catalogue, would not have been possible without the generations of scholars and students who have contributed to the authoritative files on the artist, on each work of art, on the circle of artists around the Prendergast brothers, and on the broader issues that influenced them. This accumulation of knowledge has provided a basis for ongoing interpretation.

At Williams College, we work within an extraordinary academic community, which includes scholars from many disciplines, students whose research and contributions have been invaluable, and library and technological services that have facilitated the gathering and storing of information. Because of this fertile environment, we have been able to mount other major exhibitions that place art in a broad interdisciplinary context, including *Moving Pictures: Art and Early Film, 1880–1910* (2005), *Beautiful Suffering: Photography and the Traffic in Pain* (2006), and, most recently, *Making It New: The Art and Style of Sara and Gerald Murphy* (2007). These exhibitions share a commitment to understanding art in relation to the range of complex historical forces that shape cultural production. We are most grateful to the faculty, students, and administration of Williams College for their ongoing cooperation and support for these kinds of collaborative

endeavors. We especially thank the president, Morton O. Schapiro, and the provost, William Lenhart, for their enthusiastic and continuing advocacy for the dynamic role a college museum can play in a liberal arts curriculum.

I am deeply grateful to the staff of the Williams College Museum of Art for their professionalism and dedication. The success of this project reflects their cumulative creativity, intelligence, and commitment to excellence.

A teaching museum has a unique mission: to forge relationships with works of art that inspire and challenge faculty and students, and to serve as a crossroads between campus and community. Equally important is our mission to connect Williams College to the world. In our galleries and classrooms we do this by transmitting powerful ideas. Through this international traveling exhibition, it is works of art that create the bridge between time and place, between Williamstown, Massachusetts, in contemporary New England and turn-of-the-century Italy. We are proud to have this opportunity to share our world, and that of Maurice Prendergast, with museum visitors in Venice and New York.

Lisa G. Corrin
Class of 1956 Director
Williams College Museum of Art

TERRA FOUNDATION FOR AMERICAN ART

Prendergast in Italy is the fifth international exhibition co-organized by the Terra Foundation for American Art since 2006, and is evidence of the foundation's commitment to bring American art to international audiences and to foster multinational perspectives and participation—all in an attempt to enlarge and enliven the study of American art. The foundation is proud to partner the Williams College Museum of Art in presenting *Prendergast in Italy*, which examines work created by Maurice Prendergast during two critical trips to Italy in 1898–99 and 1911. In Venice, which established the Venice Biennale in 1895 to celebrate contemporary art, Prendergast encountered issues of modernity. The paintings, watercolors, and monotypes he created in response demonstrate the melding of his American identity, his recognition of modernity, and the timeless beauty of Italy, especially Venice.

A tourist in the democratic sense of the word, Maurice Prendergast found Italy's ancient monuments and modern crowds equally compelling. He admired historic Venetian paintings while exploring contemporary Venice, but throughout his Italian sojourns he retained an unmistakably American point of view. The result was an extraordinary body of work that established his place in the canon of American art. This exhibition provides a unique opportunity to examine Prendergast's work contextually, both through the inclusion of important ephemera and through the presentation in Venice, where much of the art was created. The Terra Foundation awarded additional support to the Peggy Guggenheim Collection because we thought it important that Italian audiences have the opportunity to view Prendergast's art.

Currently, the Terra Foundation both initiates and grants awards for exhibitions and projects in the field of American art and actively acquires works of art to enhance its collection, which spans the colonial era through 1945. The Terra Foundation collection contains the largest group of Prendergast monotypes held by any public institution, as well as a significant holding of Prendergast's paintings and watercolors, spanning the artist's entire career. The Williams College Museum of Art is a natural partner for the present endeavor because of the museum's extensive collection of Prendergast works and its thorough study of the artist. *Prendergast in Italy* illustrates the Terra Foundation's commitment to its collection and the collection's role in advancing American art appreciation and scholarship worldwide. Comprehensive information about the foundation's entire collection may be found on the Terra Foundation's website (terraamericanart.org).

On behalf of the Terra Foundation for American Art, I would like to thank Lisa G. Corrin, Class of 1956 Director; Nancy Mowll Mathews, Eugénie Prendergast Senior Curator of Nineteenth and Twentieth Century Art; and everyone at Williams College Museum of Art for the opportunity to share Maurice Prendergast's art with audiences in Williamstown, Massachusetts; Venice; and New York. I would especially like to thank the lenders and the scholars who have contributed to the catalogue for joining us in this effort. Throughout its thirty-year history, the Terra Foundation has created and supported programs designed to engage individuals in an international discussion of American art; this exhibition is the next step in that conversation.

Elizabeth Glassman
President and Chief Executive Officer
Terra Foundation for American Art

PEGGY GUGGENHEIM COLLECTION

There is an aura of inevitability attached to an exhibition at the Peggy Guggenheim Collection in Venice documenting the Italian journeys of Maurice Prendergast. Prendergast, an American, a chronicler of modern Venetian scenes, who through exposure to Cézanne and the European Old Masters joined the first generation of American Modernists, personified precisely that transatlantic artistic chemistry that marks Peggy Guggenheim's contribution to art history in the 1940s. More generally, one way of characterizing the cultural mission of the Peggy Guggenheim Collection, at least in terms of how its exhibition program has evolved since 1985, is as the port of entry to Italy for great American artists, who may be little-known and under-appreciated. So it has been for Jackson Pollock, Stuart Davis, William Baziotes, and Richard Pousette-Dart, for example.

The long-standing relationship between the art of Maurice Prendergast and the Williams College Museum of Art in Williamstown, Massachusetts, was forged during Thomas Krens's tenure as director there. Mr. Krens was subsequently director of the Solomon R. Guggenheim Foundation, of which the Peggy Guggenheim Collection is the Italian branch, and we owe to him the opportunity to present *Prendergast in Italy*. We are very grateful indeed to the Williams College Museum; to Lisa G. Corrin, its director; and to Nancy Mowll Mathews, its Prendergast curator, for entrusting to the Peggy Guggenheim Collection its beautiful works of art, and for bringing scholarship and connoisseurship to the exhibition.

We would like to record our gratitude to the Intrapresæ Collezione Guggenheim, the international corporate members of the Peggy Guggenheim Collection, whose annual generosity provides continuity, confidence, and optimism as we plan exhibitions in Venice year by year.

In particular, we acknowledge the ample financial support of the Terra Foundation for American Art for the Peggy Guggenheim Collection's presentation of *Prendergast in Italy*. The Terra Foundation has again underscored its dedication to bringing American art to international audiences. Indeed, the Solomon R. Guggenheim Foundation is proud to be carrying forward jointly our respective missions a second time. The Terra Foundation, which co-organized the Guggenheim's exhibition *Art in America: 300 Years of Innovation* in 2007–08, brings both curatorial expertise and an outstanding collection, including notable works by Prendergast. Thank you, therefore, to Elizabeth Glassman, President of the Terra Foundation; to Donald Ratner, Vice-President; and to Elizabeth Kennedy, Curator of Collection.

Richard Armstrong
Director
Solomon R. Guggenheim Foundation and Museum

Philip Rylands
Director
Peggy Guggenheim Collection

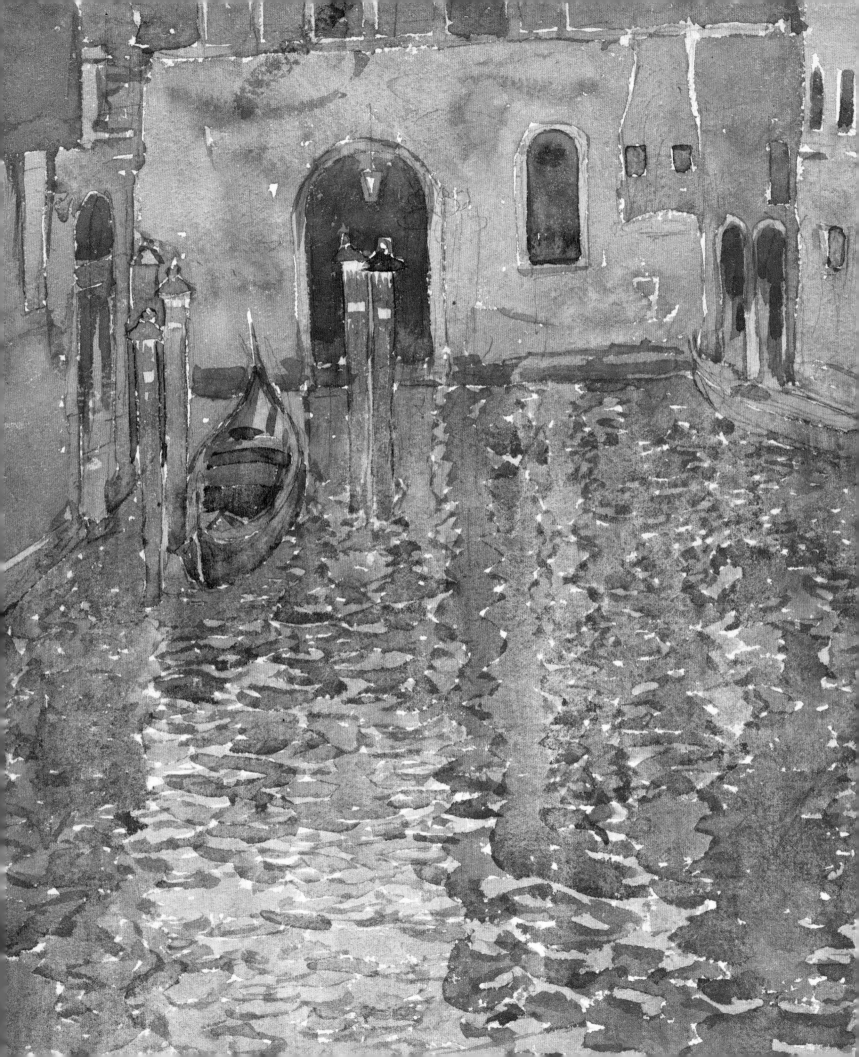

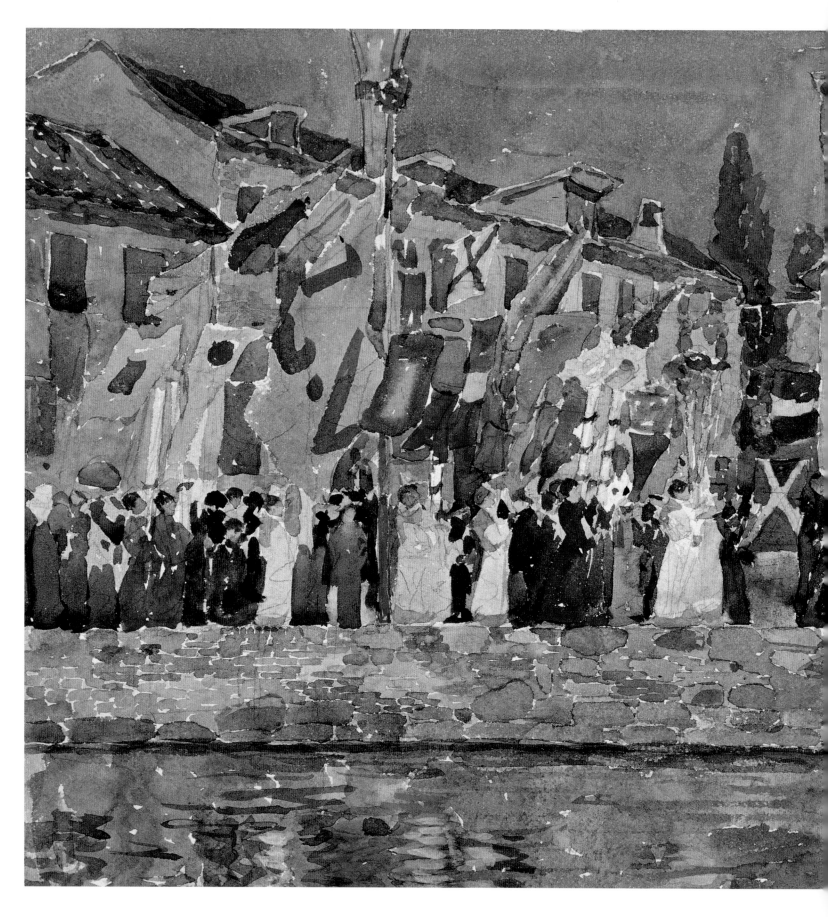

Lenders to the Exhibition

Addison Gallery of American Art,
 Phillips Academy, Andover, Massachusetts

Boca Raton Museum of Art, Florida

Cheekwood Botanical Garden and Museum of Art,
 Nashville, Tennessee

The Cleveland Museum of Art

Colby College Museum of Art,
 The Lunder Collection, Waterville, Maine

Columbus Museum of Art, Ohio

The Courtauld Gallery, London

Collection of Roy and Cecily Langdale Davis

Des Moines Art Center, Iowa

The Dixon Gallery and Gardens, Memphis, Tennessee

Collection of Judith H. Dobrzynski

Emmanuel College, Boston

Farnsworth Art Museum, Rockland, Maine

High Museum of Art, Atlanta

Honolulu Academy of Arts

Horatio Colony House Museum and Nature Preserve,
 Keene, New Hampshire

Collection of Donna Seldin Janis

Karen and Kevin Kennedy Collection

Abby and Alan D. Levy Collection, Los Angeles

The Library of Congress, Washington, D.C.,
 Prints and Photographs Division

London Family Collection

Collection of Meredith and Cornelia Long

McNay Art Museum, San Antonio

The Metropolitan Museum of Art, New York

Mount Holyoke College Art Museum,
 South Hadley, Massachusetts

Museo Thyssen-Bornemisza, Madrid

Museum of Art, Rhode Island School of Design,
 Providence

Museum of Fine Arts, Boston

The Museum of Modern Art, New York

National Gallery of Art, Washington, D.C.

The Nelson-Atkins Museum of Art,
 Kansas City, Missouri

Neuberger Museum of Art, Purchase College,
 State University of New York

A New England Collector

Norton Museum of Art, West Palm Beach, Florida

Collection of James and Barbara Palmer

The Phillips Collection, Washington, D.C.

Portland Museum of Art, Maine

Private Collection, courtesy of Avery Galleries,
 Bryn Mawr, Pennsylvania

Private Collection, courtesy of Guggenheim Asher
 Associates, New York

Private Collection, courtesy of Kodner Gallery, St. Louis

Private Collection, New York

Private Collection, St. Louis

Private Collection, Texas

Private Collections

Fayez Sarofim Collection

Terra Foundation for American Art,
 Daniel J. Terra Collection, Chicago

University of Iowa Museum of Art, Iowa City, Iowa

Williams College Museum of Art,
 Williamstown, Massachusetts

Acknowledgments

It has been a delight to bring this project to fruition. First and foremost, it realizes the missions of our respective institutions, the Williams College Museum of Art and the Terra Foundation for American Art, both of which are dedicated to the educational use of works of art. We have been fortunate in having the leadership and support of their directors, Lisa G. Corrin and Elizabeth Glassman, and their larger administration, including the board of the Terra Foundation; the Williams College president, Morton O. Schapiro; its provost, William Lenhart; and its associate provost, Keith Finan.

The funding of the exhibition and catalogue has been made possible by a partnership grant from the Terra Foundation, together with exhibition funds from the Prendergast Endowment of the Williams College Museum of Art. The Terra Foundation also provided a grant for a pre-exhibition colloquium, held in November 2007, which allowed for an exchange of ideas at a crucial time in the development of the project. From the scholars engaged in this colloquium came the following contributors to the catalogue: Olga Płaszczewska, Chair of Comparative Literature, Faculty of Polish Studies, Jagiellonian University, Kraków, Poland; Alessandro Del Puppo, Università degli Studi di Udine, Italy; Jan Andreas May, Assistant Curator, Neue Nationalgalerie, Berlin, Germany; and Carol Clark, William McCall Vickery 1957 Professor of the History of Art and American Studies, Amherst College, Massachusetts. They have provided an international and in-depth context for *Prendergast in Italy*.

The research on Maurice Prendergast that underpins such an undertaking as this has been ongoing at the Williams College Museum of Art since 1983, and acknowledging all the participants would be impossible. But recognition must go to the core group who brought it to its present state of authority: Thomas Krens, Carol Clark, Gwendolyn Owens, Charles Parkhurst, Milton Brown, Pamela Ivinski, and Carol Derby. Other scholars whose contributions to Prendergast studies and related aspects of art history have been invaluable include Ellen Glavin,

Richard Wattenmaker, Marc Simpson, Ralph Lieberman, and E.J. Johnson.

The ongoing efforts to maintain the Prendergast catalogue raisonné in the years since its publication in 1990 have allowed us to track the ownership of the many important objects listed therein, which in turn has made it possible to produce such a complete exhibition of Prendergast's Italian works. But completeness rests on our long-standing relationships with the larger art community, including museum curators, art dealers, auction houses, and collectors, all of whom have shown extraordinary generosity in helping us secure the loans for the exhibition. Of these, Barbara Weinberg and Elizabeth Athens from the Metropolitan Museum of Art, New York; Erica Hirshler from the Museum of Fine Arts, Boston; and Heather Lemonedes from the Cleveland Museum of Art must be gratefully recognized. Helping us with private collectors were Abigail Asher, Maria Friedrich, and Deborah Hatch.

From the galleries and auction houses, we would like to thank Warren Adelson, Meredith Long, Roy Davis, and Cecily Langdale, as well as Carol Pesner, Debra Force, Michael Owen, Edward Shein, Martha Parrish, Ira Spanierman, M.P. Naud, and Eric Widing, all of whom have been extremely helpful in securing Prendergast loans. We would also like to recognize the special efforts of Lisa Hankin, Zachary Ross, Stephanie Stokes, Nicole Amoroso, and Simon Wills.

As for the lenders themselves, words cannot express how grateful we are to them for their generosity. They have deprived themselves in order that this exhibition might enlighten the larger world. Although their names are listed separately (see p. 11), we would like to pay tribute to them here.

The Prendergast owners, whether they have been able to lend to the exhibition or not, have also been extremely generous in providing us with photography for our catalogue, which reproduces Prendergast's complete Italian œuvre. We have asked many of them to go the extra mile in providing photography of the versos of works that

previously have not been documented. For this and for extra help in our quest for publishable images for the catalogue, we would like to thank Elizabeth Saluk, Erin Schleigh, Maria Murguia, Erin Damon, and James Sousa. In producing this fine volume, we tip our hats to the gracious staff at Merrell, especially Nicola Bailey, Paul Arnot, Mark Ralph, and Alenka Oblak.

Finally, we wish to recognize the extraordinary efforts of the people we work with every day. We have been fortunate in being able to draw on the efforts of the talented student interns at Williams College, who have included Sarah Linford (Williams MA 2007), Mia Michelson-Bartlett (Williams BA 2008), Amy Torbert (Williams MA 2007), Layla Bermeo (Williams MA 2009), Rebecca Shaykin (Williams MA 2009), Jamie Sanecki (Williams MA 2009), Ruth Ezra (Williams BA 2010), and Bree Lehman (Williams MA 2010). We also extend the warmest of acknowledgments to our colleagues who are listed elsewhere. But we would like to single out those who made special contributions to this project. At the Williams College Museum of Art, they are John Stomberg, Dorothy Lewis, Amy Tatro, Diane Hart, Hideyo Okamura, Suzanne Silitch, Cynthia Way, Emily Schreiner, Elizabeth Gallerani, Dana Pilson, George Philip LeBourdais, Edith Schwartz, Ann Greenwood, and Arthur Evans. At the Terra Foundation, they are Jessica Beck, the Terra Curatorial Intern of summer 2007, who was dedicated to the Prendergast project; Cathy Ricciardelli; Elisabeth Smith; Ariane Westin-McCaw; and the extraordinary collegial staff of the Glore Print Study Room at the Art Institute of Chicago, especially Kimberly J. Nichols.

Nancy Mowll Mathews
Eugénie Prendergast Senior Curator of Nineteenth and Twentieth Century Art and Lecturer in Art, Williams College Museum of Art

Elizabeth Kennedy
Curator of Collection, Terra Foundation for American Art

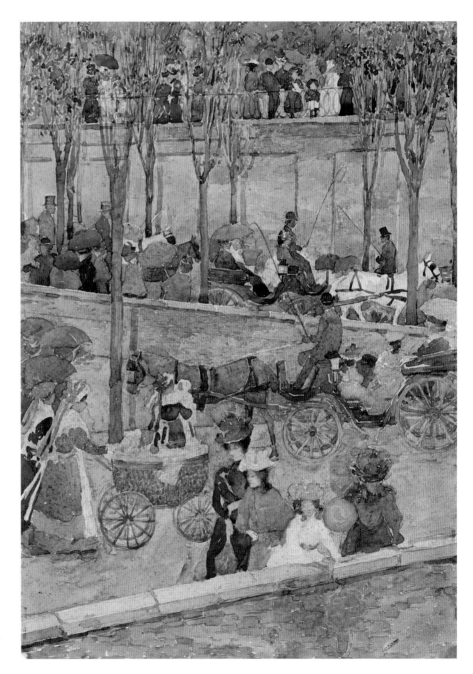

PRENDERGAST SITES IN VENICE

During Prendergast's two trips to Italy (in 1898–99 and 1911–12), he painted numerous locations throughout the city of Venice, capturing crowded tourist attractions as well as picturesque, out-of-the-way corners. Each site marked on this map has been identified using the catalogue raisonné number of the corresponding artwork (see Checklist of Italian Works, pp. 170–83).

1009 *Rialto Bridge*, ca. 1911–12

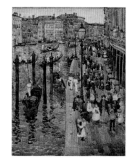

707 *The Grand Canal, Venice*, ca. 1898–99

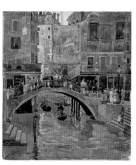

722 *Venice*, ca. 1898–99

Key to map

■ Rialto, San Polo, and Cannaregio
■ Castello
■ Canale di San Marco and Giardini
■ Dorsoduro
■ San Marco
■ Piazza San Marco

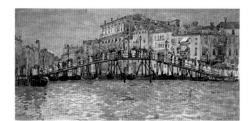

696 *The Bridge of Boats, Venice*, ca. 1899

1029 *Venice—Side Canal*, ca. 1911–12

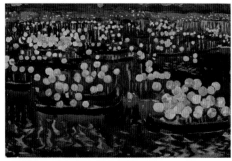

724 *Festa del Redentore*, ca. 1899

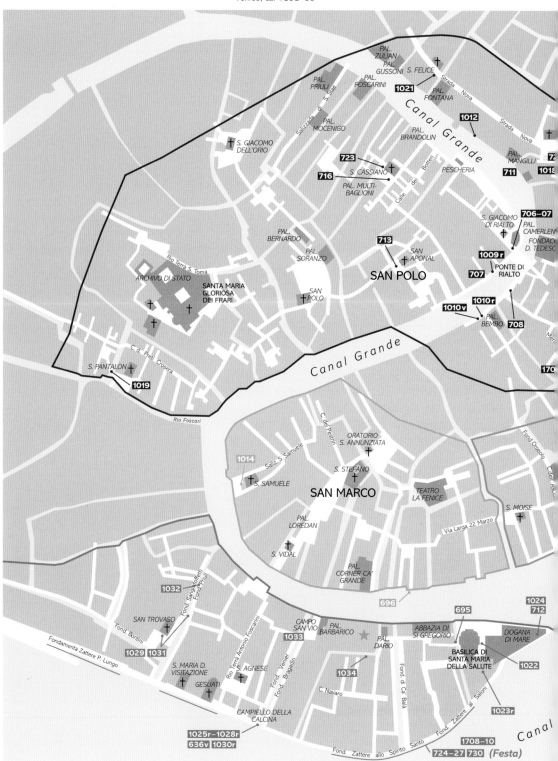

713 *Festival, Venice,*
ca. 1898–99

1016 *Campo Santa Maria Formosa, Venice,*
ca. 1911–12

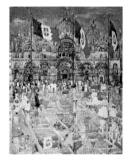

674 *Splash of Sunshine and Rain,* 1899

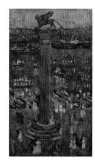

689 *St. Mark's Lion, Venice,* ca. 1898–99

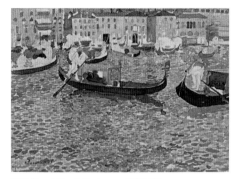

712 *Grand Canal, Venice,* ca. 1898–99

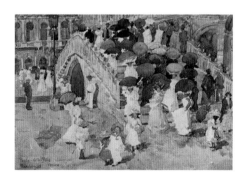

1780 *Ponte della Paglia,* ca. 1898–99

692 *Canal, Venice,* ca. 1898–99

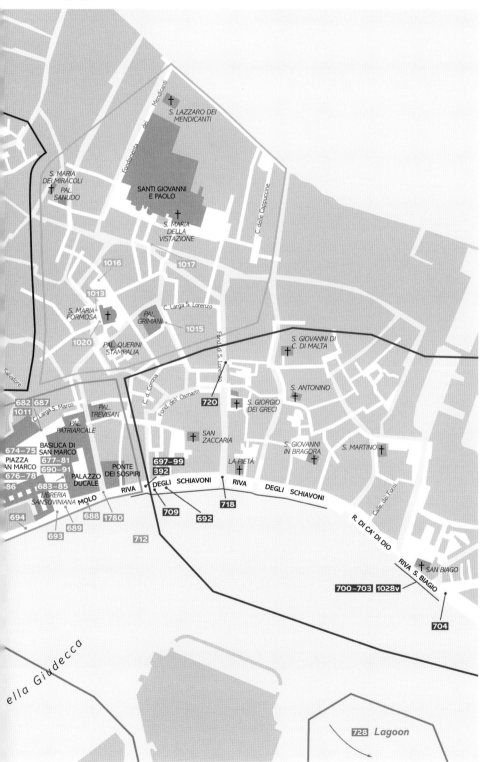

15

Prendergast in Italy

Nancy Mowll Mathews

Introduction

The exhibition of Maurice Prendergast's Italian watercolors in New York in 1900 was a critical success. Not only were the works considered beautiful; they also struck everyone as highly unusual: "Maurice B. Prendergast's watercolors and monotypes at the Macbeth Gallery form one of the most interesting and unconventional exhibitions now on view in the city."[1]

Since the exhibition consisted primarily of watercolors of Venice (fig. 1), this was a rather amazing reaction. Venice! For the last twenty years, exhibitions in New York and Boston, not to mention London, Paris, Berlin, and Tokyo, had been crowded with this very subject. In the hands of such artists as Whistler, Sargent, and Renoir in about 1880, Venice had been reinterpreted as a subject for modern art. But in the intervening years, it had become stale and predictable. In January 1898, months before Prendergast left for Italy, a critic for the *New York Times* scoffed that the only change in the watercolors of the well-known Venice specialist F. Hopkinson Smith (fig. 2) from the previous year was that "the artist had transferred his signature from the left to the right."[2] And so you would think, as Henry James had already famously written in 1882, that there was "nothing more to be said" about Venice.[3]

Nonetheless, critics agreed that the work in Prendergast's first solo exhibition in New York "has never attracted such attention,"[4] and that few artists "could bring together so interesting a collection . . . [or] possess so distinct a personality."[5] Prendergast himself wrote to his patrons in Boston, "Mr. Macbeth likes them [and] said he never had anything like them on his walls before," reporting with a chuckle, "somebody proposed having chairs in the gallery so they could sit down to recover from their shock."[6]

So Prendergast had achieved the seemingly impossible: he had found, to paraphrase James, "something more to be said" about Venice. And he went on to say something more about Siena, Rome, and Capri, to round out his recently completed eighteen-month tour of Italy. Without minimizing the "joyousness" and "spontaneity" that were universally applauded in these watercolors, it is now possible to see how Prendergast's thoughtful choice

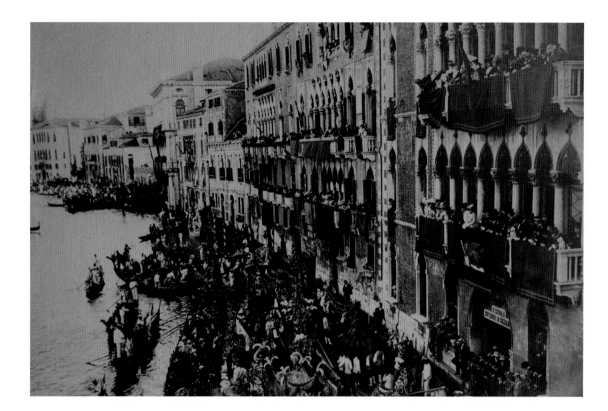

Fig. 3
Canal Scene, Venice, n.d.
Prendergast Archive and Study Center,
Williams College Museum of Art,
Williamstown, Massachusetts
Photo Credit: Arthur Evans

of subject, point of view, and expressive detail captured the shifting cultural climate of modernization that was being experienced by Italy and America at the end of the nineteenth century. At the same time, Prendergast provided Modernist solutions to artistic problems that challenged his generation.

Modernism and modernization were synonymous in much of the agonized writing about art at that time, and nowhere was this *cri de cœur* more moving than in writings about Venice, which symbolized to the international intellectual community the best of the past in terms of art and social ideals. The Venetian artist, writer, and legislator Pompeo Molmenti (1852–1928), writing in the worldwide forum of the London-based *Art Journal*, called for improvements to the city but decried "a misguided spirit of progress, and the desire to be modern, [which] wage a dogged and insidious war" along the ancient canals. Those, he went on, "who appreciate the beautiful, or have knowledge of tradition, see with bitterness the cruel desire to reduce Venice to such as those insignificant cities which modern speculation makes for us."[7]

Similar doubts were expressed about the new *International Exhibition of Art*, later called the Venice Biennale, which was established in 1895. The American artist Will Low (1853–1932) voiced the universal concern that an exhibition of modern art in Venice set up a greater opposition between modern and traditional art than anywhere else: "Venice marks the culmination of the most glorious school of painting which the world has seen, and to invite the comparison between the present and the past [is] the [better] part of valor."[8]

Coming from conservative Boston, Prendergast had grappled with Modernism and the modernization of his own home city, but he had never before had to confront the weight of past traditions of art and national pride that he encountered in Venice. The result was a unique blend of cultural references and stylistic experimentation that set Prendergast's paintings apart from all other interpretations of that symbol-laden city. The originality of Prendergast's artistic personality was tested by the issues of past and present keenly felt, and the outcome was a series of unusual works that reflect a pivotal moment in the history of modern art. Within a year of the groundbreaking exhibition of 1900, Prendergast went on to explore fully the abstract principles inherent in the works on show, with their blend of old and new, and he quickly became a leader in the development of twentieth-century Modernism in America.

LOOKING FORWARD TO ITALY

Prendergast's Background

The ties between Boston and Venice were already strong when Maurice Brazil Prendergast emerged as an important new artist in the mid-1890s. Boston could claim such famous Venetophiles as Charles Eliot Norton, Henry James, William Dean Howells, Mr. and Mrs. Daniel Sargent Curtis, Isabella Stewart Gardner, and Sarah Choate Sears. And the artists similarly claimed by Boston, such as Sargent, Childe Hassam, and Arthur Wesley Dow, had all led the way to that famous artistic city. The Boston art world had an outpost in Venice: the Curtises' apartment in the Palazzo Barbaro (fig. 4), which was frequently rented by such patrons as Mrs. Gardner and frequented by important American artists abroad. To a certain extent, it was inevitable that any important Boston artist would follow in their footsteps.

But Prendergast was not the typical Boston artist. The art world in Boston had long been dominated by the old wealthy and intellectual classes, who had produced a small circle of writers, patrons, and artists connected to Harvard University and the Museum of Fine Arts. Maurice Prendergast, instead, came from a middle-class family that lived from 1868 in reduced circumstances in Boston's unfashionable South End. He and his younger brother, Charles (1863–1948), attended public schools through the eighth grade, and then both made their way in the commercial side of art. Maurice Prendergast worked for more than ten years in the "showcard" business, painting lettered and pictorial advertising signs for use in shop windows. His goal, however, was to become a fine artist, and to advance his career he studied in the free drawing classes offered in the evenings at the Starr King School. As Ellen Glavin

Fig. 4
John Singer Sargent
(American, 1856–1925)
An Interior in Venice, 1899
Oil on canvas
25½ × 31¾ in. (64.8 × 80.7 cm)
Royal Academy of Arts, London

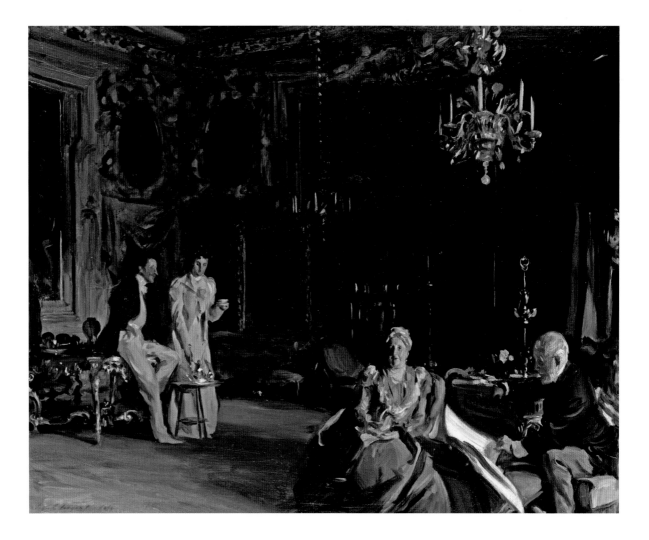

points out, the art training publicly available in Boston, in both public schools and evening classes, was geared to design skills that could be applied to a range of commercial and industrial trades.[9] For a student planning to become a fine artist, these classes would not have offered the intellectual study of historical art or ideal anatomy that an art academy might. Nevertheless, they would become an invaluable resource for Prendergast's later experiments with two- and three-dimensional composition and abstract design.

Even though his family seems to have struggled financially during his youth and he did not receive the academic art training that other Boston fine artists had, Prendergast was not without connections to Boston's educated upper classes. His grandfather had been a physician in the North End, and his mother's brother, Charles, graduated from Harvard Medical School and was a practicing physician.[10] Both in St. John's, Newfoundland (where the Prendergasts lived until 1868), and in Boston, Maurice and Charles attended schools in which their families were active. Their father, from a prominent small business family in St. John's, had a love of antiques that he passed on to both sons. When Charles Prendergast got a job with a Boston art gallery, he had the refined manners that could open

doors for himself and Maurice in fine art circles. The two brothers, who lived together for the rest of their lives, endeared themselves to all members of the art world, from artists to dealers to critics to patrons, and began to rise, both socially and artistically.

Maurice Prendergast had already been across the Atlantic twice when he sailed for Italy in the summer of 1898. He had made a youthful trip to England and Wales "on a cattle boat"[11] in the mid-1880s, and returned in 1891 for an extended period of study at the academies in Paris. At the age of thirty-three, he was a decade older than most of his fellow students at the popular Académie Julian and the Académie Colorassi, and he immediately sought out the most modern styles to be found in the exhibitions and galleries. There is little evidence of the study of Old Master art in museums or traditional academic figure painting, but rather a quick grasp of the new urban subject matter (fig. 6) that was attracting a range of artists, from Jean Béraud to Pierre Bonnard (fig. 7) and the Nabis. Prendergast made important connections in Paris, such as the Canadian expatriate James Wilson Morrice, who was a friend of Whistler. Whistler himself settled in Paris in 1892 and opened his studio to artists of all nationalities. Two Boston artists who would be

Fig. 5
Photograph of Maurice Prendergast, ca. 1875
Prendergast Archive Study Center, Williams College Museum of Art, Williamstown, Massachusetts
Photo Credit: Arthur Evans

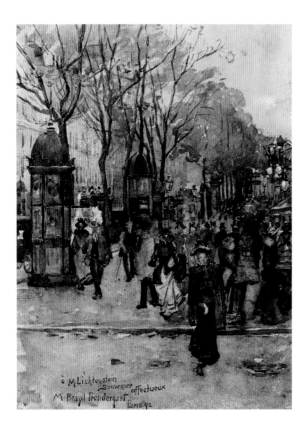

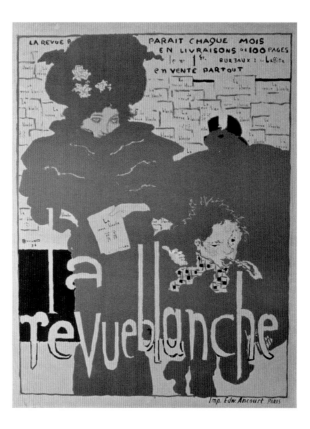

Fig. 6
Maurice Prendergast
Boulevard des Capucines, 1892
Watercolor and pencil on paper
10 × 7¼ in. (25.4 × 18.4 cm)
Private Collection
CR 541

Fig. 7
Pierre Bonnard
(French, 1867–1947)
La Revue Blanche, 1894
Lithograph
31½ × 24⅜ in. (80 × 61.9 cm)
Williams College Museum of Art, Williamstown, Massachusetts
Museum Purchase (58.16)

Fig. 8
Maurice Prendergast
Early Evening, Paris, ca. 1892
Monotype
Image: 5¾ × 5½ in. (14.6 × 11.4 cm)
Terra Foundation for American Art,
Chicago
Daniel J. Terra Collection, 1992.81
CR 1570

Fig. 9
Illustration, *The Studio*, 1, 1893,
p. 188
Photomechanical transfer of pencil
drawing on paper
Page: 11¾ × 8½ in. (29.8 × 21.6 cm)
Erroneously attributed to
Michael Dignam

Fig. 10
Photograph of Maurice
Prendergast, ca. 1891–94
Prendergast Archive and Study Center,
Williams College Museum of Art,
Williamstown, Massachusetts
Photo Credit: Arthur Evans

close friends and advocates of Prendergast—Hermann Dudley Murphy (1867–1945) and Charles Hovey Pepper (1864–1950)—were fellow students.

In the four years of his residence in Paris, Prendergast studied oil and watercolor painting, learned the color monotype process then in vogue (fig. 8), and developed a specialty in single-figure studies of fashionable women, which he executed in all three media. These studies were very popular for artists' exchanges and were related to the commercial art and illustration designs of his past work. That several of them were published under another name in the London journal *The Studio* (1893) did not diminish the honor of having his work chosen for publication.[12] Prendergast stood out among the Americans then studying in Paris for his grasp of the new style. According to later reports, he "was the most popular man in his class, and his fellows always bought everything he painted, paying from twenty-five francs upward for his sketches."[13]

Boston in the 1890s

Prendergast's success among the younger American artists in Paris, and the Boston connections he made there, positioned him advantageously for his new

occupation as a fine rather than a commercial artist when he returned home in 1894. He took on a series of book and poster commissions for Boston publishers, which helped to pay the bills, but otherwise he dived into the task of translating what he had learned in Paris about the painting of modern life into the environs of a conservative American city. Boston's most progressive artist, the Impressionist Childe Hassam (1859–1935), had moved to New York in 1889. Hassam's rather dark views of Boston, such as *Charles River and Beacon Hill* (fig. 12), showed his own attempts to adapt a Parisian style to the banks of the Charles River.

Prendergast was fortunate in that his return coincided with a radical transformation of the city itself through the creation of an extensive park system designed by Frederick Law Olmsted. Called the "emerald necklace," it connected existing green spaces downtown, such as the Boston Public Garden, with new park areas, such as the South Boston Pier in Prendergast's old neighborhood (fig. 13) and Franklin Park, the model of a modern city playground. Prendergast immediately gravitated toward the innovative spaces of these new progressive-era improvements to the city, and saw in them the sort of lively, fashionable women he had painted so often in Paris.[14] The daring curved pier and the flow of dresses and crowds made Boston seem socially, architecturally, and stylistically modern.

Prendergast's genius for taking a stodgy city that had hitherto resisted the modern brush and making it sparkle with movement and daring did not go unnoticed among those artists yearning for the transformation of art and society they had witnessed in Paris. Chief

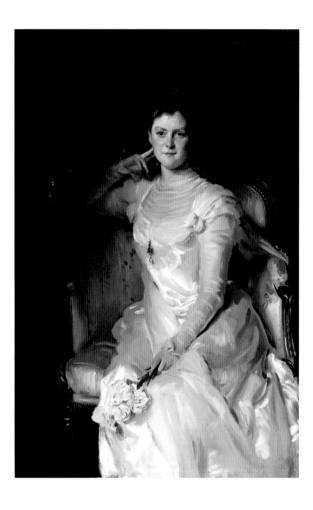

among them was the progressive artist and patron Sarah Choate Sears (1858–1935), who was painted by Sargent in 1899 (fig. 11). In addition to her privileged entrée into modern art circles abroad, Sears drew to her in Boston an international assortment of artists, including Sargent from London, Mary Cassatt from Paris, and the prominent Norwegian Impressionist Fritz Thaulow, all of whom visited her in 1898. She was a painter and photographer in the Aesthetic style and exhibited her art widely, including in the new Photo-Secession exhibitions of Alfred Stieglitz in New York. She treated all artists as her colleagues and was extremely generous toward them, arranging exhibitions, buying their work, and occasionally offering grants for travel abroad.

Sears quickly recognized the new talent that began to appear in Boston's annual exhibitions, and acquired one of Prendergast's watercolors of Olmsted's new Franklin Park (fig. 14). Other recognition came in the form of a proposed reproduction of Prendergast's work in *Harper's Weekly*.[15] Critical reaction to these and a similar series of paintings—of the renovated

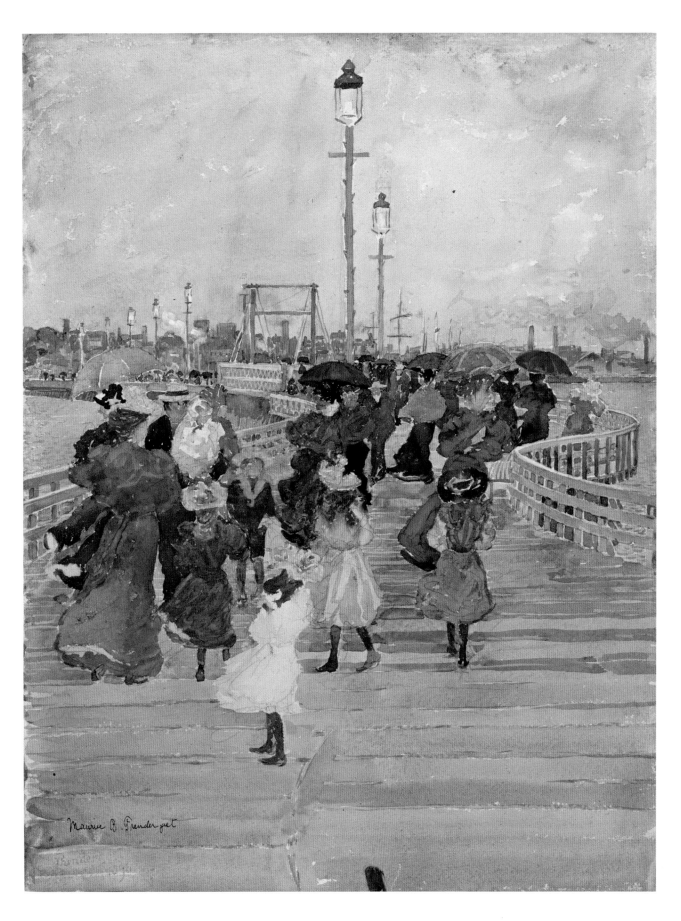

Maurice B. Prendergast

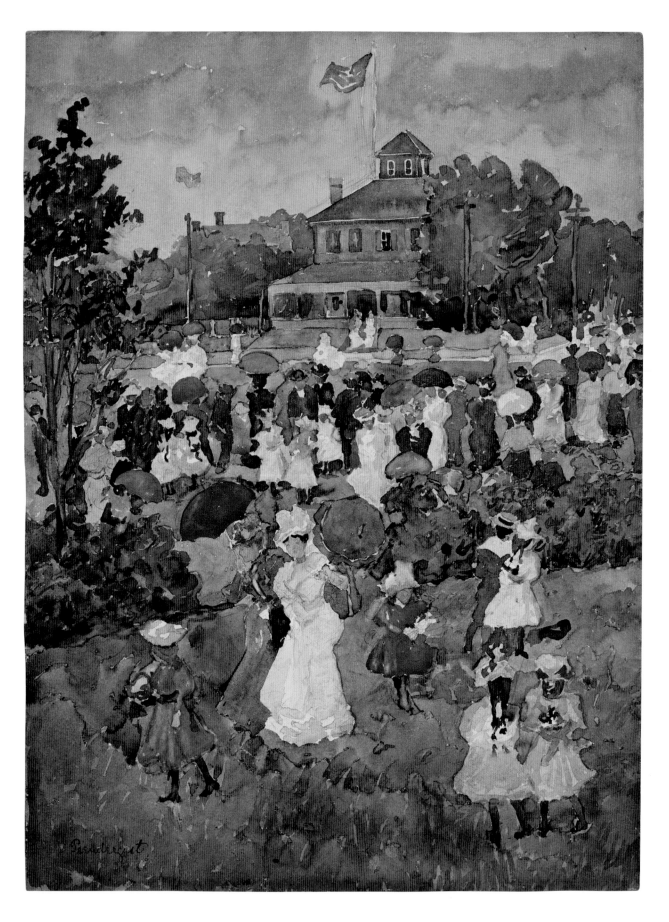

Boston-area beaches, including Revere Beach and Nantasket—helps us see the international context in which they were being assessed. They were recognized as modern both in color and in the way it was used: "Modern art . . . has found one of its distinctive expressions in pure and bright and positive color."[16] Prendergast's use of color was compared to the Italian seashores of "Fortuny," presumably Mariano Fortuny Marsal (1838–1874), the Spanish watercolorist who achieved extraordinary jewel-like tones. The prominence of color in Prendergast's watercolors, its association with modern art, and its connection to Venice were presciently established by 1897.

Simultaneously, Prendergast's much-admired color was believed to have a Japanese source of inspiration. The critic Blanche King, writing in the *Washington Post* about the Boston Art Club exhibition of 1898, echoed many other reviews in describing the color scheme in *Franklin Park* as "suggestive of a Japanese effect in its decorative sense [rather] than a local scene with which every one is familiar."[17] Japanese art, primarily in the form of the color woodblock print, was ubiquitous in artists' studios by the 1890s, and Prendergast's was no exception. Eight Japanese prints by such artists as

Hiroshige, Toyokuni, and Kuniyoshi have survived in his estate. When Kuniyoshi's *Figures in a Courtyard* (fig. 15) is compared with Prendergast's *Franklin Park*, the use of color is strikingly similar. In both, the deep blue-green background seems to surround the smaller shapes of white, red, black, and pink that are repeated throughout the composition. The inevitable flattening of the surface and lack of atmospheric perspective give a strong graphic quality to the Boston park scene. To enhance the Japanese reference, Prendergast has imitated the characteristic pose of the Japanese woman in such prints—bending at the waist to gather up her long skirts as she moves forward, and, in doing so, emphasizing the bustle in the back.

Prendergast's study of Japanese prints was aided by such friends as Charles Hovey Pepper, who later traveled to Japan and published a book on them in 1905; Ernest Fenellosa, who inaugurated the extensive Asian collection of the Museum of Fine Arts in Boston; and Arthur Wesley Dow (1857–1922), who was developing his own version of woodblock prints and formulating a system of teaching art based on their design principles.

Dow's teaching method was published in 1899 as *Composition,* one of the most widely used and enduring art manuals, still in print today. Through a series of exercises, the student is taught to view the pictorial design as a flat surface divided by abstract lines that first and foremost make a pleasing composition. The force of the finished work thus comes from the flat, abstract design, divided into areas or zones by sweeping lines. The exercises are often based on Japanese or other Asian art styles, but Dow also believed that studying architecture, especially as it was made more graphic in black-and-white photographs, could help artists improve their compositional skills.[18]

A comparison of Prendergast's *Float at Low Tide, Revere Beach* (fig. 16) with Dow's *Little Venice* (fig. 17) shows the similar way in which the two were working on the problems of opposition, transition, subordination, repetition, and symmetry in art (as Dow identified the aspects of composition in his teaching). Dow's color woodcut, done in Ipswich, Massachusetts, in the years before he traveled to Venice in 1896, employs geometric architectural shapes divided into color zones that are repeated through the reflection of the water. On a larger scale, the same devices can be seen in Prendergast's watercolor, which was also done on Boston's north shore. The intellectual framework of

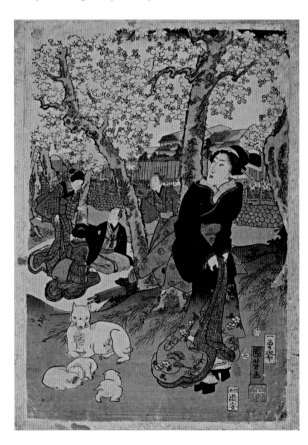

Fig. 16
Maurice Prendergast
Float at Low Tide, Revere Beach,
ca. 1896–97
Watercolor and pencil on paper
13¼ × 9¼ in. (33.7 × 23.5 cm), sight
Addison Gallery of American Art,
Phillips Academy, Andover,
Massachusetts
Gift of Mrs. William C. Endicott
(1942.2)
CR 634

this kind of pictorial design far surpasses Prendergast's work in Paris, and, although based on both artists' thorough knowledge of Parisian Post-Impressionism, it was within the Boston milieu of self-conscious art theory that Prendergast achieved the sophisticated structure that is the underpinning of his art's "spontaneity."

Planning a Trip to Venice

In 1897, Hermann Dudley Murphy, Prendergast's friend from Paris, returned to Boston. This dynamic young man had spent another two years studying in Paris and traveling around Europe, including, for an extended stay in 1894–95, Italy and Venice. Like Sarah Sears, Murphy was an organizer, and he quickly swept Prendergast up into a number of joint exhibitions over the next few years. Unlike Prendergast, Murphy was part of the elite Boston art world, having studied at the Boston Museum School with American Impressionist Joseph DeCamp in the 1880s. His figure paintings were reminiscent of Edmund Tarbell's blend of Vermeer and Asian ingredients, but he also painted landscapes and views, and he returned from Europe with a significant group of Venetian watercolors. He experimented widely with media, developing a color monotype technique that influenced Prendergast, and

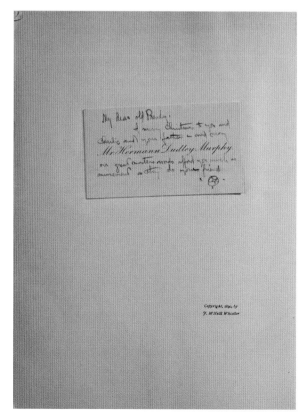

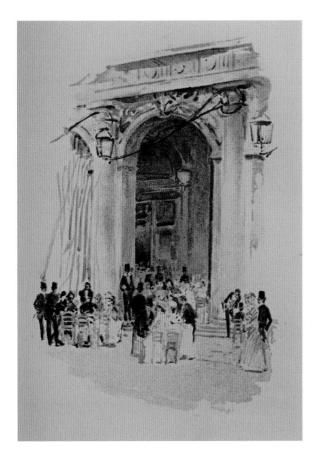

Fig. 20
Childe Hassam (American, 1859–1935)
Café Florian in the Piazza San Marco, n.d.
Reproduction in William Dean Howells, *Venetian Life*, Boston (Houghton-Mifflin) 1892, vol. 1, opposite p. 74
Private Collection
Photo Credit: Arthur Evans

Fig. 21
Ross Turner (American, 1847–1915)
A Dark and Secret Court, n.d.
Reproduction in William Dean Howells, *Venetian Life*, Boston (Houghton-Mifflin) 1892, vol. 1, opposite p. 40
Private Collection
Photo Credit: Arthur Evans

later opened the influential frame workshop Carrig-Rohane in Winchester, Massachusetts, with Charles Prendergast. In 1898, Charles and Maurice Prendergast moved to Winchester to join Hermann and Caroline Murphy in that suburb of Boston.

A symbol of the Murphy–Prendergast friendship, and also of the kind of influence Murphy brought to bear on his colleague, was the gift of Whistler's *The Gentle Art of Making Enemies* (1890), which still bears the calling cards and Christmas wishes of Mr. and Mrs. Murphy. The inscription reads: "My dear old Prendy, A Merry Christmas to you and Charlie and your father and may our great master's words afford you as much amusement as they do your friend, [HDM monogram]." Murphy's message, albeit light-hearted, and his Whistleresque monogram convey the esteem in which he held "the Butterfly." His Venetian watercolors echo the quietude of Whistler's etchings and pastels of the side canals of Venice, and he also tried his hand at nocturnes in oil.

Murphy's enthusiasm at this moment clearly nudged Prendergast to follow the well-worn path of the "great master" (and of Murphy) to Venice. Murphy seems to have made another gift of a book in 1898—Baedeker's *Northern Italy*—in which Murphy annotated the location of his former hotel and studio in Venice. It was also Murphy who stored the watercolors that Prendergast sent home from Venice and arranged for them to be transported between exhibitions in Boston and a joint show that Murphy arranged at the Art Institute of Chicago while Prendergast was still abroad.

With the urging of his friend, and the ubiquitous Boston prejudice toward Venice as the ideal artistic destination, Prendergast needed only the funds to make a trip to Italy a reality. These came in the form of a kind of loan or grant from Sarah Sears, who "staked" him to a year in Venice.[19] Judging from the fact that an artist could live in Italy for over a year on $500, including steamship travel, we can imagine that was the sum offered him. The fact that Mrs. Sears acquired at least five important watercolors from this trip, when the prices ranged up to $100 a piece, suggests that the loan was repaid in art. It would have been advantageous for Prendergast to have such a progressive patron and the guaranteed sale of so many works.

Aside from Murphy's Venetian watercolors, Prendergast would have contemplated other recent watercolors of Venice, such as those reproduced in a deluxe new edition of William Dean Howells's *Venetian Life* (1892). Published in two precious volumes decorated in gold, this new edition of Howells's book included commissioned works by well-known American artists who had previously painted in Venice, including Childe Hassam, F. Hopkinson Smith, Ross Turner, and Rhoda Holmes Nichols. Hassam's depiction of Caffè Florian in St. Mark's Square (fig. 20) showed Venice with Parisian elegance, while Smith's *Corner of the Rialto* took the genre painter's approach to the local scene. Turner, an artist and architecture professor at the Massachusetts Institute of Technology (MIT), came the closest to Whistler's sketchy style in his Japoniste study *A Dark and Secret Court* (fig. 21). Howells's much-loved evocation of Venice was first published in 1866, during one of Italy's darkest periods, and has an elegiac tone. The plates, on the other hand, represent a more current view of Venice—fashionable and Whistlerian.

Whistler's own Venetian works could be seen in Boston. His first and second Venice sets (fig. 23) were in many American collections, while nocturnes that evoked the Venice paintings, including Isabella Stewart

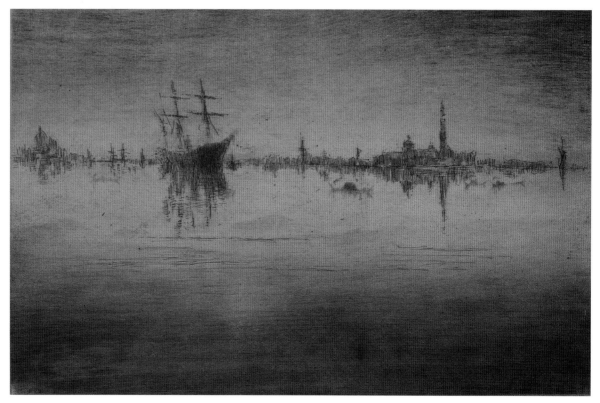

Fig. 24
Photograph of Maurice
Prendergast (standing), ca. 1898
Prendergast Archive and Study Center,
Williams College Museum of Art,
Williamstown, Massachusetts
Photo Credit: Arthur Evans

Gardner's *Nocturne, Blue and Silver: Battersea Reach*, were also available for study.[20] At a glance, Prendergast's work of the mid-1890s was far from the hazy, suggestive style that Whistler had made famous in about 1880. But Prendergast's openness to Japanese devices was part of the Whistler legacy in American art. Furthermore, Whistler was an inspiration to any artist who had an original vision of new art for modern times. The Venice section of *The Gentle Art of Making Enemies* recorded the scathing critical comments published in response to the Venice pictures (" 'Another crop of Mr. Whistler's little jokes.' *Truth*"[21]), and served as a reminder to all

artists to follow their own paths without fear of being misunderstood by critics.

Thus, armed with money, encouragement, and inspiration, Maurice Prendergast applied for a passport on June 29, 1898, and set sail for Italy soon afterward. He stayed almost a year and a half, before starting for home again on November 16, 1899. During this time, he spent almost a year in Venice itself and took the winter of 1898–99 to travel south to Florence, Siena, Assisi, Rome, and Capri, among other Italian destinations. Knowing he had exhibitions and patrons waiting, he was extremely productive. Featured in the

Fig. 25
Title page of Karl Baedeker,
*Italy: Handbook for Travellers:
Northern Italy*, Leipzig
(Karl Baedeker) 1895
Prendergast Archive and Study Center,
Williams College Museum of Art,
Williamstown, Massachusetts
Photo Credit: Arthur Evans

Fig. 26
Maurice Prendergast
Sketchbook
("Italian Sketchbook"),
ca. 1898–99
6¾ × 4½ in. (17.1 × 11.4 cm)
The Cleveland Museum of Art
Gift of Mrs. Charles Prendergast
(51.422)
CR 1479

present catalogue are 144 works created or based on this trip (not including individual sketchbook pages or the second side of double-sided works from the same period), but there were undoubtedly many more that cannot be identified today. As Prendergast said in a letter before he left, "it has been the visit of my life."[22]

The Prendergast Archive and Study Center is fortunate to have not only Prendergast's guidebook for this trip (Baedeker's *Northern Italy*; fig. 25) but also a collection of seven photographs of Venice probably acquired there. In addition, a sketchbook with related sketches and frame studies for Italian works is in the Williams College Museum of Art. The Cleveland Museum of Art holds a rich sketchbook (fig. 26)

probably used during the second half of Prendergast's stay, since it includes a draft for a letter about his return, cited above. A handful of published essays on Prendergast, one written during his lifetime by his friend Charles Hovey Pepper, discuss the trip and offer some brief and informal information about his travels. But other than these sources, there is an intimidating lack of documentary evidence; no letters, journals, or memoirs from the artist or his family and friends have survived. Our understanding of the artist and his works thus depends mainly on looking closely at the works themselves and on a patient accumulation of contextual literature that was published in books and periodicals available to Prendergast in Boston.[23]

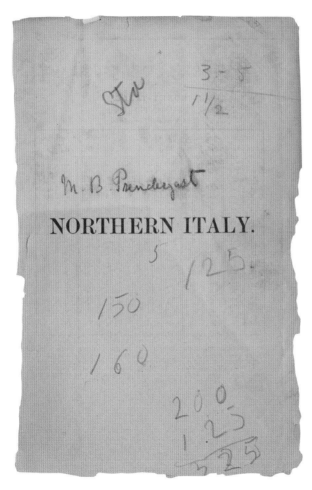

Church and State: Modern Life in Venice

Three monumental flagpoles were erected in front of the basilica of St. Mark's in 1376, and for more than five hundred years they flew the red-and-gold banners of the Venetian Republic. St. Mark's was an unusual basilica because, although part of the Roman Catholic Church, it famously maintained its independence. It was also unusual because of its direct ties to the Venetian state: it originated as the chapel of the Doge's Palace and, as it was enlarged into a great church and the city's spiritual center, it remained physically tied to the palace itself. Political as well as religious ceremonies took place in the basilica, and the piazza, or square, in front of it was the religious, political, and social hub of Venice. In the nineteenth century, Venice's successful assimilation of religion and politics was much discussed in terms of modern-day struggles to achieve the best national balance between church and state. Americans in particular identified with the freedom they saw in Venice's almost secular approach to the union of the two and the fact that, as Harvard professor Charles Eliot Norton noted, her people were "First Venetians and then Christians."[24]

The ancient Venetian Republic, much admired by such Americans as Norton, had come to an end with Napoleon's defeat of the city in 1797. For most of the following seventy years, Venice was under Austrian rule, until, in 1861, it became part of the newly formed kingdom of Italy. One of Napoleon's legacies in Venice was the new flag of the kingdom of Italy—green, white, and red—which he designed to show the connection of Italy to France and the French tricolor (fig. 29).[25] It was not used during Austrian rule, but it was revived during a brief period of independence, in 1848. In 1866, the flag acquired the shield of the house of Savoy, a white cross on a red ground, in honor of the new king. It was this flag of the kingdom of Italy, with its complex political associations, that flew in front of St. Mark's until after the Second World War, when the Savoy shield was removed and the current Italian tricolor was established.

The flags are on view in St. Mark's Square only on Sundays and holidays, so it is not too surprising that the many views of this church from the nineteenth century, including Whistler's *Nocturne: Blue and Gold— St. Mark's, Venice* (fig. 31), do not include them. Nor

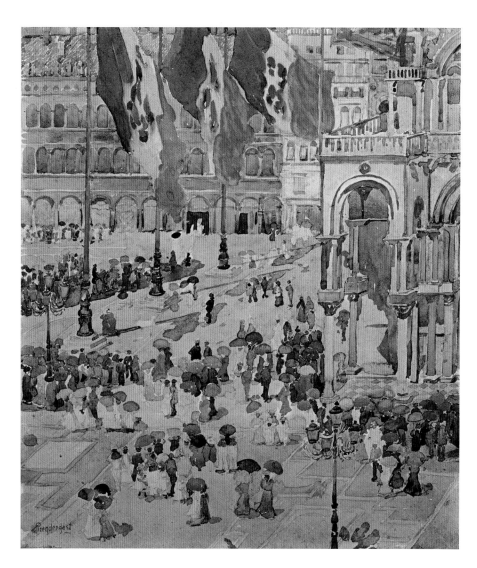

Fig. 27
Maurice Prendergast
Piazza of St. Mark's,
ca. 1898–99
Watercolor and pencil on paper
16⅛ × 14⅛ in. (41 × 36 cm)
Private Collection, New York
CR 684

Fig. 28 (opposite)
Maurice Prendergast
Splash of Sunshine and Rain,
1899
Watercolor and pencil on paper
19⅜ × 14¼ in. (49.2 × 36.2 cm)
Private Collection
Courtesy of Avery Galleries,
Bryn Mawr, Pennsylvania
CR 674

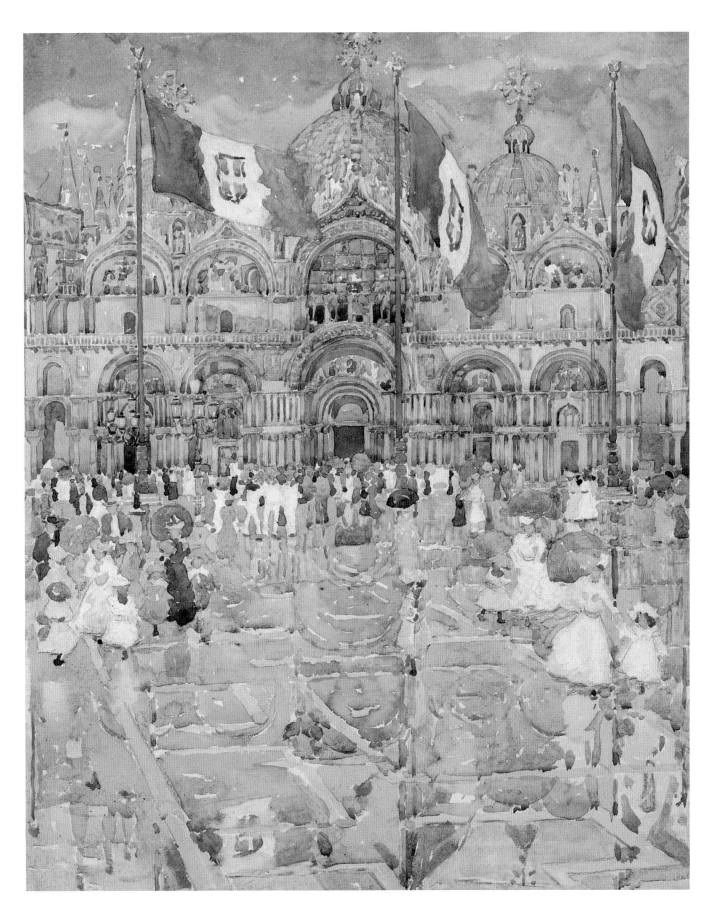

Fig. 29 (below)
Flag of the kingdom of Italy,
from W.J. Gordon, *Flags of the
World*, London (Frederick Warne
& Co.) 1915, pl. 30
Sawyer Library, Williams College,
Williamstown, Massachusetts
Photo Credit: Arthur Evans

Fig. 30 (bottom)
Maurice Prendergast
Venice, ca. 1898–99
Watercolor and pencil on paper
14⅛ × 20¾ in. (35.9 × 52.7 cm)
Williams College Museum of Art,
Williamstown, Massachusetts
Gift of Mrs. Charles Prendergast
(86.18.61)
CR 678 (recto)

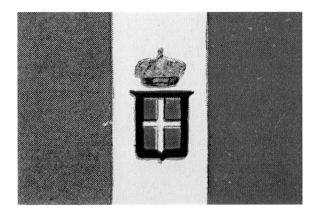

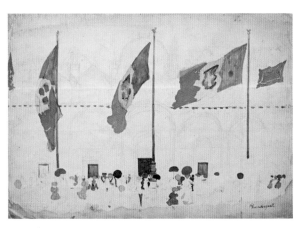

does Ruskin's famous description of entering St. Mark's Square in 1853: "beyond those troops of ordered arches there rises a vision out of the earth . . . a multitude of pillars and white domes, clustered into a long low pyramid of coloured light."[26]

The virtual absence of these flags in the artistic consciousness of the nineteenth century makes Prendergast's adoption of them that much more striking. Not only do the colorful shapes give a modern look to his paintings (figs. 27, 28), but also the flags themselves convey a complicated message about modern Italy and Venice's relationship to it. They can be read as both positive and negative statements about the new country and its painful

process of modernization. Since they were flown only on holidays, they can also be seen to symbolize another aspect of modern Venice: the "holiday" character of the city, as reflected in the proliferation of *feste* and the tourist industry. If there were no other innovations in Prendergast's views of Venice, his use of the flags to signal the transformation of ancient Venice into a modern city was a sufficiently original contribution.

Why would Prendergast have focused on such a motif? Possibly because national flags in front of such a church as St. Mark's would have been an unusual sight to American eyes. Back home, the American flag, which Prendergast was quick to use in his views of Boston—for example, *Franklin Park*—was not typically flown in

Fig. 31 (top)
James McNeill Whistler
(American, 1834–1903)
*Nocturne: Blue and Gold—
St. Mark's, Venice*, 1879–80
Oil on canvas
17½ × 23½ in. (44.5 × 59.7 cm)
Amgueddfa Genedlaethol Cymru,
National Museum of Wales, Cardiff

Fig. 32 (above)
St. Mark's Square with Pigeons,
1897
Photograph
Prendergast Archive, Williams College
Museum of Art, Williamstown,
Massachusetts
Photo Credit: Arthur Evans

front of religious buildings. This startling combination in St. Mark's Square would have been Prendergast's introduction to the atmosphere of freedom offered by Venice's traditional tolerance, even encouragement, of strong beliefs. Even though such a literal combination of church and state would not be found on American shores, the ideals it represented were a source of American pride. The Italian psychologist Cesare Lombroso (1835–1909), writing about the former greatness of Venice, recognized the passing of the torch to America in that country's ability to nurture great ideas: "in democratic governments, where the ferment of freedom creates tolerance for new things, men of genius make their way much more easily."[27] Prendergast, as an artist striving for a new style himself, would have appreciated the fostering of new ideas that the flags and their placement symbolized.

By placing these colorful banners so prominently in his compositions (figs. 30, 33), Prendergast could also immediately demonstrate that he meant to paint the Venice of his day, rather than the timeless monument to the past that had preoccupied writers and artists throughout the nineteenth century. He consciously departed from the dematerialized "vision" of an unchanging St. Mark's that Ruskin had made the norm from mid-century and that, ironically, was rendered so beautifully by Ruskin's enemy in the London art world, Whistler (see fig. 31). Although Prendergast showed he too could dematerialize St. Mark's, for instance in the reflections of a flooded piazza seen in *Splash of Sunshine and Rain* (fig. 28) and *St. Mark's, Venice* (CR 675; see p. 170), he used the prominent flags to fix his painting irrevocably in the present.

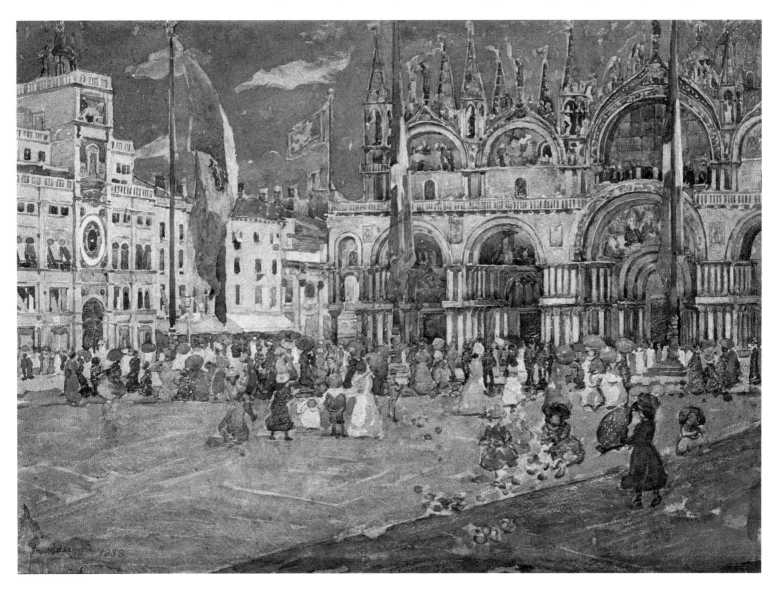

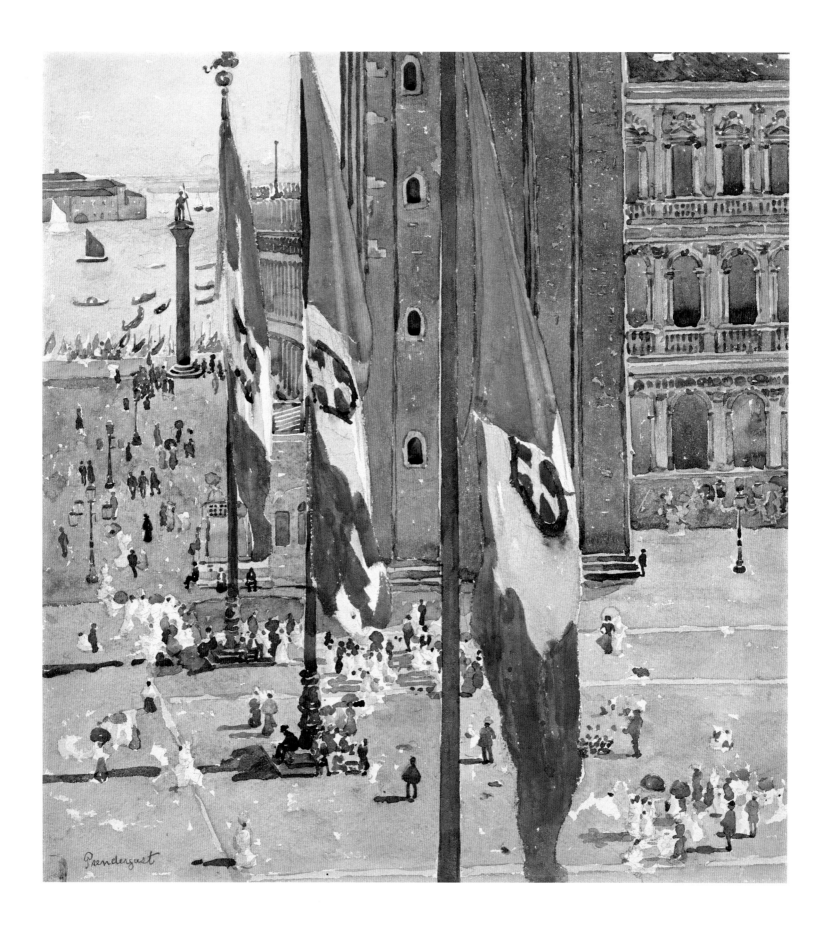

If Prendergast had recast reality and replaced the Italian tricolors with the red-and-gold ducal flags of Venice (seen on either side of the façade of the church), he might have evoked ancient Venice, as Ruskin and Whistler had. Prendergast's "reality" was not so literal that he copied everything he saw. In his *Piazza di San Marco* (fig. 34), for example, he simplified the inlaid design in the pavement of the piazza when he painted it from an upper floor of the clock tower. And he was not above altering flags in his paintings of Venice. The civic flag of the city of Venice, with its gold lion, was replaced by a flag with a double cross when the artist went from the sketch for *Market Place, Venice* to the finished watercolor (figs. 38, 39). Even in his many depictions of the flags of St. Mark's, he simplified the flag of Venice, which in reality had varying numbers of "tails."

But Prendergast did not alter the enormous banners of the kingdom of Italy. Rather, he sketched the blowing shapes obsessively and even showed the subtle variations of the designs of the official flags

when each was hoisted. In the unfinished *Piazza S. Marco, Venice* (fig. 36) and *Flags in Piazza San Marco* (fig. 37), he depicts the "crowned" flag, which denoted an official government or military context[28] and probably marked a state visit by the king of Italy or another head of government. He was obviously observing the banners closely and preserving every bit of symbolism.

The result was that the flags would have been jarring not only in an artistic sense (for admirers of Ruskin and Whistler) but also in a political one. By 1898, even after four decades of struggle, Italy was far from harmoniously unified. Each region of the Italian peninsula claimed its own identity and chafed under the rule of the king and the capital in Rome. Nowhere was this truer than in Venice, which had always maintained its distance from Rome, in both church and state matters. The domination of the large green, white, and red banners over the smaller red-and-gold flags in St. Mark's Square was a constant reminder of Venice's subjugation to the king of Italy.

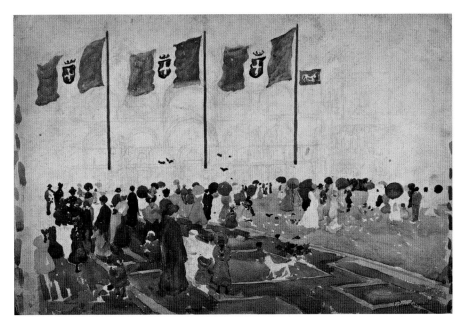

Fig. 35 (top)
Maurice Prendergast
Pencil drawings of flags
Sketchbook
("Italian Sketchbook"),
ca. 1898–99
6¾ × 4½ in. (17.1 × 11.4 cm)
The Cleveland Museum of Art
Gift of Mrs. Charles Prendergast
(51.422)
CR 1479

Fig. 36 (above)
Maurice Prendergast
Piazza S. Marco, Venice,
ca. 1898–99
Watercolor and pencil on paper
13⅛ × 19½ in. (33.3 × 49.5 cm)
Collection of Roy and Cecily Langdale
Davis
CR 677

Fig. 37 (right)
Maurice Prendergast
Flags in Piazza San Marco,
ca. 1898–99
Watercolor and pencil on paper
19¼ × 12½ in. (48.9 × 31.7 cm)
Williams College Museum of Art,
Williamstown, Massachusetts
Gift of Mrs. Charles Prendergast
(91.28.6)
CR 1023 (verso)

Politically and artistically, Prendergast's flags disrupt the illusion of Venice's glorious past and force the viewer into the present, with all the tensions and anxieties that went with the modernization of that unique city. But modernization was inevitable, and Prendergast was not alone in recognizing that it could also be good. By the 1890s, despite regional unrest, the unified Italy had undergone considerable development in terms of industry and infrastructure. New roads, railroads, buildings, and factories, as well as agricultural advances, had transformed many parts of the country. Although her geographical peculiarities excluded her from much of this development, Venice too saw her share of modern prosperity. The city was designated the official port of Italy, giving new life to the old shipping and shipbuilding industries. In the outlying areas of the islands and the Giudecca, factories sprung up. While modern modes of transportation were rendered almost impossible in the dense city, motorboats appeared, including the public steam-powered omnibuses called *vaporetti*, instituted in 1883 despite the protests of gondoliers. This was a desirable change to the many observers who thought

the aesthetic of picturesque poverty in Venice was patronizing: "Venice, prosperous and smiling, conscious of the increase of commerce which has come to her through her well-loved parent, Italy . . . is no longer an object of pathetic pity."[29]

In the same spirit, Prendergast's reinterpretation of St. Mark's by foregrounding the Italian flags, the emblems of her modern identity, was also a celebration of the new. When the watercolors were first shown in Boston, in the spring of 1899 (while Prendergast was still in Italy), the flags were noticed right away. His new work appeared to be a continuation of his previous scenes of modern life with new focus, particularly the "highest notes of color massed effectively in the great banners of green, white and red."[30] Because the appearance of the flags in and of itself meant that it was a Sunday or holiday, they were immediately associated with colorful non-workday dress and activities. The rise in the Venetian economy afforded greater leisure to its people—a worldwide phenomenon at the end of the nineteenth century—as well as encouraging tourism.[31] There was no longer any need

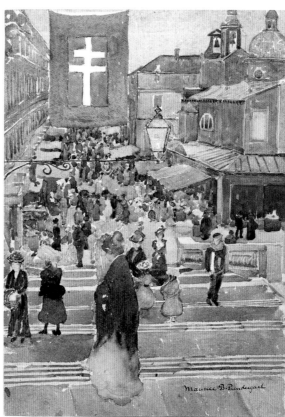

Fig. 38
Maurice Prendergast
Pencil sketch for *Market Place, Venice*
Sketchbook
("Italian Sketchbook"),
ca. 1898–99
6¾ × 4½ in. (17.1 × 11.4 cm)
The Cleveland Museum of Art
Gift of Mrs. Charles Prendergast
(51.422)
CR 1479

Fig. 39
Maurice Prendergast
Market Place, Venice,
ca. 1898–99
Watercolor and pencil on paper
13⅜ × 10 in. (39.9 × 25.4 cm)
Private Collection
CR 706

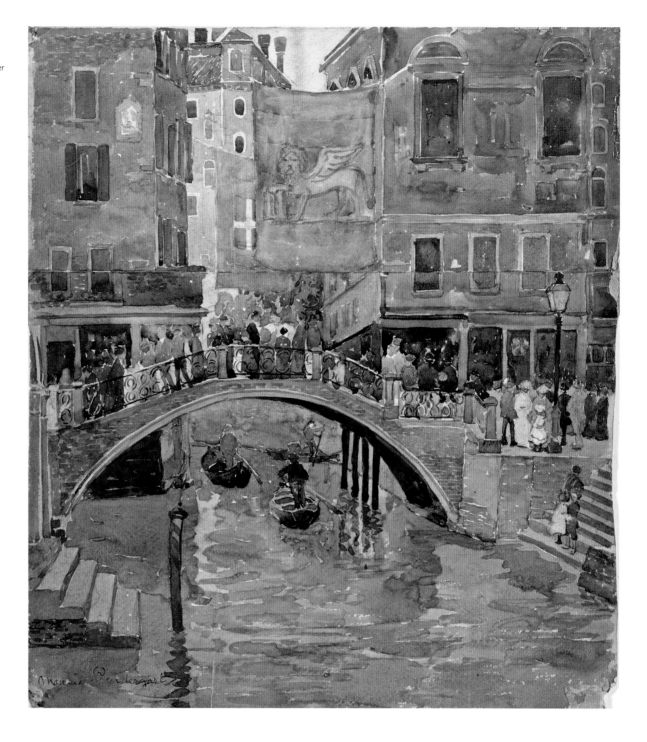

to elegize the city for its decay; instead, it could now be admired for its "joyfulness of life . . . the stir and bustle of a prosperous community."[32]

Complex and shifting in meaning, the flags of Italy in front of St. Mark's evoked issues of church and state, the pros and cons of unification, and the tension brought about when the new is suddenly inserted into the context of the old. Prendergast's choice of such a

rich motif for his paintings of modern Venice gave dimension to the whole series and explains their originality, even if all the symbolic associations were not immediately grasped. His thoughtful choice of motifs in the Italian series makes us look twice at the rest of his work, and makes us look deeper into even the most seemingly casual depictions of modern life in Venice.

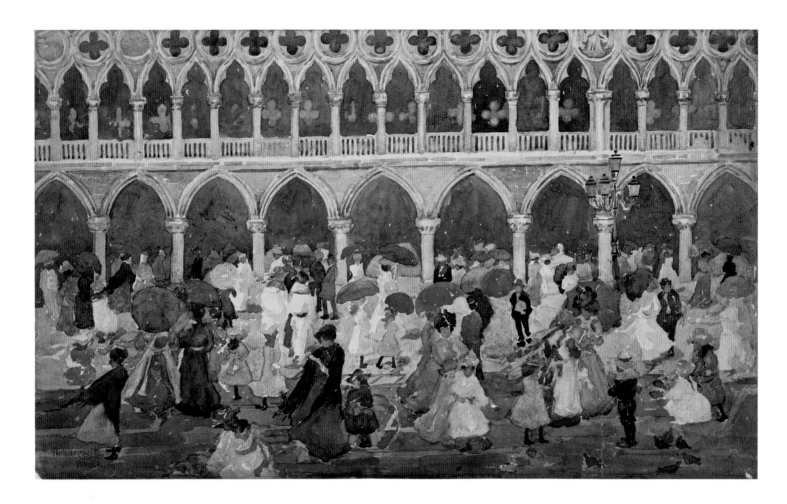

Festivals, Tourism, and the Americanizing of Venice

With the growth of urban centers in the nineteenth century, crowds became a compelling new theme for art and literature. Such cities as Paris, London, and New York became known for the distinctive patterns of modern life seen in their new boulevards and market districts. This became true in Venice also, as writers and artists struggled to characterize the crowds that were such an important part of the experience of this unique city (figs. 39, 40). The center of activity was St. Mark's Square and its radiating arms: the shopping street called the Merceria in one direction, and the areas along the Grand Canal—the Piazzetta, Ponte della Paglia, and Riva degli Schiavoni—in the other. Secondary sites were the Rialto Bridge, leading to the other side of the Grand Canal, and the promenade of the Zattere in Dorsoduro.

Cleverly capitalizing on the "floating" character of Venice, Henry James used the metaphor of a ship to portray these areas, describing "the Piazza as an enormous saloon and the Riva degli Schiavoni as a promenade deck."[33] Others focused purely on the social scene around St. Mark's. Baedeker's *Northern Italy* (1895), which Prendergast owned, described the Piazza as a "huge open-air drawing-room."[34] Some sense of this random, socializing crowd in the southern branch of the square can be seen in Prendergast's *Sunlight on the Piazzetta, Venice* (fig. 41). But the saloon or drawing-room was only one of the many types of crowd activity that were distinctively Venetian; others included the procession, the promenade, the *festa* (on land and on sea), and the crowd of people in gondolas. Prendergast, who had already established himself as a keen interpreter of crowds in Paris and Boston, studied them all.

Like the Italian flags in front of St. Mark's, the presence of so many people participating in a variety of social activities was a sign of the new life of Venice. This was true in two very specific ways: the resurgence of *feste* after the liberation from Austria, and the growth of organized tourism in the second half of the nineteenth century. That *feste*, even religious celebrations and

Fig. 41
Maurice Prendergast
Sunlight on the Piazzetta, Venice,
ca. 1898–99
Watercolor over graphite pencil on paper
12⅜ × 20⅝ in. (31.8 × 52.4 cm)
Museum of Fine Arts, Boston
Gift of Mr. and Mrs. William T. Aldrich,
61.963
CR 690

Fig. 42 (opposite, top)
Maurice Prendergast
Festival Day, Venice, ca. 1898–99
Watercolor and pencil on paper
12⅝ × 20 in. (32.1 × 50.9 cm)
Mount Holyoke College Art Museum,
South Hadley, Massachusetts
Purchase with the Gertrude Jewett Hunt
Fund in memory of Louise R. Jewett,
1951.167.1 (b).Pl
CR 691

Fig. 43 (opposite, bottom)
*Feeding the Pigeons in Front
of the Ducal Palace*, n.d.
Prendergast Archive and Study Center,
Williams College Museum of Art,
Williamstown, Massachusetts
Photo Credit: Arthur Evans

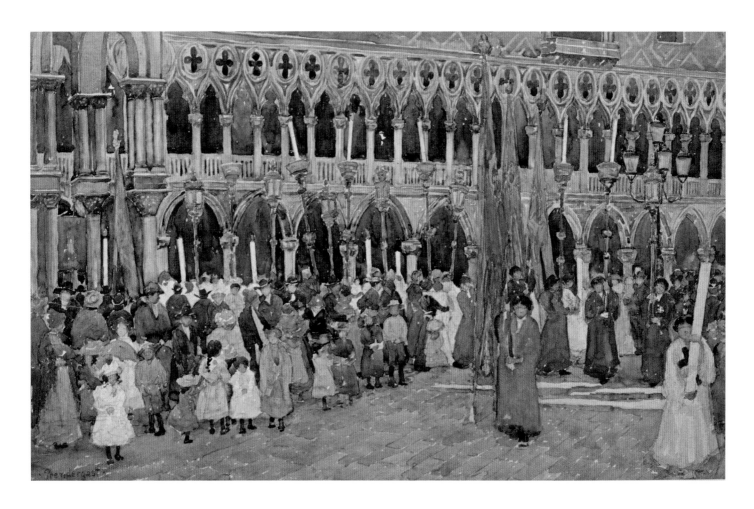

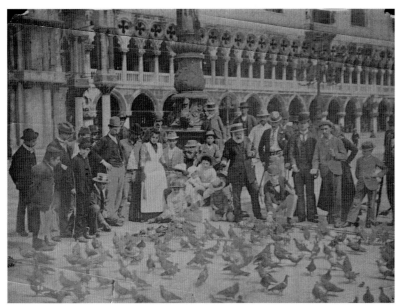

processions, went hand in hand with tourism might be inferred from Prendergast's "twin" watercolors of the Piazzetta in front of the Doge's Palace: *Sunlight on the Piazzetta, Venice* (fig. 41) and *Festival Day, Venice* (fig. 42). At a glance, they show Venice's past and present, but a closer look shows how the past is the present in Prendergast's depiction. The religious procession was just as much modern spectacle as it was spiritual experience, and it would be replaced on the Piazzetta within moments by the equally interesting group of "drawing-room" socializers in *Sunlight on the Piazzetta*.

It had always been characteristic of Venice to combine its religious and secular history. As Horatio Brown, the popular interpreter of Venice in the nineteenth century, pointed out, "no event of foreign or domestic importance to Venice . . . would occur, but the Government ordained its commemoration by an ecclesiastical function. . . . So Venice became a city of festivals and processions, in which the people flattered their patriotism and honoured their own achievements."[35] The crowds circulating around the

Fig. 44
Maurice Prendergast
Festival, Venice, ca. 1898–99
Watercolor and pencil on paper
18⅜ × 14⅜ in. (46.6 × 36.4 cm)
The Museum of Modern Art, New York
Gift of Abby Aldrich Rockefeller
(133.1935)
Digital Image © The Museum of
Modern Art/Licensed by Scala/
Art Resource, New York
CR 713

Fig. 45 (opposite, left)
Maurice Prendergast
Easter Procession, St. Mark's,
ca. 1898–99
Watercolor and pencil on paper
18 × 14 in. (45.7 × 35.6 cm), sight
Collection of Joyce and Erving Wolf,
New York City
CR 680

Fig. 46 (opposite, right)
Maurice Prendergast
*The Porch with the Old Mosaics,
St. Mark's, Venice*, ca. 1898–99
Watercolor and pencil on paper
16 × 11¼ in. (40.6 × 28.6 cm)
Private Collection, St. Louis
CR 679

city could at any given time witness or even be incorporated into these events (fig. 44). In addition to the great city-wide celebrations, such as the festival of the Madonna della Salute (November 21), the Redentore (third Sunday in July), and Corpus Christi (Palm Sunday), each parish church held an annual celebration in honor of its patron saint.[36] Processions were also organized for funerals and other personal occasions. Since all of these Venetian events took place outdoors in public and involved special dress, the carrying of banners, statues, and other church symbols, and the decoration of buildings and streets, they were otherworldly spectacles but also a normal part of modern city life. Prendergast emphasized this fact by painting *Festival Day, Venice* (fig. 42) and *Easter Procession, St. Mark's* (fig. 45) with equal numbers of participants and spectators. It may even be inferred from depictions of religious architecture with spectators, such as *The Porch with the Old Mosaics, St. Mark's, Venice* (fig. 46).

The implication of Prendergast's work is that spectacles depend on spectators for their meaning, if not for their very existence. The theme of the observer and the observed ran throughout nineteenth-century

French art and literature and was famously summed up by Baudelaire's idea of the artist as *flâneur*, or boulevardier, devoted to the study of life on the streets of Paris. Prendergast's Paris pictures, such as *Boulevard des Capucines* of 1892 (fig. 6), and his Boston park and beach scenes show his work in this vein. In his Venice watercolors, however, he depicts not just the crowds as observed by the artist but also the crowds as observed by one another.

It is the importance of the spectator in Prendergast's interpretation of modern Venice that makes his art at once bolder and yet more subtle in its treatment of that ubiquitous Venetian sight—the tourist. Neither flattering nor caricaturing these determined wanderers through the monuments of Venice, Prendergast gives a knowing but tolerant view of how modern tourism had affected the city. As one observer put it:

[T]he Venetian strives to make every day a holiday and every night a festival. If the gayety is forced a little, or has a commercial aspect, we will not think so. If the illuminated boats in the Grand Canal, with bands of floating serenaders, are too visibly for the entertainment of strangers, and not the spontaneous expression of a gay moonlight sentiment, we will not believe it. The nights are just as beautiful as ever.[37]

The frequency of nighttime *feste* reached its peak in the late nineteenth century in response to tourist demand. In addition to the elaborate and ancient Festa del Redentore (Feast of the Redeemer), which is still mounted today, there were seemingly endless *serenate*, which involved boats coasting up and down the Grand Canal carrying musicians, behind which would come gondolas carrying tourists and other merrymakers. These music boats, decorated with colored lanterns, made an exotic spectacle, whether witnessed from the banks of the canal—as in Prendergast's two "columns," *Column of St. Theodore* (fig. 47) and *St. Mark's Lion, Venice* (fig. 48)—or from a gondola. On special nights, the palaces along the Grand Canal would also be brightly lit, creating a magical, dematerialized blend of color, light, and reflections, which was described by many tourists. Memorable *feste* were organized to honor important diplomatic events, such as the visit of Empress Eugénie of France in 1869 and the meeting of the king of Italy and the emperor of Germany in 1895. On these occasions, as on the eve of the Festa del Redentore, fireworks would add to the spectacle.

In keeping with the international flavor of these festivals, Prendergast used several devices to convey a rich mixture of people and traditions. In *Via Garibaldi* (fig. 49), for instance, the people promenading underneath the banners are in typical Western garb except for the most prominent woman in the foreground, who wears the traditional white holiday dress and long fringed shawl of Venice. The two dress codes coexisted

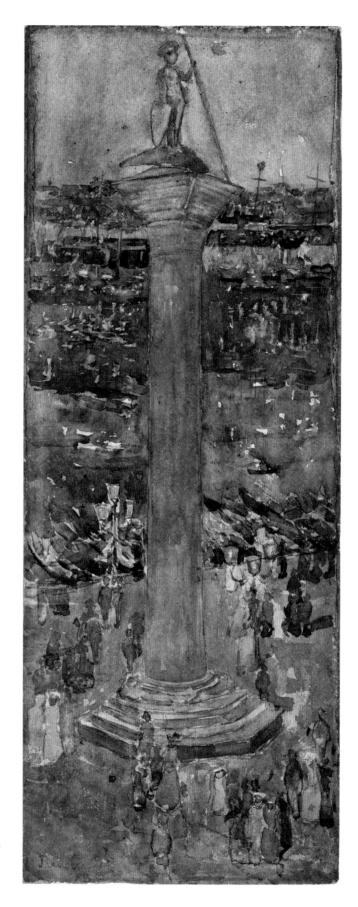

Fig. 47
Maurice Prendergast
Column of St. Theodore,
ca. 1898–99
Watercolor and pencil on paper
15½ × 6 in. (39.4 × 15.2 cm)
Williams College Museum of Art,
Williamstown, Massachusetts
Gift of Mrs. Charles Prendergast
(95.4.93)
CR 693

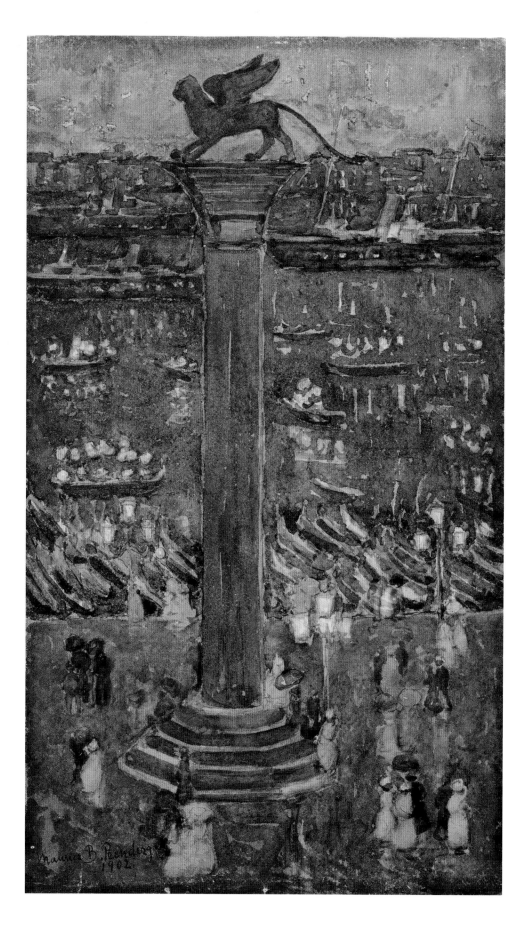

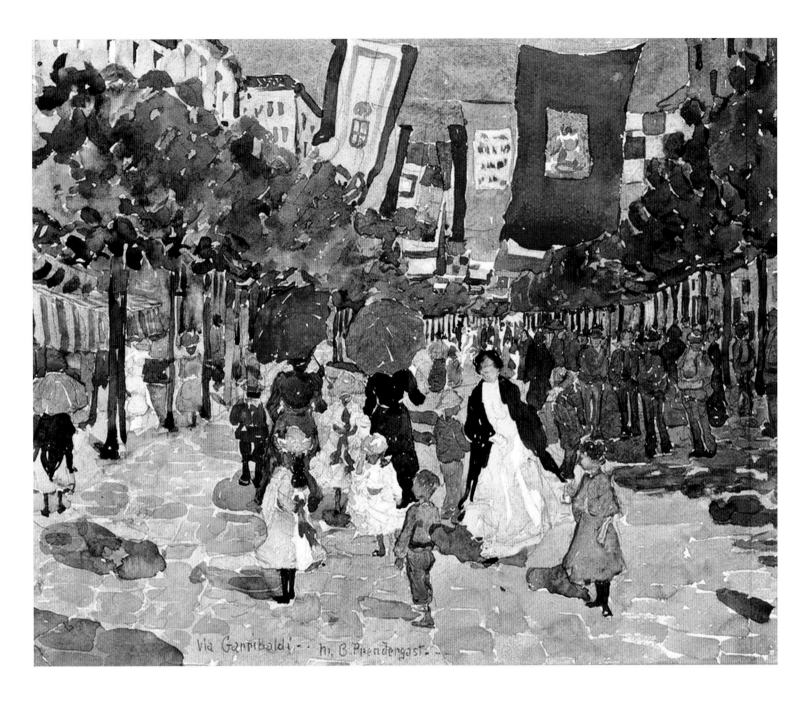

Fig. 49
Maurice Prendergast
Via Garibaldi, ca. 1898–99
Watercolor and pencil on paper
11⅛ × 13⅞ in. (28.3 × 35.2 cm)
Cheekwood Botanical Garden and
Museum of Art, Nashville, Tennessee
Museum Purchase through the Bequest
of Anita Bevill McMichael Stallworth
CR 705

Fig. 50 (opposite)
Maurice Prendergast
Fiesta—Venice—S. Pietro in Volta,
ca. 1898–99
Watercolor and pencil on paper
13⅜ × 12½ in. (34 × 31.7 cm)
Williams College Museum of Art,
Williamstown, Massachusetts
Gift of Mrs. Charles Prendergast
(86.18.76)
Photo Credit: Arthur Evans
CR 729

in a city that had long hosted foreign guests and styles but kept its fierce local pride. By comparison, in a similar composition, nonsensically entitled *Fiesta— Venice—S. Pietro in Volta* (fig. 50), showing the small town of San Pietro in Volta in an outlying area of the Lido (not Venice), only local dress is portrayed, indicating a provincial, non-tourist society. Prendergast's sense of fashion and costume was acute by this time in his career, and he made the most of it while he was in Italy.

In addition to conveying the mixture of people and traditions in Venice through costume, Prendergast also

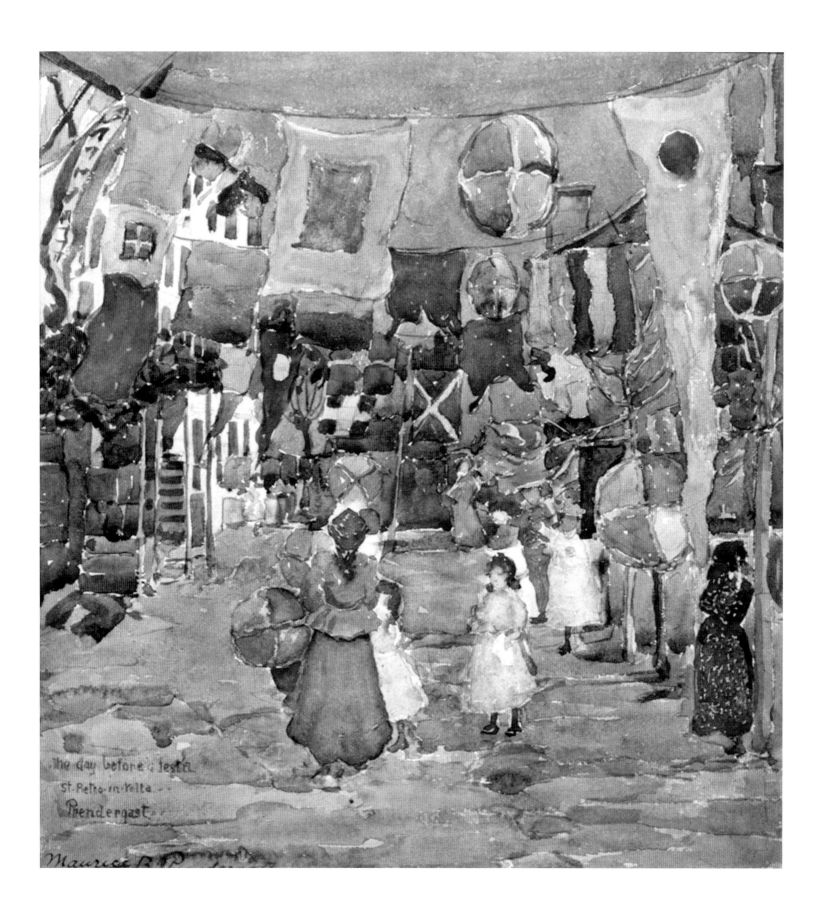

The day before a festa
St. Pietro in Volta
Prendergast

Maurice B. Prendergast

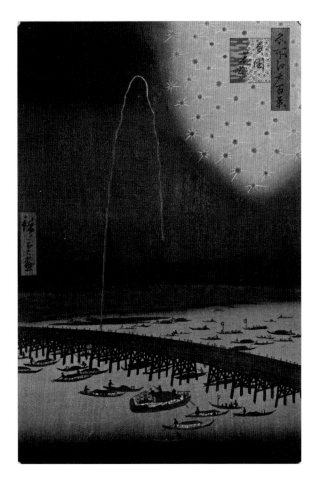

used an identifiably Japanese style to inject an even more international flavor into his compositions. The influence of Hiroshige's famous *Fireworks at Ryogoku* (fig. 51) can be detected in Prendergast's patterning of lights across the water on a dark night. The complex and detailed *The Bridge of Boats, Venice* (fig. 52) shows what such a scene might look like in daylight. The Bridge of Boats was constructed for the procession of the Festa del Redentore, which took place on a Sunday after fireworks and floating nighttime celebrations the night before (fig. 53). The procession started at St. Mark's and crossed both the Grand Canal and the Giudecca Canal on bridges constructed on top of special boats or barges. The destination was the basilica of Il Redentore (the Redeemer), designed by Andrea Palladio and constructed to commemorate the city's salvation from a disastrous plague in 1576.

Hiroshige can also be perceived behind Prendergast's *Ponte della Paglia (Marble Bridge)* (fig. 57), which, with its high point of view, flattens the perspective even more than the Japanese print (fig. 54). Such references to well-known prints by Hiroshige were consistent with recurring comparisons of sights in Venice to the people and culture of the East. From Ruskin onward, the blending of East and West in Venice, and particularly

Fig. 51
Utagawa Hiroshige
(Japanese, 1797–1858)
Fireworks at Ryogoku (Ryogoku Hanabi), No. 98 from One Hundred Famous Views of Edo
Edo Period, Ansei Era, August 1858
Woodblock color print
Image: 13⅜ × 8⅞ in. (34 × 22.5 cm)
Brooklyn Museum, New York
Gift of Anna Ferris (30.1478.98)

Fig. 52
Maurice Prendergast
The Bridge of Boats, Venice, ca. 1899
Watercolor and pencil on paper
9⅝ × 19⅛ in. (24.4 × 48.6 cm), sight
Private Collection, New York
CR 696

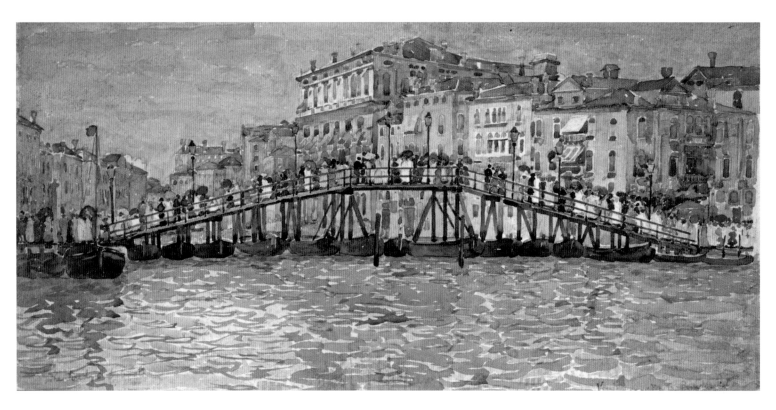

in St. Mark's, was unavoidable. Ruskin proclaimed that "the Venetians deserve especial note as the only European people who appear to have sympathized to the full with the great instinct of the Eastern races."[38] This statement was echoed, for example, by the Welsh poet Arthur Symons, who wrote in 1895 that "All Venice is a piece of superb, barbaric patch-work, in which the East and the West have an equal share."[39] Symons goes on to note that one of the distinctive physical types of Venetian has a Japanese appearance: "Remembering that nearness which Venice has always had to the East, it is not altogether surprising to find among the Venetian types, and not least frequently, one which is almost Japanese."[40] He notes the type's small features, dark hair, and puffed, drawn-back hairstyle. Prendergast sketched this type many times, making the long Venetian shawl resemble a kimono (fig. 55).

But the Ponte della Paglia series, unlike *Via Garibaldi*, for instance, does not show a mixture of fashionable and traditional garments. This series shows a strictly non-traditional Venetian crowd crossing a

"Hiroshige" bridge (fig. 56) as though nothing of the local culture remains once the swarm of tourists overtakes the town from May until October. In these works, Venice, unlike any other city, is the property of the world.

This, of course, was the great fear of the Venetophiles, both Venetians and others: that Venice would be completely overrun by tourists and made over by their foreign vision. The greatest fear of all was of Americans, who came to Venice in increasing numbers and who saw in the former Republic of Venice their own national ideals. Americans had already produced their own version of Venice in the canals and lagoon of the *World's Columbian Exposition* of 1893 held in Chicago. This conceit would be repeated in the *Pan-American Exposition* of 1901 in Buffalo, and again in the design of the town of Venice, California ("The Venice of America"), in 1904.

Americans not only copied Venice; for many years, they had also been taking it home with them. The great antiquities market of Venice, in which old buildings

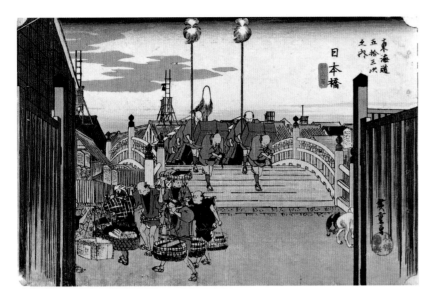

and their contents were systematically dismantled and sold, was the special haunt of Americans. Every year there were "more palaces turned into antiquity shops—indeed, the whole city is a sort of antiquity bazaar, a tarnished jewel-box."[41] If Venice might be considered a museum, as Henry James described it,[42] then the antiquities market was the museum shop. Many American courtyards and gardens at this time were graced with the distinctive carved well-heads of Venice.[43]

American export of the pieces and parts of old Venice may have been frowned upon, but American intrusion into Venice itself caused real alarm. As the old *palazzi* became white elephants to the financially

struggling Venetians, they were bought up by Americans, including the Curtises of Boston.[44] Even more alarming was the advent of American-style advertising billboards throughout the city. In the 1890s, the Grand Canal had an American look, not only because of the number of Americans living along it, but also because of the "large signs thrust out upon the palaces in a way that recalls the march of trade up Fifth Avenue in New York."[45] Prendergast, interestingly, did not paint this aspect of the Grand Canal, although he included other signs of modernization, such as the *vaporetto* stops, and he might have been tempted to include the interesting shapes of the signs. Nevertheless, he made numerous references to shopping in Venice, including the famous *St. Mark's Square, Venice (The Clock Tower)* (see Carol Clark's essay, fig. 2), in which tourists happily stream in and out of the arched entrance to Venice's main shopping street, the Merceria, oblivious to the extraordinary sight of the clock tower above them. Like the tourists, Prendergast noted and accepted the commercialism that went along with the newest adaptation of this ancient international city.

Local Color: Modern Art in Venice

Prendergast's interesting interpretation of modern life in Venice, with references to the changes that had brought the city to the brink of the twentieth century, was accompanied by a similar sorting out of old and new practices of art in Venice. He came with a grounding in the Modernist styles currently developing in the 1890s in Paris and, through the teachings of Arthur Wesley Dow, in Boston. He had matured sufficiently to know that his talent lay in his original sense of color, along with a fresh representation of reality. The first known review of his work, in April 1895, praised his "finely disciplined sense of pure and brilliant color, subordinated to a vivacious and accurate style of depiction."[46] He applied these talents to the different circumstances of Paris and Boston, so that his work in each location was distinct in both style and subject matter.

On arriving in Venice, Prendergast immersed himself in the art, the architecture, and the city itself (fig. 58). As his friend Charles Hovey Pepper wrote about ten years later, "He spent the first week studying in the galleries. He was most forcibly impressed by Tintoretto and Carpaccio. Much of the time was also spent in studying the architecture of the city's old palaces and

churches. He soaked up Venice. Then, saturated, he worked."[47] Venice could not have been more suited to Prendergast's talents. In the area of color alone, it offered both a spectacle of colorful effects everywhere you looked and galleries full of Old Venetian Masters who had based their entire "school" on a lush handling of color. In fact, Venice was so associated with the study of color that this may have been what ultimately persuaded him to make the trip.

It is easy to see how a coastal city with 150 canals and 378 bridges acquired a reputation for colorful light and reflections. Writers stretched to find fresh ways of describing it: "It is a saturnalia of color";[48] "Venice is the consecrated home of that seven-robed daughter of light that men call 'color'";[49] and "Everything about Venice seems to reek with color."[50] But for Prendergast, just having a colorful subject was not enough. He had studied the color of commercial art,[51] the color of the Impressionists, the color of Whistler, and the color of the Japanese. His approach to local color in any given motif would have been a matter of choosing the right approach. In Venice, he studied the Venetian Old Masters.

Even though it is clear from Pepper's account, above, that Prendergast studied Tintoretto and Carpaccio, it is difficult to see at first what impact that study might have had on his work—and how it might make his Venetian watercolors different from those he had so successfully created in Boston. Prendergast is not known to have studied Old Master art before his trip to Italy; in Paris, he had resisted copying in museums and

other such academic pedagogical practices. But he was fortunate to have arrived in Venice after the renovation of the Accademia, which had been repainted, rehung, and relit in 1895, making it one of the most modern museums in Europe.[52] Along with the renovation of the galleries came conservation work on the paintings themselves. For the first time, information was available about how the color was applied from a purely technical viewpoint. An article published in 1897 in the widely read American art journal *The International Studio* provided useful insights into Venetian techniques for any artist seeking to adapt them to his or her own work.[53]

Within the series of watercolors from Prendergast's trip to Italy, a large number of unfinished works have survived—either unfinished versos of finished works or incomplete compositions abandoned altogether (figs. 59–61). In these we see echoes of the techniques described in the *International Studio* article, which became common knowledge among those interested in learning the Venetian style. The first essential point was that the Venetians painted on a pure-white ground in one sitting, "so that the white ground shone through, giving the greatest possible luminosity." Then the work progressed "bit by bit," the colors being applied side by side with a separate brush for each. The Venetians mixed their pigments as little as possible, and often with white only.[54] If this method sounds modern, it is probably because, given the then-recent Impressionist and Post-Impressionist painting styles, the author was trying to tie the Venetians to the painting practices of his own day.

Fig. 59
Maurice Prendergast
Caffè Florian, Venice,
ca. 1898–99
Watercolor and graphite on wove paper
11 × 15⅜ in. (27.9 × 39.1 cm)
National Gallery of Art, Washington, D.C.
Gift of Ernest Hillman, Jr., in memory
of his friend John Davis Skilton, Jr.
(2003.123.1)
Image courtesy of the Board of Trustees,
National Gallery of Art, Washington, D.C.
CR 686

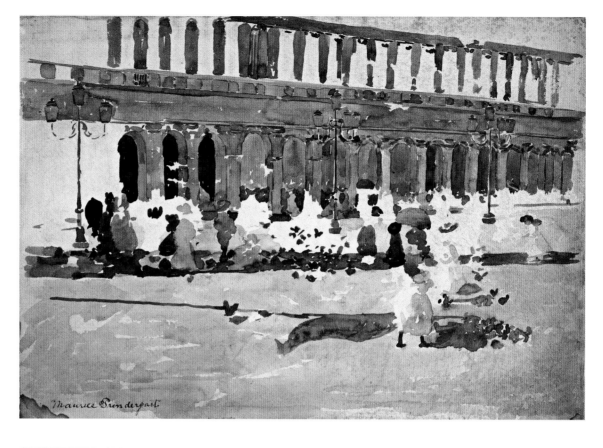

Fig. 60
Maurice Prendergast
Gondolas, Venice, ca. 1898–99
Watercolor and ink wash on paper
10½ × 14¾ in. (26.7 × 37.5 cm)
Private Collection
CR 694 (recto)

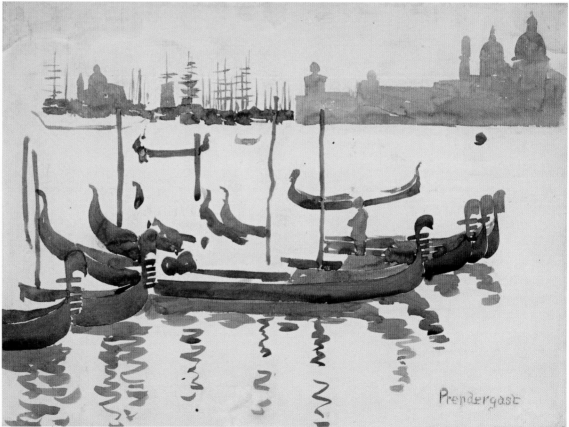

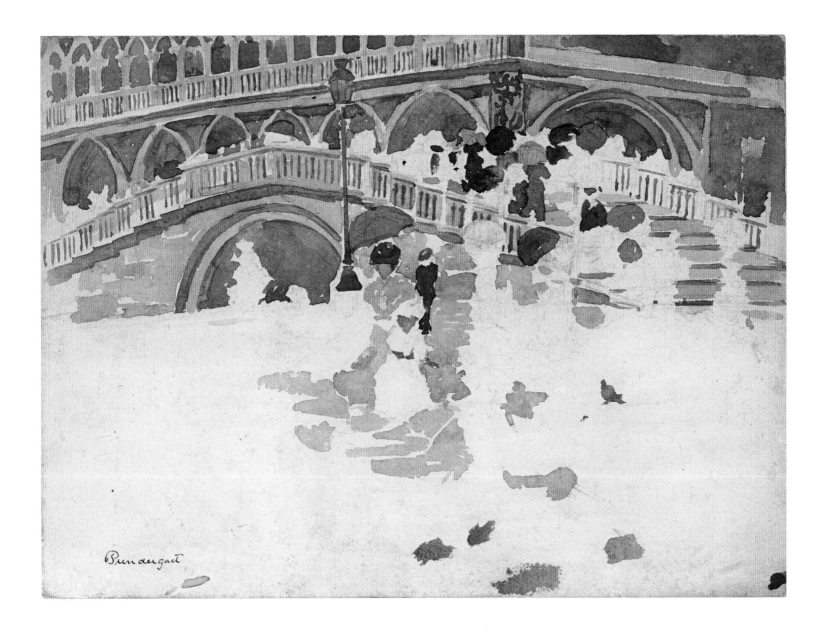

For Prendergast, contemplating his forthcoming trip to Venice, the clear outline of the method would have been especially helpful. And in the unfinished works, we see just this approach: pure colors applied "bit by bit" in discrete areas on a white background, covering the whole surface without losing luminosity. An uncomplicated painting style, which Prendergast could see particularly in Carpaccio when he reached Venice, was always a goal of his. If we do not see overt echoes of Carpaccio, Titian, or Tintoretto in his Italian compositions, we should appreciate how Prendergast absorbed the coloring of the Venetians ("a synonym for all that is rich and rare"[55]) as it was understood in his day. This also explains Prendergast's

new appreciation for the art of the past and the surprising statement in his sketchbook (fig. 72) as he was just about to leave Italy: "I have seen so many beautiful things it almost makes me ashamed of my profession today."

Carpaccio also influenced Prendergast's choice of ordinary Venetian subjects, which were painted in equal numbers to his scenes of St. Mark's and other spectacles of Venice. As Alessandro Del Puppo points out in his essay in this volume (see pp. 137–45), Carpaccio was considered by nineteenth-century observers to have been the great and faithful painter of Venetian life in his day. Those who were familiar with Venice, such as Henry James, saw the beauty

Fig. 61
Maurice Prendergast
Umbrellas in the Rain, Venice,
ca. 1898–99
Watercolor and graphite on off-white
wove paper
10 × 13¾ in. (25.4 × 34.9 cm)
The Metropolitan Museum of Art,
New York
Bequest of Joan Whitney Payson, 1975
(1976.201.4)
Image © The Metropolitan Museum
of Art, New York
CR 699

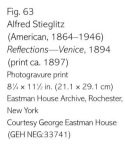

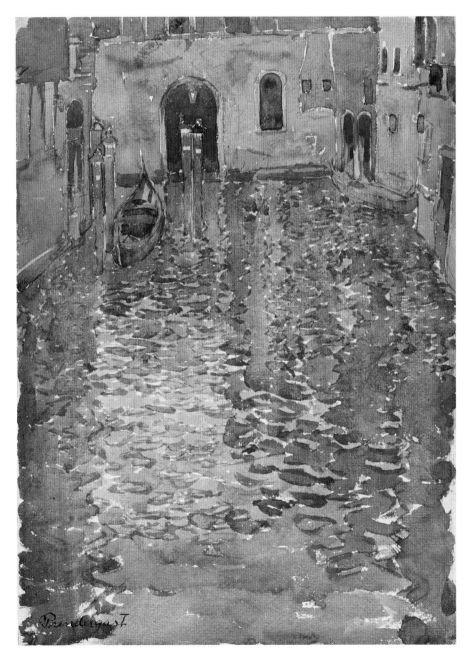

of the city only in the out-of-the-way places where tourists seldom ventured: "I simply see a narrow canal in the heart of the city,—a patch of green water and a surface of pink wall."[56] Prendergast and many others tried to match James's vision, Prendergast in such works as *Venetian Canal* (fig. 62), which is almost subject-less in its study of color, shape, and reflection.

The rejection of anecdote, to the extent of suppressing subject altogether, was the compelling tenet of Modernism that led to the great twentieth-century schools of abstraction. This approach was not only practiced by Alfred Stieglitz, the colleague of Prendergast's patron, Sarah Sears, but was also forcefully articulated in avant-garde photographic literature of the time that referenced Stieglitz's Venetian work, for example *Reflections—Venice* (fig. 63).[57] As with modern painting, modern photographers followed Dow's theory, discussed earlier, which sought to minimize the anecdotal power of human figures and aim for "composition of values or masses" and think of the motif as "shapes and colors in a pattern."[58]

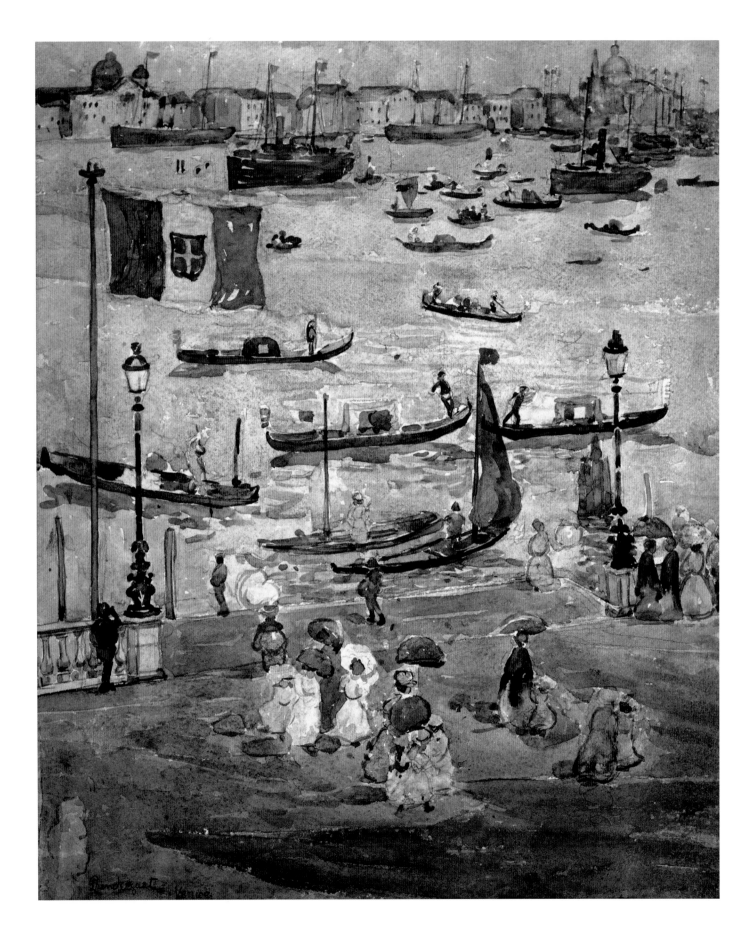

In so many of Prendergast's Italian watercolors, the abstract lines of the composition are breathtaking in their power. They can take the form of a strong horizontal series of zones, as in *Venetian Palaces on the Grand Canal* (fig. 65) or *Canal, Venice* (fig. 64); or the vertical lines of the two *fondamente*, or quays, opposite each other at either end of the Rialto Bridge; or the curved lines of bridges themselves, as in *Venetian Canal Scene* (fig. 68) or *Riva San Biagio, Venice* (fig. 69). One of the most dramatic compositions is derived from the repeated lines of the steps and plaza of the church of Santa Maria della Salute as seen from above (fig. 70). When compared with Sargent's similar fragmentary view of this famous church (fig. 71), we see how extreme Prendergast's simplification and geometric abstraction were at a time when others were striving for the same thing. It is not a surprise to see in his

Fig. 64 (opposite)
Maurice Prendergast
Canal, Venice, ca. 1898–99
Watercolor and pencil on paper
16 × 13½ in. (40.6 × 34.3 cm)
Abby and Alan D. Levy Collection,
Los Angeles
CR 692

Fig. 65
Maurice Prendergast
Venetian Palaces on the Grand Canal, 1899
Watercolor and pencil on paper
14 × 20¾ in. (35.6 × 52.7 cm)
Karen and Kevin Kennedy Collection
CR 711

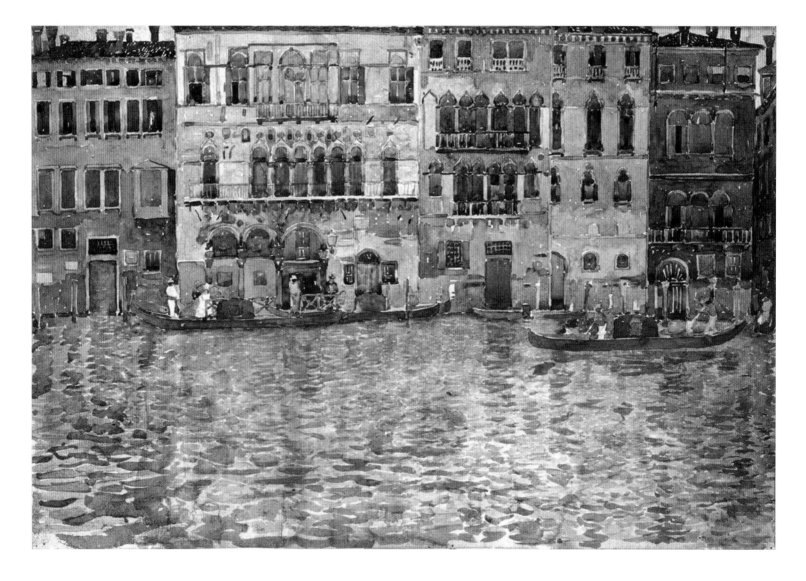

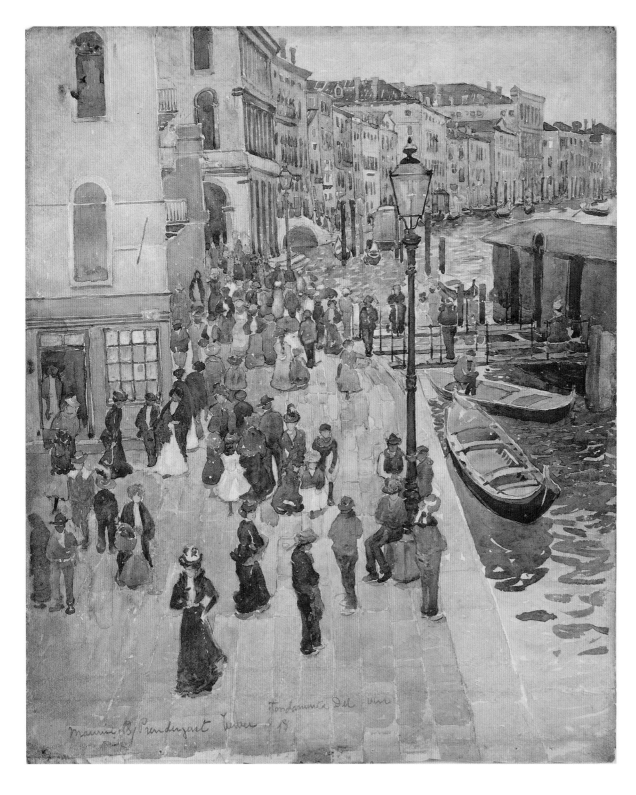

Fig. 66
Maurice Prendergast
Venice, ca. 1898–99
Watercolor and pencil on paper
18¼ × 15 in. (46.4 × 38.1 cm)
Colby College Museum of Art,
The Lunder Collection, Waterville,
Maine
Photo Credit: Alan LaVallee
CR 708

Fig. 67 (opposite)
Maurice Prendergast
The Grand Canal, Venice,
ca. 1898–99
Watercolor and pencil on paper
17¾ × 13¾ in. (44.1 × 34.9 cm)
Terra Foundation for American Art,
Chicago
Daniel J. Terra Collection, 1999.123
CR 707

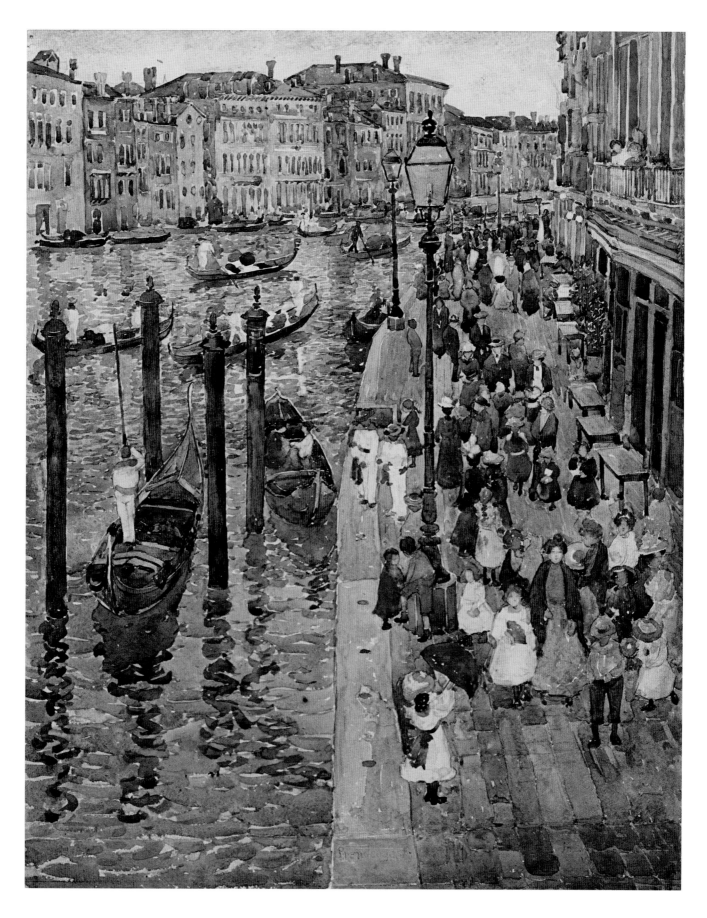

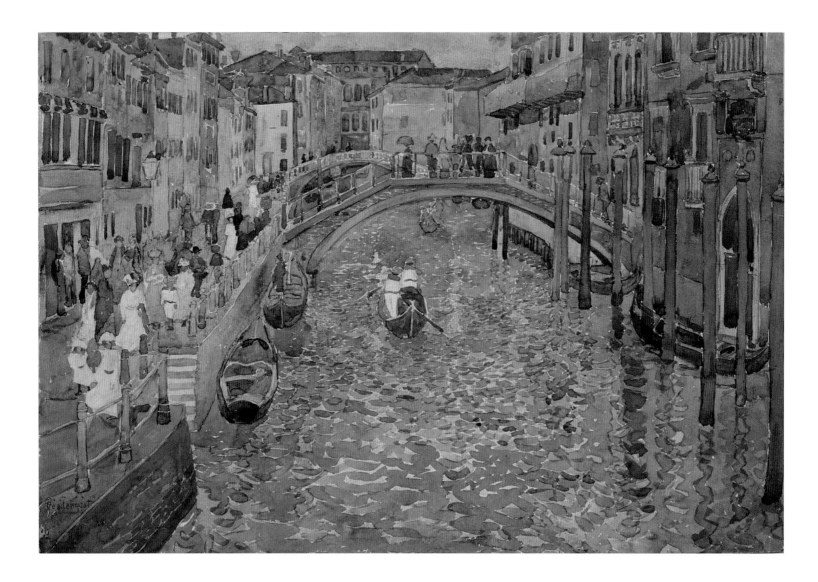

Fig. 68
Maurice Prendergast
Venetian Canal Scene,
ca. 1898–99
Watercolor and pencil on paper
13⅞ × 20⅜ in. (35.2 × 51.8 cm)
Private Collection, New York
CR 720

sketchbook (CR 1479; see p. 181) a series of phrases all featuring the word "Design," as though he were casting about for a title for a book he planned to write on the subject.

Prendergast's study of local color in Venice, in terms of both the glorious Venetian School of the past and the abstracted "ordinary" scenes of church pavements and canal reflections, shaped the distinctive Modernist style that he used in the Italian series of watercolors (figs. 66, 67). And, since modern art was on his mind, he would have had increasing opportunities to study modern art in Venice, particularly the contemporary Italian painters. Prendergast followed the routine of all artists in Venice, taking coffee at Caffè Florian in St. Mark's Square and haunting the Accademia and the Doge's Palace. He may have seen what his fellow artists were doing as they sketched and painted outdoors, and many

local artists, such as Ettore Tito, opened their studios to the public. There was a gallery for the Società Veneta Promotrice di Belle Arti in the Palazzo Reale and a sales gallery called "Plancich's."[59] In addition, the exciting Venice Biennale had been opening its doors every two years since 1895. Prendergast would have seen the third biennale in the summer of 1899.

This important advance in the history of art in Venice is discussed in Jan Andreas May's essay in this volume (see pp. 147–59), and it is worth emphasizing how the interjection of such an international survey of contemporary art into the Venetian art scene of the 1890s brought issues of past and present to the fore. For the first time in Venice, modern art rivaled the art of the past and, parenthetically, the city itself as an artistic spectacle. Such American artists as the classicizing painter Will Low were struck by the

Fig. 69
Maurice Prendergast
Riva San Biagio, Venice,
ca. 1898–99
Watercolor and pencil on paper
13⅛ × 10⅝ in. (33.3 × 27 cm)
Private Collection, New York
CR 702

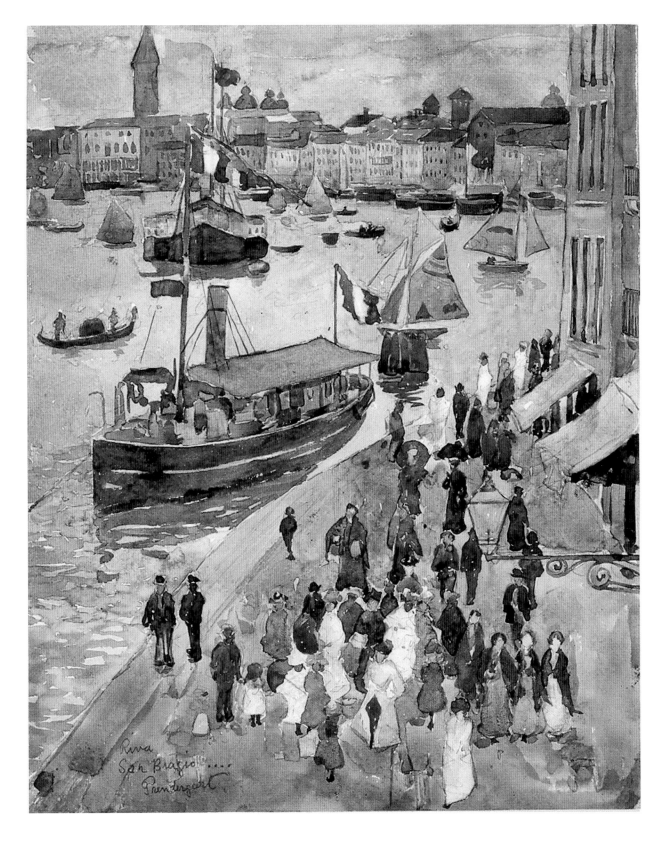

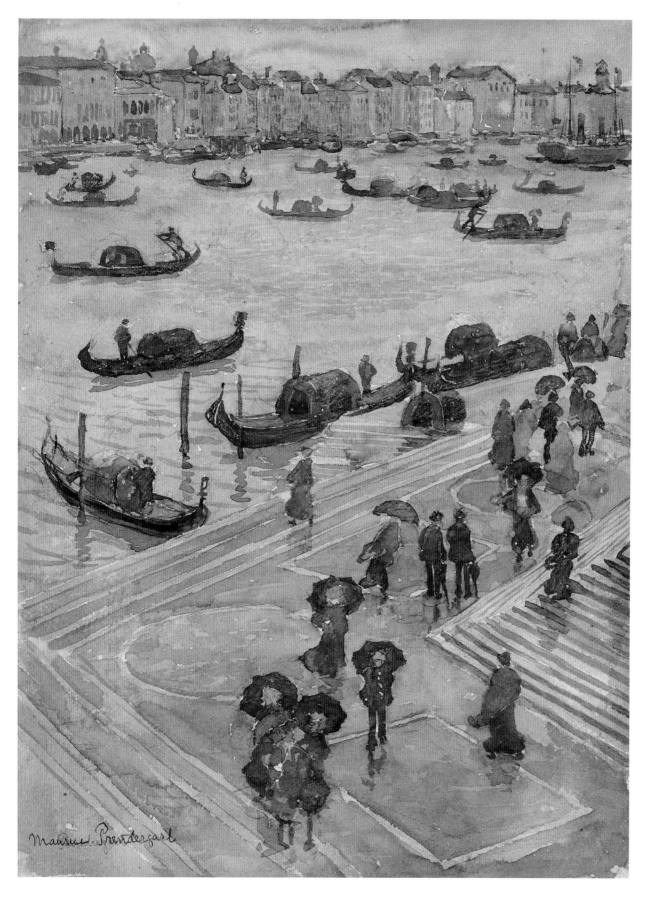

Fig. 70
Maurice Prendergast
Rainy Day, Venice,
ca. 1898–99
Watercolor and pencil on paper
16¾ × 12½ in. (42.5 × 31.7 cm)
Wichita Art Museum, Kansas
The Roland P. Murdock Collection,
M36.42
CR 695

Fig. 71 (above, left)
John Singer Sargent
(American, 1856–1925)
Santa Maria della Salute, Venice,
ca. 1904–08
Oil on canvas
25¼ × 36¼ in. (64 × 92 cm)
The Fitzwilliam Museum, Cambridge

Fig. 72 (above, right)
Maurice Prendergast
Notes on design,
drawing of woman
Sketchbook
("Italian Sketchbook"),
ca. 1898–99
6¾ × 4½ in. (17.1 × 11.4 cm)
The Cleveland Museum of Art
Gift of Mrs. Charles Prendergast
(51.422)
CR 1479

bravado of instituting such an event in Venice and thoughtful about its effect on the course of modern art in Italy. For artists to show their work in an international context was one thing, but to show in the midst "of the most glorious school of painting which the world has seen" was a "comparison from which the boldest might shrink."[60] Nevertheless, as Low concludes, the American attitude was to wish this daring experiment success and to look forward to a transformation of art produced in Venice.

At the exhibition, Prendergast viewed the more than five hundred works from European and American artists, including Whistler, whose early work *The Princess from the Land of Porcelain* (1864; Freer Gallery of Art, Washington, D.C.) attracted the most attention, and the French painters of modern life, especially Jean-François Raffaelli. With his head full of the Venetian color and "modern life" that he had just learned from Carpaccio, Titian, and Tintoretto, perhaps the moderns he saw did not measure up. But the clash of modern and Old Master art in itself was galvanizing, and in the

Venetian watercolors can be seen Prendergast's search for new, more abstract, and original ways of meeting the challenge.

The Other Italy: Siena, Capri, and Rome

Venice had been Prendergast's destination on this trip. After arriving in late July or August, he took some time to study and orient himself and then got to work. In the months of September, October, and perhaps early November, he finished at least twenty watercolors—enough to ship off to Boston for the spring exhibitions. We are not entirely sure which works these were. The titles listed in exhibition catalogues and reviews are difficult to identify with certainty, since there were so many works of the same subject. And dates and inscriptions, added over a long period of time afterward and not necessarily by the artist himself, are helpful only to a degree. What we can say is that Prendergast gravitated first to urban locations where the people were—St. Mark's Square, the nighttime *serenata*, and the gondolas. The only exception was his visit to the

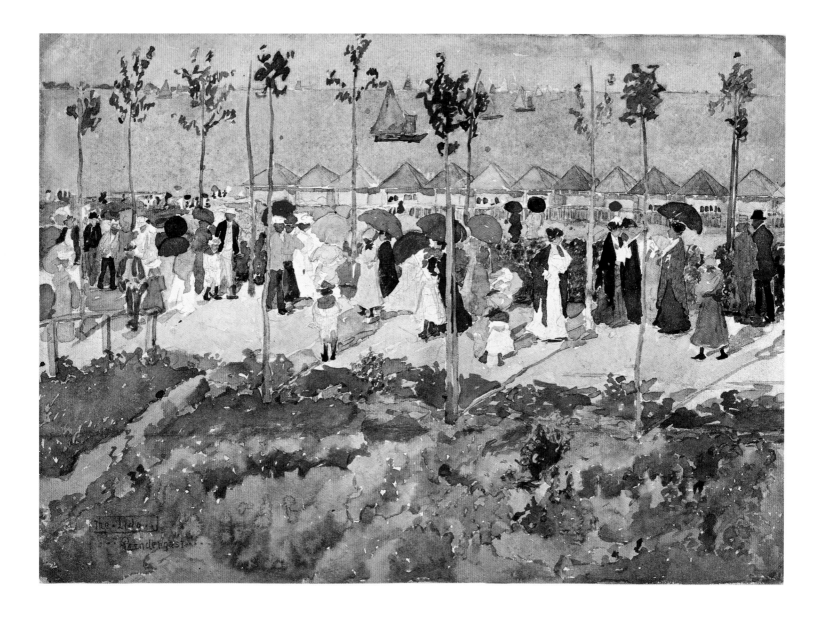

Lido—Venice's equivalent to the beach resorts around Boston, which Prendergast had recently made an important theme. The Lido is a long, thin island protecting the coast of Venice from the open sea; at the time of Prendergast's visit to the city, the Adriatic Sea beach on the eastern side of the Lido had recently been upgraded to a modern bathing facility. Only a few minutes away by *vaporetto*, the Lido attracted both tourists and locals and would have attracted Prendergast while the weather was still summery. *The Lido* (fig. 73) is the first glimpse that he gives us of Italy outside the city of Venice.

In the sea beyond the beach cabanas of the Lido were the characteristic fishing boats of the region, which sported orange, pink, and rust-red sails. The

sailboats in Venice's lagoon (*The Lagoon, Venice*; fig. 89) and farther out to sea were popular themes in the tourist literature about Venice, adding to the city's reputation for color. They also serve to identify the region of Italy, since local differences, despite Italian national unification, were pronounced.

When Prendergast accomplished his mission of creating a Venetian body of work within a mere four months, he set off to explore other potential painting sites in Italy and to avoid the cold, wet winter in Venice. Traveling southward, he stopped in Padua, Florence, Siena, Orvieto, Assisi, and Rome, studying the art in the museums and adding to his portfolio of Italian watercolors. He ended up in Naples and Capri, where he took a brief rest before returning to Venice for the

Fig. 73
Maurice Prendergast
The Lido, Venice, ca. 1898–99
Watercolor and pencil on paper
10½ × 15 in. (26.7 × 38.1 cm)
Private Collection
Courtesy of Guggenheim Asher
Associates
CR 732

summer and fall of 1899.[61] This trip must have taken four or five months, during which time Prendergast produced approximately twenty-five identified watercolors in Siena, Assisi, Capri, and Rome. Although Venice was his main focus overall, the body of work he painted in the rest of Italy was consistent with the Venetian set in ambition and creativity, and he was quick to exhibit the paintings as soon as he returned home.

The first time Prendergast opened his paint box for an extended series of works after Venice was in Siena. It is clear from *Siena, Column of the Wolf* (fig. 75) that he still had Venice very much on his mind. His choice of another column, painted, like *St. Mark's Lion* (fig. 48) and the *Column of St. Theodore* (fig. 47), in a vertical format, is an intentional echo. But it also marks the emergence of what would become a theme of his trip through the rest of Italy: the regional pride that made the country so interesting yet so fragmented. These "columns" of Venice and Siena spoke of the unique history of each city. In Venice, St. Mark's lion and St. Theodore referred to the two patron saints of the early development of Venice as a world power. In Siena, the column holds the sculpture of the she-wolf that suckled Romulus and Remus, which, according to legend, was stolen from Rome. It is the symbol of Siena because Remus's sons were the city's founders.

With the symbol-laden public spaces of Venice as a precedent, Prendergast approached Siena in very much the same spirit. The Column of the Wolf stands next to the façade of Siena Cathedral, which Prendergast does not show us. Like the Italian flags in front of St. Mark's, the Column of the Wolf in Siena has a civic significance that competes with the religious significance of the church. At the time that Prendergast was preparing for

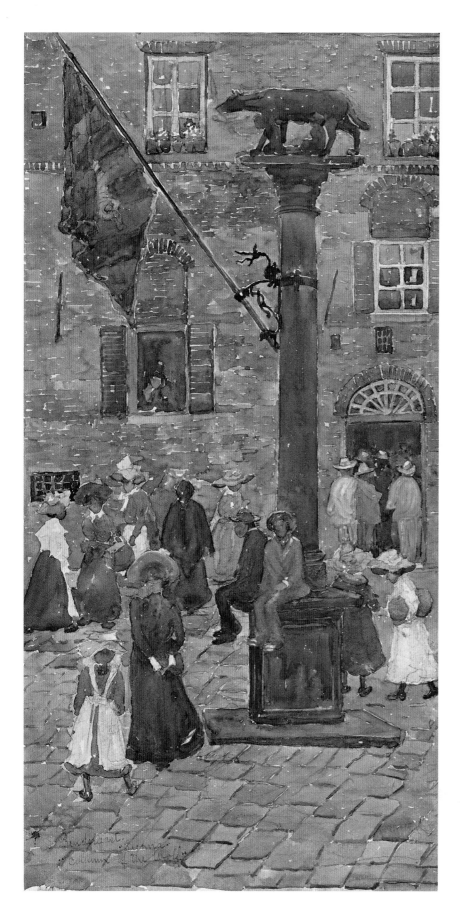

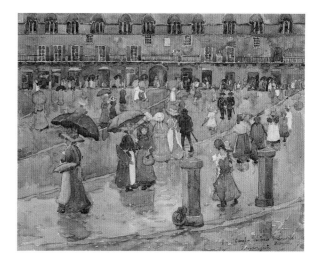

his trip to Italy, such Italian civic monuments were being touted as precedents for such American civic buildings as the Library of Congress and the Boston Public Library, which were designed to "cement the social fabric."[62] Prendergast went on to paint Siena's answer to St. Mark's Square, the Piazza del Campo, then called the Campo Vittorio Emanuele (fig. 76), and scenes of Siena's distinctive architecture. His *Courtyard Scene in Siena* (fig. 77), the first painting in his Italian œuvre to feature children, echoes his scenes of children playing in Franklin Park but is different in costume, setting, and activity.

Like any artist painting in an exotic location, Prendergast was anxious to show how it differed from the look of things back home. But showing how Italy differed from Boston was just the beginning: he also took great pains to show how one Italian region differed from every other. In the 1890s, much was written, particularly in the American press, about the slow progress of unification throughout the country, not just in Venice. The observation by the Austrian Prince Metternich in his memoirs in 1883 that "Italy" was nothing more than a "geographical expression" was frequently invoked.[63] Many despaired that it would be impossible to "stitch together . . . different races, conflicting manners, repugnant traditions."[64]

Prendergast honors this common understanding about Italian factionalism when he paints not only the distinctive architecture and landscape of Siena or Capri (fig. 78) but also the local costume, physical type, and tools, such as baskets. In the several watercolors Prendergast completed while "on vacation" on the

Fig. 75 (opposite, left)
Maurice Prendergast
Siena, Column of the Wolf,
ca. 1898–99
Watercolor and pencil on paper
19⅛ × 9½ in. (48.6 × 24.1 cm)
A New England Collector
CR 742

Fig. 76 (opposite, right)
Maurice Prendergast
Campo Vittorio Emanuele, Siena,
ca. 1898–99
Watercolor and pencil on paper
11¼ × 13¾ in. (28.6 × 34.9 cm)
Private Collection
CR 741

Fig. 77
Maurice Prendergast
Courtyard Scene in Siena,
ca. 1898–99
Watercolor and pencil on paper
14 × 10¼ in. (35.6 × 26 cm)
Honolulu Academy of Arts
Gift of Mrs. Philip E. Spalding, 1940
(11,654)
CR 736 (recto)

Fig. 78
Maurice Prendergast
Capri, 1899
Watercolor and pencil
on paper
14 x 10½ in.
(35.6 x 26.7 cm)
Norton Museum of Art,
West Palm Beach, Florida
Gift of Elsie and Marvin
Dekelboum, 2005.53
CR 752

Fig. 79
Maurice Prendergast
At the Shore (Capri), ca. 1898–99
Watercolor and pencil on paper
10¼ × 14¾ in. (26 × 37.5 cm), sight
Private Collection, New York
CR 755 (recto)

Fig. 80
Maurice Prendergast
Grande Marina, Capri,
ca. 1898–99
Watercolor and pencil on paper
11 × 15⅜ in. (27.9 × 39.1 cm)
Private Collection
CR 758 (recto)

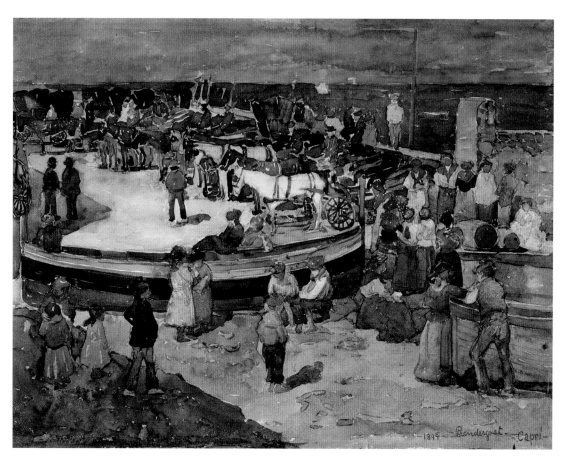

island of Capri, the most striking example of his choice of regional subject matter is his attention to the special shape and bright colors of the fishing boats (figs. 79, 80). The difference between these boats and those found around Venice, where the vessels themselves are drab but the sails are beautifully colored, could not be greater.

Nowhere are the most striking differences between the regions of Italy (and between Italy and the US) more visible than in the series of monotypes Prendergast produced of Venice, Rome, Siena, and possibly other locations (see Elizabeth Kennedy's essay, pp. 99–127). In the sixteen known monotypes, local costumes, markets, promenades, and *feste* are highlighted, as though Prendergast were making an album of charming Italian scenes. Compared with the watercolors, the monotypes are much more like a typical series of "souvenirs" of Italian life treasured by an American abroad—a collection of postcards to send home. But the predictability of the subject matter is belied by Prendergast's complex approach to color, composition, and monotype technique, making the Italian monotypes some of the most ambitious of his œuvre. Very few are actually based on the watercolors (*Monte Pincio (The Pincian Hill)* and *Festa del Redentore, Venice*; see Kennedy essay, figs. 14, 40), and most are new subjects altogether.

When Prendergast arrived in Rome in the winter of 1898–99, he faced a different challenge. Like Venice, Rome was full of fashionable people, many of them tourists in such locations as the Pincian Hill or the Spanish Steps, to which Prendergast gravitated. This neighborhood was the traditional "foreigners" sector— full of hotels and cafés. Nevertheless, the crowds looked very different from those in Venice, and the tension between church and state was visible not in the flags, which were non-existent on the Roman streets, but in the ubiquity of ecclesiastical dress. Like flags in Venice, the brilliant, flowing robes of the clerical population in Rome give life and pattern to the crowds. In the midst of the bustle of tourists, artists' models, and children with their nurses thronging the Spanish Steps are the "long converging lines of black or scarlet theological students," or cardinals, prelates, and nuns.[65] They are prominently seen in *Early Spring—Monte Pincio* (fig. 81) and the monotype *The Spanish Steps* (see Kennedy essay, fig. 41), and mixed into the crowds in such works as *Steps of Santa Maria d'Aracoeli, Rome* (fig. 82).

Of Irish descent, Prendergast was baptized as a Roman Catholic in St. John's, Newfoundland. But

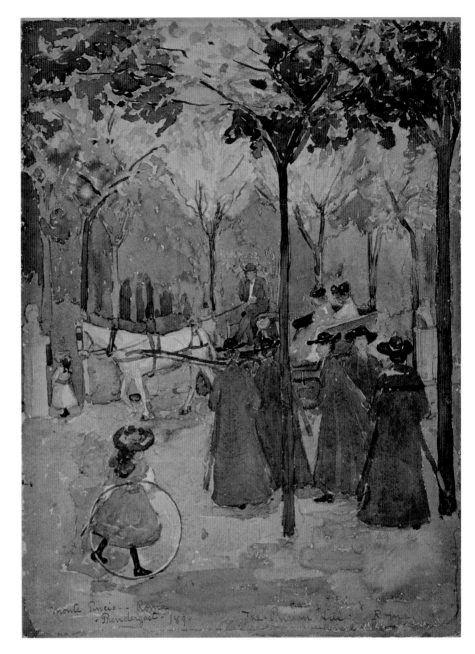

even for American Catholics, the constant presence of the church on the streets of Rome was an unusual and thought-provoking sight. The establishment of the king and his government in Rome in 1870 had forced the Vatican to cede power to the state and caused an uneasy tension between king and pope. Visitors to Rome who were not inured to the situation were constantly reminded of the "perpetual war to the death, that is always being fought and is never fought out, between the old and the new, the last and the last but one."[66]

Fig. 81
Maurice Prendergast
Early Spring—Monte Pincio,
ca. 1898
Watercolor and pencil on paper
14½ × 10¾ in. (36.8 × 27.3 cm)
Private Collection
Courtesy of Adelson Galleries,
New York
CR 744

Fig. 82
Maurice Prendergast
*Steps of Santa Maria d'Aracoeli,
Rome*, ca. 1898–99
Watercolor and pencil on paper
20⅜ × 14⅛ in. (51.8 × 35.9 cm)
Private Collection
CR 749

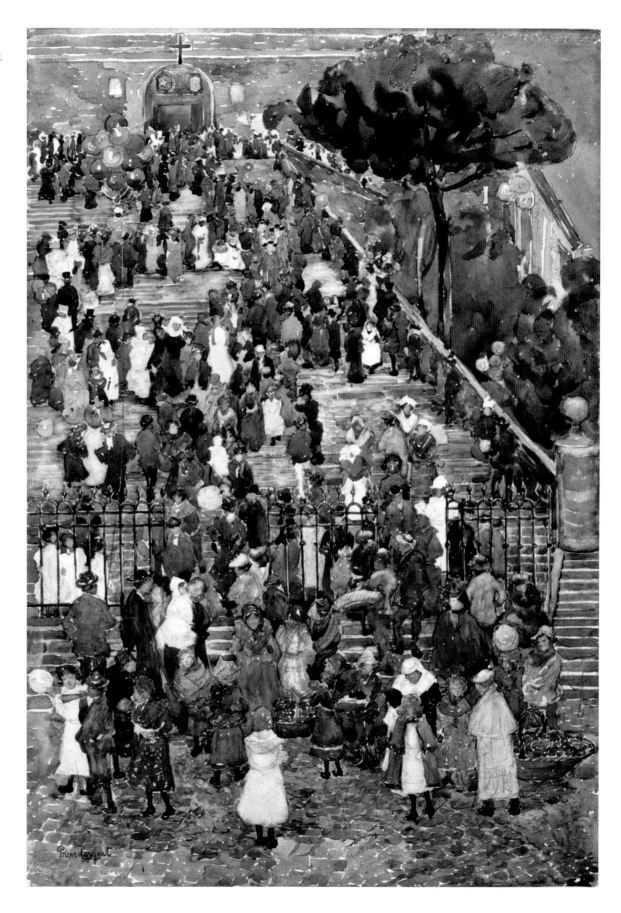

The war between the old and the new was also being fought in the art world in Rome. Although there were still many international academies in Rome, and the French Prix de Rome was still being awarded, the center of modern art in Italy had suddenly shifted to Venice and its biennale. Prendergast no doubt visited the collections in the Vatican and other famous art galleries, but, in contrast to his practice in Florence or Padua, he made no sketches or mention of them. Instead, in the midst of this newly emerged European capital, he caught the "fever for work" and painted constantly in the vast, glorious public spaces of the city (fig. 83). In these scenes of modern life, he again infused the central concerns of the day and made art out of the burning issue affecting the whole of Italy: the tension between past and present.

Prendergast returned to Venice to resume painting there during the summer and fall of 1899 and sailed for home on November 16. In the end, he produced more than 120 finished works in watercolor and monotype (with two oils) and another 100 or more sketches and unfinished compositions. He had received enthusiastic responses to the watercolors he had already sent home and exhibited in two exhibitions in Boston, so he had reason to believe that the new work was going to be important to his career. He could not have known, as he stepped on to the boat in Genoa, how important.

Fig. 83
Maurice Prendergast
Borghese Garden, Rome, Race Track, ca. 1898–99
Watercolor and pencil on paper
14 × 18⅛ in. (35.6 × 36 cm)
Museo Thyssen-Bornemisza, Madrid
© Museo Thyssen-Bornemisza. Madrid
CR 747

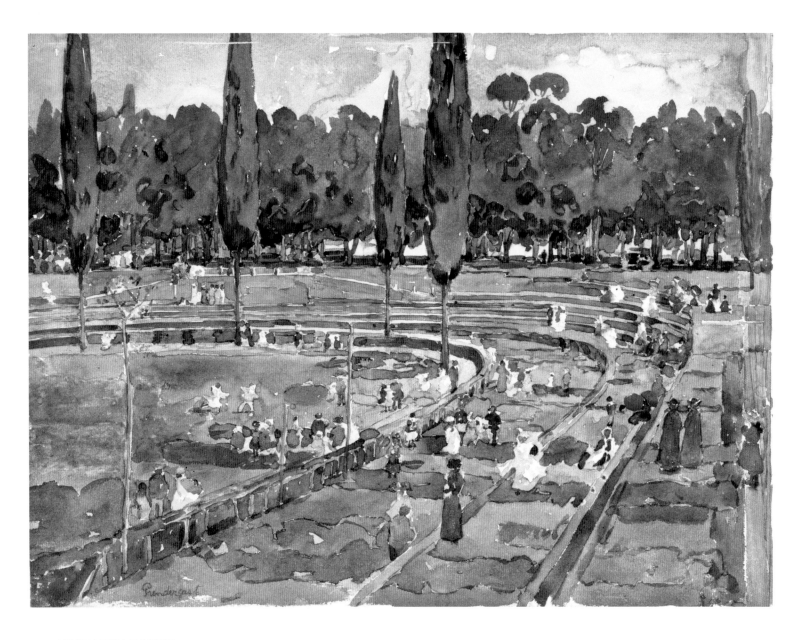

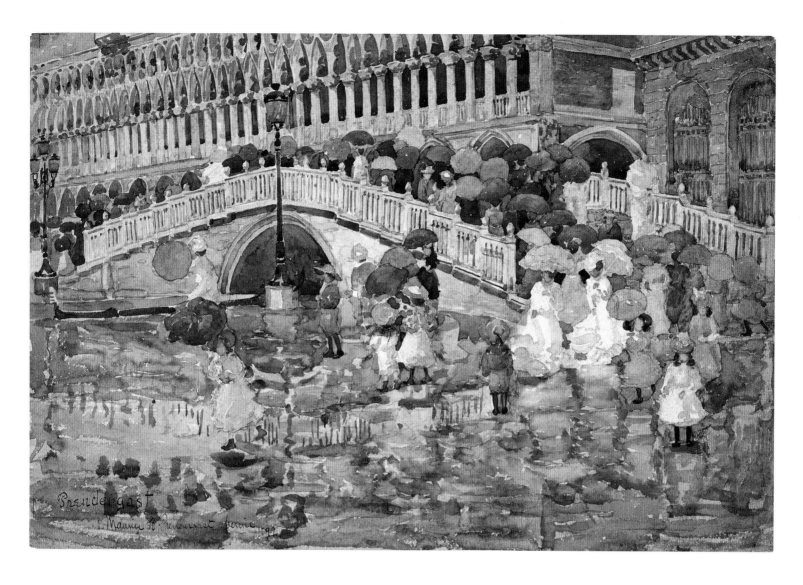

Fig. 84
Maurice Prendergast
Umbrellas in the Rain,
ca. 1898–99
Watercolor over graphite pencil
on paper
13¹⁵/₁₆ × 20⅞ in. (35.4 × 53 cm)
Museum of Fine Arts, Boston
The Hayden Collection—Charles Henry
Hayden Fund, 59.57
CR 698 (recto)

ITALIAN CONSEQUENCES

Critical Reaction and New Directions

Reflecting on the trip and its consequences with his friend Charles Hovey Pepper ten years later, Prendergast felt it had changed the entire course of his career. As Pepper explained: "The result of this Italian work was an exhibition at Macbeth's, in New York, and was the means of his being known to the men with whom he is now so strongly allied: [William] Glackens, [Robert] Henri, [John] Sloan, [George] Luks, [Everett] Shinn, [Arthur B.] Davies, [Ernest] Lawson. 'The Eight.' Men who, like himself, believe a man should paint in his own way."[67]

In this assessment, the Italian works had two important outcomes that led Prendergast in two different directions. First, in a practical sense, they were the means by which Prendergast rose to the top of the New York modern art world through his new ties to Henri and the group later known as "The Eight." With this new group of colleagues, Prendergast broke out of the limited Boston art scene and achieved national prominence. Although his work did not correspond stylistically to the slashing oil techniques of Henri and Sloan, the artists shared an interest in Modernism and modernization, often with political overtones, that can be seen in Prendergast's Boston, Italian, and New York watercolors of the turn of the century.

We can see in the work Prendergast did immediately after the Macbeth Gallery exhibition of 1900, such as *The Terrace Bridge, Central Park* (fig. 87), that the positive response to the Italian works encouraged him

Fig. 85
Photograph of Maurice
Prendergast, ca. 1901
Prendergast Archive and Study Center,
Williams College Museum of Art,
Williamstown, Massachusetts
Photo Credit: Arthur Evans

to tackle New York in much the same way. He found complex settings that were emblematic of the modern city, such as Central Park or the East River, and focused on festivals, such as May Day, or events that had recent political significance, such as "Chair Sunday."[68] Prendergast used his eye for the modern motif that he had so successfully honed in Italy to give a deeper meaning to his lively designs.

Secondly, the new work positioned Prendergast within the Modernist theoretical framework with an emphasis on individuality and originality—both highly charged terms in the turn-of-the-century art world. Having been recognized for his cutting-edge methodology, Prendergast laid the groundwork for an increasing experimentation with color and abstract form that would soon transform his style and make him a leader in early American Modernism. But unlike the approach he took in New York immediately after his return from Italy, this new direction suppressed subject matter that might evoke modern life and political issues in favor of pure style. Again drawing on his Italian work, by 1902 Prendergast had begun a series of oils simply called "promenades" (for example, *Promenade on the Beach*; fig. 91), which took his crowd studies and his experiments with color and form to create an image beyond historical circumstance.

Within the Italian series lay the seeds for both outcomes, but over time Prendergast gravitated toward modern art rather than modern history. He may even have been influenced by the modern art in Italy, where a new school called the "Divisionists" had emerged. In the Venice Biennale exhibitions, Italian artists had the largest proportion of gallery space, so trends in modern Italian art were easy to grasp. By far the most important of these artists was Giovanni Segantini (1858–1899), whose recent death had drawn further attention to the painter. Segantini had developed a Pointillist style with Symbolist subject matter that was related to trends in Post-Impressionist Paris. For Prendergast, Segantini's work in Italy, such as *Love at the Fountain of Youth* (fig. 88), would have been his introduction to the style he would not see in Paris until 1907.

When critics called Prendergast's work original, they were making the easy comparison between such works

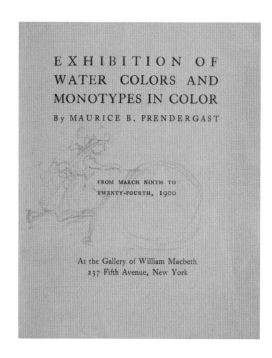

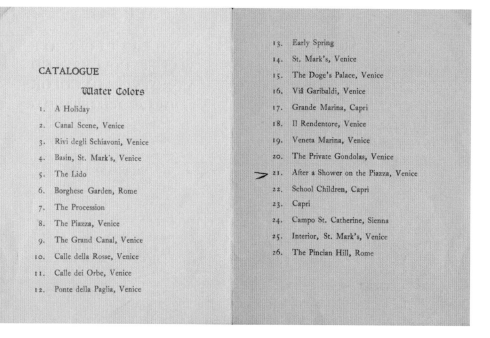

Fig. 86 (above, left and right)
Title page and list of works from
Exhibition of Water Colors and Monotypes in Color by Maurice B. Prendergast, exhib. cat., Gallery of William Macbeth, New York, 1900
Prendergast Archive and Study Center, Williams College Museum of Art, Williamstown, Massachusetts
Photo Credit: Arthur Evans

Fig. 87
Maurice Prendergast
The Terrace Bridge, Central Park, 1901
Watercolor and pencil on paper
15¼ x 22½ in. (38.7 x 56.9 cm)
The Art Institute of Chicago, The Olivia Shaler Swan Memorial Collection
© 1989 The Art Institute of Chicago. All Rights Reserved. (1939.431)
CR 782

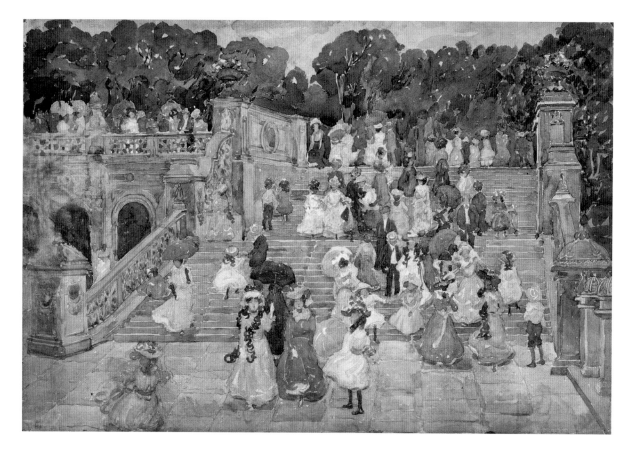

Fig. 88
Giovanni Segantini
(Italian, 1858–1899)
Love at the Fountain of Youth,
1896
Oil on canvas
27½ × 38½ in. (70 × 98 cm)
Civica Galleria d'Arte Moderna, Milan
Photo Credit: Scala/Art Resource,
New York. Image ref.: ART305079

as *The Lagoon, Venice* (fig. 89) and similar subjects by such well-known Venetian specialists as W. Gedney Bunce (1840–1916)—for instance, *Venetian Boats* (fig. 90). In the exhibition of the Boston Water Color Club in 1899, Bunce's work was dismissed by critics ("The small group of somewhat foxy-toned Venetian sunset effects by Mr. Bunce calls for no extended comment"[69]), while Prendergast's was given an enthusiastic reception ("Mr. Prendergast sends seven twinkling tableaux of Venetian life, with glimpses of Rome, Siena and Capri. They are fascinating for their movement and gayety"[70]). It is worth noting, however, that Bunce bought one of Prendergast's Italian watercolors from the Macbeth show.[71]

Prendergast's flat areas of unmodulated brilliant color, derived from the Japanese, and his introduction of "modern" people into the scene made his paintings appear fresh compared with Bunce's traditional modeling and pretentious aggrandizement of the same subject. But there was also an aggressive crudeness to the drawing of the sails and the people, which created the jarring effect so sought after by avant-garde painters.

This was not always noticed by critics, who were exhilarated by the freshness, but it would soon emerge in the discussions of Prendergast's work, pro and con. A conservative critic for the *Brooklyn Daily Eagle* was not going to be fooled by these new methods: "The watercolors by Maurice B. Prendergast at the Macbeth galleries are an odd lot, though they display that quality usually called cleverness. The artist uses high color fearlessly and restlessly . . . there is a riot of color . . . and in the composition there is commonly an unconvincing artificiality." He went on to advise the viewer to pass over this exhibition in favor of the other art in the gallery, which displayed the "more serious painting of the younger American painters."[72]

But other critics, as well as the gallery owner, William Macbeth, and Prendergast's new colleagues, including Henri and Davies, saw something in this fearless approach to color and composition that was rare among American artists: a new vision of art that rivaled the Modernist experiments of Paris. Through the study of the Old Masters, as Cézanne would also preach,

Fig. 89
Maurice Prendergast
The Lagoon, Venice, 1898
Watercolor and pencil on paper
11⅛ × 15⅜ in. (28.3 × 39.1 cm)
Fayez Sarofim Collection
CR 728

Fig. 90
W. Gedney Bunce
(American, 1840–1916)
Venetian Boats, 1885
Oil and pencil on panel
14⅛ × 17⅛ in. (35.9 × 43.5 cm)
Museum of Fine Arts, Boston
Bequest of Ernest Wadsworth
Longfellow, 23.473

Prendergast found a way to simplify color and form to transform even the most familiar subjects into something entirely new. When he applied this principle to his familiar beach subjects during the summer of 1900, a more sympathetic critic caught his intention:

For abruptness of method, rudeness of style and harshness of execution [Prendergast's works] fairly take away one's breath. But they show a vigor of perception, an almost brutal insistence on material facts and a readiness of expression that are most impressive. They are not delightful or beautiful pictures, but they are a mighty lot of other things that are artistically worthwhile.[73]

As Prendergast pursued radical form, he let go of the politically charged symbolism of modernization that had run through the Boston, Italian, and New York watercolors until about 1902. To their credit, the other members of The Eight, most of whom continued to search out gritty urban subject matter, still embraced Prendergast. As Pepper put it, their bond was their strong belief that each artist "should paint in his own way." Prendergast exhibited with them in 1904, showing a series of small oils, all called *Promenade*, and again in 1908, in the exhibition of The Eight at the Macbeth Gallery. All along, Prendergast had been studying the art magazines and quizzing recent returnees for news of modern art in Paris. In 1907,

Fig. 91
Maurice Prendergast
Promenade on the Beach,
ca. 1902–04
Oil on panel
10⅜ × 13¾ in. (26.4 × 34.9 cm)
Williams College Museum of Art,
Williamstown, Massachusetts
Bequest of Mrs. Charles Prendergast
(95.4.20)
CR 37

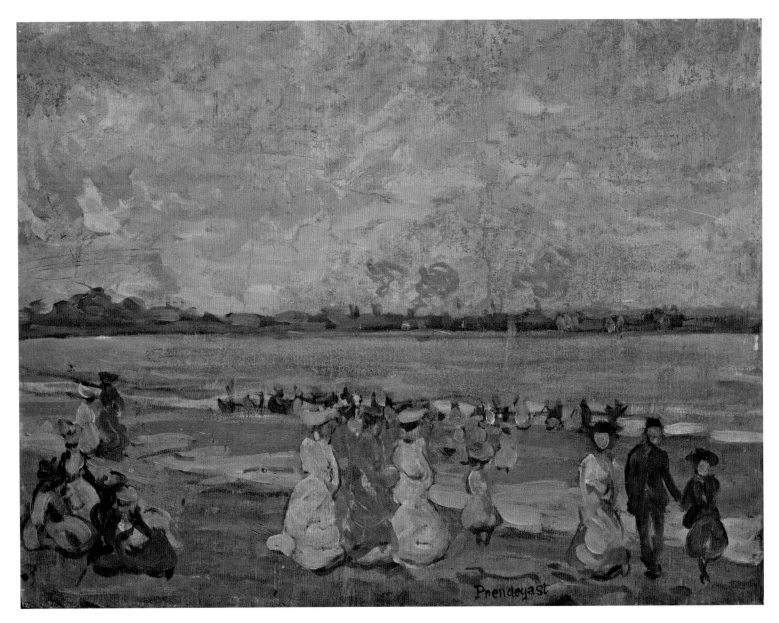

Fig. 92
Paul Cézanne
(French, 1839–1906)
Mont Sainte-Victoire, 1885–87
Oil on canvas
26 × 35⅞ in. (66 × 89.9 cm)
The Courtauld Gallery, London
Acquisition, Samuel Courtauld, Gift,
1934 (P.1934.SC.55)

Fig. 93
Maurice Prendergast
Louvre, ca. 1907
Watercolor and pencil on paper
14 × 20 in. (35.6 × 50.8 cm)
Private Collection
Courtesy of Adelson Galleries,
New York
CR 917

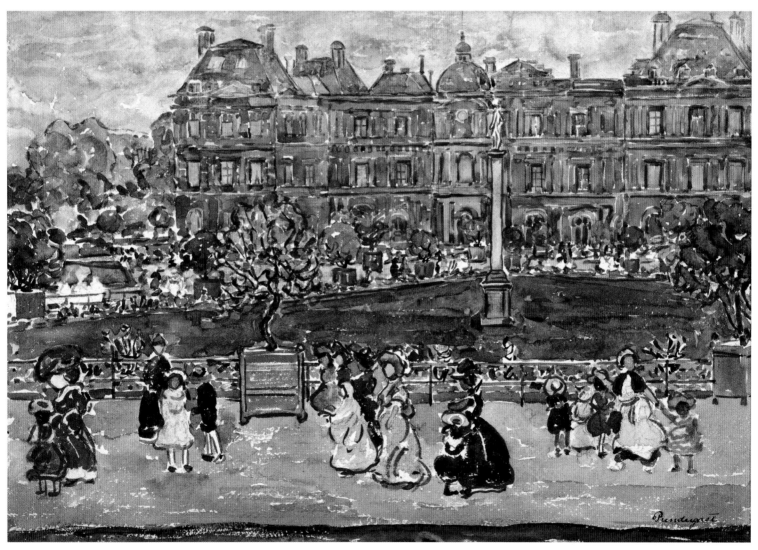

Fig. 94
Henri Matisse (French,
1869–1954)
Le Luxe (I), 1907
Oil on canvas
82⅝ × 54⅜ in. (210 × 138 cm)
Musée National d'Art Moderne,
Centre Georges Pompidou, Paris
Succession H. Matisse, Paris/ARS,
New York
Photo Credit: Erich Lessing,
Art Resource, New York.
Image ref.: ART137425

Fig. 95
Maurice Prendergast
Pencil drawing after Matisse's
Le Luxe (I)
Sketchbook ("Sketchbook 38"),
ca. 1907
6½ × 4¼ in. (16.5 × 11 cm)
Museum of Fine Arts, Boston
Gift of Mrs. Charles Prendergast
in honor of Perry T. Rathbone,
1972.1128
CR 1486

in preparation for The Eight show, he had finally amassed the money to go.

Fortunately, letters have survived from this trip—no such correspondence from the Italian expedition still exists—so we have much more evidence of what Prendergast was thinking and seeing. What is striking is not only his intense absorption of the most modern art in Paris (such as that of Cézanne and Matisse; see figs. 92, 94, 95) but also how casually he weaves new and old art into his account of the exhibition season. As he wrote to his friend Esther Williams: "I have been extremely fortunate in regard to the exhibitions, not only in the Spring with the Salons but Chardin, Fragonard, etc. and the delightful fall exhibitions which . . . have all Paul Cézannes, Berthe Morisot and Eva Gonzales."[74] The art he produced in Paris and on the Normandy coast, such as *Louvre* (fig. 93) and *St. Malo* (fig. 96), shows a shift to a very strong palette and broken forms throughout, including the sky, as inspired by Cézanne and Matisse.

Prendergast's new work in The Eight show established him as the one member of the group who was attuned to the latest of Parisian styles. He was now routinely called a Neo-Impressionist or even a Fauve. When Stieglitz showed Matisse's work for the first time in New York, in April 1908, critics pointed out Matisse's connection to Prendergast: "His color work, like that

of Maurice Prendergast in the recent display of 'The Eight,' would seem to be simply spots of paint."[75] As The Eight exhibition traveled around the country, Prendergast's new style was the "storm center of criticism" because he believed that art should "represent" rather than "reproduce."[76]

There was much talk of another exhibition of The Eight in the coming years, but instead the artists formed other exhibiting opportunities, including The Independents, a loosely formed group that invited and allowed other artists to participate. Increasingly, the newer American artists looked abroad to the many "internationals" being held in Germany, the UK, and Italy. A visitor to the Venice Biennale of 1909 could see the work of George Bellows as well as that of Childe Hassam, J. Alden Weir, and Edmund Tarbell. The ninth biennale was brought forward to 1910, in deference to a major international exhibition, *Art and History*, that was being planned in Rome. This event was intended to celebrate fifty years of Italian unification (officially begun in 1861) and to show that Rome was now on a par with the other great world capitals. Each nation was invited to contribute a pavilion and exhibition of its own, and the brick neo-Colonial building erected by the US housed a selection of works by The Independents, including Maurice Prendergast.

Back to Italy

In August 1911, a little over ten years after his first trip, Prendergast returned to Italy, applying for an artist's pass to the country's museums (see fig. 98). He joined his brother, Charles (fig. 99), who had arrived a month earlier to study frames and medieval art, and the two of them traveled to Capri and up to Rome (to see Maurice's painting in the Rome international exhibition) before settling in Venice for a long stay. Charles returned to Boston in October, leaving Maurice to "have another w[h]ack at the canals."[77] But before Maurice had made more than a few sketches (fig. 102), he was felled by prostate problems and spent most of October and November being treated and recuperating (see Carol Clark's essay, pp. 161–69). In contrast to the exhilarating experience he had had during his first stay in Venice, Prendergast looked around with pained eyes.

Everything about Venice and Italy had changed in the decade between the two trips. On the Giudecca,

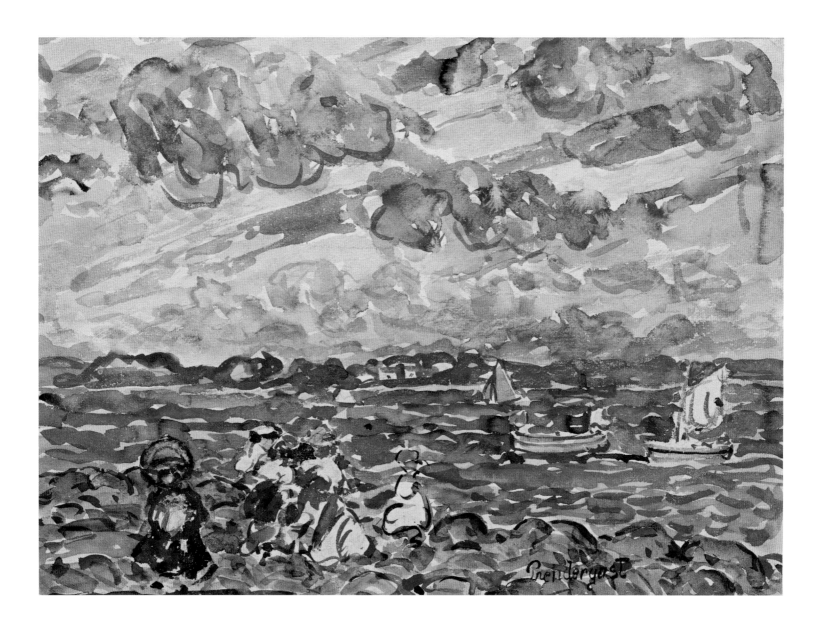

Fig. 96
Maurice Prendergast
St. Malo, ca. 1907
Watercolor and pencil on paper
11¼ × 15¼ in. (28.6 × 38.7 cm)
Williams College Museum of Art,
Williamstown, Massachusetts
Gift of Mrs. Charles Prendergast
(86.18.75)
CR 883

where Maurice and Charles stayed for their first week and where Maurice was treated at Lady Layard's Cosmopolitan Hospital, Prendergast was in the neighborhood of Venice's burgeoning factory sector, the most visible sign of modern Venice. All the modernization efforts that had been talked about in the 1890s were now in full swing, including the rebuilding of the campanile in St. Mark's Square, which had collapsed in 1902 and had just reopened. Tourism too had continued to grow. "Going to Venice is just as easy as going to Newark," one New York travel agent insisted, showing the casualness of the new breed of American tourist.[78] Although seeing and being seen were still important, dressing in the latest fashions was

not. The new, shorter skirts in vogue by 1910 sparked an outcry and a movement among such Venetian fashionistas as Mariano Fortuny to return to the Renaissance.

Most importantly, the relationship between Italy and the US had changed. An overwhelming wave of Italian immigration to New York and even Boston in the years between 1900 and 1910 had affected the romantic attitude Americans had long held toward Italy.[79] Poverty and high taxation, especially in southern Italy, drove millions to seek work across the Atlantic, bringing a new and often uneasy cultural familiarity that had not been the experience of such nineteenth-century American travelers as Henry James. Immigration had such a transformative effect on American cities that most of

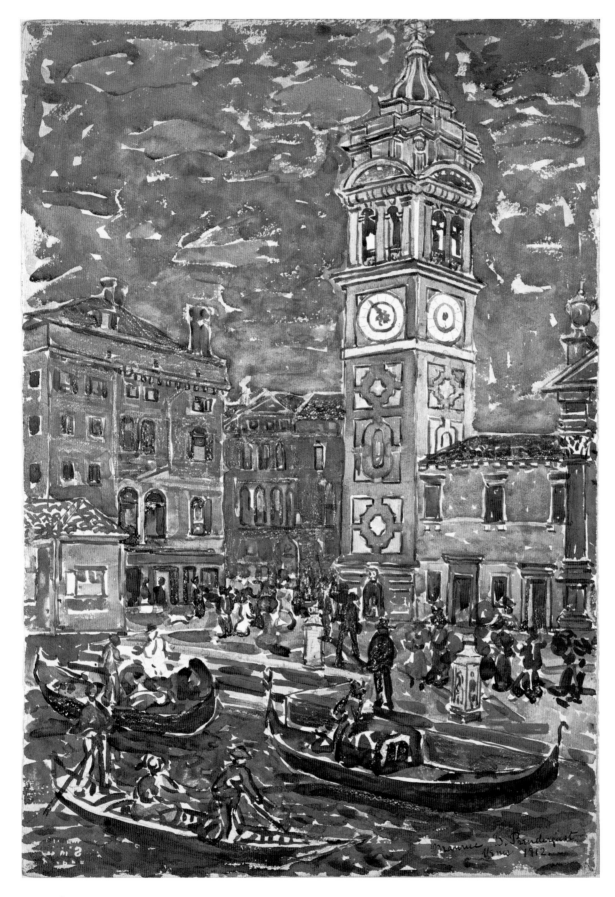

Fig. 97
Maurice Prendergast
Santa Maria Formosa, Venice,
ca. 1911–12
Watercolor and graphite pencil
on paper
22 × 15¼ in. (55.8 × 38.9 cm)
Museum of Fine Arts, Boston
The Hayden Collection—Charles Henry
Hayden Fund, 59.58
Photograph © 2009 Museum of Fine
Arts, Boston
CR 1013

Fig. 98 (right)
Photograph of Maurice
Prendergast, ca. 1911
Prendergast Archive and Study Center,
Williams College Museum of Art,
Williamstown, Massachusetts
Photo Credit: Arthur Evans

Fig. 99 (far right)
Photograph of Charles
Prendergast, ca. 1910–13
Prendergast Archive and Study Center,
Williams College Museum of Art,
Williamstown, Massachusetts
Photo Credit: Arthur Evans

Fig. 100
Maurice Prendergast
Pencil drawing of frames
Sketchbook
("Sketchbook of Frame Studies"),
ca. 1898–1903
6⅞ × 4 in. (17.5 × 10.2 cm)
Williams College Museum of Art,
Williamstown, Massachusetts
Gift of Mrs. Charles Prendergast
(85.26.9)
CR 1481

ITALY

FROM THE ALPS TO NAPLES

HANDBOOK FOR TRAVELLERS

BY

KARL BAEDEKER

WITH 25 MAPS AND 52 PLANS AND SKETCHES

SECOND EDITION

LEIPZIG: KARL BAEDEKER, PUBLISHER
LONDON: T. FISHER UNWIN, 1, ADELPHI TERRACE, W.C.
NEW YORK: CHARLES SCRIBNER'S SONS, 153-157 FIFTH AVE.
1909
All rights reserved.

the artists of The Eight, including Prendergast to a certain extent, considered New York itself and new urban life to be Modernist themes. Italy and Italians had played a large part in this new vision.

When Prendergast's health finally improved and he was well enough to begin painting, it was not the tourists or the complex issues of Italian church and state evident in St. Mark's Square that were his main interest so much as the canals—and not just the canals themselves, with their iridescent reflections, but the many bridges over them. For the first time, Prendergast painted the span of the Rialto Bridge in two grand views of left and right (figs. 103, 104). He went on to paint the more modest bridges, mostly in the neighborhoods of the Accademia and the Zattere in Dorsoduro (across the Grand Canal from St. Mark's), where he stayed after leaving the hospital. In the repetition, he celebrates the arching span of the bridges and the sweeping lines of their marble edges. People are so vaguely defined that you cannot tell whether it is tourists or Venetians crossing the bridges in ones and twos (figs. 105–108).

As with the Italian flags in front of St. Mark's or the processions of all kinds that he had painted during his first trip, Prendergast draws attention to the bridge motifs and invites a deeper interpretation. A clue to

Fig. 101
Title page with name and address of Charles Prendergast
From Karl Baedeker, *Italy from the Alps to Naples*, 2nd edn, Leipzig (Karl Baedeker) 1909
Prendergast Archive and Study Center, Williams College Museum of Art, Williamstown, Massachusetts
Photo Credit: Arthur Evans

Fig. 102 (below, left and right)
Maurice Prendergast
Pencil drawing and listing
Sketchbook ("Sketchbook 74"), ca. 1911–12
6⁵⁄₁₆ × 4⅛ in. (16 × 10.5 cm)
Museum of Fine Arts, Boston
Gift of Mrs. Charles Prendergast in honor of Perry T. Rathbone (1972.1164)
CR 1499

Fig. 103
Maurice Prendergast
Rialto Bridge, ca. 1911–12
Watercolor and graphite
on off-white wove paper
15⅜ × 22¼ in. (39.1 × 56.5 cm)
The Metropolitan Museum of Art,
New York
The Lesley and Emma Sheafer Collection,
Bequest of Emma A. Sheafer, 1973
(1974.356.1recto)
Photograph © 2000 The Metropolitan
Museum of Art, New York
CR 1009 (recto)

Prendergast's thinking about this subject can be found in the article "In Praise of Bridges" (1910), by the mathematician and cultural commentator Archibald Henderson. Henderson picks out bridges as the perfect vehicle to express the meaning of modern life. He focuses on the Brooklyn Bridge, with its "stupendous cables and interwoven superstructure" supporting "the hurrying throng that passe[s] and repasse[s] forever over those everlasting spans."[80] But bridges are such important cultural symbols that all bridges built by every society throughout history have meaning. In particular, Henderson notes, we should study the "pearly richness and architectural beauty of [Venice's] bridges" because New York has inherited their beauty and functionality, redesigned for a new age.[81] New York bridges had already been adopted by The Eight as important subjects, but it was after 1910 that such

modernists as John Marin and the Italian immigrant Joseph Stella made new interpretations of the Brooklyn Bridge worthy of Henderson's grand vision.

That Prendergast chose to focus on Venice's bridges satisfied the other side of Henderson's argument. The older monuments evoked the new and continued to be beautiful and functional within the present-day context of the new Italy. Prendergast's reconciliation of past and present, like Henderson's, was in opposition to the radical suggestion made by the Futurists in a protest in St. Mark's Square in the spring of 1910, when the Futurist manifesto, printed in large numbers, was dropped from the top of the as-yet-unfinished campanile. Preaching the end of the antique-worship and tourism that had made Venice a "magnificent wound of the past," the Futurists advocated its transformation into a modern city full of factories,

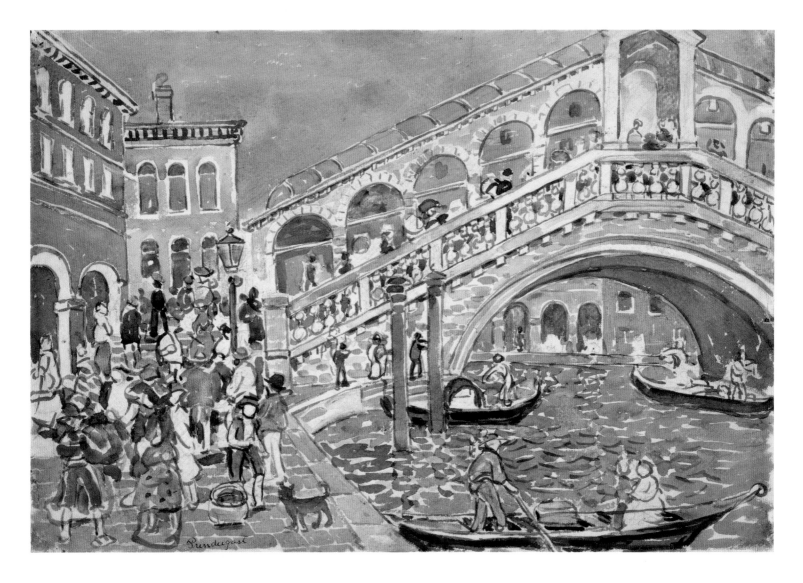

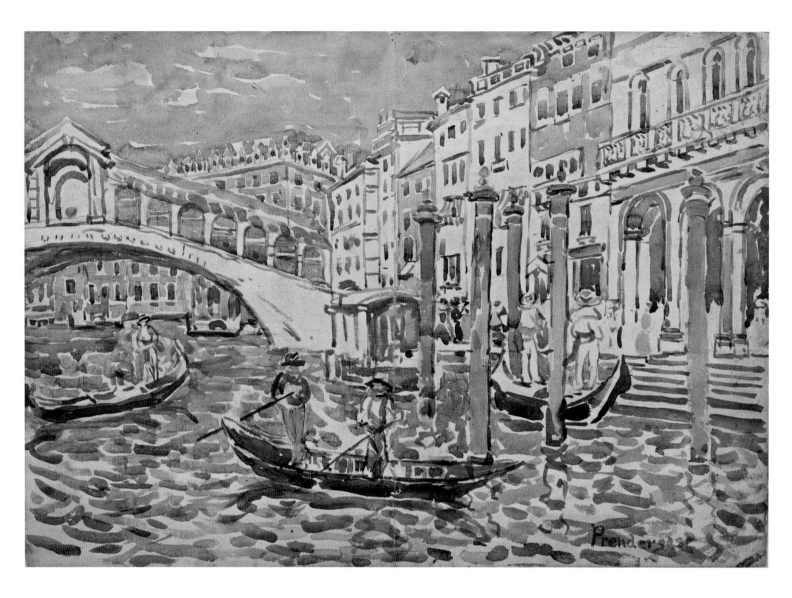

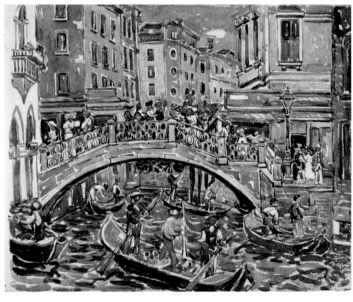

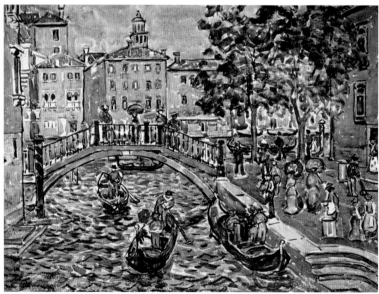

Fig. 104 (opposite, top)
Maurice Prendergast
Rialto, Venice, ca. 1911–12
Watercolor and pencil on paper
14⅞ × 21⅝ in. (38.1 × 55.9 cm)
Williams College Museum of Art,
Williamstown, Massachusetts
Gift of Mrs. Charles Prendergast
(86.18.79)
CR 1010 (recto)

Fig. 105 (opposite, bottom left)
Maurice Prendergast
Canal, ca. 1911–12
Transparent watercolor over graphite
on heavyweight textured wove paper
15½ × 22⅟₁₆ in. (39.4 × 56 cm),
overall—irregular
Munson-Williams-Proctor Arts Institute,
Museum of Art, Utica, New York
Edward W. Root Bequest, 57.213B
CR 1018 (recto)

Fig. 106 (opposite, bottom right)
Maurice Prendergast
Scene of Venice, ca. 1911–12
Watercolor and pencil on paper
15 × 20½ in. (38.1 × 52.1 cm)
Collection of Ann and Gordon Getty
CR 1033

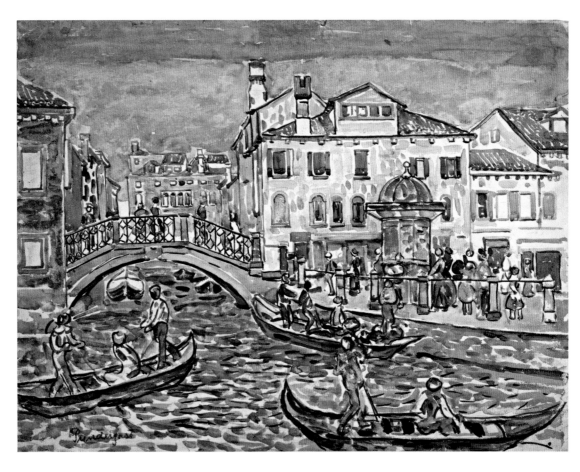

Fig. 107
Maurice Prendergast
Venice, ca. 1911–12
Watercolor, pencil, and pastel on paper
17⅛ × 23⅛ in. (43.8 × 58.7 cm)
Collection of the McNay Art Museum,
San Antonio
Bequest of Marion Koogler McNay,
1950.116
CR 1019 (recto)

Fig. 108
Maurice Prendergast
*View of Venice
(Giudecca from the Zattere)*,
ca. 1911–12
Watercolor and pencil on paper
15¼ × 22 in. (38.7 × 55.9 cm)
Private Collection
Courtesy of Kodner Gallery, St. Louis
CR 1025 (recto)

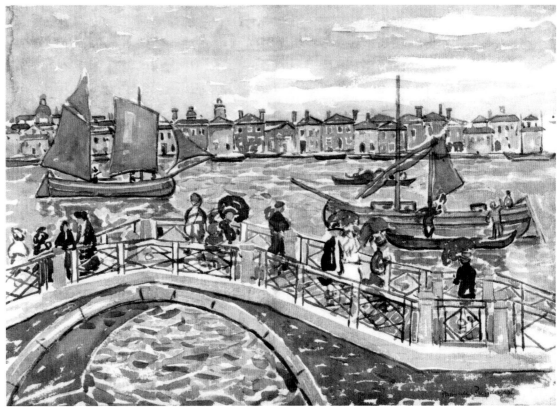

machines, and guns. The palaces should be bulldozed into the canals and the gondolas burned, they said. In their place, they called for "the rigid geometry of large metallic bridges and manufactories with waving hair of smoke" and the abolition of "the languishing curves of the old architectures!"[82] The scale of the publicity for the Futurists' actions and their declarations in the *New York Times* (fig. 109) and elsewhere in the American press invites the speculation that both Henderson and Prendergast were offering a more palatable view of Venice and the modern.

At that time, Futurist art itself was little known by American artists, although Prendergast had become acquainted with the work of such proto-moderns as Segantini during his first trip to Italy. Boccioni's *The Grand Canal in Venice*, of 1907 (fig. 110), shows his adherence to the Italian Neo-Impressionist style of Divisionism, which was quite similar to the style used by Prendergast in his earlier "spotty" canvases. While the bridge compositions were conservative in

comparison to most of Prendergast's work after 1907, a number of watercolors (figs. 111–14, 116, 117) were quite radical in color and in the abstraction of natural forms. *Campo Santa Maria Formosa*, for instance, with its patterns of clouds, architectural lines, and crowds of people, fractures the surface of the image as though it were bubbling with movement.

Many of the finished watercolors from Prendergast's second trip to Venice are painted on sheets of paper that he had already used. If you turn them over, you find not only abandoned sketches from a day's work (as is common in the watercolors from the first trip) but also abandoned sketches from years before—beach scenes from the 1890s, Venice sketches, and Central Park scenes from his efforts up to 1905. There are so many that we must conclude that he had taken these used sheets with him on the second trip to Italy. At this point in his career, he was far from poor, and it had never been his practice before to save and reuse papers over such a long period of time. The unfinished

Fig. 109
"'Futurists' Desire to Destroy Venice: Would Pull Down Its Palaces and Replace Them with Modern Factories"
Article heading
New York Times, July 24, 1910, p. C2
Photograph courtesy of NYPL Express, New York Public Library

Fig. 110
Umberto Boccioni
(Italian, 1882–1916)
The Grand Canal in Venice, 1907
Oil on canvas
26¾ × 26¾ in. (68 × 68 cm)
Galleria dello Scudo, Verona, Italy
Photo Credit: Alinari/Art Resource, New York. Image ref.: ART20065

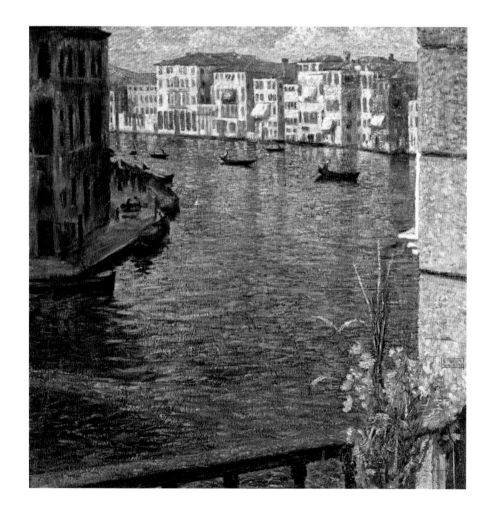

"FUTURISTS" DESIRE TO DESTROY VENICE

Would Pull Down Its Palaces and Replace Them with Modern Factories.

THEY ISSUE A MANIFESTO

Want a Commercial and Military City on the Adriatic, Able to Brave the "Eternal Enemy, Austria."

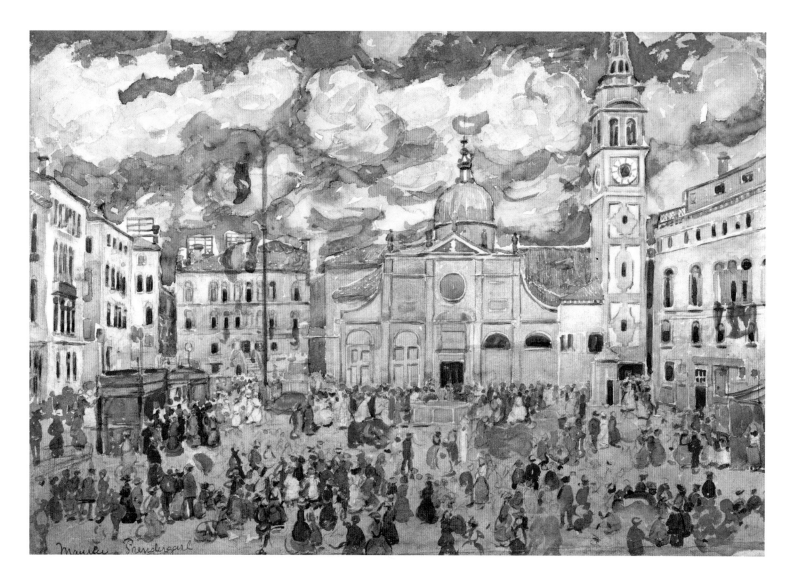

Fig. 111
Maurice Prendergast
*Campo Santa Maria Formosa,
Venice,* ca. 1911–12
Watercolor and pencil on paper
12¾ × 18½ in. (32.4 × 47 cm)
Fayez Sarofim Collection
CR 1016

sketches from his first trip to Italy may have served as mental notes to help him recover and finish what he had started then, but how to explain the beach and Central Park scenes, such as the verso of *Rialto Bridge* (figs. 103, 115)? Whatever the intention, the effect is eerily nostalgic, as though Prendergast were carrying around his own past, turning it over, and making something more modern out of it.

Prendergast believed that these new watercolors of Venice far surpassed his work up to that point. Comparing one of the bridge scenes, *Canal* (fig. 105), with works he had done just a couple of years earlier, he wrote to the owner, "It struck me as a very interesting water color—miles ahead of the [other] two." Prendergast entered the new paintings into exhibitions in 1912, including that of the New York Watercolor Society, and received the expected response:

"They are like a cluster of red-cheeked hoydens bursting into a mid-Victorian assembly of anemic ladies. Possibly a trifle too noisy to live with, but certainly refreshing to encounter on an afternoon stroll."[83] There were fewer finished works from Prendergast's second trip to Italy, and there was never the kind of critical response that followed the first, with its exposure at the Macbeth Gallery in 1900 immediately after the artist's return. Prendergast did not have as much riding on these particular Venetian watercolors.

Nevertheless, the works reverberated in curious ways during the next few crucial years for Prendergast and the course of Modernism in New York. When Prendergast returned to the US in the winter of 1912, he immediately became embroiled in plans for New York's answer to the Venice Biennale and other

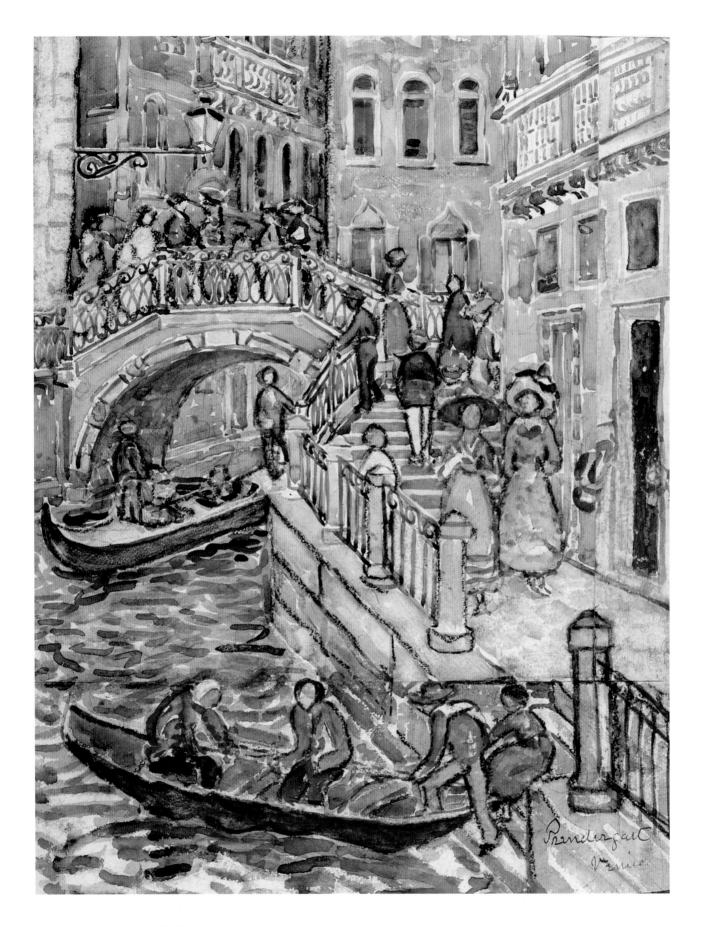

Fig. 112 (opposite)
Maurice Prendergast
Bridge and Steps, Venice,
ca. 1911–12
Watercolor, graphite, oil pastel,
gouache, and charcoal on paper
20⅞₁₆ × 15¼ in. (51.6 × 38.7 cm)
Norton Museum of Art,
West Palm Beach, Florida
Bequest of R.H. Norton, 53.155
CR 1015

Fig. 113
Maurice Prendergast
Palazzo Dario, ca. 1911–12
Watercolor and pencil on paper
11¼ × 15¼ in. (28.6 × 38.7 cm)
Collection of Donna Seldin Janis
CR 1034 (recto)

Fig. 114
Maurice Prendergast
Campo San Samuele, Venice,
ca. 1911–12
Watercolor and graphite on laid paper
11¼ × 15⅜ in. (28.6 × 39.1 cm)
Portland Museum of Art, Maine
Gift of William D. Hamill, 1991.9.1
Photo by Benjamin Magro
CR 1014 (recto)

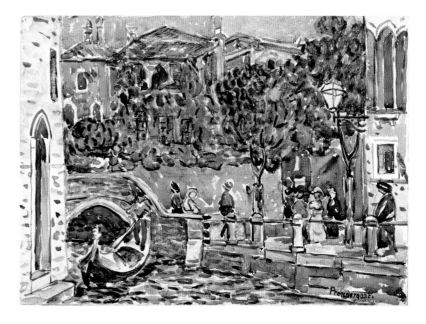

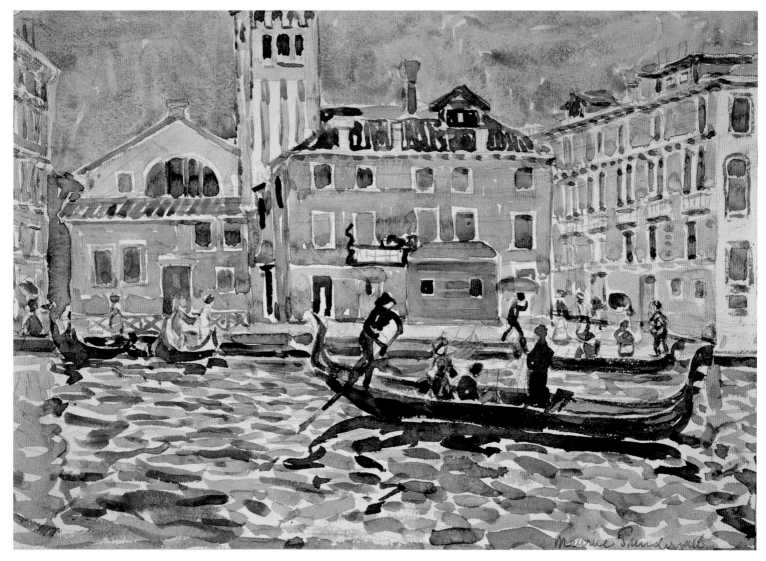

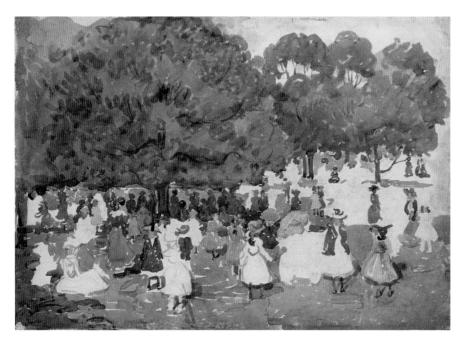

Fig. 115
Maurice Prendergast
Central Park Scene,
ca. 1900–03
Watercolor and graphite
on off-white wove paper
15⅜ × 22¼ in. (39.1 × 56.5 cm)
The Metropolitan Museum of Art,
New York
The Lesley and Emma Sheafer Collection,
Bequest of Emma A. Sheafer, 1973
(1974.356.1 verso)
Image © The Metropolitan Museum
of Art, New York
CR 1009 (verso)

Fig. 116
Maurice Prendergast
Venice, ca. 1911–12
Watercolor and graphite on paper
14⅝ × 21¼ in. (37.5 × 54 cm)
Columbus Museum of Art, Ohio
Gift of Ferdinand Howald, 1931.251
CR 1021

Fig. 117
Maurice Prendergast
Venice, ca. 1911–12
Watercolor and pencil on paper
13¼ × 19½ in. (33.7 × 49.5 cm)
Private Collection
Courtesy of Owen Gallery, New York
CR 1030 (recto)

"internationals": the so-called "Armory Show" of 1913, or the *International Exhibition of Modern Art.* Not only was he anxious to finish his entries into the exhibition, but he also served on one of the selection committees. He submitted several large canvases, one of which, *Beach Scene, Maine* (fig. 121), featured nude and clothed bathers on a rocky shore. In the reviews, he would have been pleased to read that his friend William Glackens considered him "consistently and thoroughly modern,"[84] but he may have been surprised to see one of his paintings reproduced under the headlines "The New Idea: 'Cubists' and 'Futurists,'"[85] and "Look Out for Your Horses, the Futurists are Coming."[86]

The irony of being called a Futurist at this point in his career was that, as we have seen, Prendergast believed in a relationship between the past and the present that was very different from the one described by the Futurists. As on his first trip to Italy, he returned from his second trip with a renewed interest in what a modern artist can learn from the art of the past. Like many Modernists, he developed an interest in Giotto while he was there, and even learned more than color

ideas from such later Italian artists as Titian and Veronese.[87] The sketchbooks from the second Venetian trip are full of sketches of mythological scenes that Prendergast developed into richly colored pastels, such as *Horseback Rider* (figs. 118, 120). Typical of this period, *Horseback Rider* has an unfinished composition of a Venetian canal on the back (fig. 119), as though Venice were "behind" his new interest in timeless subject matter.

When Prendergast was given his first career retrospective, at the Carroll Galleries in New York in 1915, the Italian works from both trips were put into the context of a twenty-year œuvre for the first time. Their importance was immediately visible. They clarified Prendergast's direction at two key points of his career and demonstrated that he had a lifelong desire to reconcile the present and the past, the timely and the timeless. Virtually all the works in the exhibition could be summed up by this critic's statement: "Color, the attractiveness of waterways and the rhythm of processions occupy the thoughts of Maurice Prendergast almost to the exclusion of

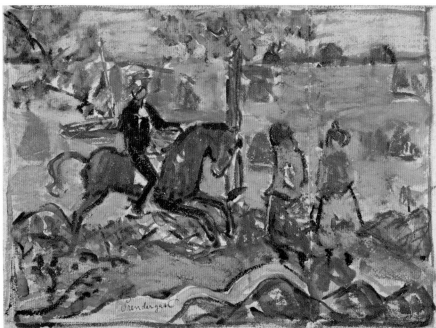

Fig. 121
Maurice Prendergast
Beach Scene, Maine,
ca. 1910–13
Oil on canvas
30½ × 34 in. (77.5 × 87.6 cm)
Williams College Museum of Art,
Williamstown, Massachusetts
Gift of Mrs. Charles Prendergast
(86.18.51)
CR 366a

other topics. His impressions are elusively presented, and one must accept or reject them much as one accepts or rejects music."[88]

Although in Italy Prendergast was occasionally struck by the importance of a particular subject (flags, bridges) to the meaning of modern life, the repetition of that subject released him to go beyond it to a subtle study of abstraction in color and form. This talent and thoughtfulness were the basis for Prendergast's position

of honor and respect in the modern art world even as newer movements eclipsed him. Despite the fact that he did not found a "school" or make it easy for other artists to follow directly in his footsteps, he became an inspiration to all those who strove for unique, individual expression. The ultimate tribute to his lifelong search for a personal vision—even of the most often used themes, such as Venice—was put succinctly: "An imitation Prendergast is almost unthinkable."[89]

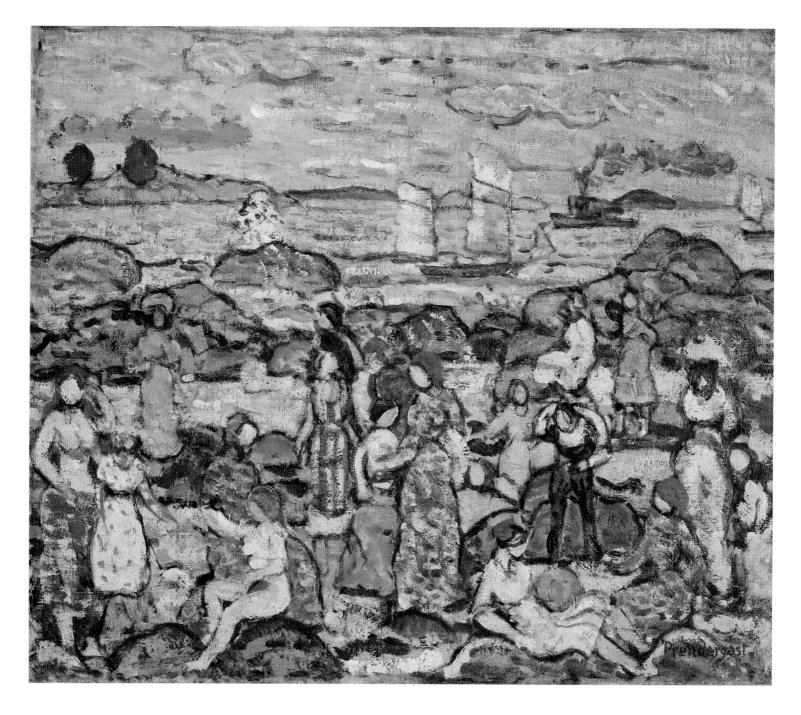

Notes

1 "Art Notes," *New York Mail and Express*, March 17, 1900, p. 5.

2 "In the Art World," *New York Times*, January 15, 1898, p. 46.

3 Henry James, "Venice," *The Century Magazine*, 25, November 1882, p. 3.

4 David C. Preyer, "Editorial," *The Collector and Art Critic*, 11, March 15, 1900, p. 163.

5 "Mr. Prendergast's Water Colors and Monotypes at the Macbeth Gallery," *Evening Sun*, March 13, 1900, p. 4.

6 Maurice Prendergast to J. Montgomery Sears, February 24, 1900, private collection, quoted in Erica Hirshler, "The Fine Art of Sarah Choate Sears," *The Magazine Antiques*, September 2001, pp. 320–29.

7 Pompeo Molmenti, "Venice," *Art Journal*, 62, March 1900, p. 87.

8 Will Low, "A Century of Painting," *McClure's Magazine*, 7, August 1896, p. 226.

9 For this and other information about art training in Boston public schools, see Ellen Glavin, "The Early Art Education of Maurice Prendergast," *Archives of American Art Journal*, 33, 1993, pp. 2–12.

10 Ellen Glavin, "The Newfoundland Ancestry of Maurice and Charles Prendergast," *Newfoundland Studies*, 10, 1994, p. 91.

11 Hamilton Basso, "Profiles: A Glimpse of Heaven—II," *The New Yorker*, 22, August 3, 1946, p. 28.

12 Charles Prendergast believed they had been stolen from his brother, but they may have been erroneously captioned in the publication. See "Anecdotes of Maurice Prendergast," in *The Prendergasts: Retrospective Exhibition of the Work of Maurice and Charles Prendergast*, exhib. cat. by Van Wyck Brooks, Andover, Mass., Addison Gallery of American Art, Phillips Academy, 1938.

13 "Rising Painters," in *Artists' Exhibition and Sale, in the Gallery of C.O. Elliett*, exhib. cat., Malden, Mass., April 21–May 4, 1897.

14 See Nancy Mowll Mathews, "Franklin Park," in *The Art of Leisure: Maurice Prendergast in the Williams College Museum of Art*, Williamstown, Mass. (Williams College Museum of Art) 1999, pp. 17–20.

15 "Gallery and Studio Notes," *Boston Evening Transcript*, November 9, 1897, p. 5. This does not seem to have been carried out.

16 "The Fine Arts—Fifty-Sixth Exhibition of the Boston Art Club," *Boston Evening Transcript*, April 3, 1897, p. 7.

17 Blanche V. King, "Art Notes," *Washington Post*, April 10, 1898, p. 23.

18 See Nancy Mowll Mathews, *Maurice Prendergast*, Munich (Prestel in association with Williams College Museum of Art) 1990, pp. 15, 18.

19 Basso, "Profiles: A Glimpse of Heaven—II," p. 32.

20 Gardner acquired this work in 1895.

21 James McNeill Whistler, *The Gentle Art of Making Enemies*, New York (John W. Lovell Co.) 1890, p. 93.

22 Draft of a letter from Maurice Prendergast to an unknown recipient in *Sketchbook* (CR 1479; see p. 181), The Cleveland Museum of Art, Gift of Mrs. Charles Prendergast (51.422).

23 I would like to thank Amy Torbert and Rebecca Shaykin, along with Jamie Sanecki and Ruth Ezra, for assembling a complete library of articles about Italy in the English and American press from about 1860 to 1911, now housed in the Prendergast Archive and Study Center, Williams College Museum of Art, Williamstown, Massachusetts.

24 Charles Eliot Norton, "Venice and St. Mark's," *Atlantic Monthly*, 41, February 1878, p. 202.

25 W.J. Gordon, *Flags of the World: Past and Present*, London (Frederick Warne & Co.) 1915, p. 233.

26 John Ruskin, *The Stones of Venice*, ed. and abridged J.G. Links, London (Penguin) 2001, p. 148.

27 Cesare Lombroso, "Sociological and Ethnical Sources of the Greatness of Italy," *Forum*, December 1898, p. 500.

28 Gordon, *Flags*, p. 233. I would like to thank Ruth Ezra for pointing this out and for her research into the flags of Venice.

29 Gerturde E. Campell, "Outdoor Venice," *Art Journal*, 54, February 1892, p. 38.

30 "Boston Notes," *Art Interchange*, 42, April 1899, p. 78.

31 See Mathews, *The Art of Leisure*, passim.

32 Campbell, "Outdoor Venice," p. 38.

33 James, "Venice," p. 6.

34 Karl Baedeker, *Italy: Handbook for Travellers: Northern Italy*, Leipzig (Karl Baedeker) 1895, p. 244.

35 Horatio F. Brown, *Life on the Lagoons*, London (Rivingtons) 1900, p. 167.

36 F. Cooley, "Venetian Fetes—Past and Present," *The Chautauquan*, 19, September 1894, p. 655.

37 Charles Dudley Warner, "Editor's Study," *Harper's New Monthly Magazine*, 91, September 1895, p. 642.

38 Ruskin, *Stones of Venice*, p. 153.

39 Arthur Symons, "Venice in Easter," *Harper's New Monthly Magazine*, 90, April 1895, p. 740.

40 *Ibid.*, p. 746.

41 Warner, "Editor's Study," p. 642.

42 James, "Venice," p. 5.

43 See advertisement for "Old Venetian Well-Heads," *The Art Journal Advertiser*, 66, January 1904, p. 3.

44 Theodore Purdy, "Housekeeping in Venice," *Outing*, 30, April 1897, p. 15: "The Curtises of Boston occupied the Palazzo Barbaro and the Washingtons, Browns, and Van Beurens all lived in the immediate vicinity."

45 William Henry Bishop, "An American at Home in Europe," *Atlantic Monthly*, 70, December 1892, p. 816.

46 "The Boston Art Club's Fifty-Second Exhibition," *Sunday Herald*, April 7, 1895, p. 33.

47 Charles Hovey Pepper, "Is Drawing to Disappear in Artistic Individuality?" *The World Today*, 19, July 1910, p. 719.

48 M.E.W. Sherwood, "Venice," *The Galaxy*, 14, November 1872, p. 665.

49 Cooley, "Venetian Fetes," p. 651.

50 "Still Waters," *The Living Age*, 218, August 13, 1898, p. 494.

51 For a good commentary on how this early training can be seen throughout Prendergast's color notations, see Glavin, "The Early Art Education of Maurice Prendergast," pp. 10–11.

52 Warner, "Editor's Study," p. 642.

53 Thomas Schaefer, "The Colouring of the Venetians," *The International Studio*, 2, 1897, p. 222.

54 *Ibid.*, p. 224.

55 *Ibid.*, p. 222.

56 James, "Venice," p. 13.

57 See "Artistic Photography," *The Art Amateur*, 38, January 1898, p. 42: "To the real artist the pictorial qualities of the subject are of much more account than the story."

58 *Ibid.*, p. 43.

59 Baedeker, *Italy*, p. 238.

60 Low, "A Century of Painting," p. 226.

61 Pepper, "Is Drawing to Disappear in Artistic Individuality?" p. 719.

62 Allen French, "Municipal Art in Italy," *New England Magazine*, 24, March 1898, p. 51.

63 See, for example, Francis P. Nash, "Italy as a 'Great Power,'" *The Nation*, 65, August 19, 1897, p. 146.

64 Federico de Roberto, *Illusions* (1891), cited in Nash, "Italy as a 'Great Power.'"

65 Percy Lubbock, "An Amateur in Rome," *MacMillan's*, 87, December 1902, p. 143.

66 *Ibid.*, p. 144.

67 Pepper, "Is Drawing to Disappear in Artistic Individuality?" p. 719.

68 See Mathews, *The Art of Leisure*, pp. 29–31, for a discussion of ethnic May Day celebrations and the dispute over park benches in 1901.

69 "The Fine Arts," *Boston Evening Transcript*, February 13, 1900, p. 8.

70 *Ibid.*

71 Although the work has not been identified, William Milliken tells us that "the only water color sold [from the Macbeth show] was a Venetian one to the late William Gedney Bunce, a touching tribute, really, from one who loved Venice and who painted her beauties so often." "Maurice Prendergast, American Artist," *The Arts*, April 1926, p. 186.

72 "Fine Arts," *Brooklyn Daily Eagle*, March 15, 1900, p. 9.

73 "The New York Watercolor Club," *The Sun*, November 9, 1900, p. 6.

74 Maurice Prendergast to Esther Baldwin Williams, October 1907, Esther Baldwin Williams Papers, Archives of American Art, Smithsonian Institution, Washington, D.C. (hereafter AAA).

75 "Exhibitions Now On: Work by Henri Matisse," *American Art News*, 6, April 11, 1908.

76 "'The Eight' Stir Up Many Emotions," *Newark Evening News*, May 8, 1909, p. 4.

77 Maurice Prendergast to Esther Baldwin Williams, September 15, 1911, Williams Papers, AAA.

78 Henry Hoyt Moore, "A Day or Two in Venice," *The Outlook*, 90, December 26, 1908, p. 929.

79 In 1903–04, some 15,000 Italian immigrants a day passed through Ellis Island. See John Foster Carr, "The Coming of the Italians," *The Outlook*, 82, February 24, 1906, pp. 418–31.

80 Archibald Henderson, "In Praise of Bridges," *Harper's Monthly Magazine*, 121, November 1910, p. 926 (photographs by Alvin Coburn).

81 *Ibid.*, p. 930.

82 F.T. Marinetti, "Futurist Venice," reprinted in "'Futurists' Desire to Destroy Venice," *New York Times*, July 24, 1910, p. C2.

83 "At Home and Abroad," *New York Times*, April 28, 1912, p. SS15.

84 William Glackens, "The American Section: The National Art," *Arts and Decoration*, 3, March 1913, p. 164.

85 "The New Idea: 'Cubists' and 'Futurists,'" *Evening Post Saturday Magazine*, February 8, 1913, p. 1.

86 "Look Out for Your Horses, the Futurists are Coming," *Chicago Daily Tribune*, March 18, 1913, p. 5.

87 Maurice Prendergast to Esther Baldwin Williams, March 8, 1912, Williams Papers, AAA. "I am glad I went for I have accumulated some fine ideas studying the Giotto's [*sic*]."

88 "What is Happening in the World of Art," *The Sun*, February 21, 1915, p. 2.

89 *Ibid.*

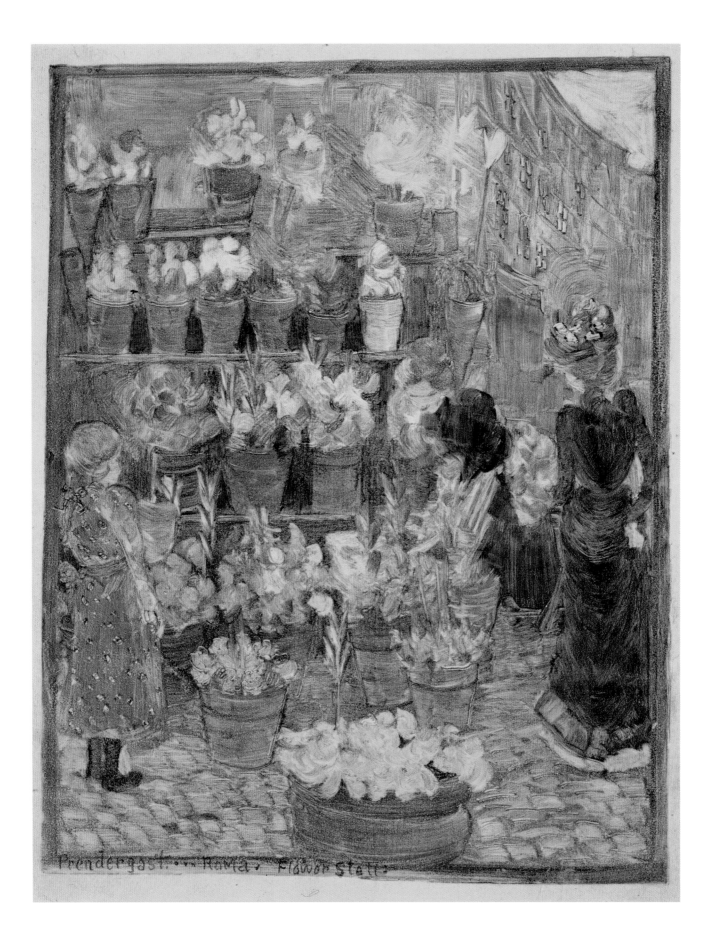

Expressions of Modernity: The Italian Monotypes

Elizabeth Kennedy with Kimberly J. Nichols

Mr. Prendergast is particularly happy in the line of monotypes, leaving less to chance he strives for a careful delineation of the subject, and the work reminds one of a most dainty Water Color.

This puzzling statement appeared as the introduction to the list of monotypes in the Detroit Museum of Art's brochure for November 1901, which accompanied the exhibition of Maurice Prendergast's watercolors and colored monotypes.[1] The observation ostensibly refuted the perceived wisdom that Prendergast's monotype process was an effortless artistic endeavor, characterized in a review of 1897 as "full of the natural impulse of freedom of spontaneous and joyful production, and of true artistic spirit."[2] In drawing a direct comparison between Prendergast's monotypes and his watercolors, the Detroit statement also seems to be an attempt to counter the belief that the former were not appreciated as worthy equivalents to the latter. After this major solo exhibition, the artist stopped exhibiting his monotypes as part of his career strategy, and soon afterward ceased producing them altogether.[3]

As with much of Prendergast's œuvre, the dating of the monotypes is something of a mystery, and most of our knowledge of them is gleaned from the works themselves.[4] Approximately 150 monotypes are extant from about 200 works identified with secure dates ranging from 1892 to 1902; twelve works bear the inscription 1895, the largest number of dated monotypes.[5] Scholars are baffled by the lack of a noticeable stylistic evolution in this modest number of colored prints and are bemused by the diverse range of subjects, from the clichéd "Prendergast Girl," with swishing skirts and a pert nose, typified by the young woman in *Red Haired Lady with Hat* of about 1891–94 (fig. 2), to *Summer Day*

of about 1900–02 (fig. 3), a Modernist, almost formalist, two-dimensional play of color and space.

Intriguingly, the monotypes inspired by Prendergast's Italian journey of 1898–99, their precise dates and locations of execution unknown, are among his most unusual in design and modern in temperament. Famous for their marvelous detail and brilliant color, Prendergast's Italian watercolors showcased his mastery of the procession, enlivened by a panoply of human gestures as the animated crowd pass before renowned

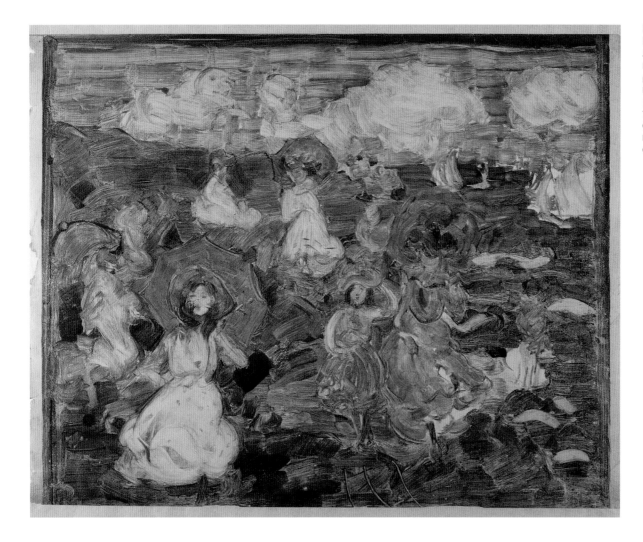

Fig. 3
Maurice Prendergast
Summer Day, ca. 1900–02
Monotype on paper with
pencil additions
Image: 11³⁄₁₆ × 13¾ in.
(28.4 × 34.9 cm)
Terra Foundation for American Art,
Chicago
Daniel J. Terra Collection, 1992.109
CR 1764

architectural monuments. Conversely, the few monotypes (only sixteen) associated with Italy, either by the title of the work inscribed in the plate or by an obvious subject, demonstrate an unrelated aesthetic. The focus of this essay is to consider the novel aspects of Prendergast's Italian monotypes as early expressions of his modern mindset.

Monotypes

Aptly described as a painterly print, a monotype was a rarity before the late nineteenth century.[6] Less labor-intensive than traditional printmaking and requiring no printmaking expertise, monotypes are simply drawings in printer's ink or oil paint on a smooth surface, traditionally a metal plate, which are transferred from plate to paper by means of pressure, either from a printing press or by less conventional techniques, ranging from a roller to the back of a spoon or even the palm of the hand.[7] Inventive image-making was further exploited

by employing unorthodox tools, from rags to sticks to thumbs, to yield prized prints. Inherently, the monotype is a studio production, as the artist must work quickly to keep his pigments wet and malleable. The apparent ease of accomplishment and its hybrid status as the fusion of two media have contributed to the monotype's humble rank in the hierarchy of works of art.

The sources for Prendergast's monotypes, both European and American, modern and Old Masters, have been exhaustively considered; consensus acknowledges a plethora of possibilities, although two influences are paramount.[8] While the artist never explored printmaking *per se*, much of his compositional vocabulary is adapted from his knowledge of Japanese woodblock prints. Early commentary on his monotypes recognized this inspiration: they are "amusing and artistic color prints after the Japanese method," which seemed especially relevant to his figures of elegant women so evocative of their Japanese counterparts, as seen in the work of

Fig. 4
Utagawa Toyokuni
(Japanese, 1769–1825)
Untitled: Standing Female Figure,
n.d.
Color woodcut on paper
15 × 10¹³⁄₁₆ in. (38.2 × 27.4 cm)
Williams College Museum of Art,
Williamstown, Massachusetts
Gift of Mrs. Charles Prendergast,
92.19.A

Fig. 5
Maurice Prendergast
Street Scene, ca. 1895–1900
Monotype on cream Japanese paper
Image: 8½ × 12¼ in. (21.6 × 31.1 cm)
Terra Foundation for American Art,
Chicago
Daniel J. Terra Collection, 1992.107
CR 1624

Utagawa Toyokuni (fig. 4).[9] The artist's most obvious adaptations are the high horizon line and the "climbing perspective" of figures, diminishing in scale as they rise vertically on the page to create a sense of spatial ambiguity.[10] The Japoniste sensibility of the widely influential American expatriate artist James McNeill Whistler (1834–1903) is also perceptible in Prendergast's monotypes: in the elegant, curving lines of the stylishly dressed females, noted above in *Red Haired Lady with Hat*; in the shop façades of such charming street scenes as *Street Scene* of about 1895–1900 (fig. 5); and in the formula of tripartite bands of color adopted for such monotypes as *Figures Along the Shore*, dated 1895 (fig. 9).

The long history of monotype shows in Boston encouraged Prendergast to exhibit his works in this medium as fine art. In 1881, the Bostonian Charles Alvah Walker (1848–1920) introduced his painterly prints, calling them "monotypes," a term he claimed to have coined, while the same year Albion Harris Bicknell (1837–1915) exhibited a remarkable eighty-two monotypes.[11] The monotypes by Walker and Bicknell were mostly monochromatic landscape pictures reminiscent of French Barbizon landscape paintings. Far from being spontaneous manipulations of ink, these painterly prints began with a preparatory sketch.

The *Colored Print* exhibition at the Boston gallery Hart & Watson in 1897, comprising works by Prendergast and two colleagues, Hermann Dudley Murphy (1867–1945) and Charles Hopkinson (1869–1962), continued the tradition of Boston monotype shows. One reviewer, however, alerted his audience to the fact that these colored prints differed from monotypes "by a process comparatively little used by artists, and only in recent years developed from monotypes into what the present exhibitors . . . catalogue as 'Color Prints.'" While Murphy is credited with inventing "the new artistic process," Prendergast's achievements are recognized as the most accomplished: he "takes the fullest advantage of this process. . . . The peculiar subtleties of these prints seem especially fitted to interpret Mr. Prendergast."[12]

There is little in the way of textual evidence to enlighten Prendergast scholars concerning the artist's colored monotype theory and practice. The artist's only recorded statement is a letter written in 1905 to his student and friend Mrs. Oliver Williams (Esther), in which he describes a monotype technique: "Paint on copper in oils, wiping parts to be white. When the

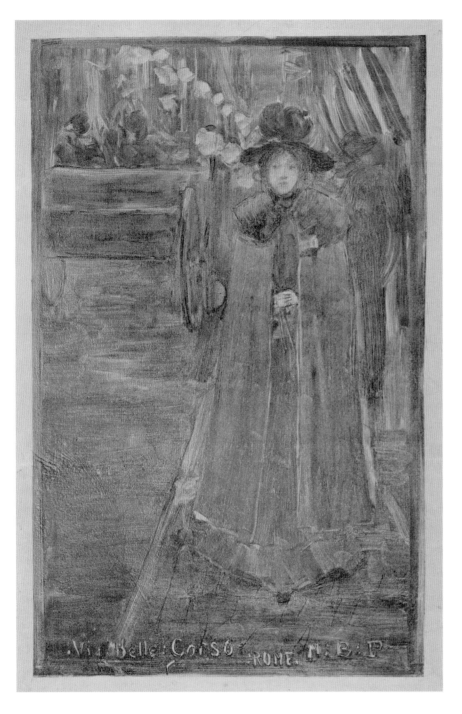

Fig. 6
Maurice Prendergast
On the Corso, Rome, ca. 1898–99
Monotype with graphite on cream Japanese
paper, laid down on Japanese paper
Image: 11¾ × 7½ in. (29.8 × 19 cm)
Terra Foundation for American Art, Chicago
Daniel J. Terra Collection, 1992.96
CR 1702

Fig. 7 (top)
Maurice Prendergast
On the Corso, Rome (detail),
ca. 1898–99
Magnification, reticulated surfaces
Photograph by Kimberly J. Nichols,
The Art Institute of Chicago,
Conservation Lab
CR 1702

Fig. 8 (above)
Maurice Prendergast
On the Corso, Rome (detail),
ca. 1898–99
Fabric matrix
Photograph by Kimberly J. Nichols,
The Art Institute of Chicago,
Conservation Lab
CR 1702

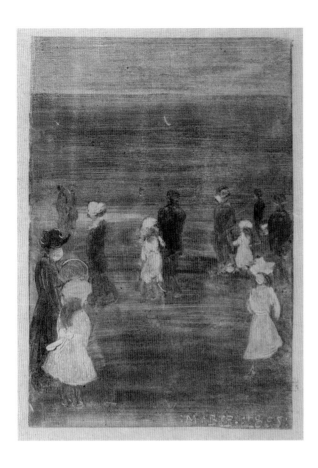

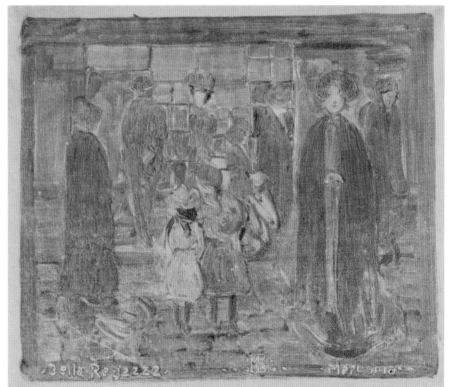

picture suits you, place it on Japanese paper and either press in a press or rub with a spoon till it pleases you. Sometimes the second or third plate [*sic*] is the best."[13] Thirty years later, Maurice's brother, Charles, shared a humorous anecdote about the creative trials and tribulations of Prendergast's monotype process:

> He could not afford a regular press and his quarters in Huntington Avenue were so cramped that he had no room for a work-bench. So he made his monotypes on the floor, using a large spoon to rub the back of the paper against the plate and thus transfer the paint from plate to the paper. As he rubbed with the spoon, he would grow more and more excited, lifting up the paper at one of the corners to see what effects the paint was making.[14]

Despite the limited primary sources, an examination of the monotypes themselves discloses a creative mind intent on experimentation. Oil paint is consistently cited in the literature as Prendergast's medium for monotypes, no doubt because of his letter of 1905. However, an examination by Kimberly J. Nichols,

Associate Paper Conservator at the Art Institute of Chicago, of a number of Italian monotypes challenges the traditional explanation of Prendergast's monotype process.[15] While oil paint and oil-based ink both contain a derivative of linseed oil as a binding medium, the appearance of monotypes produced by each product is distinctive. The look of a monotype made with printer's ink is reticulated or has a grainy surface. An oil paint monotype has a smooth appearance, and, when not altered with solvent, the color is intense. Perhaps the most dramatic evidence of a monotype created with oil paint is the yellowish stain, or halo, that appears on the back of the print owing to the absorption of the raw linseed oil into the fibers of the paper.[16]

Nichols observed that the investigated monotypes all have a grainy surface. Moreover, none of them has the yellow halo normally produced when raw linseed oil oxidizes the paper. These observations suggest that the artist did not use oil paint for his monotypes.[17] Evidence from the examination of *On the Corso, Rome* (fig. 6) and *Bella Ragazza: Merceria* (fig. 10) is revelatory. Clearly visible in the magnification of a detail from *On the Corso, Rome* (fig. 7) is the grainy surface associated with printer's ink. Experimentation with varied matrices to support the drawings is another possibility for the unusual and reticulated appearance of the monotypes. A break in the "plate," visible in the bottom-left corner of *Bella Ragazza: Merceria* (fig. 11), implies millboard was the matrix for the monotype. Another option is a fabric matrix, which could have produced the effect witnessed in a magnification of the lower-left corner of *On the Corso, Rome* (fig. 8). Prendergast also varied his choice of absorbent Japanese papers, at times using ones that had a light-reflective surface coating of mica to increase the luminosity—for example, in *Venice* (fig. 12) and *Monte Pincio (The Pincian Hill)* (fig. 14).[18]

Another peculiar characteristic of Prendergast's monotypes is the almost invisible plate marks that are often seen along the image edge. When observed under a microscope using raking light, they appear as embossed lines in the paper, indicating the artist most likely hand-printed his images. Furthermore, he did not work the image to the plate's edge but drew a line border around the drawing with such precision that a hard edge or tape was used to achieve perfection. These observations indicate the plate was larger than the drawing or the transfer paper sheet.[19] Pinholes are observable at the corner of many images, perhaps used

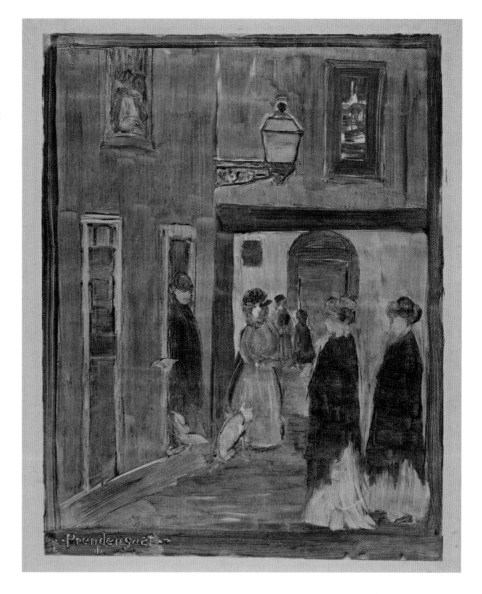

for securing the paper to the plate for hand-printing. There are, however, no visible signs of a selective transfer of inks through to the verso of the paper, as usually corresponds to the pressured contact of a spoon. It is possible that, at times, the artist used a roller rather than a spoon as the transfer method for some of his colored monotypes.[20] While these observations of selected Italian monotypes do not provide definite answers, they affirm that Prendergast was at his most experimental when working with his monotypes.

Italian Monotypes
Although silent on the process of his experimental monotypes, Prendergast's colored prints speak eloquently through his choice of subjects. It is obvious

Fig. 12
Maurice Prendergast
Venice, ca. 1898–99
Monotype on cream Japanese paper
Image: 10 × 7⅞ in. (25.4 × 20 cm)
Terra Foundation for American Art, Chicago
Daniel J. Terra Collection, 1992.114
CR 1707

that he had an appreciative eye for the ladies, and, not surprisingly, his penchant for beautiful girls found expression in his Italian monotypes. The vibrant example of an idealized young woman, embodied in the character of the Gibson Girl created by illustrator Charles Dana Gibson, was pervasively popular in America in the "Gay '90s." Prendergast, a dapper and genial bachelor, was not immune to the charms of these illustrations, and he too paid tribute to jaunty young women and charming, carefree girls in his art.[21] Verifying his brother's fondness of "a pretty dress, blue, green, yellow or old rose, as one saw in all his pictures to the end of his life," in an interview in 1938, Charles Prendergast attributed Maurice's love of women's fashion to his days working in a dry goods store.[22] Another possible explanation of Prendergast's fascination with attractive, well-dressed women is to recognize the death of his twin sister, Lucy, when they were in their late teens, as a subliminal inspiration for this noticeable leitmotif in his art. Originating from

Fig. 13 (above)
Maurice Prendergast
Monte Pincio (The Pincian Hill)
(detail), 1898
Detail of wall
Photograph by Kimberly J. Nichols,
The Art Institute of Chicago,
Conservation Lab
CR 1699

Fig. 14 (right)
Maurice Prendergast
Monte Pincio (The Pincian Hill),
ca. 1898–99
Monotype with watercolor on cream
Japanese paper
Image: 7 ½ × 9 ⅜ in. (19 × 23.8 cm)
Terra Foundation for American Art,
Chicago
Daniel J. Terra Collection, 1992.94
CR 1699

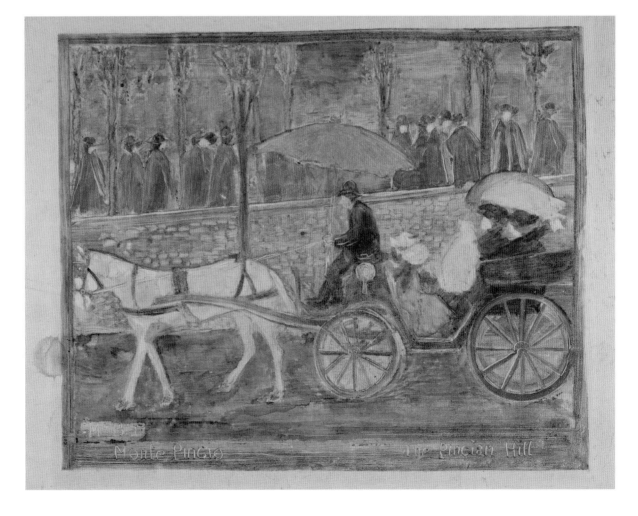

fond memories, popular culture, or personal preference, young women and girls are the dominant subject of Prendergast's monotypes. Nevertheless, it is critical to affirm that his artistic agenda was the expression of formal elements—color, form, and composition—which were often explored in the portrayal of nocturnal scenes where reflected light on wet surfaces was the *raison d'être*. This confounding schism within Prendergast's monotype œuvre, between representations of the stylish Prendergast Girl and those works displaying imaginative formalist explorations of color and form, defies conclusive interpretive analysis. Yet there is no doubt that Prendergast was at his most aesthetically experimental when working with his monotypes before 1902.

The Italian watercolors gaily integrate a *mélange* of local folk and umbrella-wielding tourists; the monotypes, on the other hand, are focused on depicting only Italian women, particularly of the working class. Sensitive to women's clothing as an indicator of economic status from his student years in Paris, Prendergast was immediately drawn to the already celebrated Venetian woman, notable for her fringed shawl wrapped closely around her shapely figure, captured in paintings and tourist photographs (see fig. 15).[23] The novelist Henry James unkindly characterized the infamous garments as "faded yellow shawls that hang like old Greek draperies" but redeemed by "young girls with faces of a delicate shape, and a susceptible expression, with splendid heads of hair."[24] Prendergast's quick notations of women wearing dark, fringed shawls, presumably his first studies of the subject, are conspicuous throughout his so-called "Italian Sketchbook" (CR 1479; see p. 107) and reappear in many Venetian watercolors and monotypes.[25] Such sketches explored aspects of this "Venetian type" as visual clues to convey an array of information, including economic status. Several drawings in the "Italian Sketchbook" refer to his portrayal of difference: a notational sketch of a woman, for example, seen in profile with a shawl wrapped about her, is opposed to another young woman stylishly modern in her hat and shirtwaist dress (fig. 19b). The two sketches are incorporated in the monotype *Bella Ragazza: Merceria* (fig. 10), identified by its inscription "Merceria" as the main shopping street of Venice, which leads from

Figs. 16, 17a, 17b, 18 (top row,
left to right), 19a, 19b, 20a, 20b
(bottom row, left to right)
Maurice Prendergast
Pencil drawings of Venetian
women with shawls
Sketchbook ("Italian
Sketchbook"), ca. 1898–99
6¾ × 4½ in. (17.1 × 11.4 cm)
The Cleveland Museum of Art
Gift of Mrs. Charles Prendergast
(51.422)
CR 1479

beneath the clock tower facing on to St. Mark's Square directly to the legendary Rialto Bridge. Even without the inscription, the *fin-de-siècle* cosmopolitan viewer would have recognized the scene as Venetian, based on the long, fringed shawl associated with Venetian women's attire.

Another portrayal of difference is the "beautiful girl" of *Bella Ragazza: Merceria*, enveloped by the graceful, curving lines of her fringed shawl, who is adorned by an intricate hairstyle, colloquially called a pompadour, which was described in the 1890s as "sometimes drawn back in the Japanese manner."[26] Behind her, a woman, emerging from the *sottoportego*, or covered passage, appears to have her hair covered by a kerchief, a symbol of a mainland peasant. The preparatory drawing for this figure may be found in the "Italian Sketchbook" (fig. 20b), and is not an anomaly, as headscarves on women appear in such monotypes of market scenes as *Orange Market* (fig. 21) and *Market Scene* (fig. 22), ensuring their recognition as rural women. Nevertheless, these nuanced observations of class are overshadowed by Prendergast's focus in his monotypes on the abstraction of objects into simple shapes. In his watercolors, circular forms—hats, umbrellas, or balloons—are abundantly placed and frequently minimized but are easily identified; in the monotypes, suggestively wiped swirls of yellow ink create a formless description of oranges through color. This daring non-representation of objects in simple shapes is seen exclusively in the monotypes.

One instructive example of how Prendergast approached different media in different ways is observable in the monotype *Roma: Flower Stall* (fig. 1) and the watercolor *Italian Flower Market* (CR 734; see p. 176).[27] The watercolor is a picturesque cliché of a floral subject, but, in contrast, the monotype's spatial construction is extraordinary in its tipped-up perspective of the shelves, burdened with cut flowers spilling from multiple terracotta pots. The tipsy structure is stabilized by opposites: the precisely drawn pavement and the sketchily rendered curving wall of the multistoried building. More amazing is the comparison of the monotype's production in an hour or less with the hours of work required to complete the architectural details of the watercolor.

The inscription "Via delle Corso ROME," drawn on the plate, ensures that the print *On the Corso, Rome* (fig. 6) is linked to the Eternal City's most famous

Fig. 21
Maurice Prendergast
Orange Market, ca. 1898–99
Monotype on paper with pencil additions
Image: 12 7/16 × 9 1/8 in. (31.6 × 23.2 cm)
The Museum of Modern Art, New York
Abby Aldrich Rockefeller Fund
(169.45)
Digital Image © The Museum of
Modern Art/Licensed by Scala/
Art Resource, New York
CR 1711

Fig. 22
Maurice Prendergast
Market Scene, ca. 1898–99
Monotype on paper with pencil additions
Image: 7⅝ x 9⅜ in. (19.4 x 25.1 cm)
Collection of the Prints and
Photographs Division, The Library of
Congress, Washington, D.C.
Pennell Fund (540031)
CR 1713

shopping street; this print depicts the only fashionable woman in the Italian monotypes. Created several years after Prendergast had begun making monotypes, the Italian colored prints are often exceptional because they unite a clichéd scene with remarkable formalist flights of fancy. When the Roman shopping scene is contrasted with *Rainy Day in Boston* (fig. 23), the dynamism of the Italian monotype becomes apparent. Both works of art depict the rear view of a horse-drawn hansom cab, but the vigorous rotating red wheels of the Roman cab exemplify the artist's increasing involvement in exploring formal innovations with a familiar subject. Relying on his repertoire of jazzy stripes in flags, banners, and awnings, Prendergast boldly transforms them here into pure color and shape—achieved through the varied character of his brilliant subtractive wiping techniques— to energize the visual field surrounding the columnar figure of the young woman in a fur-collared cape. The American artist's sensitivity to the nuances of movement anticipates the Italian Futurists' Modernist agenda of depicting agitated motion.

As studio creations by necessity, monotypes merge memories of life and art into inspired pictures. Long before Prendergast arrived in Italy, many of his monotypes reflected his admiration for Whistler's famous façade of shopfronts, where the interplay of solid wall planes and the deep voids of doorways is humanized by the faint figures of women and children, notable in *A Chelsea Shop* (fig. 24). Prendergast's virtuoso interpretation of this Whistlerian theme in *Bella Ragazza: Merceria* (fig. 10) is an exceptional monotype for the number of figures thrust into the limited space of the foreground. Yet the unsettling ambience is completely belied by the bright, almost Fauvist, palette of purple, orange, and green. If the Roman shopping monotype was about the physical sensation of movement, the Venetian variant is an ode to optical jolts of vibrant, unrealistic colors.

Within the modest grouping of the Italian monotypes, the sensation of movement and the manipulation of color have been considered. In *Venice* (fig. 12), the successful creation of spatial ambiguity makes for one of Prendergast's most original works in exploring novel or modern ways to think about space. The artist's penchant for unusual angles of vision, frequently employed in his Venetian watercolors, is also linked to the city's more modest squares discovered along short *calli*, or streets. Exploiting the Whistlerian grid of voids alternating with solid planes, Prendergast here rejects the conventional parallel alignment of succeeding planes for a riddle of geometric shapes that confound a rational understanding of space. The flat walls, colored with a somber palette of deep blue-green, yellow, and brown and reminiscent of some Italian "primitive"

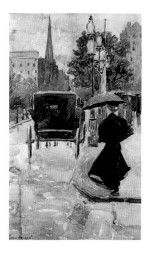

Fig. 23
Maurice Prendergast
Rainy Day in Boston, ca. 1895
Watercolor and pencil on paper
13¾ × 8¼ in. (34.9 × 21 cm), sight
Last known with Maxwell Galleries,
San Francisco, 1970
CR 598

Fig. 24
James McNeill Whistler
(American, 1834–1903)
A Chelsea Shop, ca. 1894–95
Oil on panel
Image: 5 × 8⁷⁄₁₆ in. (12.7 × 21.4 cm)
Terra Foundation for American Art,
Chicago
Daniel J. Terra Collection, 1992.148

Trecento (fourteenth-century) frescoes, proffer an aged patina over a contemporary scene. Prendergast's admiration of contemporary Venice through the lens of the early Renaissance artist Vittore Carpaccio's St. Ursula cycle (see Alessandro Del Puppo's essay, fig. 5) inspired an intricately layered space that embodies the edgy *frisson* of modern life, lived in small passageways. The claustrophobic atmosphere of the crowded passageway is relieved by the presence of two stately women, garbed in their Venetian black shawls, who were first drawn in the "Italian Sketchbook" (fig. 25).

Prendergast combined the pair of women wrapped in black shawls, his most effective cipher for the exotic city of canals, with an equally irresistibly Venetian monument, a Baroque marble well-head, in several media. Illustrating an appealing multifigured scene of shawl-draped women gathering at the local square's ancient octagonal well-head, the monotype *Venetian Well* (fig. 26) is a mere 4 in. (10.2 cm) smaller than the almost identical image on a small oil panel, *Well, Venice* (fig. 27). In the "Italian Sketchbook," there is a

drawing of a young woman, distinguished by her pert Prendergastian nose, and carrying a water bucket, who anticipates this scene. Spatial ambiguity and depth in the monotype, an environment created by a few dexterous strokes of a brush, allow the figures to move freely before the evocatively suggested buildings towering in the background. The gentle swirling movement of the monotype's figures stands in stark contrast to the static placement of the women in the similar oil painting.[28] The liveliness of the monotype when compared with the oil painting is pronounced, and embodies the conceit of ordinary Venetian life as "relaxed." *Festival, Venice* (CR 713; see p. 174), a brightly hued watercolor that also celebrates the themes of women, well-head, and flag pole in a festively decorated campo, is ingenious in its specificity of inventive gestures echoing a rich portrayal of Byzantine space. The watercolor is a masterwork of precision and imagination. The abstract sensibility and movement of the humble monotype, however, anticipate the artist's later explorations into timelessness.

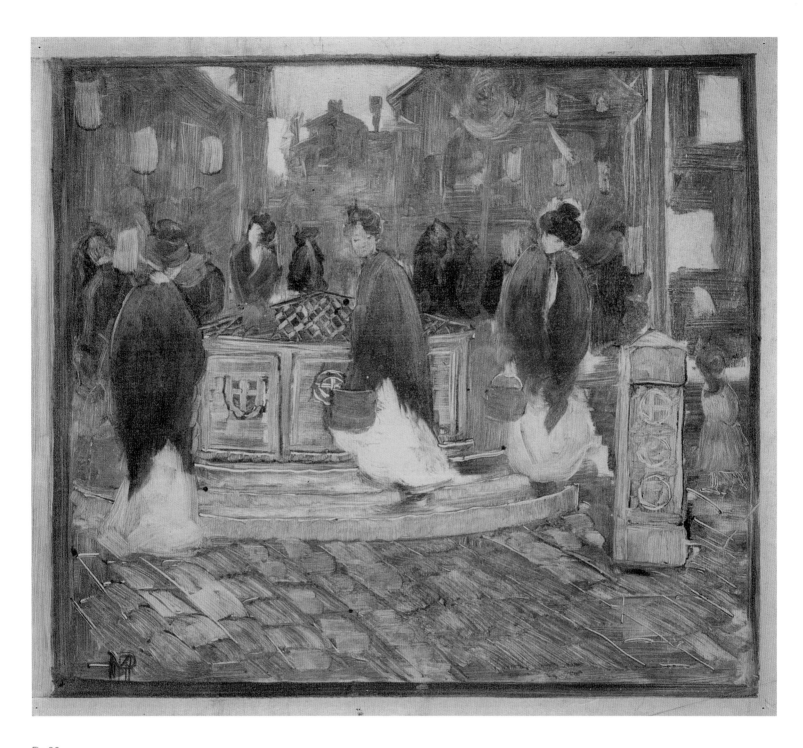

Fig. 26
Maurice Prendergast
Venetian Well, ca. 1898–99
Monotype and graphite
on wove tissue paper
Image: 9 x 10⁵⁄₁₆ in. (22.9 x 25.9 cm)
Addison Gallery of American Art,
Phillips Academy, Andover,
Massachusetts
Museum Purchase, 1939.5
CR 1704

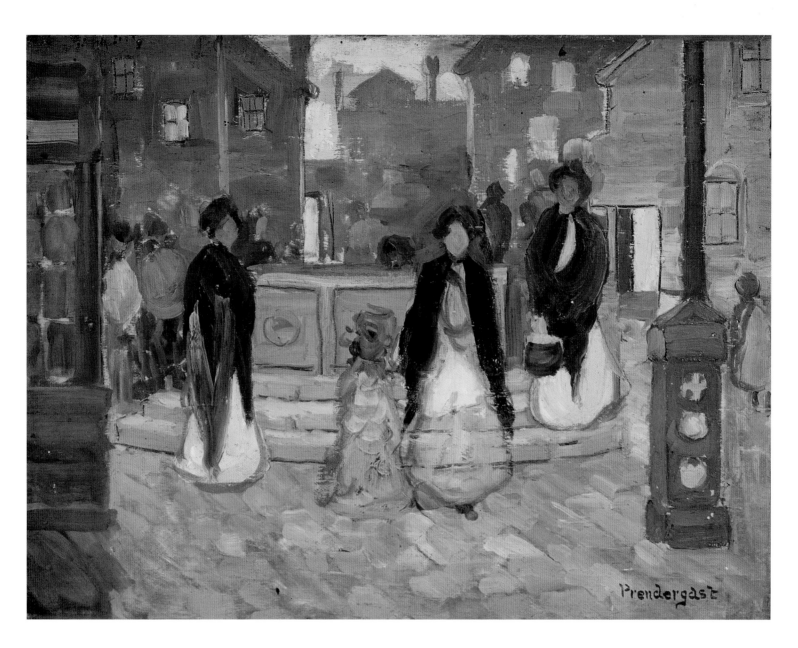

Fig. 27
Maurice Prendergast
Well, Venice, ca. 1898–99
Oil on panel
10½ × 13¾ in. (26.7 × 34.9 cm)
London Family Collection
CR 30 (recto)

Fig. 28
Maurice Prendergast
Venetian Well, ca. 1898–99
Monotype with graphite
on cream Japanese paper
Image: 7½ × 5¾ in. (19 × 14.6 cm)
Terra Foundation for American Art, Chicago
Daniel J. Terra Collection, 1992.115
CR 1705

Fig. 29
Composite of *Venetian Well* (fig. 28)
and *Venetian Court* (fig. 30)
Terra Foundation for American Art, Chicago
Daniel J. Terra Collection, 1999.124
Photographs by Kimberly J. Nichols,
The Art Institute of Chicago, Conservation Lab
CR 1705, CR 1706

Two final monotypes of a Venetian well-head
provide another insight into Prendergast's process.
Venetian Well (fig. 28) and *Venetian Court* (fig. 30),
when united, form a single composition (fig. 29),
although their drastically varied color intensity
indicates they are from separate pulls. Apparently,
a larger monotype and its cognate (the second print
pulled from the same plate, which displays a fainter
image) were cut, creating four monotypes—two of
which survive. Kimberly J. Nichols examined them
under transmitted light and noted that the subtle
irregularities along the cut edges of the prints

Fig. 30
Maurice Prendergast
Venetian Court, ca. 1898–99
Monotype on grayish-ivory China paper
Image: 7 7/16 × 5 15/16 in. (18.9 × 15.1 cm)
Terra Foundation for American Art, Chicago
Daniel J. Terra Collection, 1999.124
CR 1706

Fig. 31
Maurice Prendergast
Pencil drawing of Venetian women
with shawls
Sketchbook ("Italian Sketchbook"),
ca. 1898–99
6 3/4 × 4 1/2 in. (17.1 × 11.4 cm)
The Cleveland Museum of Art
Gift of Mrs. Charles Prendergast (51.422)
CR 1479

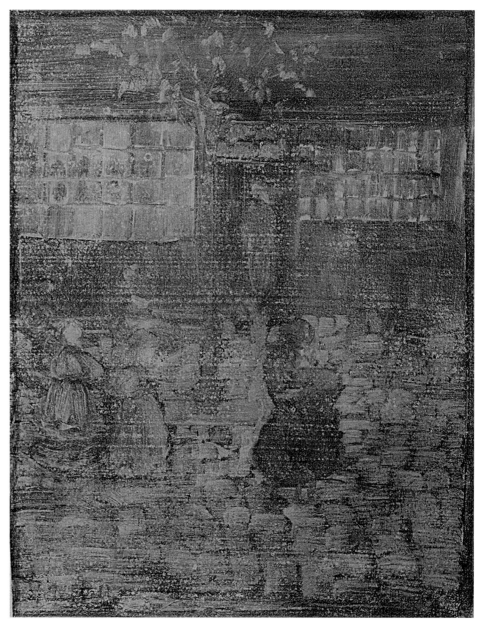

corresponded perfectly. Apparently, the two larger monotypes were cut simultaneously. Prendergast continued to manipulate them, as a print image is visible under the left edge of the line border of *Venetian Court*, while the right edge of *Venetian Well* lacks a border, despite having one on the other three sides.[29] A related drawing in the "Italian Sketchbook" (fig. 31) shows a woman walking past a row of Whistlerian doors, a window, and a well-head, all sketchily indicated. While curious in their present state, these two monotypes are a testimony to Prendergast's inquisitive creative processes.

The several monotypes associated with the Festa del Redentore (Feast of the Redeemer), one of the most famous celebrations in Venice, vary considerably and exemplify Prendergast's experimental attitude within this medium.[30] A pencil drawing of the pontoon bridge built for the processional, *Festa del Rendentore* (fig. 32), illustrates the artist's fascination with the unusual engineering feat of constructing two temporary pontoon bridges on boats and gondolas to cross over the Giudecca Canal from St. Mark's Square to reach the Palladian church of Il Redentore.[31] A more fanciful view of the pontoon bridge is seen in the elegant, Japanese-inspired *Festa del Redentore* (fig. 34), an outstanding monotype in Prendergast's astonishingly stylistically diverse Venetian portfolio. The monotype pays homage to the nocturnal spectacle of lights bursting over a bridge and boats below in Hiroshige's *Fireworks at Ryogoku* (see Nancy Mowll Mathews's essay, fig. 51). Prendergast's delicate incisions defining the outlines of the foreground lantern, scratched with the end of a brush and seen here in magnification (fig. 33), are indicative of his facile yet skilled manipulation of his tools. The extreme artificiality of the Italian monotypes, in some cases close to total abstraction, clearly illuminates Prendergast's unconventional attitude toward making colored monotypes, which had no equivalent in his watercolors.

The Saturday evening before the religious procession of the Redentore, fireworks would illuminate the sky and the lagoon with sparkling lights, delighting the audience of Venetians and international tourists. At his most modern in his aesthetic investigations, Prendergast explored stylistic alternatives to illustrate the Venetian pyrotechnics. Years earlier, in 1892, he had been captivated by the evening lanterns lighting Parisian boulevards for Bastille Day. The monotype *Bastille Day (Le Quatorze Juillet)* (fig. 35) is not only a tribute to Whistlerian festive lights but also emphasizes Prendergast's own invention: bodies that sway and move, united—a crowd. The monotype *Early Evening, Paris*, of about 1892 (see Mathews essay, fig. 8), demonstrates that the artist was enchanted by night light and movement, which he transcribed into his personal aesthetics of Modernism, found almost always in his monotypes. When again in Boston, in late 1894, Prendergast continued to experiment with nocturnal settings that allowed him to test his ideas about reflective colored light and crowds. A fireworks scene (possibly

Fig. 32
Maurice Prendergast
Festa del Redentore,
ca. 1899
Pencil on paper
3½ x 4½ in. (8.9 x 11.4 cm)
Last known in Sotheby's sale, 1987
CR 1403

Fig. 33
Maurice Prendergast
Festa del Redentore (detail),
ca. 1899
Lantern magnification
Photograph by Kimberly J. Nichols,
The Art Institute of Chicago,
Conservation Lab
CR 1708

Fig. 34
Maurice Prendergast
Festa del Redentore, ca. 1899
Monotype on cream Japanese paper
Image: 12¼ × 7⁷⁄₁₆ in. (31.1 × 18.9 cm)
Terra Foundation for American Art,
Chicago
Daniel J. Terra Collection, 1992.83
CR 1708

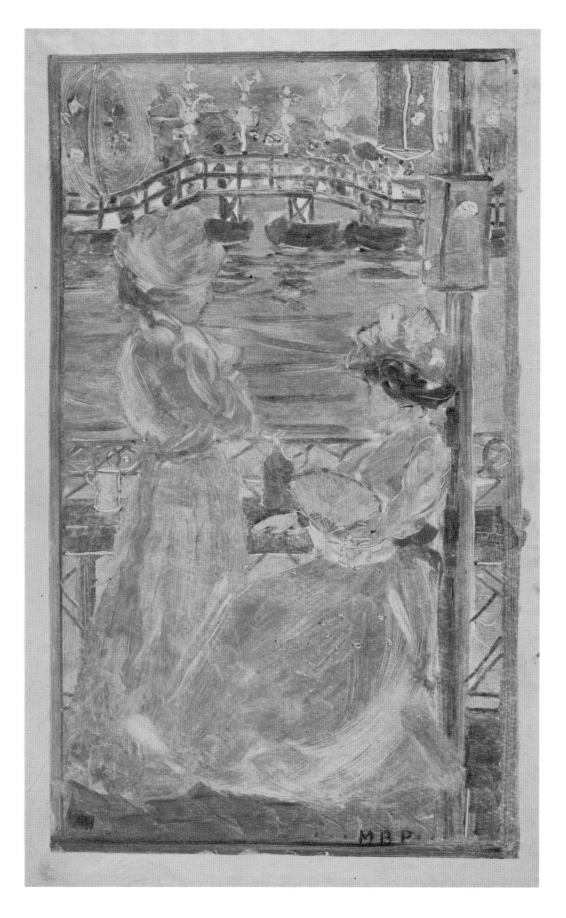

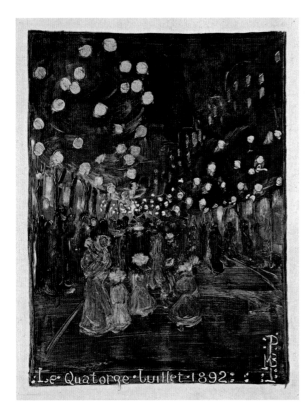

:Le Quatorze Juillet 1892:

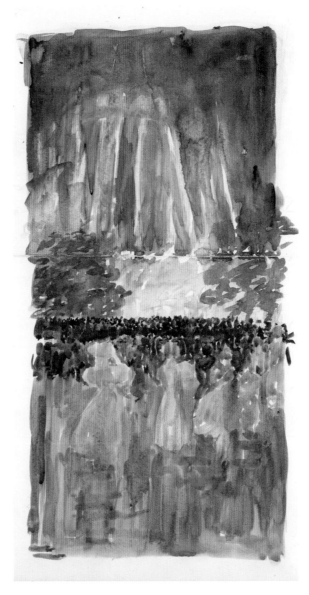

Fig. 35
Maurice Prendergast
Bastille Day (Le Quatorze Juillet),
1892
Monotype in oil colors
Image: 6⅞ × 5⅛ in. (17.4 × 13.1 cm)
The Cleveland Museum of Art,
Gift of The Print Club of Cleveland
(1954.337)
CR 1584

Fig. 36
Maurice Prendergast
A crowd watching fireworks
*Large Boston Public Garden
Sketchbook*, ca. 1895–97
Watercolor over pencil on paper
14⅛ × 11³⁄₁₆ in. (35.8 × 28.4 cm)
The Metropolitan Museum of Art,
New York
Robert Lehman Collection, 1975
(1975.1.957)
Image © The Metropolitan Museum
of Art
CR 1477

depicting celebrations on July 4), found on two pages of the *Large Boston Public Garden Sketchbook* (fig. 36), summarily accounts for multiple heads with dots of the artist's brush, as seen again in his Italian works. Abstraction of multiples is deftly achieved by circular swipes of a cloth, defining either a throng marveling at the orange glow of fireworks in *Fiesta, Venice* (fig. 37), which signifies only the essence of fireworks, or, as was seen previously in the *Orange Market*, oranges.

Prendergast's nocturnal watercolors of Venice are fairy tales of candy-colored lanterns suspended above floating black gondolas blending into the inky black-blue sky and canals—controlled exercises in simplicity depicting only boats, lanterns, and reflections: *Festa del Redentore* (fig. 38), *Festival Night, Venice* (CR 727; see p. 175), and the unique colored-glass mosaic *Fiesta Grand Canal, Venice* (fig. 39). The related monotype *Festa del Redentore, Venice* (fig. 40) is a close-up of a gondola, adorned with round multicolored lanterns and a single red star, and filled with Venetian revelers. The black boat glides parallel to the picture plane, but the artist's frequently used illusionistic device of defining depth by stacking bands of similar shapes invites an upward visual flow, layering the complex arrangement of sizes, colors, and forms.

Inspired by Rome, Prendergast invented several Italian monotypes that rival his most masterful Venetian watercolors. Belying its modest size, *The Spanish Steps* (fig. 41), identified by an inscription drawn in the plate, is Prendergast's supreme achievement among his Italian monotypes. Selecting a classic Roman tourist site, theatrical with its sweeping curves, Prendergast applied his signature processional theme to more than three dozen red-robed Catholic seminarians, who flow down the carefully delineated monumental staircase. Completed in 1725 and situated on the shoulder of Monte Pincio, the Spanish Steps linked the Bourbon Spanish Embassy on the Piazza di Spagna with the Vatican. *Children in Red Capes* (fig. 42), a monotype

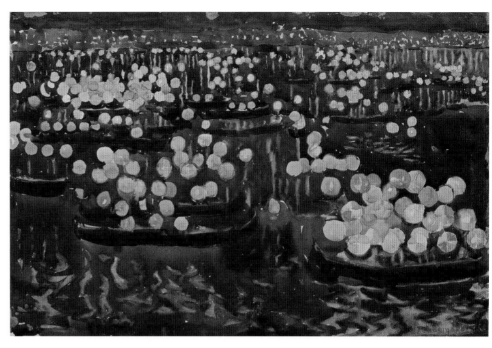

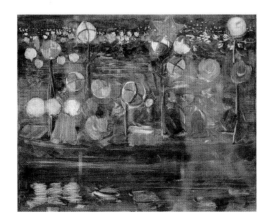

Fig. 37 (above)
Fiesta, Venice, ca. 1899
Monotype on paper
Image: 10⅛ × 7⅞ in. (25.7 × 20 cm)
Museum of Art, Rhode Island School
of Design, Providence
Anonymous Gift 1990.141.1
Photograph by Erik Gould
CR 1710

Fig. 38 (above, right)
Maurice Prendergast
Festa del Redentore, ca. 1899
Watercolor and pencil on paper
11 × 17 in. (27.9 × 43.2 cm)
Williams College Museum of Art,
Williamstown, Massachusetts
Gift of Mrs. Charles Prendergast
(91.18.5)
CR 724

Fig. 39 (right)
Maurice Prendergast
Fiesta Grand Canal, Venice,
ca. 1899
Glass and ceramic tiles in plaster
11 × 23 in. (27.9 × 58.4 cm)
Williams College Museum of Art,
Williamstown, Massachusetts
Gift of Mrs. Charles Prendergast
(95.4.79)
CR 725

Fig. 40 (left)
Maurice Prendergast
Festa del Redentore, Venice, ca. 1899
Monotype on paper
Image: 7½ × 9⅜ in. (19.1 × 23.6 cm)
The University of Iowa Museum of Art, Iowa City
Gift of John J. Brady, Jr., 1992.22
CR 1709

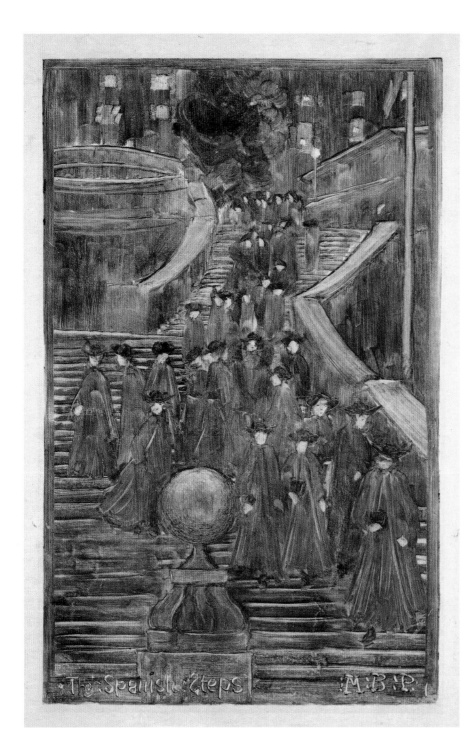

dated 1895, alludes to the artist's early interest in the notion of a processional, the dramatic contrast between red-orange garments and velvety black in a monochromatic setting, and the deliberate delineation of pavement blocks.[32] His unfinished watercolor *Spanish Steps, Rome* (fig. 43), which portrays the perpendicular orientation of the steps typical of the tourist photograph, is useful in reinforcing the originality of the monotype's oblique view and establishes it as a stunning success with an uncommon view. The judicious addition of blue-green swirls of color at the crest of the staircase to suggest foliage perfectly complements the clergy's red-orange, possibly vermillion, robes. Twice as large, the watercolor *Steps of Santa Maria d'Aracoeli, Rome* (see Mathews essay, fig. 82) replicates the tipped-up spatial perspective of the numerous steps, but the upward flow of flat, colored shapes seems stagnant by comparison.

Other Roman sites also excited Prendergast's imagination, as embodied in the Monte Pincio series, portraying the switchback carriageway that allowed access to views on top of the hill. This series includes *Pincian Hill, Rome* (fig. 44), the largest watercolor; the slightly smaller but almost identical *Monte Pincio, Rome* (fig. 45); and the smallest, reductive version of the previous two watercolors, *Afternoon Pincian Hill* (fig. 46). The monotype *Monte Pincio (The Pincian Hill)* (fig. 14) shares the vivid red ecclesiastical robes of the Catholic seminarians in *The Spanish Steps* and borrows from the watercolors the driver and carriage—its wheels transformed from yellow to red to echo the red robes—and the dominating green umbrella.[33] In addition, the diagonal slant of the pinkish-red brick retaining wall is incorporated to enhance the rhythm of the procession. Apparently not satisfied with the tone of the colored print, the artist applied a grayish watercolor over the ink, reducing the brightness of the pavement and the retaining wall behind the seminarians, and the figures in the carriage. This "drabbing" of the bright background by adding water to dilute the wall color (fig. 13) emphasizes the red-clad figures and suggests that Prendergast revised even his monotypes.[34]

The Roman Campagna (fig. 47) is particularly striking for its flat surface, the lack of spatial clues, and the idiosyncratic placement of three ladies, remarkably similar to the single female figures of Prendergast's Boston monotypes. The surreal placement of three

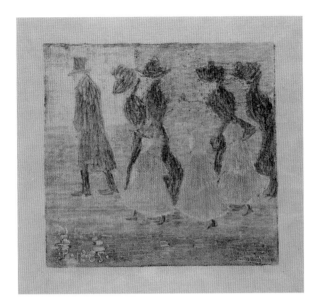

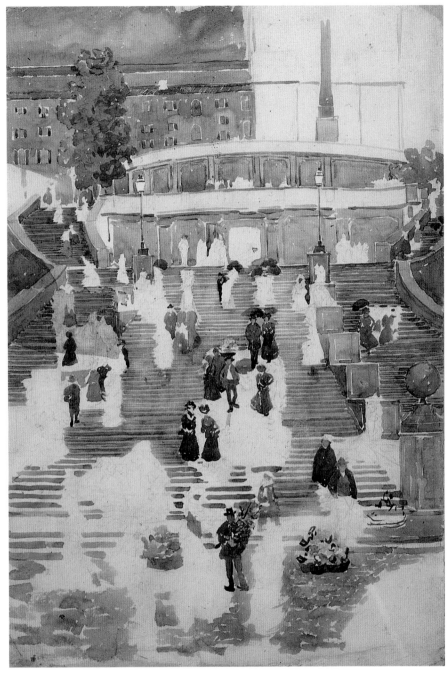

Fig. 42
Maurice Prendergast
Children in Red Capes, 1895
Monotype with graphite
on cream Japanese paper
Image: 5⅝ × 6 in. (14.3 × 15.2 cm)
Terra Foundation for American Art,
Chicago
Daniel J. Terra Collection, 1992.76
CR 1614

Fig. 43
Maurice Prendergast
Spanish Steps, Rome,
ca. 1898–99
Watercolor and pencil on paper
20¾ × 14¼ in. (52.7 × 36.2 cm)
Collection Neuberger Museum of Art,
Purchase College, State University
of New York
Gift of Roy R. Neuberger, 1996.15.01
CR 750

fashionable ladies—with their umbrellas, white
petticoats, and ruffled neckwear—in a field next to a
horseback rider dressed for a fox hunt is disorienting.
A drawing in the "Italian Sketchbook" (fig. 48) is of
the woman in blue bending over to examine something
on the ground. The strangeness of the monotype's
spatial vocabulary is apparent when compared with
Prendergast's signature "bird's-eye view," the perspective
device for the watercolor *Borghese Garden, Rome,
Race Track* (CR 747; see p. 177). Japanese in its overall
intonation, the monotype is made strange by its
unusual arrangement of individual components.

The only dated monotype associated with Italy is
Girl from Siena, from 1898 (fig. 49). Just as the fur-
collared cape indicated the class allegiance of the young
woman in *On the Corso, Rome* (fig. 6), so the apron
worn by the young woman here identifies her as a
servant girl, despite her elaborate bonnet with ribbons.
In this Italian version of the Prendergast Girl, the
young woman's pert features were penciled in after
the drawing was printed. Such penciled facial

markings are common in the monotypes, and represent
a jarring note of banal representation within some of
Prendergast's most modern moments. Did he consider
these gratuitous facial markings necessary for future
sales—another way to link his "dainty" monotypes to
his more popular watercolors? More likely, as women
remained the essential subject in Prendergast's art
throughout his career, the female figure was his
exclusive muse.

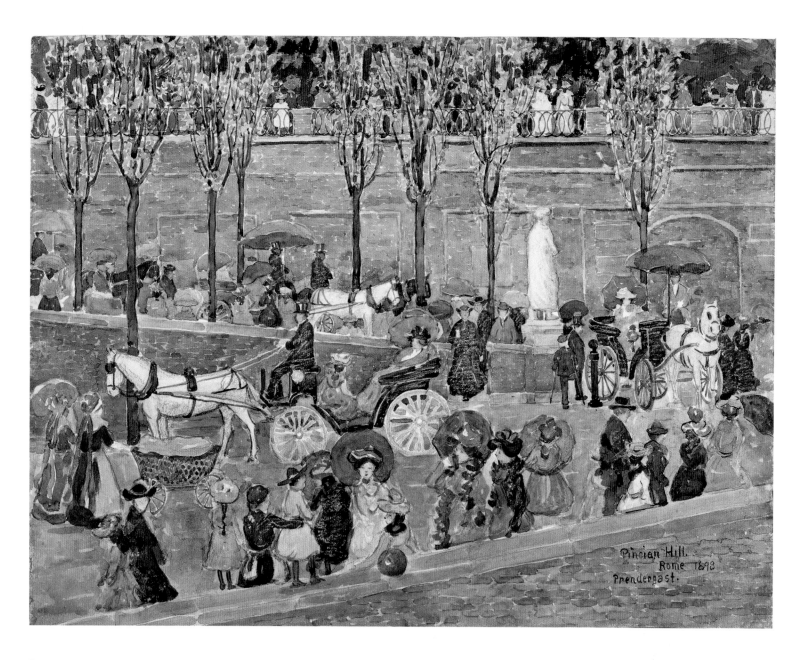

Fig. 44
Maurice Prendergast
Pincian Hill, Rome, 1898
Watercolor over graphite pencil
under-drawing on thick, medium-
textured, off-white watercolor paper
21 × 27 in. (53.3 × 68.6 cm)
The Phillips Collection, Washington, D.C.
Acquired 1920
CR 748

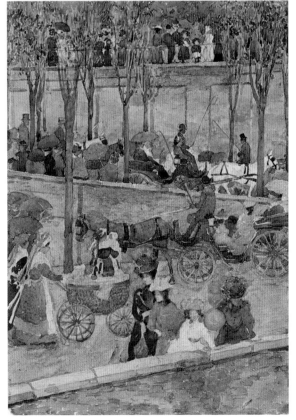

Fig. 45 (above)
Maurice Prendergast
Monte Pincio, Rome,
ca. 1898–99
Watercolor and graphite heightened
with gum arabic on ivory wove
watercolor paper
15 7/16 × 19 3/4 in. (39.4 × 50.2 cm)
Terra Foundation for American Art, Chicago
Daniel J. Terra Collection, 1999.117
CR 746

Fig. 46 (left)
Maurice Prendergast
Afternoon Pincian Hill,
ca. 1898–99
Watercolor and pencil on paper
15 1/8 × 10 3/8 in. (38.4 × 26.4 cm)
Honolulu Academy of Arts
Gift of Mrs. Philip E. Spalding, 1940
(11,653)
CR 745 (recto)

Conclusion

Even before his return from Italy in late 1899, Prendergast's Italian watercolors were exhibited to critical acclaim in Boston, but, surprisingly, his Italian monotypes were not accorded as significant a role. Before his Italian journey, Prendergast employed his monotypes to boost both his local profile and his national career. The color monotypes exhibited at the Art Institute of Chicago in January 1900 received critical notice as "altogether fascinating in [their] novel color and originality of style."[35] Three months later, the artist's début solo show at the Macbeth Gallery in New York showcased his Italian watercolors almost exclusively, and, while the accompanying monotypes were acclaimed as "the last word on monotypes in color," none of them bore an Italian title.[36] Notable in terms of the history of the monotypes' reception,

Fig. 47 (above)
Maurice Prendergast
The Roman Campagna,
ca. 1898–99
Monotype on paper
Plate: 9⅛ × 12⅜ in. (23.2 × 31.4 cm)
Des Moines Art Center, Iowa,
Permanent Collections
Purchased with funds in memory
of Truby Kelly Kirsch, 1953.21
CR 1698

Fig. 48 (left)
Maurice Prendergast
Pencil drawings of women
bending
Sketchbook ("Italian
Sketchbook"), ca. 1898–99
6¾ × 4½ in. (17.1 × 11.4 cm)
The Cleveland Museum of Art
Gift of Mrs. Charles Prendergast
(51.422)
CR 1479

Fig. 49
Maurice Prendergast
Girl from Siena, 1898
Monotype on paper
Image: 9⅞ × 4⅞ in. (25.1 × 12.4 cm)
Private Collection
Photo Credit: John Bigelow Taylor
CR 1697

the artist's spatial inventiveness troubled the critic of the *Evening Sun*, who complained of "an absence of atmosphere, which brings the street below and the hill in the distance out of their place and merges them in the foreground."[37] Another perceptive commentator, discomfited by the color disparity between the monotypes and the watercolors, observed, "Surrounding this almost kaleidoscopic showing of color [in the watercolors] is a fringe of monotypes which, although in various colors, are so delicate [in] intent as to appear almost gray by contrast."[38] Tellingly, these critical comments were of less concern to Prendergast than the dubious concept of "spontaneity" that had been applied to his monotypes. Prendergast's unease with this assessment led to the Detroit statement of 1901, which emphasized his monotypes as "careful delineation[s] of the subject" and ranked them as equal endeavors to his watercolors.

Given the time constraints of the process, the impressive effects that Prendergast achieved in many of his monotypes must have required an unimaginable effort. Importantly, his experiments with spatial ambiguity and color manipulation were calculated artistic explorations, not accidental outcomes. The lessons learned from the subtle eye–hand engagements that constituted Prendergast's imaginative colored print approach, most fully realized in his Italian monotypes, found new expression in his burgeoning experiments in oil painting.

While the Italian watercolors of 1898–99 gained national recognition for Maurice Prendergast, almost all of the monotypes associated with this watershed journey—decisively not his so-called "dainty" watercolors, which he hoped would please the same audience—were not part of this critical triumph. Between 1900 and 1901, as few as four of the Italian-titled monotypes appear to have been exhibited, and these were shown exclusively in Detroit and Cincinnati.[39] The majority of the Italian monotypes remained in the artist's possession until his death, whether by choice or for lack of patronage is unknown.[40] The question of when and where they were created is also a mystery. In Italy, did the monotypes' different tempo of execution provide a break from the artist's precise labors on the watercolors? Or were the monotypes produced in Boston in

moments of nostalgia arising from his treasured artistic adventure? The only verifiable link to the process used by the artist for these remarkable monotypes is their relationship to the "Italian Sketchbook."

True to his instincts, Prendergast was mostly silent about his artistic endeavors, but in his monotypes he left behind tantalizing insights into his first forays into progressive art. As early examples of his modern aesthetic, brilliantly conceived as fluid movement through non-naturalistic space with undefined dimensions, the Italian monotypes validate Prendergast's legacy as America's first Modernist artist.

Notes

1 *The Trustees of The Detroit Museum of Art Cordially Invite You and Your Friends to View a Special Exhibition of Water Colors and Monotypes by Mr. Maurice B. Prendergast Detroit, November, 1901*, The Detroit Museum of Art, November, 1901.

2 "Collection of Decorative Drawings Shown at Hart & Watson's, December 1897–January 1898," *Boston Evening Transcript*, December 19, 1897, p. 9.

3 The Detroit show traveled intact to the Cincinnati Art Association, where it opened in December 1901. Cincinnati prepared its own exhibition brochure, which did not contain an introductory statement. With the exception of four works, all of the twenty-eight watercolors had Italian-related titles.

4 Prendergast monotype investigations are indebted to the prodigious research of Cecily Langdale in *The Monotypes of Maurice Prendergast*, New York (Davis & Long Company) 1979, and in *Monotypes by Maurice Prendergast in the Terra Museum of American Art*, Chicago (Terra Museum of American Art) 1984. Additional critical information may be found in David W. Kiehl, "Monotypes in America in the Nineteenth and Early Twentieth Centuries," in Sue Welsh Reed *et al.*, *The Painterly Print: Monotypes from the Seventeenth to the Twentieth Century*, New York (The Metropolitan Museum of Art) 1980, pp. 40–48; Margaretta M. Lovell, *Venice: The American View, 1860–1920*, San Francisco (Fine Arts Museums of San Francisco) 1984, pp. 77–93; Carol Clark *et al.*, "The Monotypes," in *Maurice Brazil Prendergast; Charles Prendergast: A Catalogue Raisonné*, Williamstown, Mass., and Munich (Williams College Museum of Art and Prestel) 1990, pp. 574–635; Nancy Mowll Mathews, "Postscript: The Monotypes," in *Maurice Prendergast*, Munich (Prestel in association with Williams College Museum of Art) 1990, pp. 41–43; Richard J. Wattenmaker, "Maurice Prendergast at the Whitney," *The New Criterion*, November 30, 1990, pp. 33–40; Richard J. Wattenmaker, *Maurice Prendergast*, New York (Harry N. Abrams in association with The National Museum of American Art, Smithsonian Institution) 1994; Kurt Wisneski, *Monotype/Monoprint: History and Techniques*, Ithaca, NY (Bullbrier Press) 1995, pp. 48–51; and Joann Moser, "Colored Prints and Painted Sketches," in *Singular Impressions: The Monotype in America*, Washington, D.C. (National Museum of American Art by Smithsonian Institutional Press) 1997, pp. 43–54.

5 Charles Prendergast identified two monotypes as the first ones made by his brother, in about 1891. The first monotype with a date inscribed in the plate is dated 1892 and has a Parisian subject. There are twelve monotypes inscribed with a date of 1895, and five of these works have existing cognates. Only one from the Italian group is dated: *Girl from Siena*, 1898 (CR 1697; see p. 182). Four works are dated 1900; six are dated 1901 with two cognates; and one is marked 1902 and has a cognate.

6 Some time in the late 1870s, the appeal to painters of the monotype, characterized as an experimental process exploited typically by a few printmakers, dramatically increased the exposure of this amalgamation of a print and a drawing to an appreciative audience of both artists and collectors. The classic text on monotypes is Reed *et al.*, *The Painterly Print*.

7 Wisneski, *Monotype/Monoprint*, is invaluable in deconstructing the monotype process. An important clarification in terminology is that a monotype is produced from the surface of the matrix that is smooth, while a monoprint is a unique print pulled from a plate that has an image incised into it.

8 The list of possible influences for Prendergast's art found in the literature (see note 4, above) is extensive and contradictory at times. For the creativity seen in Prendergast's monotypes, however, Japanese woodblock prints and Whistler's work are universally agreed to be the foundational sources. Prendergast frequently employed a monogram of his initials, usually in a band across the bottom of the plate. The monogram, which varied at times, is similar to a Japanese printmaker's identification chop and to Whistler's famous "butterfly" monogram.

9 "Review Boston Water Color Club January 22–February 19," *Boston Evening Transcript*, February 25, 1898, p. 5.

10 Milton Brown, "Maurice B. Prendergast," in Clark *et al.*, *Maurice Brazil Prendergast*, p. 17.

11 The Boston art critic Sylvester Koehler published the term in 1881 as the invention of Walker. When he returned to New York in the same year, William Merritt Chase exhibited his monotypes as "copper plate impressions."

12 From December 1897 through January 1898, Hart & Watson Gallery exhibited fifty monotypes by the three artists: "Review of the Hart & Watson Exhibition," *Sunday Herald*, December 19, 1897, p. 30. Monochromatic monotypes had been shown in Boston since 1881, so it is possible that the new artistic process for "inventing colored prints" attributed to Murphy was for a particular chemical innovation that blended oil paint or printer's ink with a specific solvent.

13 Quoted in Hedley Howell Rhys, *Maurice Prendergast, 1859–1924*, Boston (Museum of Fine Arts, Boston, and Harvard University Press) 1960, p. 34.

14 Quoted in Van Wyck Brooks, "Anecdotes of Maurice Prendergast," *Magazine Art*, 31, October 1938. Reprinted in *The Prendergasts: Retrospective Exhibition of the Work of Maurice and Charles Prendergast*, exhib. cat. by Van Wyck Brooks, Addison Gallery of American Art, Phillips Academy, Andover, Mass., 1938, p. 36.

15 I am grateful for Kimberly J. Nichols's collaboration on this project. By applying her expertise on Japanese woodblock printing to the examination of Prendergast's monotypes, she has improved our understanding of the artist's process. She has meticulously studied the seven Italian monotypes in the collection of the Terra Foundation for American Art: *Bella Ragazza: Merceria* (TF 1992.71; CR 1703), *Festa del Redentore, Venice* (TF 1992.83; CR 1708), *Monte Pincio (The Pincian Hill)*

(TF 1992.94; CR 1699), *On the Corso, Rome* (TF 1992.96; CR 1702), *Venetian Court* (TF 1999.124; CR 1706), *Venetian Well* (TF 1992.115; CR 1705), and *Venice* (TF 192.114; CR 1707). More information for each monotype may be found at terraamericanart.org.

16 Wisneski, "Supplies and Materials," in *Monotype/Monoprint*, pp. 79–81. Additional causes of the grainy appearance may be the ink composition, possibly altered to enable the artist to work the plate longer, or simply the viscosity of the ink. The relationship of pigment, especially if it is coarsely ground, to viscous binder can affect the appearance and can cause the grainy look. Also, the artist may have added something.

17 In her report of June 22, 2008, Nichols states: "The artist most likely employed some variation of printing ink. From this preliminary examination, I am not inclined to think that oil paint was used in the making of these prints. There is no evidence of this on the versos of the prints. It is possible that the artist mixed his own inks for his pigment palette." An examination of the sixty-one monotypes in the collection of the Terra Foundation for American Art is planned to investigate further Prendergast's technical process for his colored prints. The disparity between Prendergast's statement about a monotype process, perhaps not the method he actually used, and the visual evidence gleaned from the examination of the monotypes requires additional chemical analysis to confirm the artist's medium.

18 The sizes of the papers vary from slightly smaller than 5 × 7 in. (12.7 × 17.8 cm) to the largest at 14 × 14 in. (35.6 × 35.6 cm).

19 Langdale, *The Monotypes*, p. 8.

20 For the monotypes she examined, Nichols noted that there was no evidence of the use of a metal spoon. If one had been employed, she would have expected to see burnished marks on the verso of the paper and a selective saturation of ink through to the verso of the paper corresponding to the pressure contact of the spoon, similar to circular patterns of ink seen on the backs of Japanese prints caused by the use of a "baren" for image transfer. Nichols suggests that the artist may have used a wide, soft item, such as a wooden implement of some sort, or a small hand-roller to transfer his images.

21 Carol Clark, "Modern Women in Maurice Prendergast's Boston of the 1890s," in Clark *et al.*, *Maurice Brazil Prendergast*, pp. 23–33.

22 Brooks, "Anecdotes," p. 33.

23 Not only the famous American portraitist John Singer Sargent but also other artists painted Venetian women wrapped in black shawls in the early 1880s as emblematic of the famous tourist destination.

24 Henry James, "Venice," *The Century Magazine*, 25, November 1882, p. 23.

25 In the "Italian Sketchbook" owned by the Cleveland Museum of Art (CR 1479; see p. 181), Prendergast drew eighteen pages of women wearing fringed shawls. In the "Florence Sketchbook" owned by the Museum of Fine Arts, Boston (CR 1480; see p. 181), there is a single drawing of a woman in a fringed shawl (Archives of American Art, Smithsonian Institution, roll no. 3587, frame no. 0077). Only a single watercolor sketch exists that portrays a black-shawl-clad female: *Untitled* (CR 857, verso).

26 Citation found in Lovell, *Venice*, pp. 92–93.

27 Someone other than Prendergast inscribed "Roma: Flowor Stall" on the print in pencil, and this is one of three known Italian monotypes that were sold or given away during the artist's lifetime. The monotype was possibly exhibited at the Detroit Museum exhibition of 1901 as *Flower Stall* (no. 45).

28 *Well, Venice* remained in Prendergast's possession. The artist may have reworked the surface of the oil painting, just as he reworked *Ponte della Paglia* (1898–99 and 1922), in the Phillips Collection. Both pictures have a "ghost" or incompletely painted foreground figure of a woman.

29 The Prendergast monotype expert Cecily Langdale noted the relationship of *Venetian Court* and *Venetian Well* in *The Monotypes*, pp. 41, 116–19.

30 The Festa del Redentore, held each year on the third Sunday in July, commemorates the end of the plague of 1576 with a religious procession to the church of Il Redentore, designed by the Renaissance architect Andrea Palladio and built on the island of Giudecca, south of Venice.

31 In his Boston watercolors, Prendergast had frequently depicted bridges and piers.

32 Hermann Dudley Murphy, the colleague who exhibited his colored monotypes with Prendergast in 1897, owned *Children in Red Capes*.

33 *Monte Pincio* is one of the three extant Italian monotypes that were not left in the artist's estate.

34 Charles Pankhurst, "Color and Coloring in Maurice Prendergast's Sketchbooks," in Clark *et al.*, *Maurice Brazil Prendergast*, pp. 71–84.

35 "The Murphy and Prendergast Exhibition in Chicago," *Boston Evening Transcript*, January 3, 1900, p. 11. Murphy provided seventy works, mostly paintings, for the show, while Prendergast contributed fifteen watercolors and fifteen monotypes.

36 David C. Preyer, "Editorial," *The Collector and Art Critic*, 11, March 15, 1900, pp. 164–65.

37 "Mr. Prendergast's Water Colors and Monotypes at the Macbeth Gallery," *Evening Sun*, March 13, 1900, p. 4.

38 "Art News," *Evening Post*, March 13, 1900, p. 4.

39 With the exception of four works, all of the twenty-eight watercolors in the Detroit and Cincinnati exhibition had Italian-related titles. Of the thirty-nine monotypes (thirty-six were listed, but an additional three colored prints in the show were not included in the exhibition catalogue), only four had Italian titles: *Flower Stall* (no. 45) and *Venetian Wells* (no. 53), which could be any of the monotypes that feature a well-head, and *The Black Shawl* (no. 35) and *The Blue Shawl Girl* (no. 36), both of which are unlocated.

40 A review of the provenance records found in the catalogue raisonné indicates that about twenty Italian watercolors were sold during Prendergast's lifetime. It is interesting to note that three monotypes identified as not left in the artist's estate at his death were all Roman subjects: *Monte Pincio*, *Roma: Flower Stall*, and *Spanish Steps*. It is also worth noting that Sarah Choate Sears, who sponsored Prendergast's first trip to Italy, owned the monotype *Spanish Steps* and the watercolors *Clock Tower, Campo San Cassiano* (unlocated), *Ponte Giambattista*, *Italian Flower Market*, and *Steps of Santa Maria d'Aracoeli*.

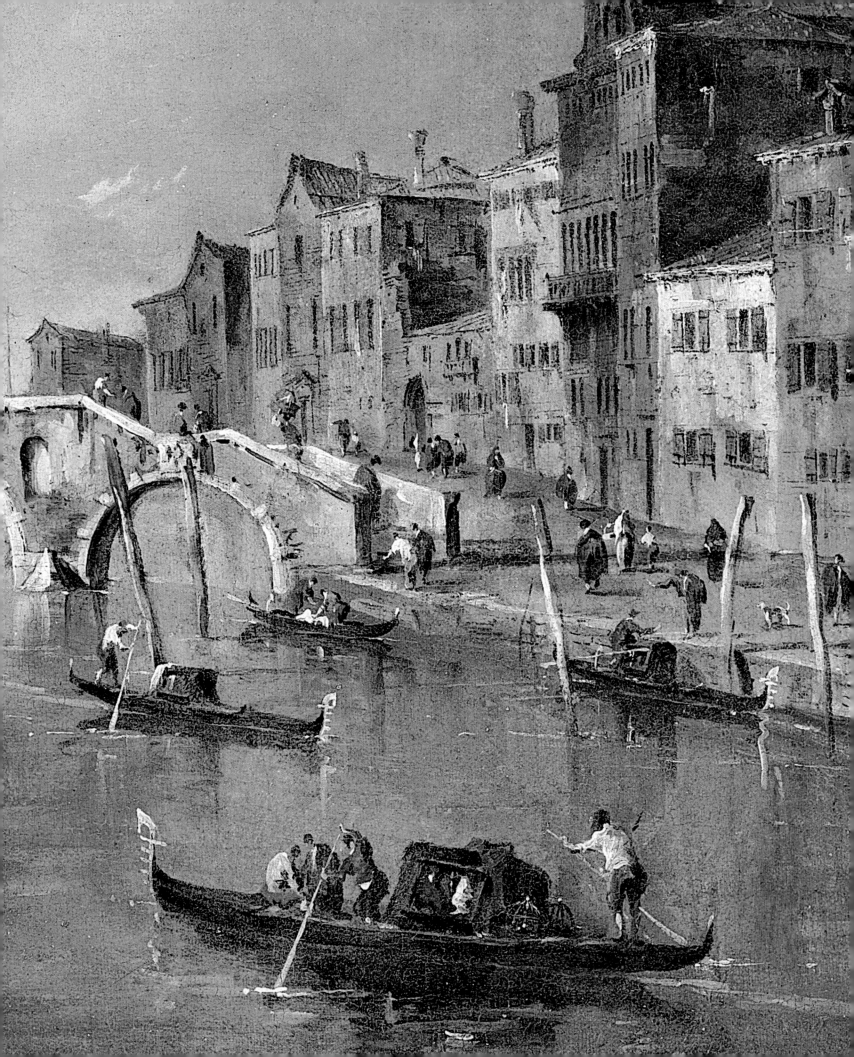

Two Ladies and Venice

SOME VIEWS OF ART IN MARIA KONOPNICKA'S *ITALIA* AND EDITH WHARTON'S *ITALIAN BACKGROUNDS*[1]

Olga Płaszczewska

Fig. 1
Title page from
Maria Konopnicka, *Italia*,
Warsaw (Gebethner i Wolff)
1901
Library of the Faculty of Polish Studies,
Jagiellonian Library, Kraków, Poland

For centuries, Italy has been perceived as a melting pot, a crossroads at which different nations rub shoulders. A multitude of traveling writers have left their evidence; countless letters, travelogues, novels, and poems have transformed Italy into a palimpsest, on which each new text is "driven to reach back to earlier texts and images."[2] One of the characteristics of the travel-writing genre is that it provides a reflection on art, and thus the aforementioned works naturally abound in deliberations on Italian paintings, sculpture, and architecture.[3] The discovery of art seems to be one of the main reasons why people visit Italy. Because of this fascination, travelers have been inclined to perceive Italy as a museum,[4] in which Venice, rich in historical and artistic monuments and with a wealth of literary and artistic legends, is one of the most significant galleries.[5]

In Maria Konopnicka's *Italia* (1901; fig. 1) and Edith Wharton's *Italian Backgrounds* (1905; fig. 2), Venice is not the central theme. The lines the two writers dedicate to the city, however, deserve attentive reading. They serve as testaments to the ability of these two women not only to live and perceive the city's art but also to transform their impressions and observations of it into a literary form.

While Wharton's *Italian Backgrounds* is a collection of nine essays on various Italian subjects, the final text of which gives some in-depth observations on Venice, Konopnicka's *Italia* is a cycle of poems that includes seven pieces in which Venice provides the background and, in certain passages, becomes the focus of the author's literary reflections. Although published almost contemporaneously, the two works cannot be defined as simple examples of travel writing in which an autobiographic or didactic theme dominates. Nor

129

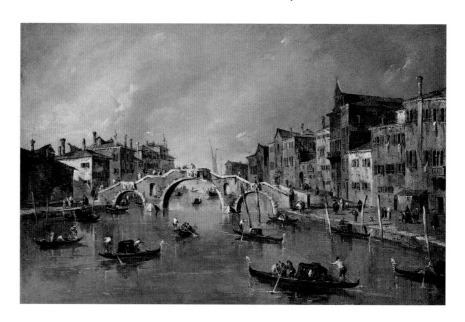

most popular destinations indicated in Baedeker or suggested by experts.[9] Nevertheless, Konopnicka had a good knowledge of the Italian language and culture through her studies and through contacts with scholars and artists resident in Italy.

The literary fruit of Wharton's Italian experiences was a surprising variety of works on diverse Italian subjects.[10] Konopnicka's Mediterranean episodes resulted first in *Impressions from Travels* (*Wrażenia z podróży*, 1884) and then in the *Italia* series (1901) and various translations from Italian.[11]

Wharton's first glimpse of Venice is as a multilayered panorama rather than as a town. She employs two crucial terms taken from the language of painting: foreground and background.[12] Wharton's decision to situate Venice in the space of pictorial art reflects her way of recognizing and organizing the world. It also reveals what really interested her as a writer. She believed that the foreground, identified with the Byzantine and medieval traditions and with sixteenth-century landscapes often described in literature, was merely a "stereotype," lacking the hidden or overlooked aspects that she valued so highly. Accordingly, her attention is directed toward the background, which to her is the city itself. For Wharton, eighteenth-century Venetian art is the medium through which it is possible to observe the "spirit" of Venice before it started to decline. Hence, Wharton's guides were Giambattista Tiepolo, Canaletto, Francesco Guardi, and Pietro Longhi. Given Ruskin's negative opinion of these artists, Wharton's views on Venetian art were evidently

Fig. 2
Front cover of Edith Wharton's *Italian Backgrounds*, designed by Margaret Armstrong, reproduced in *Spellbound by Rome: The Anglo-American Community in Rome (1890–1914) and the Founding of Keats–Shelley House*, ed. Christina Huemer, Rome (Palombi & Partner) 2005, p. 65, tab. XX

Fig. 3
Francesco Guardi (Venetian, 1712–1793)
View on the Cannaregio Canal, Venice, ca. 1765–80
Oil on canvas
19¾ × 30¼ in. (50 × 76.8 cm)
National Gallery of Art, Washington, D.C.
Samuel H. Kress Collection, 1939.1.113 (224)/PA

can they be read merely as memoirs of the Venetian tours made by the respective writers. It was not very common at that time for ladies to travel independently, and Konopnicka confesses that she appeared very eccentric to the Italians.[6] Wharton would have probably met with the same opinion had she traveled without her family, but her independence might also have been attributed to her being an American.

It should be emphasized that the familiarity of the two writers with Italy had different origins. Wharton spent a significant part of her childhood there, and as an adult she spent four months in Italy every spring from 1886 until 1904; she was in Venice in the spring of 1891.[7] Her trips through the Apennine Peninsula gave her more than a tourist's acquaintance with the country and with its art and literature. Konopnicka, on the other hand, for political and personal reasons (having left her profligate and irresponsible husband, she was rearing her six children on her own), did not visit Italy until her first trip abroad in 1882, returning in 1894–95 and later. It was in Venice that she saw the sea for the first time in her life.[8] The way in which she discovered Italy may be compared to the Italian experiences of Maurice Prendergast: both visited the

Fig. 4
Alvise Vivarini
(Venetian, ca. 1446–1502)
*Our Lady with the Sleeping
Child and Musician Angels*,
ca. 1489
Oil on panel
30¼ × 32 in. (76.8 × 81.3 cm)
Il Redentore, Venice
Photo Credit: © DeA Picture
Library/Art Resource, New York

different from those of her contemporaries and her immediate predecessors.[13] For example, she appreciates not only the documentary value of Canaletto's popular views but also their color and lucidity. At the same time, she praises Guardi's opacity and his capacity to render "the real life of the streets" (fig. 3)—something absent from Canaletto's or Bernardo Bellotto's airy spaces.[14] Wharton's way of perceiving and describing artistic masterpieces draws the reader in, as she defends objects hitherto routinely ignored or misjudged by nineteenth-century critics and travelers.

Konopnicka's perspective is different. Her Venice is a contemporary city characterized by its uniquely picturesque quality and by its symbolic resonances. She associates Venice with her native Poland, which had fallen under foreign rule at the end of the eighteenth century. Her main reflection on the Italian city concerns the whys and wherefores of its ancient grandeur and present decline.[15] As a result, her discourse on Venice has much in common with Romantic literature and was inspired by the ideas of

Madame de Staël and Lord Byron. Konopnicka was also one of the first Polish writers to accept Ruskin's theories on Italian art. Influenced by him, she preferred paintings by fourteenth-century artists to the masterpieces of the fifteenth and sixteenth centuries.[16] In the sole Venetian poem among Konopnicka's texts in *Italia* on ten different images of the Virgin, the names of Bassano and Tintoretto serve to identify the church of Il Redentore, but their pictures do not attract the observer's eye.[17] Again under Ruskin's influence, Konopnicka is drawn to an altarpiece by Alvise Vivarini hidden in the sacristy of Il Redentore, *Our Lady with the Sleeping Child and Musician Angels* (fig. 4).[18] The stark simplicity of the image becomes the subject of a poetic reflection. Konopnicka creates an almost musical interpretation of the altarpiece, one that is unusual in that the only color she mentions is white, which is of course symbolic of purity. The key elements in the description are severity, innocence, the "monastic appearance" of the Virgin, and the Christ Child's paleness, echoed by the lily. What interests Konopnicka is not the pictorial and artistic values of the artwork but its religious message, which she slightly sweetens with her artistic reconstruction of the element that is "absent" from the representation: angelic music, "heard" by the observer. Although Konopnicka's visualization serves as a vehicle for expressing her own emotions, her description, with its objectively rendered pictorial details, clearly identifies its origin in a specific work of art: the altarpiece.[19] In line with Ruskin's antipathy toward the "feeble sensualities" of modern painting, Konopnicka is fascinated by the simplicity of such early Renaissance artists as Giotto, Fra Angelico, or, in Venice, Vivarini himself.[20] From Ruskin's early writings, Konopnicka takes the idea of the decadence of Venetian art, along with a belief in the poverty and amorality of the Italians.[21] As a consequence, she is interested mainly in works created in the period of Venice's early greatness, and her attitude to art is more ethical than aesthetic.

Wharton, by contrast, focuses on the purely artistic value of a painting and enthusiastically interprets Tiepolo's work as a revival of the spirit of the Italian Cinquecento.[22] She also perceives Francesco Guardi's works as some "of the earliest impressionists," and even writes as though his canvases were precursors to the modernity of Maurice Prendergast's Venetian watercolors (fig. 5).[23] Like many of Guardi's canvases,

Prendergast's works capture the rituals of the town.[24] Wharton views each work of art as a testament to the spiritual force of Venice.[25] Her approach is original in that it does not repeat the stereotypical view of Venice as a dying city but instead treats its art as proof that Venice is still very much alive. Rather than seeing the artistic heritage of a country as separate from its "anthropological culture," Wharton demonstrates that both are coherent and valid.[26] She searches for the "interior characteristic" of Venetian society, trying to understand the Venetian mentality by tracing its embodiment in works of art.

In Konopnicka's verse, there are two Venices. The "real" one seems to exist only in the effects of light and shade. The sea and the sun act as the principal components of the "panorama of the weather" through which the essence of Venetian space is traditionally expressed in modern literature.[27] Other elements of the view are reduced to the role of accessories in the theater of nature. A third phenomenon that shapes the space depicted by Konopnicka is the mist that deadens Venetian light and voices. It is possible that Konopnicka's sensibility to fog is also derived from Ruskin's theories.[28] Such descriptive elements, however, serve merely to establish the context in which the focal event or reflection takes place. The backgrounds in Konopnicka's Venetian poems can thus be seen as resembling J.M.W. Turner's works in pencil, watercolor, or gouache, even if she does not refer to Turner by name in any of her writings.

The second Venice in Konopnicka's poetry can be seen as the imaginary one. Konopnicka's visions not only refer to the panorama of the city but also relate to more complex mental constructs, often connected with the poet's perception of art. In "A Morning in Venice" ("Ranek w Wenecji"), for instance, the personification of Earth appears much as it would in a painting by Titian:

> The Earth—Danae lies in the pearls of dew.
>> By her bed
> A silver cloud of shredded mists has just unveiled,
> And on the golden bed-head the crimson is dying out,
> The crimson of the morning roses just thrown
>> down by the dawn.[29]

This visualization undoubtedly refers to the heritage of Venetian painting. The heroine might be recognized

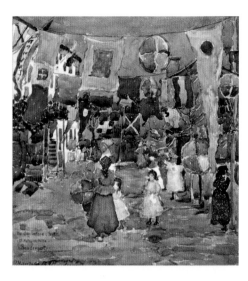

Fig. 5
Maurice Prendergast
Fiesta—Venice—S. Pietro in Volta, ca. 1898–99
Watercolor and pencil on paper
13⅜ × 12½ in. (34 × 31.8 cm)
Williams College Museum of Art, Williamstown, Massachusetts
Gift of Mrs. Charles Prendergast
(86.18.76)
Photo Credit: Arthur Evans
CR 729

Fig. 6
Paolo Veronese
(Venetian, 1528–1588)
Venice Receiving the Ducal Horn, 1553
Oil on canvas
143¾ × 57¾ in. (365 × 147 cm)
Doge's Palace, Venice
Photo Credit: Cameraphoto/
Art Resource, New York

as a personification of Venice, often portrayed as a woman in Danae's pose, for example in Paolo Veronese's *Juno Showering Gifts on Venice*, also known as *Venice Receiving the Ducal Horn* (fig. 6). As a reader of Ruskin, Konopnicka must have known Veronese's painting *Venice Enthroned*, described as "one of the grandest pieces of frank colour in the Ducal Palace."[30] It is possible that Konopnicka's vision was inspired by the works of Veronese and Titian, or by other paintings that personify Venice.

The poet's depiction of Venice in the context of a boudoir proves that Konopnicka, like Wharton, perceived the uniqueness of the city. In Venice, various forms of social life were extremely important both in the Renaissance and in subsequent epochs. The poet's attention is concentrated on the mythological references of sixteenth-century representation, while Wharton's observations also concern the historical background of a single artistic choice in the eighteenth century.

Wharton affirms that the sublime decorativeness of pious images indicates that, in Venice, religion was an aspect of daily life.[31] She suggests that the mysticism of Tiepolo's frescoes is a result of "force of technique" rather than of any ideological intention on the painter's part.[32] She demonstrates that the artist chose sensual or, at least, mundane poses for his figures, as in *The Virgin*

and Saints Rosa of Lima, Catherine of Siena and Agnes of Moltepulciano in the Gesuati (Santa Maria del Rosario) church. Judging Tiepolo's art, Wharton appears more attentive to the qualities of his painting than other critics, some of whom disapproved of his artistic style without appreciating that he was "the master of sunny visions," in which the antique and the modern, Greek and Roman mythology, and Christian symbolism are fused in inimitable fashion.[33] Wharton appreciates in Tiepolo's paintings the same "ethereal distances" and "radiant majesty" that Konopnicka finds fascinating in the canvases of Veronese and Titian.[34]

Walking along Venetian canals like a modern reporter, Wharton captures "the conjunction of magnificence and meanness" that characterizes the Italian mentality.[35] She tracks down details seen in canvases to the original buildings, for example, presenting the Palazzo Querini-Stampaglia as the theater where "the personages of Goldoni and Longhi played out their social comedy"[36] or describing the collection of manikins exhibited in the Museo Correr.[37] Wharton's interest in social questions differs from Konopnicka's sentimental attitude of pity for the poor. Her approach seems to be more balanced in its concentration on the wide-ranging manifestations of Venetian life as an artistic subject. Her reflections tend not to engage the reader's moral or political sympathies.

Fig. 7
Giambattista Tiepolo
(Venetian, 1696–1770)
Cleopatra's Banquet,
ca. 1745–50
Fresco
256¾ × 118 in. (650 × 300 cm)
Palazzo Labia, Venice
Photo Credit: Cameraphoto Arte,
Venice/Art Resource, New York

Fig. 8
Pietro Longhi
(Venetian, 1700/02–1785)
The Concert, 1741
Oil on canvas
23⅞ × 18⅞ in. (60 × 48 cm)
Gallerie dell'Accademia, Venice
Photo Credit: Cameraphoto/
Art Resource, New York

Contact with art disposes Wharton to reflect on literature, which "suggests" feelings and makes the observer more sensitive to different aspects of beauty.[38] Wharton reads religious paintings by Tiepolo through Dante's *Paradiso*, and Tiepolo's scenes from the story of *Antony and Cleopatra* (fig. 7) in the Palazzo Labia through Shakespeare's play.[39] Such interpretations emphasize the fact that literary associations arise from the grandeur of Tiepolo's works.[40] A deliberation on Pietro Longhi's painting in relation to Carlo Goldoni's theater (fig. 8) is also peculiar to Wharton. Both in Goldoni's plays and in Longhi's canvases, the personages seem to be "types," not individuals, but the scene maintains its realistic character, and may be seen as an artistic transmutation of an everyday situation.[41] Wharton emphasizes the conceptual similarity between visual and literary representations of Venetian society. Depictions of the city in both media have a sense of naïveté that is the key to understanding the place and its artists.[42] Sometimes the literary association transgresses temporal boundaries, as when Wharton anachronistically discusses Stendhal's social observations in relation to seventeenth-century sculpture.[43] Such a connection illustrates the complex stratification that the modern traveler has to deal with in Italy. Wharton's musings on Venice reflect her perception of literature and visual art as related forms of intellectual expression, which not only interact but also can be reciprocally interpreted.

Wharton's *Italian Backgrounds* and Konopnicka's *Italia* are best viewed as products of the ulterior transformation of real experiences connected with studying and contemplating Venice and its artistic masterpieces. It is also interesting to observe that Wharton, in her art criticism, perceives Venice through literature. Her vision of the place is as much inspired by literary texts as it is marked by her own direct contemplation of art. Konopnicka, meanwhile, as a poet, bases her portrait of Venice on an intense study of Venetian painting.

To understand the images of Venice created by each of these writers, we should note that there are not only two different types of creativity and sensibility involved but also two moments of reflection on Italy, indicated by the "guidelines" chosen by each of the two authors.[44] Konopnicka's point of view reflects a more "antiquated" way of describing Venice, while Wharton's approach is more modern. She does not reject the Romantic tradition, but she proposes its reinterpretation and reveals aspects of Venice neglected by Romantic convention. The modernity of Wharton's observations consists in the language she uses, which is sober but not pompous. Her language tends not to be as sublime as that of Konopnicka's verses, which are inspired by the pathos of nineteenth-century literary expression. Wharton's reflections are unusual in their concentration on the vibrancy and vivacity of Venice: the streets are crowded, the paintings portray people in their everyday activities. The Romantic tradition, by contrast, emphasizes symptoms of death: the city is deserted, and the only traffic is the black gondolas, which resemble coffins.

Edith Wharton's *Italian Backgrounds* is an erudite and curious collection of essays, in which observations on art and literature combine and interact. The musings and visions of Maria Konopnicka's *Italia* are expressed in carefully wrought verse. These writers not only offer different forms of expression, they also, above all, concentrate on different aspects of the world they are exploring, as though they are looking at two different places. For Wharton, Venice illustrates "the inner sanctum of European otherness."[45] To Konopnicka, the city is defined by its incredible accumulation of cultural heritage, distinctive in its "Italian-ness," with which she tries to identify. The common trait of the two realities created by the writers is the presence of art as the main focus of interest and the use of *ekphrasis*—the literary description of a visual work of art—as the principal rhetorical device.

Notes

1 Work on this essay was made possible thanks to the Mellon East-Central European Visiting Scholars award at the American Academy in Rome, December 2006–March 2007.

2 J. Siegel, *Haunted Museum: Longing, Travel, and the Art-Romance Tradition*, Princeton, NJ (Princeton University Press) 2005, p. xiv.

3 O. Płaszczewska, "I 'non viaggi' della tradizione romantica (X. de Maistre, F. Skarbek, J. Janin)," in *Il viaggio come realtà e come metafora*, ed. J. Łukaszewicz and D. Artico, Łask (Leksem) 2004, p. 232.

4 Siegel, *Haunted Museum*, pp. 3–8.

5 O. Płaszczewska, *Wizja Włoch w polskiej i francuskiej literaturze okresu romantyzmu (1800–1859)*, Kraków (Universitas) 2003, pp. 289–98; M. Lloyd, "Hawthorne, Ruskin and the Hostile Tradition," *English Miscellany*, 6, 1955, pp. 109–33; A. Bonadeo, *L'Italia e gli italiani nell'immaginazione romantica inglese: Lord Byron, J. Ruskin, D.H. Lawrence*, Naples (Società Editrice Napoletana) 1984, pp. 53–94.

6 M. Konopnicka, "Wrażenia z podróży," in M. Konopnicka, *Nowele*, ed. A. Brodzka, 4 vols., Warsaw (Czytelnik) 1974, vol. 1, pp. 116–17.

7 R. Soria, *Dictionary of Nineteenth-Century American Artists in Italy, 1760–1914*, Madison, NJ (Fairleigh Dickinson University Press) 1982, p. 322.

8 B. Biliński, *Maria Konopnicka e le sue liriche "Italia,"* Wrocław (Ossolineum) 1963, p. 17.

9 N. Mowll Mathews, *The Art of Leisure: Maurice Prendergast in the Williams College Museum of Art*, Williamstown, Mass. (Williams College Museum of Art) 1999, p. 24.

10 Soria, *Dictionary*, p. 323; C. von Klenze, *The Interpretation of Italy During the Last Two Centuries*, Chicago (University of Chicago Press) 1907, p. 147; W.M. Johnston, *In Search of Italy: Foreign Writers in Northern Italy Since 1800*, University Park, Pa. (Penn State University Press) 1987, pp. 192–93. See also R.W.B. Lewis, *Edith Wharton: A Biography*, New York (Harper & Row) 1975.

11 J. Baculewski, "Maria Konopnicka a nowa sztuka," in *Maria Konopnicka. Materiały z sesji naukowej*, ed. K. Tokarzówna, Warsaw (LSW) 1972, pp. 15–16.

12 E. Wharton, *Italian Backgrounds*, London (Macmillan) 1905, pp. 189–90.

13 *Ibid.*, p. 199.

14 *Ibid.*, pp. 200–01.

15 M. Konopnicka, *Poezje*, ed. A. Brodzka, Warsaw (Czytelnik) 1969, p. 253.

16 W. Olkusz, *Szczęśliwy mariaż literatury z malarstwem: rzecz o fascynacjach estetycznych Marii Konopnickiej*, Opole (WSP) 1984, p. 39.

17 M. Konopnicka, "Vivarini," in *Poezje*, p. 296.

18 Olkusz, *Szczęśliwy mariaż literatury*, p. 33.

19 *Ibid.*, p. 43.

20 J. Ruskin, *The Stones of Venice*, London (Ballantyne) 1898, vol. 1, p. 23.

21 Bonadeo, *L'Italia e gli italiani*, pp. 57–61.

22 Wharton, *Italian Backgrounds*, p. 199.

23 *Ibid.*, p. 200.

24 Mathews, *The Art of Leisure*, pp. 25–26.

25 Wharton, *Italian Backgrounds*, p. 192.

26 J. Buzard, "A Continent of Pictures: Reflections on the 'Europe' of Nineteenth-Century Tourists," *PMLA*, 108, January 1993, p. 31; jstor.org/pss/462850, accessed September 2008.

27 A. Achtelik, *Wenecja mityczna w literaturze polskiej XIX i XX wieku*, Katowice (Gnome) 2002, p. 25.

28 J. Ruskin, "In Defence of Fog," in *Modern Painters: A Volume of Selections*, London, Edinburgh, and New York (Thomas Nelson & Sons) [n.d.], p. 235.

29 Konopnicka, *Poezje*, p. 252; author's translation.

30 Ruskin, *The Stones of Venice*, vol. 3, p. 292.

31 Wharton, *Italian Backgrounds*, pp. 192–93.

32 *Ibid.*, p. 195.

33 K. Christiansen, "The Ca' Dolfin Tiepolos," *The Metropolitan Museum of Art Bulletin*, n.s., 55, Spring 1998, pp. 5–6; jstor.org/pss/3269263, accessed September 2008.

34 Wharton, *Italian Backgrounds*, pp. 193, 199.

35 Johnston, *In Search of Italy*, p. 21.

36 Wharton, *Italian Backgrounds*, p. 206; Buzard, "A Continent of Pictures," p. 40; M. Bell, "Edith Wharton and Henry James: The Literary Relation," *PMLA*, 74, December 1959, pp. 619–37; jstor.org/pss/460513, accessed September 2008.

37 Wharton, *Italian Backgrounds*, p. 213.

38 A. Brilli, *Il viaggio in Italia: storia di una grande tradizione culturale*, Bologna (Il Mulino) 2006, pp. 398–99.

39 Wharton, *Italian Backgrounds*, p. 198.

40 *Ibid.*, p. 199.

41 *Ibid.*, pp. 202–04.

42 *Ibid.*, pp. 201–05.

43 *Ibid.*, pp. 207–09.

44 Brilli, *Il viaggio in Italia*, pp. 242–43, 391.

45 Buzard, "A Continent of Pictures," p. 32.

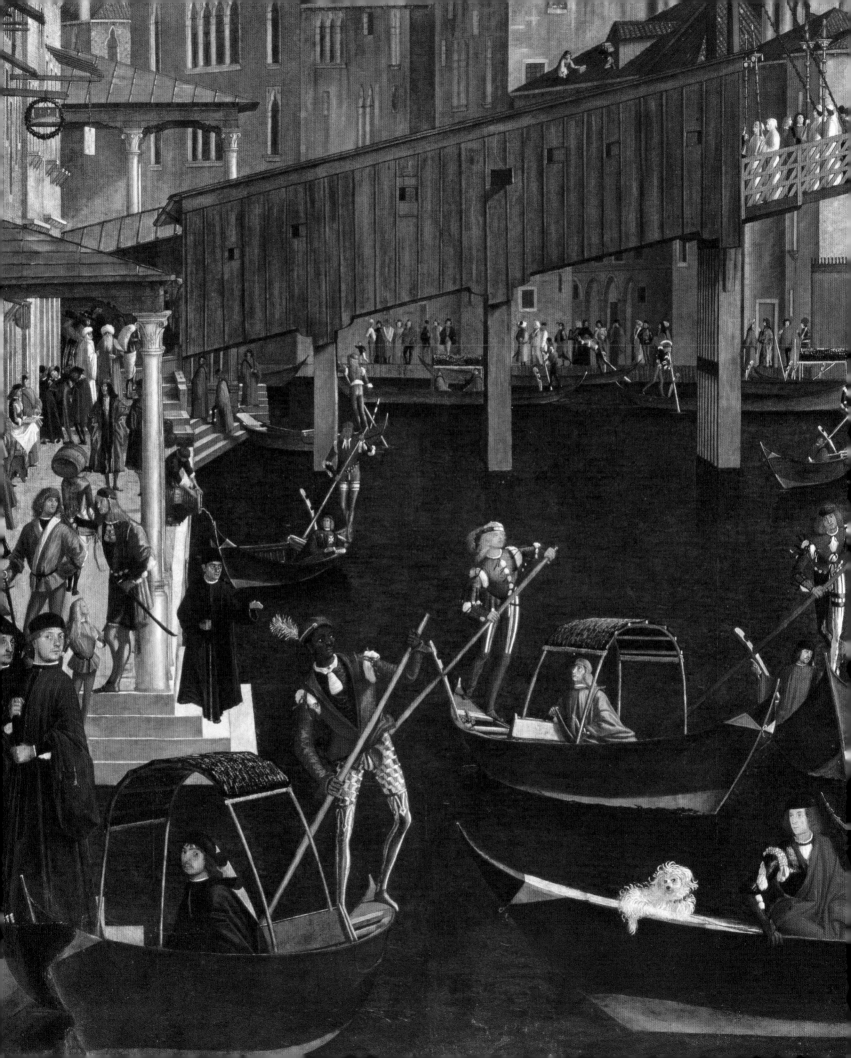

Old Masters, New Stereotypes

CARPACCIO AS PATHWAY TO PRENDERGAST'S VENETIAN SCENES

Alessandro Del Puppo

Landscape, History, Art History

To the highly cultivated people who passed through Venice in the late nineteenth century, Maurice Prendergast among them, the city may have represented a collection of paradoxes. The astonishing setting and the picturesque scenery coexisted alongside one of the most artificial and constructed of cities. The site had been invented and narrated by a plethora of writers, painters, and musicians, and thus the city was marked by the perhaps disquieting, yet unavoidable, signs of progress. It was in this progressive environment that Venetian politicians, entrepreneurs, and businessmen tried to conceive a plan for the modern development of the city. But for most foreign visitors, there was not really a city called Venice, only ideas through which Venice could be seen.

Modern Italian and international artists in Venice should be viewed as having three preoccupations: the landscape, as a physical background that makes possible the incomparable blend of nature and culture; the history of the city, summarized by the very presence of Ruskin's celebrated "stones of Venice"; and painting and architecture, as the symbolic visualization of the Venetian Republic's noble heritage.

In light of the fall of the republic, however, a fourth obsession should be added to the list: Venice's art history, considered as the great text through which Venetian culture elaborates, celebrates, and disseminates its glorious past. More specifically, it seems obvious that, in defiance of the loss of Venetian tradition after the seventeenth century, art becomes more and more art history.

For all of the nineteenth century, Venice's Accademia was the place where the memory of the past was rewritten and translated into the present. From 1809, Venetian poets, historians, and intellectuals had honored an Old Master on the first day of every academic year at the Accademia. Leopoldo Cicognara, president of the Accademia, began the tradition by celebrating Titian and Palladio as the highest representatives of artistic genius. From 1812 to 1818, tributes were paid to Giovanni Bellini, Tintoretto, Veronese, the Vivarini brothers, and Mantegna. During the 1820s, attention was paid to artists of lesser fame, including Jacopo Bassano, Padovanino, Antonio Lombardo, and Paris Bordone. In 1833, the Venetian poet Luigi Carrer sang the praises of Vittore Carpaccio. Two years later, Francesco Beltrame celebrated Cima da Conegliano. Appreciation of seventeenth-century masters came later: Rosalba Carriera was discussed in 1838, and Giambattista Tiepolo was recognized as late as 1856.[1] In parallel with these celebrations, historians studied Venetian civilization more intensely, recovering a number of documents from the city's archives; many of these documents were then published, sometimes with inaccuracies and omissions, but mostly with apologetic intentions.[2] In the course of a generation, it seems that taste, sensibility, and all "active" aesthetic values were replaced by an erudite, philological, and even antithetical set of values.

The presence of international artists in Venice at the end of the nineteenth century can be understood in terms of the way in which their work was shaped by a few key figures from the worlds of literature, art history, and even contemporary painting. When Maurice Prendergast arrived in Venice, the rediscovery and reappraisal of Vittore Carpaccio (1460/66–1525/26) as a paradigmatic figure were in full swing as part of the reassessment of Venetian culture as a representation of "Venice" as a whole. Carpaccio's paintings can thus be seen as part of a larger process by which Venice's Old Masters moved from being the subject of religious

and academic consideration to being the focus of secular, modern interpretations.

Religious, Realistic, Symbolist

In the nineteenth century, the critical reassessment of Quattrocento Venetian painting, such as that of Carpaccio, took place in three distinct stages. First, the paintings were regarded with a religious and pietistic slant, especially by Catholic writers. In *De la poésie chrétienne dans son principe, dans sa matière et dans ses formes*, Alexis-François Rio (1797–1874) was the first to consider Carpaccio's St. Ursula series (fig. 5) as "monument colossal de l'art chrétien." Rio anticipated here the well-known writings of John Ruskin.[3] Among other nineteenth-century painters, Jules-Eugène Lenepveu (1819–1898) reprised in his work the religious and pietistic interpretations of Carpaccio. After winning the Prix de Rome in 1847, Lenepveu worked in Rome and Venice. His *Martyrs in the Catacombs* (Paris, Musée d'Orsay) triumphed at the *International Exhibition* in Paris in 1855, an event that prompted Théophile Gautier to write: "Un sentiment très-pur, très-naïf de christianisme des premièrs siècles règne dans cette toile, d'un aspect religieux et placide, où

l'auteur a cherché et trouvé la simplicité croyante des anciens maîtres, sans pousser cependant jusqu'à l'archaïsme du dessin et de la couleur."[4] No one so far has pointed out the iconographic similarity of Lenepveu's painting to Carpaccio's *Burial of Saint Jerome* (1502), in the Scuola di San Giorgio degli Schiavoni, a work that Lenepveu clearly accepted as an eloquent example, in its soberly heroic figures, of primordial Christianity.

The second stage of the critical reassessment of Carpaccio and his contemporaries consisted of an eclectic reinterpretation of their work by Realists and Symbolists alike. Throughout the 1860s and the 1870s, Carpaccio was rediscovered by a new generation of painters. Gustave Moreau was the first to make a large number of copies (in 1858), and James Tissot (1836–1902) soon followed suit. Tissot stayed in Venice in 1862 and wrote to Edgar Degas: "Je suis dans les Carpaccio et je n'en sors pas. Quel cœur avait cet artiste, la manière dont il reproduit cette vie de Sainte Ursule est ce qu'il y a de plus touchant."[5] Tissot's *The Departure of the Prodigal Child from Venice* is the first canvas of a diptych (exhibited at the Salon of 1863, now in the Musée du Petit Palais, Paris) that in fact

Fig. 1
Jean-Léon Gérôme
(French, 1824–1904)
L'Eminence grise, 1873
Oil on canvas
27 × 39¾ in. (68.6 × 101 cm)
Museum of Fine Arts, Boston
Bequest of Susan Cornelia Warren,
1903 (03.605)

known to more and more painters and art historians, including Charles Blanc, Hippolyte Taine, and the Goncourt brothers.[8] At the same time, his paintings lost their religious and pietistic connotations, becoming known instead for their sensational *mise-en-scènes*, lavish settings, and opulent details. Having been considered initially as unsmiling examples of religious subjects, Carpaccio's paintings became models of secular art.

One final example may be viewed as paradigmatic. *L'Eminence grise* (fig. 1) was the masterpiece for which Jean-Léon Gérôme was awarded the gold medal at the Salon of 1874. I would like to suggest that the whole composition and some of its details derive from Carpaccio's *Farewell of the Ambassadors* (1493–95): the spectacular marble inlays in Carpaccio's royal palace are converted by Gérôme into the great tapestry suspended on the wall of the staircase; the figures succeeding from left to right are reversed, locked, and posed along a diagonal that leads toward the Eminence; Gérôme's great column on the left, which suggests the depth of theatrical painting, echoes the break of Carpaccio's vertical polychrome pilaster.

In my opinion, the connections between the two works are not simply formal. In 1873, a copy of Carpaccio's *Farewell of the Ambassadors*, commissioned from the French painter Jean Lecomte du Noüy (fig. 2), entered the collection of the École Nationale des Beaux-Arts in Paris. Gérôme would surely have studied this work, if only briefly, as Lecomte du Noüy was one of his most promising students.

This leads me to the third stage of the critical reappraisal that took place in the *fin-de-siècle* years: a trend toward secular criticism around this time, exemplified by such writers as Walter Pater, Maurice Barrés, and Theodor de Wyzewa. It was also in the 1890s that Carpaccio studies began to attract international attention.

An International Lingua Franca

A key figure in this *fin-de-siècle* conjuncture was Pompeo Molmenti (1852–1928). Molmenti was a typical intellectual of his time. A liberal who had been brought up on progressive ideas, he was engaged in the mission of rescuing and redeeming Venice's past. He wrote about every aspect of Venetian history, from its literature to its economic and social conditions. Close to the circle around Isabella Stewart Gardner, he became a point of reference for many intellectuals traveling at this time.[9]

Fig. 2
Jean Lecomte du Noüy
(French, 1842–1923)
The Departure of the Ambassadors (after Vittore Carpaccio), ca. 1873
Oil on canvas
130¾ × 120 in. (338 × 305 cm)
École Nationale des Beaux-Arts, Paris

constitutes a pastiche of Carpaccio's *The Return of the Ambassadors* (1497–98) and *Arrival in Cologne* (1490), from the St. Ursula series.[6] Edward Burne-Jones, who visited Venice in 1859, also explicitly referred to *Saint Ursula's Dream* (1495) in his *Annunciation*, an amazing watercolor of 1863.[7]

Of course, Carpaccio's fame was not restricted to those who visited Venice. The early attention was followed by the distribution of photographic reproductions, engravings, and copies. As a result, Carpaccio was more widely recognized, and he became

Molmenti was one of the promoters of the international exhibition in 1887 and of the first Venice Biennale in 1895, along with such artists as Anders Zorn, James McNeill Whistler, Ettore Tito, and Giacomo Mancini. His first book, and his most important, was published in 1880 and was highly successful. As the title suggests, *La storia di Venezia nella vita privata dalle origini alla caduta della repubblica* was not a book about art history *per se* but rather a sociological study. Molmenti was one of the first writers to focus on the private lives of Venetians rather than on the golden age of the doges and the republic.

In contrast to the ethical and philosophical claims advanced by Ruskin and his followers, Molmenti presents Carpaccio as a realist and a naturalist. To him, Carpaccio's works can be viewed as authentic visual documents:

> The happy fervor of Venetian life attracts Carpaccio and Gentile [Bellini]. They show us, as a photograph, the city of sublime islands. In Carpaccio especially abound the most intimate and curious details, and that wonderful chronicler of the brush describes costumes, parties, ceremonies with the same evidence as and more vividness than Martin Sanudo's *Diarii* and old documents and archives. Carpaccio was able to gather two qualities that seem opposite: a taste for magnificent appearances and inner depths of feeling.[10]

In 1885, Molmenti published *Il Carpaccio e il Tiepolo: studi d'arte veneziana,* in which he identifies the Carpaccio and Tiepolo families as the alpha and omega of the Venetian tradition. Molmenti considers Carpaccio as the "twilight of Venetian art," set against the "blazing and steamy sunset light" of Tiepolo (1676–1770). Carpaccio's "shy and clumsy" character is the opposite of the "arrogant and unfair" Rococo painter. The "chaste genius" and unruffled sentiments of the ingenuous Quattrocento painter give way to the "florid imagination" and "competitive spirit" of the "corrupt and profligate" Settecento artist. For Molmenti, however, the two painters are alike in their firm rejection of pictorial convention and their "wonderful harmony of the ideal with the real."[11]

Molmenti discusses Carpaccio and Tiepolo in order to make a statement about the present. He criticizes both Neo-classical rules and the exhaustive

tradition of Romantic painting. Carpaccio's naïveté (for example, in the "funny little Carpatios [*sic*]" observed by Isabella Stewart Gardner at Scuola di San Giorgio degli Schiavoni[12]) and Tiepolo's whimsy (as in the tremendous ceiling painting *The Glorification of the Barbaro Family* (ca. 1750), formerly in the Palazzo Barbaro, Venice, now in the Metropolitan Museum of Art, New York) are seen as two approaches, chronologically poles apart, to getting around pictorial convention before the canonical rules established during, respectively, the Renaissance and Neo-classicism.

It was from these opposing tendencies that the real lingua franca of international painting in Venice seems to have arisen. To cite just one example, John Singer Sargent's *The Bead Stringers of Venice* (1880–82) merges the genre of the contemporary scene with a fresh, quick, and brilliant Tiepolesque style of brushwork. This is exactly the style, comparable to Quattrocento and Settecento models, that Julius Meier-Graefe referred to as an international "Impressionism without impressionists."[13]

Molmenti's works were well known by the French art historian Eugène Muntz, whose *Histoire de l'art pendant la Renaissance,* issued in three volumes between 1889 and 1895, reflects this appreciation of Carpaccio as more of a chronicler and decorator than a religious painter. Indeed, Muntz confirmed such a view of Carpaccio, which soon became integral to our idea of the painter, as is evident in many pages of Marcel Proust's *A la recherche du temps perdu* (1913–27). The critic Georges Lafenestre considered Carpaccio's paintings as a clear example of genre transmutation: "Les épisodes de l'Evangile entre ses mains deviennent des simples tableaux de genre. . . . On ne saurait donc s'étonner des sympathies qu'il inspire de notre temps."[14]

In *The Venetian Painters of the Renaissance,* Bernard Berenson describes Carpaccio as an artist who resolved the problems of "atmospheric truth," of the depth of space, and of the sense of volume. While Berenson recognizes Carpaccio's formal achievements, he considers these to be qualities "of a painter of genre, of which he was the earliest Italian master."[15]

In 1899, Paul Flat published *Les premiers vénitiens,* with a preface by Maurice Barrès (republished in 1903 as the introduction to Barrès's *Amori et dolori sacrum: mort de Venise*). Flat calls Carpaccio "l'incarnation vivante du génie décoratif vénitien" and the St. Ursula series "le plus magnifique exemplaire qui soit en aucun

musée d'Europe d'un art tout à la fois *intime et décoratif,* et dans laquel se trouve condensé tout le génie d'une race."[16] Here "décoratif" refers to the staging of myths and legends in contemporary costume. This renewed attention to contemporary life is also reflected in the works of Joseph Lindon Smith (1863–1950), who visited Venice regularly in the 1880s. Smith's watercolor *The Critics: Interior of San Giorgio degli Schiavoni, Venice* (fig. 3) depicts two characters in sixteenth-century clothes, conversing before the canvases of St. George.

When Molmenti published his research, with the help of Gustav Ludwig, in the huge monograph *Vittore Carpaccio: la vita e le opere* (1906), Theodor de Wyzewa wrote a review that defined the painter as a "petit bourgeois vénitien" and an "aimable illustrateur" whose works are "le miroir de Venise d'il y a quatre siècles."[17] Even very different publications, such as Mary Knight Potter's *The Art of Venice Academy* (1906), confirm this interpretation: "What ever story Carpaccio tells," Potter writes, "it is always Venice that is his background."[18]

A Model of Real Presence

For Carpaccio, the city was thus a background to explore and a story to tell. At the beginning of the twentieth century, despite exhausted interpretations, such as Gabriele d'Annunzio's notorious digression about *Saint Ursula's Dream* in the novel *Il fuoco* (1900), Carpaccio's œuvre became, for international spectators, a sort of visualized Baedeker. His images recall the experience and recognition of the Venetian landscape (fig. 7). Compared with Canaletto's views, Carpaccio's canvases appear lyrical and more brilliant in tone and color. His renderings of Venetian palaces may seem approximate and crude, but they are nonetheless passionate and full of longing. As Berenson noted in 1916, "We are won by their spontaneity."[19] In contrast, Canaletto's works, while rigorous and accurate, are unfriendly and cold. For most viewers of that time, and for artists too, Carpaccio depicts lovely settings while Canaletto provides only a useful map.

This, in short, is the pivotal role of Carpaccio at the turn of the twentieth century. His style can be appreciated as an alternative to the more sophisticated fifteenth-century Florentine tradition trumpeted by the Pre-Raphaelite and Symbolist circles. His paintings offer a repertoire of luxurious settings and the lure of Orientalism, but they also provide a collection of everyday actions and scenes.

Fig. 3
Joseph Lindon Smith
(American, 1863–1950)
The Critics: Interior of San Giorgio degli Schiavoni, Venice, 1894
Watercolor on paper
30 × 45¾ in. (76.2 × 116.2 cm), sight
Museum of Fine Arts, Boston
Gift of Mrs. Henrietta Page, 1918
(18.405)

It is difficult, and perhaps even unproductive, to make strict distinctions between the large variety of artists at work in Venice at the turn of the twentieth century. We can, however, identify two general approaches. Sargent was close to a generation that attempted to restore, against Ruskin's doctrines, sixteenth-century painting, from Michelangelo's masses to Benvenuto Cellini's "linea serpentinata." Sargent admired Veronese and Tintoretto and gravitated toward less recognizable views of Venice.[20] Prendergast, on the other hand, along with many others, preferred crowded scenes and the bright and vivid *tranches de vie* of the city's festivals. From this point of view, Carpaccio offered the archetypal description of everyday Venetian life, and his style provided a possible example for up-to-date genre painting.[21] The chronicle of the past, reflected by and captured in the present, became a living subject. The secular interpretation at last developed into a focus on the ordinary life of the present time. These images were often poetic; artists recognized the importance of everyday life and drew

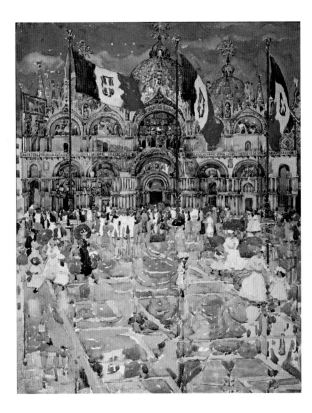

Fig. 4
Maurice Prendergast
Splash of Sunshine and Rain, 1899
Watercolor and pencil on paper
19⅜ × 14¼ in. (49.2 × 36.2 cm)
Private Collection
Courtesy of Avery Galleries,
Bryn Mawr, Pennsylvania
CR 674

Fig. 5
Vittore Carpaccio
(Venetian, 1460/66–1525/26)
Meeting and Departure of the Betrothed, detail from *The Legend of St. Ursula*, 1495
Oil on canvas
110 × 240⅜ in. (280 × 611 cm)
Gallerie dell'Accademia, Venice
Photo Credit: Cameraphoto/
Art Resource, New York

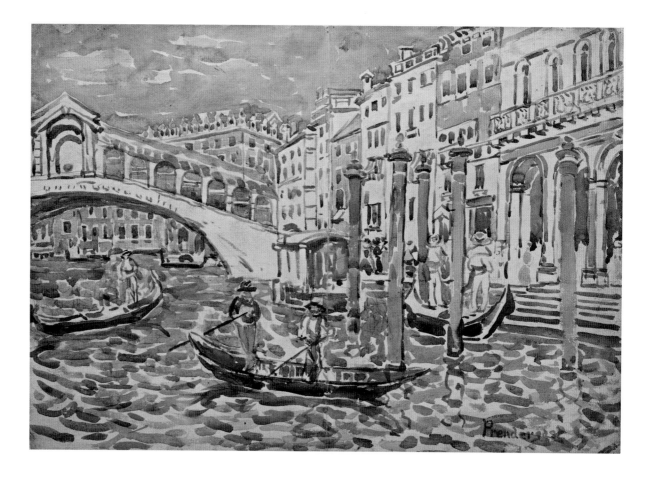

inspiration from personal experience. Carpaccio became the best example of both the "high" and the "low mimetic mode" (to adopt Northrop Frye's distinction).[22]

Indeed, Carpaccio became a pathway to Venetian modernity, a model of real presence. In Prendergast's *Splash of Sunshine and Rain* (fig. 4), we appreciate the painting's contemporary staging while at the same time connecting it to such an archetype as Carpaccio's *The Departure of the Pilgrims* (1495). Such a simple procession along a humble *fondamenta* may recall the finest artistic depictions, confirming the eternal quality of Venetian scenes.

In my opinion, Carpaccio's paintings are important for all artists because they represent, instead of a sublime and distant past, shared experiences that are repeatable as visual models. It is only in such a city as Venice that painters can feel physically present in a place where Old Masters once worked. Prendergast must have felt this sense of participatory connection while completing his Venetian watercolors (fig. 6). Although time passes, what remains is at least the

same visual and living experience of the Venetian crowds, the architecture, the gondolas, and, of course, the courtesans. For example, although depicted in 1903–04, Walter Sickert's courtesans (fig. 8) reflect Carpaccio's *Two Venetian Gentlewomen* (fig. 9).

As we have seen, for many painters Vittore Carpaccio's narrative cycles provided a stirring exemplar. They represented one of the best ways to rediscover a specific form of heritage. Venetian history gradually prompted contemporary work, and a new taste for early Cinquecento painting indicated a shift from an erudite view of antiquity to a modern artistic agenda based on secular values. This phenomenon provides a crucial viewpoint from which to reconsider international art in turn-of-the-century Venice. It is true that, at the beginning of the twentieth century, Carpaccio's influence was allayed by the growing presence of other visual models. Perhaps Prendergast's generation was the last to be influenced by Carpaccio

in the way discussed. But Carpaccio's lesson seems to have remained relevant.

In "Squaring up a Drawing," a lecture delivered by Sickert in 1934 to the students of the Margate School of Art, the painter, arguing that "there are really no original things," declared:

Carpaccio was one of the very great painters of the world. . . . Carpaccio used to put in the background of his compositions exact copies of the architecture that was current in his day, such things as one sees nowadays in such papers as the *Mirror* and the *Sketch*. If a man like Carpaccio did not think it was wrong to copy, why should poor worms like us think that we are not justified also? . . . If Carpaccio who was one of the greatest painters who has ever been on the face of this earth cribbed, why should not we crib?[23]

Of course, painters crib.

Fig. 8
Walter Sickert
(British, 1860–1942)
Les Vénitiennes, 1903–04
Oil on canvas
18 × 22½ in. (45.7 × 57.2 cm)
Museum of Fine Arts, Boston
Anonymous Gift 1938 (38.776)

Fig. 9
Vittore Carpaccio
(Venetian, 1460/66–1525/26)
Two Venetian Gentlewomen,
ca. 1490
Tempera and oil on wood on panel
25¼ × 37 in. (64 × 94 cm)
Museo Correr, Venice
Photo credit: Alinari/Art Resource,
New York

Notes

1 *Scritti d'arte del primo Ottocento*, ed. Fernando Mazzocca, Milan (Ricciardi) 1998, p. 852.

2 Emanuele Antonio Cicogna, *Saggio di bibliografia veneziana*, Venice (Merlo) 1847; Girolamo Soranzo, *Bibliografia veneziana*, Venice (Naratovich) 1885; Giuseppe Cappelletti, *Storia di Venezia*, Venice (Antonelli) 1849–55; Samuele Romanin, *Storia documentata di Venezia*, Venice (Naratovich) 1853–61.

3 Alexis-François Rio, *De la poésie chrétienne dans son principe, dans sa matière et dans ses formes*, Paris (Debécourt) 1836; John Ruskin, *Modern Painters*, London (Smith, Elder & Co.) 1846, vol. 2, book I, section VII, para. 28.

4 "A very pure and very naïve feeling of the first centuries of Christianity prevails in this religious and placid painting, where the artist searched and found the simplicity of belief in the Old Master, without pushing, however, up to the archaism of the design and color." Théophile Gautier, *Les Beaux-Arts en Europe, 1855*, Paris (Michel Lévy Frères) 1856, vol. 2, pp. 6–7; author's translation.

5 "I'm on to the Carpaccios now, and I can't get over them. What a heart this artist had; the way he represents Saint Ursula is what is most touching." Michael Wentworth, *James Tissot*, Oxford (Clarendon Press) 1984, p. 40; author's translation.

6 *Ibid.*, pp. 40–41.

7 *Edward Burne-Jones. 1883–1898: un maître anglais de l'imaginaire*, Paris (Réunion des Musée Nationaux) 1988, n. 27.

8 Charles Blanc, "De Paris à Venise," *L'Artiste*, 14, 1857, pp. 220–21; Edmond and Jules de Goncourt, "L'Italie la nuit: Venise," *L'Artiste*, 5, 1857, pp. 80–84; Edmond and Jules de Goncourt, *L'Italie d'hier: notes de voyages, 1855–1856*, Paris (Charpentier et Fasquelle) 1893, pp. 26–27; Hippolyte Taine, *Philosophie de l'art*, Paris (Hachette) 1865, p. 103; Hippolyte Taine, *Voyage en Italie*, Paris (Hachette) 1866, vol. 1, p. 106.

9 Monica Donaglio, *Un esponente dell'élite liberale: Pompeo Molmenti politico e storico di Venezia*, Venice (Istituto Veneto di Scienze, Lettere ed Arti) 2004; *L'enigma della modernità: Venezia nell'età di Pompeo Momenti*, ed. Giuseppe Ravanello, Venice (Istituto Veneto di Scienze, Lettere ed Arti) 2006.

10 Pompeo Molmenti, *La storia di Venezia nella vita privata dalle origini alla caduta della repubblica*, Turin (Roux e Favale) 1880, p. 525; author's translation.

11 Pompeo Molmenti, *Il Carpaccio e il Tiepolo: studi d'arte veneziana*, Turin (Roux e Favale) 1885, p. 12.

12 *Gondola Days: Isabella Stewart Gardner and the Palazzo Barbaro Circle*, ed. Elizabeth Anne McCauley *et al.*, Boston (Isabella Stewart Gardner Museum) 2004, p. 10.

13 Julius Meier-Graefe, *Entwicklungsgeschichte der modernen Kunst*, Munich (Piper) 1927, p. 49.

14 "In his hands, the episodes of the Gospel become simple genre painting. . . . One should not be surprised by the sympathy he inspires in our time." Georges Lafenestre, *La peinture italienne*, Paris (Quantin) 1885, p. 321; author's translation.

15 Bernard Berenson, *The Venetian Painters of the Renaissance*, New York (Putnam) 1894, p. 27.

16 "[T]he living incarnation of Venetian decorative genius"; "the most magnificent example, in any European museum, of an art at once *intimate and decorative*, and in which is condensed all the genius of a race." Paul Flat, *Les premiers vénitiens*, Paris (Laurens) 1899, pp. 105, 110; author's translation.

17 "[T]he mirror of Venice of four centuries ago"; Gustavo Ludwig and Pompeo Molmenti, *Vittore Carpaccio: la vita e le opere*, Milan (Hoepli) 1906; Theodor de Wyzewa, *Les maîtres italiens d'autrefois: école du nord*, Paris (Perrin) 1907, pp. 201, 189; author's translation.

18 Mary Knight Potter, *The Art of Venice Academy*, London (George Bell and Sons) 1906, p. 105.

19 Bernard Berenson, "The Enigma of Carpaccio's *Glory of St. Ursula*," in *The Study and Criticism of Italian Art*, London (Bell) 1916, p. 125.

20 Stephanie L. Herdrich, "John Singer Sargent and Italian Renaissance Art," in *Sargent and Italy*, ed. Bruce Robertson, Los Angeles (Los Angeles County Museum of Art) 2003, pp. 99–115.

21 Milton W. Brown, "Maurice B. Prendergast," in *Maurice Brazil Prendergast; Charles Prendergast: A Catalogue Raisonné*, ed. Carol Clark *et al.*, Munich and Williamstown, Mass. (Prestel and Williams College) 1990, p. 16.

22 Quoted in Margaretta Lovell, *A Visitable Past: Views of Venice by American Artists, 1860–1915*, Chicago (University of Chicago Press) 1989, p. 35.

23 *Walter Sickert: The Complete Writings on Art*, ed. Anna Gruetzner Robins, Oxford (Oxford University Press) 2003, pp. 634–40.

"A Terrible Impressionist Mania Now Prevails"

AGAINST MODERN ART IN VENICE AROUND 1900

Jan Andreas May

Opposite
Detail of Frank Brangwyn,
Quayside Porters, Venice,
ca. 1907 (see fig. 7)

Today, the Venice Biennale is one of the most important events on the international art calendar. Many visitors, however, do not come to Venice to see contemporary art. This contradiction has accompanied the exhibition from its very beginnings. The following text will focus on the paradoxical success story of how Venice, the dwindling city of the past, became the venue for a major modern art exhibition.

Ever since 1895, when the first biennale took place as the *International Exhibition of Art of the City of Venice,* the display of modern art in Venice has met with opposition. In the nineteenth century, most influential art lovers preferred to see Venice as a city shaped by its glorious past. The collections of any one of the world's major museums testify to this glorification. The role of Venice as an art capital drew to a close, however, with the fall of the Venetian Republic in 1797. The almost total decline of Venice's Accademia was a logical consequence of the economic collapse that followed soon after the end of the republic. The Accademia's last important artist, Antonio Canova, died in 1822 in Rome.

When Alan Chong wrote in 2004 about Venice's artistic life, he focused on a well-known coterie of international painters: Ludwig Passini, Whistler, Anders Zorn, John Singer Sargent, and Ettore Tito.[1] Since we have information neither about Maurice Prendergast's exact whereabouts in Venice nor about the other painters he may have met there, this article will provide a general overview of the situation of local and foreign artists in Venice in the period between 1895 and 1914.

Idealizing the Glorious Past: Art Life in Venice Before 1895

In the nineteenth century, art life in Venice was dominated by the masters of the city's past. Under Austrian rule, Titian was honored with a monument in the Frari, and Bellini, Titian, Tiepolo, and Veronese were heralded in important museums and collections around the world. Many artists came to Venice to study or to copy the works of the Old Masters for international collectors. Such visitors probably had Ruskin's *The Stones of Venice* (1851–53) in mind during their stay. Yet only a handful of foreign artists became famous through their images of Venice: J.M.W. Turner, Whistler, Sargent, and Prendergast are the painters most often associated with the city.

The public's sentimental view of Venice's past made the city a popular subject for amusement parks all over the world. Venetian palazzi, canals, streets, and gondolas were reproduced for the *Italian Exhibition* in London (1888), *Venedig in Wien* in Vienna (1895), the *Ausstellung Italien* in Hamburg (1895), and the *World's Columbian Exposition* in Chicago (1893). At the same time, Venetian painting experienced a renaissance and gained in popularity at international exhibitions throughout Europe. The local art scene was dominated by a small group of artists largely made up of the Ciardi family (Guglielmo, Beppe, and Emma), Tito, Lino Selvatico, Cesare Laurenti, and Luigi Nono.[2] At the *Esposizione Nazionale Artistica* held in Venice in 1887, foreign art critics considered the Venetian school to be the finest in Italy. One of them, the German painter August Wolf, underlined this view, stating: "Unter allen Venezianern ist nicht ein Impressionist; Verrücktheiten der abgeschmacktesten Art, denen wir da und dort auf der Ausstellung begegnen, sind bei ihnen undenkbar."[3]

Wolf went to Venice to copy the works of Old Masters for Count Schack's gallery in Munich. Like other artists of his age, Wolf admired the city's "glorious" past, a sentiment he shared with the Austrian painter

Eugen von Blaas. In contrast, many of the citizens of Venice wanted to change what they perceived to be a "backward" view of their city; they sought to infuse new life into the lagoon's past maritime, industrial, and artistic significance. The first step toward realizing this new way of thinking—this new *venezianità*—was the organization of the *Esposizione Nazionale Artistica* in 1887. The local superstar of this exhibition was Giacomo Favretto, who died in the same year. Favretto was enthusiastically championed by the historian Pompeo Molmenti, known as the "defender of Venice."[4] Molmenti had studied the life and works of Vittore Carpaccio and Giambattista Tiepolo and saw Favretto as belonging to the same tradition as these Old Masters.

Many foreign artists were also referring to the likes of Carpaccio and Tiepolo through their choice of technique and subject matter, producing popular historical paintings of Venice. In 1895, at the first *International Exhibition of Art*, a very good example of this work, by the Spanish artist José Villegas, went on view.[5] The huge canvas, titled *The Coronation of the Dogaressa Foscari* (1893), dominated the French and Spanish section of the exhibition palace (fig. 1). Villegas frequently painted Venetian subjects on such huge canvases and was very popular in his day. As Wolf wrote: "Hier tummelt sich das venezianische Publikum am liebsten; das ist Fleisch von seinem Fleisch und ihm vollkommen verständlich und genießbar."[6]

A year later, Molmenti curated a huge exhibition of works by Tiepolo at the Doge's Palace.[7] He criticized contemporary art for not respecting the long tradition of painting in the city: "Con grande dispendio si apre una Esposizione d'opere d'arte moderna, per accrescere le attrattive della città singolarissima. E bene, Venezia è e deve essere una Esposizione permanente. Le antiche bellezze hanno maggiori fascini dei quadri moderni."[8]

The Early Success of the International Exhibition of Art

By the time Venice decided to establish its own show, international art exhibitions were going through a fundamental crisis. The city's first exhibition thus took place in a difficult climate and with little financial support. It was based on the model of the Munich Secession. One of the founders' principal motives was to support the local art school by introducing students to contemporary artistic trends from throughout Europe, especially those from Paris, the art capital

of the nineteenth century. Was Venice too late? It appeared so: in 1895 alone, large-scale international art exhibitions were also held in Berlin, Hamburg, London, Munich, Paris, and Vienna. With slightly more than 500 exhibits, the *International Exhibition of Art* in Venice was modest in scale when compared to the more established exhibitions of other major European cities. As a result, the Venetian exhibition was initially completely ignored by French art critics, although it was covered from the outset by the influential German art periodicals *Kunstchronik* and *Die Kunst für Alle*. The exhibition's small size was very much to the visitors' taste, however, rendering it exclusive and elite.

In contrast to many official salons in the European capitals, the *International Exhibition of Art* in Venice included both conservative and modern artists. On display were many works from German, Scottish, and

Fig. 1
José Villegas
(Spanish, 1844–1921)
The Coronation of the Dogaressa Foscari, 1893
Oil on canvas
149½ × 256 in. (380 × 650 cm)
Larz Anderson Collection, Washington, D.C.
Shown in gelatin silver photograph of Room H, *International Exhibition of Art of the City of Venice*, 1895
Courtesy Archivio Storico delle Arti Contemporanee, La Biennale di Venezia

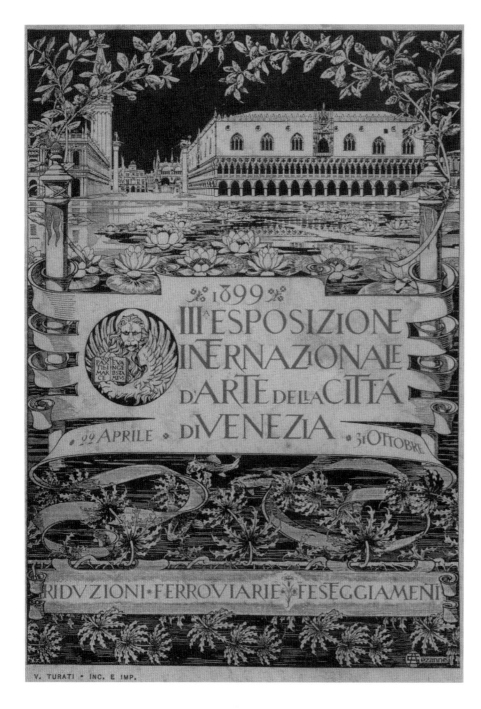

Fig. 2
Title page, *IIIa Esposizione Internazionale d'Arte della città di Venezia 1899*, illustrated catalogue, Venice (Carlo Ferrari) 1899

other north European artists influenced by the Barbizon school or the Impressionists.[9] The exhibition catalogue nevertheless emphasized that many of the participating painters were strongly influenced by the Italian tradition in painting.

The first exhibition having proved to be a great success, surpassing all of the founders' expectations, the event became more modern in emphasis in 1897. The inclusion of German art in particular was seen as being up to date. Modern art in Germany was associated with the group of artists centered around Max Liebermann, who himself founded the Berlin Secession in the same year.[10] The reaction to these new works by Lady Enid Layard, a famous British expatriate, was resoundingly negative:

> The German school was too appallingly bad—One room was entirely dedicated to the "Scotch" school —a thing one had never heard of before—mostly pictures from Glasgow—very sketchy & rather queer! The Italian school had some good things. The American school also a few—Sargent had 3 pictures. Two horrors & one a portrait of a French Dr. Powerful but unpleasant a work of some 15 years back—He evidently had deteriorated since & become more mannered & less true to life.[11]

The Italian art critic Vittorio Pica, an early admirer of the French Impressionists and the Symbolists, saw things differently. He wrote that he wanted to see more of these artists in Venice, but

> Tale numero di opere degli Impressionisti e di tale importanza caratteristica che i visitatori di questa seconda mostra di Venezia potessero alfine formarsi un'idea chiara ed esatta delle innovazioni ardite di questo tanto discusso e combattuto gruppo di pittori. Disgraziamente esso invece non è rappresentato che da Quattro piccole tele di assai secondaria importanza e non è certo da esse che si può con coscienza giudicare uno dei più interessanti tentative di rinnovazione pittorica dei tempi nostri.[12]

When Maurice Prendergast arrived in Venice in the summer of 1898, he intended to work for Sarah Choate Sears, who had paid for his trip to Italy. The city in the lagoon had by this time become an important source

of inspiration for painters, especially those from Boston. Prendergast must have known some of the American artists already residing in Venice, as the city had a very small artistic scene at the time. The third *International Exhibition of Art* took place in the Giardini in 1899 during Prendergast's first stay in Venice (fig. 2).[13]

In that year, it became clear that the exhibition's organizers were restraining their avant-garde desires in favor of conservative realities. The show's publicity was, by then, impeccably handled, and the artists on display were announced in the *New York Times* as early as March of 1899.[14] It was written that "Degas himself will be present at Venice, and that several important works by Corot and other famous members of the French school will be lent to grace the wall of this division."[15] Despite this announcement, however, Degas did not attend, and it was in 1899 that the glorification of the city's past reached its climax. In a one-man show of Giacomo Favretto, which included a total of forty-three paintings, two rooms were dedicated to the so-called "Goldoni del pennello" (Goldoni of the brush). The

show celebrated the "Golden Age" of the eighteenth century, a term that was also adopted by critics at the time.[16] The year's other retrospective showcased the Munich painter Franz von Lenbach, whose paintings reflected his desire to remember the glorious past. Lenbach owned two portraits by Titian, one of his idols.

The tension between conservative taste and the increased participation of avant-garde groups at the *International Exhibition of Art* can be seen as symptomatic of this period. In 1899, artists were chosen from such varied sources as the Munich Secession, Gruppe XI from Berlin, the Société Nationale des Beaux-Arts in Paris, and the Salon de la Libre Esthétique in Brussels. The most important figure among those represented was Jean-François Raffaelli, with twenty-six works. The presence of the Belgian Symbolist Fernand Khnopff was also significant, and some critics thought that Whistler's *The Princess from the Land of Porcelain* (1864) was the most important painting in the show. As mentioned above, one-man exhibitions were

Fig. 3
Carlo Naya Photographic Studios (1857–1918)
Untitled (Protest Against the Exhibition Committee, Venice), 1899
Albumen photographic print on paper
7⅞ × 10¼ in. (20 × 26 cm)
Osvaldo Böhm,
Fotografo Editore, Venice
20568 N
© Osvaldo Böhm

dedicated to Favretto and to Lenbach, but for Lady Layard this nod to the past was not enough to elevate the exhibition: "It was a trying thing, the pictures in general were so bad. The Dutch school was the only one which was really fine. The Scotch school one of the worst. By 3 o'clock we were quite exhausted."[17] Lenbach, she noted, "has several pictures there—but in general there is nothing remarkable there."[18]

The intelligent mix of old and new was ultimately the secret of the exhibition's success. Many critics were keen to observe as much in their periodicals. One in particular remarked that "Zu den besten gehört, die der Berichterstatter bis jetzt im In- und Auslande gesehen hat."[19]

It was not only the *International Exhibition of Art* itself but also Venetian citizens who had the intention of making long-term gains from the city's ephemeral art events. To them it was only logical for the Galleria Internazionale d'Arte Moderna, one of the first international art galleries, to be established in the Ca' Pesaro. The Galleria was financed both by the city and by wealthy citizens. Locating this eminent

institution in the huge Ca' Pesaro made it possible to combine the gallery with the Fondazione Bevilacqua La Masa, which was set up to give young artists studio space and scholarships that would enable them to work in Venice.

The city soon added a number of other events to the *International Exhibition of Art*, such as a small photography show, which opened on August 12, 1899, in some rooms of the Zecca. The *New York Times* commented: "The moment was well chosen also, and the exhibition in question may be considered as an annex to the important International Exposition of Modern Art, which is drawing large crowds of visitors to the city on the Adriatic this summer."[20] The addition of the photography exhibition was only incidental, however. In 1899, a number of artists from the Campo Santa Margherita scene criticized the commercial character of the *International Exhibition of Art*, which was rapidly becoming an important market for art. They attacked the members of the organizing committee—the "ars corpora in speculato serenata"— who were responsible for choosing the exhibited art.

Antonio Fradeletto, Riccardo Selvatico, and other committee members were caricatured as "big head" figures during the carnival (fig. 3). The critics' aim was to *sublimire* (sublimate) the art and, as can be seen from their traditional costumes, to link modern art to the eternal traditions of painting's past. *Ars* ("art" or "skill") may have been liberated from commercialization in the context of the carnival performance, but in reality Fradeletto continued his exhibition policy of showing internationally renowned artists in combination with local favorites to satisfy the wishes of his visitors.

When the collection of Alexander Young from London was shown in 1901, the Barbizon school suddenly became very well represented in the Venetian lagoon. Paris also figured prominently that year; reflecting the city's dominance as a center of art, many works by French and American artists from the French capital were on display. The most popular exhibitor, with more than a dozen pieces, was Auguste Rodin, who received great acclaim, as he had the previous year in Paris. August Wolf, who had admired the Venetian painters in the 1880s and 1890s, was by now frustrated at seeing modern, foreign works "ruining" the excellent Venetians: "They are all infected by the Nordic disease; they paint only fog and rainy weather or anguished figures."[21] For him, the aim of developing the city's local arts through the *International Exhibition of Art* had failed completely.

Two years later, at the fifth *International Exhibition of Art* in 1903, two popular young artists got their chance to exhibit in Venice: Frank Brangwyn from London and Ignacio Zuloaga from Barcelona, who showed a total of fourteen paintings. Works by Walter Sickert were also showcased. Lady Layard mixed up the show's artists and was again very negative in her opinion, commenting on Liebermann's painting *Samson and Delilah* (fig. 4): "I then went on to the Modern Exn of pictures in the public gardens which I think gets worse every time I see it. Some of the pictures are simply disgusting, so low are the types chosen by the artists as models—There is a Samson & Delilah by a Spaniard if I remember rightly; almost the work of a madman & too disgusting."[22]

Layard's opinion was shared by many other conservative visitors to Venice at the time. These travelers were probably influenced by such periodicals as *Die Kunst für Alle* or the London-based *The Studio*, which reported on the exhibition politics in Venice and focused especially on the strict jury led by Fradeletto. Nevertheless, Venice was seen as an inspiration to other art shows because it gave the viewer

> eine gute Orientierung über die verschiedenen Richtungen und Motive der modernen Kunst und der ruhige Genuß von ausgewählten Kunstwerken, die ohne wesentliche Opferung des eigenen Verstandes und ohne die uns jetzt so häufig zugemutete Tortur des gutwilligen Beschauers zu Ehren der Experimente und der Bizarrerien besonders begnadeter Aestheten genießbar sind.[23]

Furthermore, the dominating Old Masters always struck back. When one art critic wrote about the German painter Max Slevogt, he advised the artist to study the paintings of Tintoretto to learn how to render perspective correctly: "I wish an artist such as Slevogt would take a closer look at this fabulous painter."[24] It was a trying thing for every single artist to have to step out of these huge shadows of the glorious past.

In 1905, Venice's *International Exhibition of Art* became a truly official event with the national participation of the UK, France, Germany, Sweden, and the Kingdom of Hungary. Every country had a commissioner, who was appointed by the government or a state museum. Fradeletto was well acquainted with Europe's various artistic currents, and he had excellent links to all the major art capitals; he was thus able to "filter" the art flowing into Venice. He was very much aware that the work of some artists would not be well received by the more conservative Venetian audience. Yet 1905 marked an important step in the growing recognition—and critical acceptance—of the exhibition and of the city itself as an art center. Contemporary critics made much of the fact that in Venice in particular the decorative arts played an important role in showing the art of each individual country to be part of a *Gesamtkunstwerk*. Such periodicals as *The Studio* published extensive articles on the British salon. Even French critics had to admit the success of the Venice exhibition. The publisher of *L'Art Décoratif,* Gustave Soulier, wrote a long article about painting in Venice over the course of the previous few decades.[25] In *Art et Décoration* he wrote: "Cette exposition de Venise est devenue un des organismes artistiques les plus actifs et plus important de l'Europe. Il convient d'y ajouter

Fig. 5
Pablo Picasso
(Spanish, 1881–1973)
Acrobat and Young Harlequin,
1905
Gouache on paper
41¼ × 30 in. (105 × 76 cm)
Private Collection, Belgium

que c'est également aujourd'hui un grand marché d'art, car le chiffre des affaires n'est pas loin d'atteindre le demi-million."[26]

Having established such a reputation, Venice could have gone on to become synonymous with the avant garde, but the story of the *International Exhibition of Art* is unfortunately one of lost opportunities. The city and its premier exhibition were marked by the general tensions that plagued the European arts before the First World War. A man of extraordinary abilities, Fradeletto knew very well what was going on outside Italy in the art capitals of Europe. But his job was to run a successful exhibition, which meant compromising between introducing avant-garde artists and appeasing his conservative visitors. For example, when Ignacio Zuloaga, who had been awarded a gold medal by the exhibition jury in 1903, invited the young Pablo Picasso to exhibit in the Spanish room, Venetian exhibition policy rendered the hanging impossible. Although Picasso's work was not that different from that of Zuloaga, the younger Spaniard was seen as taking art one step further in the march of modernity. Picasso sent two pictures to Venice, but we have a record of only

Fig. 6
The Belgian pavilion at
the Venice Biennale, 1907
(architect: Leon Sneyers)
From L. Dumont-Wilden,
L'Art flamand et hollandais, vol. 4,
Antwerp (J.E. Buschman) 1907, p. 13

one, *Acrobat and Young Harlequin*, from 1905 (fig. 5). As the criticism of Lady Layard demonstrates, most of the visitors to the Venetian exhibition did not think highly of art that was too avant garde. Weighing up the wishes of his public, Fradeletto had Picasso's paintings removed from the Spanish room, and four years later, in a letter to Ardengo Soffici, Picasso wrote: "Je avais été oficiellement invité par Zuloaga . . . mon tableau est resté acroché deux ou trois jours mais après ces jours on me l'a envoyé à Paris."[27]

The International Exhibition of Art, 1907–10

With the seventh *International Exhibition of Art* in 1907, the Venice show affirmed its position as one of the most important events on the European exhibition circuit. It was clear in 1905 that the Venice exhibition owed its success in part to crises in the conservative, official salons of the art capitals of Europe. Only one-off exhibitions, such as the international art exhibition in Mannheim in 1907, could compete with its variety. The works of such official representatives as Léonce Bénédite, the director of the Musée du Luxembourg in Paris, and Hippolyte Fierens-Gevaert, the secretary of the Royal Museum of Fine Arts in Brussels, were shown along with the Hagenbund from Vienna, Frank Brangwyn from London, and the Russian avant-garde group Mir Iskusstva, headed by the impresario Sergei Diaghilev. The most important event of 1907 was the opening of a pavilion for the first time, the Belgian pavilion, designed in an up-to-date Secessionist style with sculptures by Georges Minne and decorative

paintings by Fernand Khnopff (fig. 6). Other examples of modern art included Brangwyn's decorative panels in the British salon (fig. 7). Just as he had done two years previously, Brangwyn chose Venetian scenes to decorate the walls, which were dominated in turn by portraits by John Singer Sargent.

The dissenting voices of conservative critics could not be silenced, however. Lady Layard commented: "I thought most of the works very bad & a terrible impressionist mania now prevails wh[ich] apparently does away with the necessity for correct drawing. The Italian schools were less violently bad—the Russian the most startlingly horrible!"[28] The attacks from critics were indeed harsh; modern artists were referred to as "madmen" on the basis of the lunacy, deceit, and primitivism apparently present in their paintings. The end of the nineteenth century saw a swift succession of avant-garde movements denouncing the bourgeois understanding of art, which expected painters to produce solid, academic, and technically brilliant works. Fradeletto did not ignore this trend entirely, but he remained cautious in his choice of artists for solo shows, favoring those who had already established international reputations before coming to Venice. Lenbach, Rodin, Sargent, Stuck, Zorn, Bernard, Brangwyn, Klimt, and Renoir were, by 1907, undisputed superstars and were thus safely included in the *International Exhibition of Art*.

The most successful of Venice's exhibitions were in the years 1909 and 1910, when more than 450,000 visitors came to see the art in the Giardini.[29] Foreign

Fig. 7
Frank Brangwyn
(British, 1867–1956)
Quayside Porters, Venice,
ca. 1907
Oil on canvas
77½ × 191⅜ in. (197 × 486 cm)
Collection of the Dunedin Public Art
Gallery, New Zealand

Fig. 8
Gustav Klimt
(Austrian, 1862–1918)
Adele Bloch-Bauer I, 1907
Oil, silver, and gold on canvas
54 × 54 in. (138 × 138 cm)
Neue Gallerie, New York
Acquisition made available in part
through the generosity of the
heirs of the Estates of Ferdinand
Bloch-Bauer

Une exposition d'art moderne dans la patrie des Bellini et de Carpaccio, de Tintoret et de Véronèse, de Guardi et de Tiepolo, cela parut une chose impossible ou folle; cela, fit à certains l'effet d'un blasphème. . . . Parmi les étrangers qui de mai à octobre peuplent l'enchanteresse ville, pélerins enthousiastes de son passé et de sa gloire, combien y en aura-t-il pour s'intéresser à une exposition d'art moderne?[30]

The city's exhibition of 1910 is today looked back on as the most avant-garde exhibition before the First World War. On display were works by Gustav Klimt (1862–1918), singular and modern in their incorporation of elements the artist admired in Byzantine mosaic art from Ravenna or Venice. The main painting of the exhibition was Klimt's well-known and very popular portrait of Adele Bloch-Bauer from Vienna (fig. 8). This image of a beautiful young woman on a shining golden background has since become an enigmatic symbol of Klimt's art. For the Venetians in 1910, Klimt was the perfect artist to visit the city: he both admired Venetian art and was already regarded as an international superstar.

In addition to the presence of Klimt, an attack on Venice by the Futurists in 1910 furthered the *International Exhibition of Art's* particular importance that year. In my opinion, however, the event has become somewhat overstated in art-historical accounts; what we know about it is based mainly on Filippo Marinetti's perfect public relations machinery.[31] The "attack" was strategically carried out to accompany Umberto Boccioni's show in Ca' Pesaro (see Nancy Mowll Mathews's essay, fig. 110).[32] On the day the event took place in Venice, the *New York Times* reported on it and wrote that the Venice Biennale "has gradually become one of the most important artistic events in the world" (see Mathews essay, fig. 109).[33] The Futurist attack thus seems to have served only to underline Venice's accepted importance as an art center.

Glorifying the War/Past and the End of a Golden Era, 1912–14

In the thirteen years following Prendergast's first visit to Venice, the city underwent dramatic changes. The years 1909 and 1910 saw the climax of the *International Exhibition of Art* before the outbreak of the First World War. When Prendergast visited Venice for the second time, from August 1911 to January 1912,

journals reported enthusiastically on the show. After the premiere of the first pavilion in 1907, three new pavilions had their début in 1909. One, the Bavarian pavilion, was conceived as an extension of the Ausstellungsgebäude in Munich and contained art brought from the Secession to the lagoon. Another secret of the exhibition's success in these years was its intelligent choice of artists. The Venice Biennale may not have exactly been an avant-garde show, but it certainly did have more modern elements than the anachronistic salons or the official shows held in Berlin, London, and Vienna. The Venice show had the advantage of being run directly by the city and continued to be held under the auspices of shrewd management. Furthermore, the exhibition was known for its variety, with no one group of influential artists being allowed to dominate the show.

Yet even in 1909, the *International Exhibition of Art* was still being compared to the past. Gabriel Mourey wrote in *L'Art et les Artistes*:

Fig. 9
Pieretto Bianco (Italian,
1875–1937)
L'Arsenale, 1912
Oil on panel
258¼ × 141⅜ in. (656 × 359 cm)
Town Hall, Puos d'Alpago,
Veneto, Italy
Photo Credit: Mauro Magliani

there was no exhibition in the Giardini. We simply cannot know whether he ever saw Claude Monet's series or if he was influenced by Walter Sickert's experiences in the years 1903 and 1904, when he created his famous nudes.

It was just after Prendergast's stay that war broke out between Italy and the Ottoman Empire. The most patriotic event of this time was the inauguration of the Campanile di San Marco on April 25, 1912. The installation was seen as a heroic moment for the Italian nation. With the war, Venice once again became an important harbor city for Italy, a role reflected in the decorations and frescoes by Ettore Tito and in the decorative panels in the exhibition hall itself. Growing nationalism in Italy also influenced the Venetians' policy in selecting works for the exhibition of 1912. The central salon was dominated by Pieretto Bianco's series of four paintings, *Il risveglio di Venezia*, which, in *L'Arsenale* (fig. 9), for example, glorified the new naval industry.

It seems rather paradoxical that the last new pavilion built in 1914 was for the Russian Empire. Nevertheless, the critic Selwyn Brinton, writing for *The Studio*, loved the exhibition:

> The Venice Exhibition of this year has two points in its favor, which it is far from easy to combine. It is original, in that it strikes at new paths in art and opens new vistas; and it is at the same time marvelously inclusive—as may be seen from the pretty extensive list that I have here given of all the best progressive elements in modern Italian art.[34]

What Brinton meant exactly by "progressive" is difficult to define from today's point of view, especially since truly progressive art was at the time being shown at quite different exhibitions in Europe and the US.

With the growing success of Italian art, the Venice exhibition became more nationalistic. Just as it had in Berlin or Paris, renewed nationalism now posed a threat to the once celebrated international quality of the exhibition. In cautiously supporting contemporary artists, Fradeletto appears, in hindsight, to have done

an excellent job, especially when compared with the conservative official salons in the European capitals. In a letter to the art critic Ugo Ojetti, in 1911, he wrote: "Tu fai le belle Esposizioni coi morti; io sono condannato a farle, belle o brutte, coi vivi."[35]

Conclusion

When the first *International Exhibition of Art* took place in Venice in 1895, the show's organizers wanted to revitalize the city's art life and inspire its artists by bringing together works by contemporary artists from all over Europe. The shadow of the past still loomed large in the minds of Venetians, however, and people visiting Venice came with no desire to see contemporary art. The inclusion of retrospective exhibitions in 1899 was the key to the *International Exhibition*'s future success. The show's organization remained, after all, flexible and pragmatic. At the helm, Fradeletto attempted to follow the trends of the art capitals of Europe, and although he was often behind the times, on occasion he managed to keep his hand on the pulse of the avant garde. Lawrence Alloway wrote in 1968: "During the period 1895 to 1914 it would be unreasonable to expect 'peripheral' Italy, not yet accustomed to French Impressionism, to show German Expressionists and French Cubists."[36] As I have shown, conservative tastes, an aversion to modern art in Venice, and even the past itself were strong forces that at times hindered the overall success of the exhibition. But despite these problems, the city of Venice initiated its own secession by creating the exhibitions in Ca' Pesaro in 1908, curated by the young Nino Barbantini. By choosing to exhibit young Italian artists at his shows, Barbantini proved to be clearly opposed to many of Fradeletto's decisions.

To judge the *International Exhibition of Art* from today's point of view is to misunderstand the exhibition's beginnings. One would think that a show devoted to Degas in 1899–1901 or to Picasso in 1905 would have been appropriate for Venice. There is no reason, however, to expect Venice to have shown artists who still remained unpopular even in Paris, the very art capital of Europe itself. In addition, most of the French artists of the modern movement worked exclusively with such private dealers as Paul Durand-Ruel or Ambroise Vollard. They had no interest in sending paintings to the commercial exhibition in Venice. Their clients lived in Paris or Berlin and did not overlap with the crowds that traveled to Venice at the turn of the century in search of the past.

But, as we have seen, there were many possibilities for avant-garde exhibitions. Many secessions were well represented in Venice. Furthermore, Fradeletto was very well informed about the artistic movements of his day; when he organized an international conference in 1905, the conference committee included what were then the most important names in the European arts.[37] But Fradeletto worked primarily for his clientele, who would surely have been shocked at the sight of an early Picasso. Yet I am sure that if Picasso had painted a gondolier, Fradeletto would also have been more accepting of his art:

> Après cette longue promenade à travers l'art contemporain, on n'a qu'un pas à faire pour découvrir, à travers les arbres, le miroitement nacré de la lagune, les sourires du ciel, la beauté des palais de marbre, là-bas, sur le quai blanc au ras de l'eau, et la floraison des Domes et des campaniles dans la lumière . . . et cela est délicieux.[38]

Notes

1 Alan Chong, "Artistic Life in Venice," in *Gondola Days: Isabella Stewart Gardner and the Palazzo Barbaro Circle*, ed. Elizabeth Anne McCauley *et al.*, Boston (Isabella Stewart Gardner Museum) 2004, pp. 87–128.

2 Ashton Rollins Willard, "Venice," in *History of Modern Italian Art*, London (Longmans Green) 1902, pp. 279–86; Jarno Jessen, "Neu-Venetianische Malerei," *Moderne Kunst*, 16, 1901–02, pp. 233–34.

3 "Among all Venetians there is not one Impressionist; follies of the vulgar kind, which we see here and there in the exhibition, are quite unthinkable for them." August Wolf, "Die nationale Kunstausstellung in Venedig," *Kunstchronik*, 22, June 2, 1887, p. 553; author's translation.

4 Pompeo Molmenti, *Giacomo Favretto*, Rome (Malcotti) 1895.

5 See *José Villegas Cordero*, exhib. cat., Seville, Museo de Bellas Artes; Cordoba, Sala de Exposiciones Museísticas CajaSur, 2001. Villegas became very popular at the end of the nineteenth century through his many paintings on Venetian subjects.

6 "This is what the Venetian public clamor most for; it's flesh of their flesh, and they relate to him and enjoy his pictures completely." August Wolf, "Erste Internationale Kunstausstellung in Venedig, II," *Kunstchronik*, n.s., 6, July 25, 1895, p. 497; author's translation.

7 See *Mostra Tiepolesca*, exhib. cat., Venice, Palazzo Ducale, 1897.

8 "With great dispensation an exhibition of modern art is opening to enhance the appeal of this most unique city. Indeed, Venice is and deserves to be a permanent exhibition; age-old beauty is more fascinating than modern paintings." Pompeo Molmenti, *Venezia: nuovi studi di storia e d'arte*, Florence (Barbera) 1897, p. 24; author's translation.

9 Ivana Mononi, *L'orientamento del gusto attraverso le Biennali*, Milan (Edition La Rete) 1957.

10 Margherita Grassini Sarfatti, "Venice," *The Studio*, 11, July 1897, pp. 128–30.

11 Enid Layard, diary, September 26, 1897. Lady Layard's journals (Manuscript Collection, British Library) have been transcribed and made available in electronic form at the Armstrong Browning Library, Baylor University, Waco, Texas; browningguide.org/browningcircle.htm, accessed September 2008. For more on the art from Glasgow, see Roger Billcliffe, *The Glasgow Boys: The Glasgow School of Painting, 1875–1895*, London (John Murray) 1985.

12 "[There are] such a number of Impressionist works and of such important character that the visitors to this second Venetian exhibition could finally formulate a clear and exact idea of the daring innovations of this so much discussed and embattled group of painters. Disgracefully, however, this group is represented by only four small canvases of secondary importance, and from this it is not certain that one can consciously judge one of the most interesting efforts of pictorial renovation of our time."

Vittorio Pica, "I pittori francesi," in *L'arte mondiale a Venezia*, Naples (L. Pierro) 1897, p. 127; author's translation. The paintings shown in 1897 were *La Veduta di Ventimiglia* and *Paessaggio di Primavera* by Claude Monet, and *Place de la Concorde* and *Place Saint-Michel* by Jean-François Raffaelli.

13 At the third *International Exhibition of Art* in 1899, the following American artists exhibited their work: Edwin Austin Abbey, Eugene Benson, George Henry Boughton, Alexander Harrison, John MacLure Hamilton, Gari Melchers, Henry Muhrman, Isabel M. Ross, Julius Stewart, Elizabeth R. Taylor, and James McNeill Whistler. See *Terza esposizione internazionale d'arte della citta di Venezia 1899*, Venice (Carlo Ferrari) 1899, pp. 51–53.

14 F.M.P., "Venice Art Exhibition; The Beautiful City Prepares for the Third International Event," *New York Times*, March 5, 1899, p. 7.

15 *Ibid.*

16 Gilberto Secretant, "La sala Favretto alla III. Esposizione Internazionale di Belle Arti a Venezia," *L'Illustrazione Italiana*, September 14, 1899.

17 Layard, diary, April 25, 1899.

18 *Ibid.*, September 15, 1899.

19 "[It] ranked as one of the finest that this reporter has ever seen, both at home and abroad." Karl Voll, "Die III. Internationale Kunstausstellung in Venedig," *Die Kunst für Alle*, 17, June 1, 1899, p. 279; author's translation.

20 "Beautiful Postal Cards," *New York Times*, September 10, 1899, p. 19.

21 August Wolf, "Die vierte internationale Kunstausstellung in Venedig," *Kunstchronik*, 12, May 17, 1901, p. 387.

22 Layard, diary, October 6, 1903.

23 "a good feel for the various movements and motives of modern art as well as the calm pleasure of seeing selected pieces of art, without one necessarily having to sacrifice one's reason to them and having to go through the torture, nowadays so often demanded of the good-natured viewer, of having to pay homage to the experiments and curiosities which apparently seem to give exceptionally gifted aesthetes such satisfaction." Wolfgang von Oettingen, "Die fünfte Venezianer Kunstausstellung," *Die Kunst für Alle*, 18, August 15, 1903, p. 525; author's translation.

24 G. Gr., "Die sechste internationale Kunstausstellung in Venedig," *Kunst und Künstler*, 4, November 6, 1905, p. 90.

25 Gustave Soulier, "Les peintres de Venise," *L'Art Décoratif*, 7, January 1905, pp. 1–64.

26 "This exhibition in Venice has become one the most active and important artistic events in Europe. It is important to add that it is also a great contemporary art market, for the number of transactions is not far from reaching half a million." Gustave Soulier, "La sixième exposition internationale de Venise," *Art et Décoration*, November 1905, pp. 2–3; author's translation.

27 "I was officially invited by Zuloaga . . . my painting hung for two or three days, but after that they sent it back to me in

Paris." Letter from Picasso to Ardengo Soffici, June 24, 1909, in Jean-François Rodriguez, *Picasso alla Biennale di Venezia, 1905–1948*, Padua (CLEUP) 1997, p. 15; author's translation.

28 Layard, diary, June 26, 1907.

29 Gabriel Mourey, "La VIIIe Exposition Internationale de enise," *L'Art et les Artistes*, 9, 1909, pp. 161–83. The *International Exhibition of Art* did not take place in 1911 because a huge international art exhibition was held in Rome in the same year to celebrate the fiftieth anniversary of the unification of Italy in 1861.

30 "An exhibition of modern art in the homeland of the Bellinis and Carpaccio, of Tintoretto and Veronese, of Guardi and Tiepolo, that seems an impossible or mad thing; it creates for some the effect of blasphemy. . . . Among the foreigners who from May to October populate this enchanting city, pilgrims enthused by its past and glory, will there be a way to interest them in an exhibition of modern art?" Mourey, "La VIIIe Exposition Internationale de Venise," pp. 161–83; author's translation.

31 Willard Bohn, *The Other Futurist: Futurist Activity in Venice, Padua, and Verona*, Toronto, Buffalo, and London (Toronto University Press) 2004.

32 August Wolf, "Permanente Ausstellung im Palazzo Pesaro," *Kunstchronik*, 21, August 26, 1910, pp. 594–95.

33 "'Futurists' Desire to Destroy Venice," *New York Times*, July 24, 1910, p. C2.

34 Selwyn Brinton, "Venice," *The Studio*, 62, July 1914, p. 252.

35 "While you're busy doing nice exhibitions with dead artists, I am doomed to do them, nice or bad, with the living." Antonio Fradeletto to Ugo Ojetti, October 14, 1911, Galleria Nazionale d'Arte Moderna, Rome, Fondo Ojetti, cass. 32 (I); author's translation.

36 Lawrence Alloway, *The Venice Biennale 1895–1968: From Salon to Goldfish Bowl*, Greenwich, Conn. (New York Graphic Society) 1968, p. 47.

37 Invitation in English to the International Art Congress, September 21–28, 1905, Archivio Municipale di Venezia, 1905–09, VII.10.15. Members included Alfred Lichtwark (Hamburg), Hugo von Tschudi (Berlin), Georges Berger (Paris), Robert de la Sizeranne (Paris), and Roger Marx (Paris).

38 "After this long promenade across contemporary art, one has only to take a single step to discover, through the trees, the pearly sparkle of the lagoon, the smiles of the sky, the beauty of the marble palaces, there, on the white pier on the brim of the water, and the flowering of the domes and bell towers in the light . . . and that is delicious." Mourey, "La VIIIe Exposition Internationale de Venise," p. 183; author's translation.

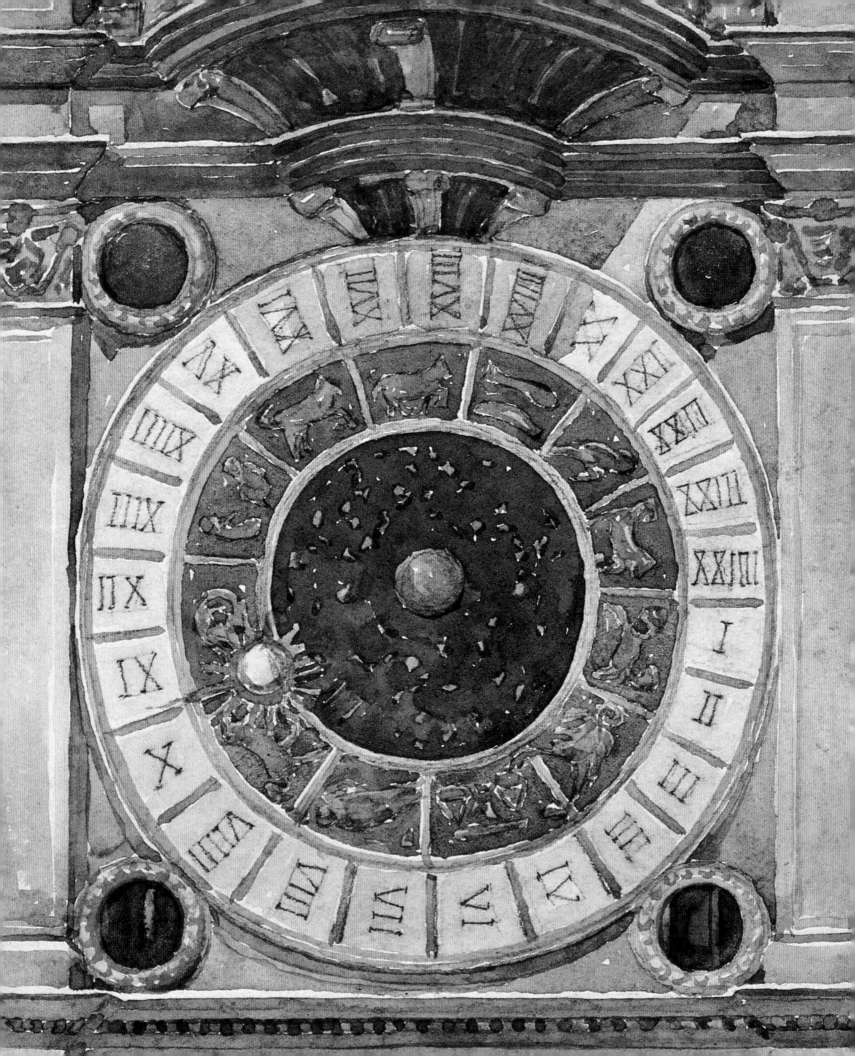

Marking Time in Venice

Carol Clark

When Maurice Prendergast returned to Venice in 1911, he described a city transformed since his first visit. Although he identified himself as a tourist—someone who was "taking in all the sights"—he was wary of what he saw. "It is the same Venice," he wrote to a friend in Boston, "but it does not seem to have the attraction for me [that it did] when I was here ten years ago." One source of Prendergast's disappointment was the degradation of the buildings he observed from Casa Frollo, his pensione on the Giudecca: "mostly all the surrounding palaces are turned into coal yards and manufactories," he wrote. He expressed resignation at the loss of an older Venice—a loss epitomized by the reproduction that replaced St. Mark's bell tower, which had collapsed in an immense, if tidy, pile of brick and stone on July 14, 1902. Noting that the structure was "up again still surrounded in some parts by scaffolding," Prendergast concluded that "what I see of it looks awfully new." New, too, were the habits of women in the "fashionable crowd." At Caffè Florian, he saw such women wearing "black hats as big as parasols"; in measured words that withheld judgment, he observed that "smoking cigaretts [*sic*] seems to be on the increase among them."[1]

Change was brewing in the fabric of the city and in the customs of its denizens, but Prendergast too had changed. In the dozen years since his only other visit to Italy, he had progressed from a promising Boston watercolorist to a nationally recognized artist associated with a leading group of New York painters. The turning point of his early career was a solo exhibition in 1900 at the gallery of William Macbeth in New York. The show highlighted his Italian watercolors of 1898–99. In 1911, Prendergast might have enjoyed a triumphant return to the site of inspiration for his past success. Instead,

his second trip was another kind of turning point. After falling ill two months into his stay in Venice, he underwent prostate surgery and endured a difficult recovery. He emerged from the ordeal, however, motivated by nature and by Italian Old Master paintings to a renewed artistic commitment. This essay focuses on Prendergast's experience of time closing in and on his search for inspiration in gardens and in books while he recuperated in Venice.

In December 1911, on the eve of his departure from Venice, Prendergast sounded relieved to put the experience behind him. "All the same with all its beauty," he wrote, "I'm never going to do my best work here. Boston for mine with its surrounding green hills."[2] He had come to this realization by looking past Venetian architecture and beyond the women on St. Mark's Square to notice the city's natural setting. "I am commencing," he wrote to his brother, Charles, "to like Venice immensely[;] the winter is so different and the color seems to get richer and deeper and on clear days you can see the surrounding Mountains covered with snow."[3]

Prendergast's words articulate a process of slowing down and seeing past and more deeply into his immediate surroundings, something his illness forced him to do. Surgery and recovery also compelled him to face his own mortality. He wrote to Charles that his doctor "said I was a tough beggar to kill."[4] Responding soon after to an offer of help from a "Mlle. Thevin" with making travel arrangements to go home, he replied: "I am glad her letter did not arrive when I thought I was going to die for I would have requested her to look after my remains and have them cremated."[5] By casting his ordeal into a darkly humorous narrative, Prendergast masked the memory of real fear.

Fig. 1
Giacomo Brogi (Italian, 1822–1881)
Clock Tower, Venice, ca. 1900
Albumen photographic print
6¼ × 7⅞ in. (16 × 20 cm)
Archivi Alinari, Florence

The passage of time was on Prendergast's mind before his illness. The clock tower was among the Venetian buildings and bridges that he painted in 1898–99 and returned to in 1911 (fig. 1). In both of the two watercolors he devoted to the subject (figs. 2, 3), he extracted the building's central bay. By doing so, he constructed an image of dense, colorful patterns in an exaggerated vertical format. His decision also focuses the viewer's thoughts on the building as time-keeper and passageway: beneath the clock, an arch opens to shelter the entrance to the Merceria, the central artery between St. Mark's and the Rialto. Passing through the clock tower is thus equated with passing through time. Time is marked here with a magnificent structure: a hand in the form of a sunburst points to the hour, the dominant sign of the zodiac, and the current phase of the moon, all within an elaborately decorated concentric circle. The clock tower also layers civic power and religion between expressions of time: the city is present in the form of the symbol of its patron saint, the winged lion; and above the face of the clock is a statue of the Virgin and Child flanked by a mid-nineteenth-century "digital" display of time. From the summit, bronze giants sound the passage of time by striking an immense bell. In each watercolor, Prendergast captured and reframed the tower's central bay, the most expressive fragment of a building that embodied the complexities of the passage of time.

In the fall of 1911, while Prendergast painted this spectacular symbol of the public proclamation of time, he privately pondered how he would spend the time that was slowly expanding as he recovered from his brush with mortality. Perhaps on the recommendation of other international visitors, he chose to recuperate from surgery at the Cosmopolitan Hospital. Founded by Lady Enid Layard (widow of the diplomat, collector, and archeologist Sir Henry Layard), the hospital occupied a quiet spot on the Giudecca that she and other members of the Anglo-Venetian community had shaped for physical and emotional healing (figs. 4, 5). Describing the hospital in a letter to Charles, Prendergast identified one of the wonders of Venice: unprepossessing exteriors that mask extraordinary interiors. "You would be surprised if you visit this place," he wrote. "You go up an old alley way[,] open the street door of [a] dingy looking house and find oneself in spacious rooms surrounding a fine garden."[8]

Prendergast's fear was not, I believe, occasioned by the surgery he had in Venice to remove a prostate tumor, or even the prospect of a second operation. It was instead the expression of a broader anxiety about his future. The dozen letters he wrote to Charles from Venice are filled with longing for his brother's company: he told Charles that letters from him were his "only consolation"[6] and that he yearned to resume the artistic life they shared, remembering that "we together were such a fine team."[7] His choice of the past tense turned nostalgia into uncertainty about the future.

Fig. 2
Maurice Prendergast
*St. Mark's Square, Venice
(The Clock Tower)*, ca. 1898–99
Watercolor and graphite on paper
23⅞ × 6⅛ in. (60.6 × 15.6 cm)
Farnsworth Art Museum,
Rockland, Maine
Museum Purchase, 1944; 44.316
Photo Credit: Melville D. McLean
CR 687

Fig. 3
Maurice Prendergast
*Clocktower, St. Mark's Square,
Venice*, 1911
Watercolor and pencil on paper
22⁷⁄₁₆ × 6⁷⁄₁₆ in. (57 × 15.4 cm)
Iris & B. Gerald Cantor Center
for Visual Arts at Stanford University,
Palo Alto, California
Gift of Janet Churchill Green, 1984.88
CR 1011

The rarity of a garden in Venice is a well-worn story, best told by Henry James. There is no evidence that Prendergast had read James's *The Aspern Papers* (1888), but he would no doubt have appreciated the narrator's ingratiating invocation of desire for the "idea of a garden in the middle of the sea."[9]

The Cosmopolitan Hospital's garden was the first of two that Prendergast frequented in the autumn of 1911. "Opposite the canal," he wrote to Charles, "is a huge brick [wall] running for a half mile and on the side is a lovely garden with a green field where I go and sit on a sunny afternoon."[10] Prendergast had discovered a private garden, to which its owners, appropriately named Eden, admitted visitors (figs. 6, 7). Like the hospital, this garden was the creation of members of the Anglo-Venetian community. Caroline and Frederic Eden had transformed a large plot of tangled overgrowth purchased in 1884 into a series of formal and informal gardens, which included flowers, vegetables, and even a herd of cows. There, Frederic Eden sought relief from his own maladies, which he identified as physical and spiritual. In the book that he published on his garden in 1903 (fig. 8), Eden explained the relief from Venice that a garden offered, not surprisingly summoning the biblical Fall:

Adam and Eve, I fancy, were perfectly sick of Paradise before they sinned to leave it. . . . One's eyes got satiated with the very beauty of palace and church, of sky and sea, and my nerves ajar with the perfection of repose, broke out one afternoon more lovely than its fellows, and said, "I'm sick of all this water . . . I thirst for dry land and green trees and shrubs, and flowers; a garden."[11]

Fig. 4
Map of Venice
From Karl Baedeker, *Italy from the Alps to Naples*, 2nd edn, Leipzig (Karl Baedeker) 1909
Prendergast Archive and Study Center, Williams College Museum of Art, Williamstown, Massachusetts
Photo Credit: Arthur Evans

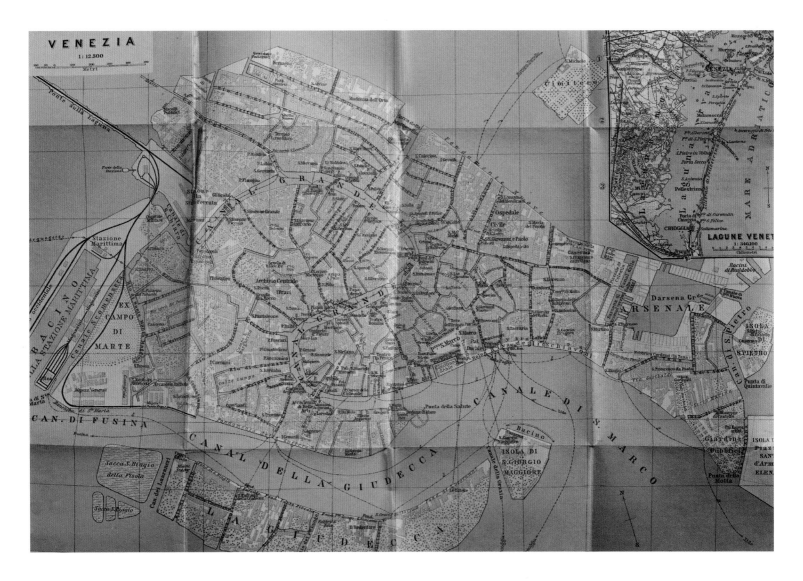

Fig. 5
"Ospedale Cosmopolitano:
The English Hospital on the
Giudecca (Rio S. Croce)"
From Lonsdale Ragg and
Laura M. Ragg, *Things Seen in
Venice*, New York (E.P. Dutton)
1912, opposite p. 149
Private Collection
Photo Credit: Stephen Petegorsky

Fig. 6
"Our Fondamenta and
the Rio della Croce"
From Frederic Eden,
A Garden in Venice, London
(Country Life) 1903,
opposite p. 46
W.E.B. DuBois Library, University
of Massachusetts, Amherst
Photo Credit: Stephen Petegorsky

Fig. 7
"An Open Spot"
From Frederic Eden,
A Garden in Venice, London
(Country Life) 1903,
opposite p. 56
W.E.B. DuBois Library, University
of Massachusetts, Amherst
Photo Credit: Stephen Petegorsky

Fig. 8
Frontispiece ("The Cortile")
and title page
From Frederic Eden,
A Garden in Venice, London
(Country Life) 1903
W.E.B. DuBois Library, University
of Massachusetts, Amherst
Photo Credit: Stephen Petegorsky

A similar sense of relief may have inspired Prendergast's renewed interest in painting. These two Venetian gardens certainly smoothed Prendergast's recovery and, I believe, sparked his new appreciation of the city's natural surroundings.

The balm of a garden in a water-bound city was part of the process of restoration that enabled Prendergast to return to work. He wrote to Charles of his "delight" at being "able to go to my trunks again[,] rummage about them and look at the water colors,"[12] undoubtedly referring to work he had begun in Venice before he fell ill. Relieved to have the two months of illness behind him, he reconnected with other artists and settled into a pensione, from which he wrote to Charles that "getting out of the hospital the artist awakes at once."[13]

Although he was "keen about getting a hold of my water colors again for I would like to finish some of them while I am here,"[14] Prendergast also started something new by painting scenes glimpsed from a pensione he called "Casa Festari."[15] Its address and the views he painted from his corner room identify it as Pensione Seguso in Campiello della Calcina. Perhaps the reasonable rates drew him there, but it is as likely that he relished the pensione's situation, for it suited

his new perceptions of Venice. From his window and from the campiello below, he constructed at least five freshly observed views. Four of them feature Ponte Calcina gracefully arching over the side canal, Rio San Vio, and set against the horizon formed by buildings along the Giudecca. Three include the walled garden along the quay of Rio San Vio. The most fully developed of these watercolors articulates Prendergast's new understanding of the city. In *Venice* (fig. 9), he complemented the visual pleasure of a garden with an open view across the water, all bound into the fabric of buildings and of bridges over which pedestrians pass. In these works and in letters home, Prendergast expressed his transformation from the world-weary tourist he appeared to be two months earlier. At that time, he wrote to a Boston friend that he would "probably" stay in Venice to "have another w[h]ack at the canals,"[16] his American vernacular articulating the boredom captured by Frederic Eden in the phrase "perfectly sick of paradise." Both men recovered from their tedium by seeking inspiration in a garden.

Prendergast's "artist" was reawakened not only in Eden's garden but also through his contact with others. Social interaction with patrons of the Cosmopolitan

Hospital also advanced his recovery. Lady Layard, a leader of the diminishing group of aging English expatriates in Venice, founded the hospital as part of the charitable work she undertook there and in her home in London. In 1903, she rented, and two years later purchased, property with a building that was formerly a summer villa on the Giudecca. She carried out plans to admit British sailors and other foreign visitors who fell ill while in Venice, and she made the hospital a focus of Anglo-Venetian philanthropy in the early years of the twentieth century. The hospital housed and tended patients for a small fee, which Prendergast recorded at 5 lire a day—even less than he would have paid for a room at a modest Venetian pensione.[17] In many ways, the Cosmopolitan Hospital was like a pensione, and homier than its name suggests.

The atmosphere that Lady Layard cultivated at the hospital included persuading her friends to visit and entertain its patients. Such diversion turned out to be a benefit that Prendergast enjoyed. He wrote to Charles that he took pleasure in playing cards with "some of the women visitors that drop in."[18] Probably referring to employees as well as patrons of the hospital, he expressed gratitude to "the women here . . . who know all about sickness and misery."[19] Socializing was, however, far from easy for the almost deaf artist; he admitted frustration at the afternoon teas he felt obliged to attend. The teas "are charming," he wrote, "but I find them a great Nuisance. I have to shake hands with many people and I can't hear a word they say."[20] He was able to hear enough, however, to describe his interaction with members of the Anglo-Venetian community who made the hospital part of

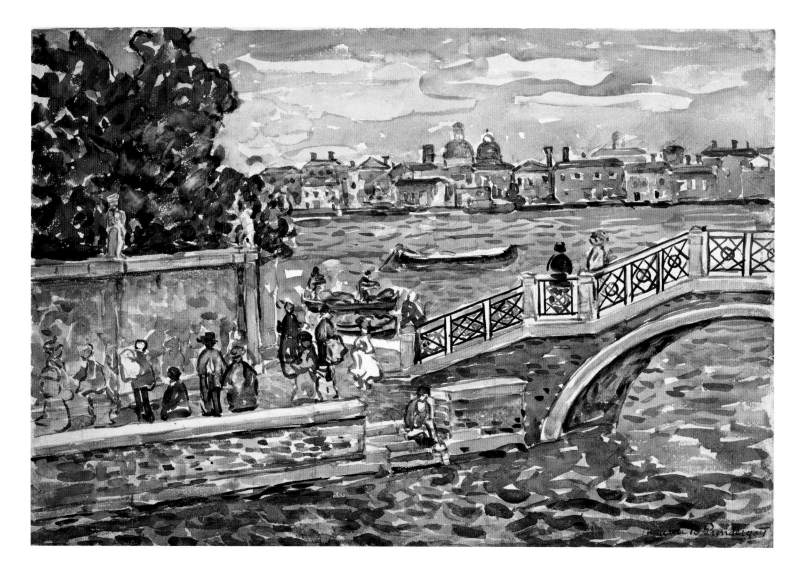

their social lives. In particular, he boasted to Charles that he was "getting well acquainted" with Lady Layard, adding that "she is a very interesting woman about 65 years old and must have been fine when she was young."[21]

Prendergast's name does not appear in Lady Layard's extensive journals,[22] and his letters are the only evidence of their encounter. Prendergast reported that Lady Layard invited him to travel across Venice in the company of Edith Chaffey, the Cosmopolitan Hospital's matron, to see the collection the Layards had assembled at Ca' Capello.[23] Perhaps he made the short trip in Lady Layard's gondola, which she made available to guests, sometimes including the hospital's patients. Prendergast noted that he had been "out in the Gondola" more than once, although he did not specify his destinations.[24] If Prendergast visited Ca' Capello, he would have seen a celebrated collection of Italian paintings in private hands.

Works of Italian Renaissance art were on Prendergast's mind during his stay at the Cosmopolitan Hospital. Whether or not he supplemented his experiences at the Accademia with a look at the Layard collection, he immersed himself in books that reproduced Italian Old Master paintings. In early 1912, after he had returned to Boston, he reflected on the literary side of his residence at the hospital: "The two months rest I had laying in bed reading books and newspapers seems to have done me a lot of good . . . I have accumulated some fine ideas studying the Giotto's [sic] and the school of Ferrara painting."[25] A few months earlier, he had declared Italy to be "the place for Ideas."[26] I believe he had time to contemplate such ideas during the period of quiet that his recovery demanded, despite the fact that, as he described it, "my sketching experience this time has been disastrous."[27] Lady Layard may have made available to hospital residents the two recently published books that Prendergast mentioned, but the artist later owned at least one of them.[28] Perhaps he bought the volume in Venice on one of the many shopping excursions he took both before and after his stay at the Cosmopolitan Hospital.

Picture frames and portable architectural fragments lured Prendergast into the city's shops. He was on the look-out for frames that he and Charles might "invest in" for their shared business,[29] and he sought out marble fountains and garden seats to acquire for patrons in Boston.[30] He was a savvy buyer, bargaining and planning for the future. He wrote to Charles, for example, that "to keep in touch with a frame man here would be a good speculation," and that "I may buy a trunk and bring some [frames] home myself" because they "would sell at a good price."[31]

Prendergast thought beyond the business of reselling frames and fragments, however, in his search for objects of more personal meaning. As soon as he was able to leave the hospital and walk around the city, he headed through the clock tower to shop in the Merceria, where he admired and planned to buy for Charles "one or two fat silk [neck]ties."[32] Despite Prendergast's expression of distaste for the "booths . . . selling a lot of trash and people rushing headlong to buy" at Christmas time,[33] he was an eager shopper, who, sounding as though he coveted it, revealed to Charles that he had "bought one of those little watches already."[34] Time, in the form of a personal watch or a public clock, was on his mind.

Prendergast was also concerned with summing up time in another form: that of a souvenir. The letter in which he mentioned this object is primarily forward-looking: he anticipated "the first exhibition of mine with collected canvases" at New York's Cosmopolitan Club.[35] If the upcoming show represented the future, Venice was the past—an experience that he put behind him, or, more concretely, that he absorbed into a souvenir that he gave away. Any souvenir authenticates the experience it symbolically represents. As the poet and cultural critic Susan Stewart noted, a souvenir "moves history into private time."[36] Prendergast wrote that he had tried to get a "real" seahorse, "which the attendants sell to the bathers at the Lido," but, because "it was late in the season," he could acquire only a brass replica. Yet, in the end, he proclaimed the simulacrum to be better than the object it represented: "I think [it] is much handsomer," he wrote to his intended recipient, "and will last longer."[37] The brass seahorse, then, is like a work of art: experience transformed into something palpable to show, to sell, or to give away. When Prendergast gave the souvenir brass seahorse to his friend, he effectively encapsulated and brought to a close his encounter with Venice.

Notes

1 Maurice Prendergast to Esther Baldwin Williams, September 15, 1911, Esther Baldwin Williams Papers, Archives of American Art, Smithsonian Institution, Washington, D.C. (hereafter AAA).

2 M. Prendergast to Williams, December 18, 1911, AAA.

3 M. Prendergast to Charles Prendergast, December 14, 1911, Prendergast Archive and Study Center, Williams College Museum of Art, Williamstown, Massachusetts (hereafter WCMA).

4 M. Prendergast to C. Prendergast, November 28, 1911, WCMA.

5 M. Prendergast to Williams, December 18, 1911, AAA.

6 M. Prendergast to C. Prendergast, November 9, 1911, WCMA.

7 M. Prendergast to C. Prendergast, November 13, 1911, WCMA.

8 M. Prendergast to C. Prendergast, November 18, 1911, WCMA.

9 Henry James, *The Aspern Papers; Louisa Pallant; The Modern Warning*, London and New York (Macmillan) 1888, p. 24.

10 M. Prendergast to C. Prendergast, November 18, 1911, WCMA.

11 F. Eden, *A Garden in Venice*, London (Country Life) 1903, pp. 12–13.

12 M. Prendergast to C. Prendergast, November 18, 1911, WCMA.

13 M. Prendergast to C. Prendergast, December 14, 1911, WCMA.

14 M. Prendergast to C. Prendergast, November 26, 1911, WCMA.

15 M. Prendergast to C. Prendergast, December 14, 1911, WCMA.

16 M. Prendergast to Williams, September 15, 1911, AAA.

17 M. Prendergast to C. Prendergast, November 11, 1911, WCMA; Karl Baedeker, *Italy from the Alps to Naples*, 2nd edn, Leipzig (Karl Baedeker) 1909, p. 69.

18 M. Prendergast to C. Prendergast, November 18, 1911, WCMA.

19 M. Prendergast to C. Prendergast, November 11, 1911, WCMA.

20 M. Prendergast to C. Prendergast, November 26, 1911, WCMA.

21 M. Prendergast to C. Prendergast, November 22, 1911, WCMA.

22 See Jan Andreas May's essay, n. 11.

23 M. Prendergast to C. Prendergast, November 26, 1911, WCMA.

24 M. Prendergast to C. Prendergast, November 18, 1911, WCMA.

25 M. Prendergast to Williams, March 8, 1912, AAA.

26 M. Prendergast to C. Prendergast, November 26, 1911, WCMA.

27 M. Prendergast to Williams, December 18, 1911, AAA.

28 Henry Thode, *Giotto*, Bielefeld and Leipzig (Verlag von Velhagen und Klasing) 1910, is in the Prendergasts' library now at the WCMA. The second book to which Prendergast referred is probably Edmund G. Gardner, *The Painters of the School of Ferrara*, London (Duckworth) 1911, which he also cited in a sketchbook of about 1911–12 (CR 1498; see p. 181).

29 M. Prendergast to C. Prendergast, December 5, 1911, WCMA.

30 M. Prendergast to C. Prendergast, November 6, 1911, December 8 and 14, 1911, WCMA.

31 M. Prendergast to C. Prendergast, November 26, 1911, WCMA.

32 M. Prendergast to C. Prendergast, November 22, 1911, WCMA.

33 M. Prendergast to C. Prendergast, December 23, 1911, WCMA.

34 M. Prendergast to C. Prendergast, December 14, 1911, WCMA.

35 M. Prendergast to Williams, April 4, 1912, AAA.

36 Susan Stewart, *On Longing: Narratives of the Miniature, the Gigantic, the Souvenir, the Collection*, Baltimore (Johns Hopkins University Press) 1984, p. 138.

37 M. Prendergast to Williams, April 4, 1912, AAA.

CHECKLIST OF ITALIAN WORKS

The following list includes all the works by Maurice Prendergast that are known to have been created in Italy or based on work created in Italy during his two trips in 1898–99 and 1911. The list serves to update the information published about the Italian works in *Maurice Brazil Prendergast; Charles Prendergast: A Catalogue Raisonné*, Williamstown, Mass., and Munich (Williams College Museum of Art and Prestel) 1990. Thus, many conventions established for the catalogue raisonné have been followed here, including the numbering; the separation of media into oils, watercolors, drawings, sketchbooks, and monotypes; the inclusion of alternate titles; the use of "circa" dates; and the identification of sites. Double-sided works have been noted, and both recto and verso illustrated whenever possible. Some pencil sketches that appear as versos have proved to be too light to reproduce. When recto and verso are both Italian but of different dates or subject matter, they appear in the checklist twice so that each side may be seen in its proper stylistic context. Sketchbooks are briefly described, with Prendergast's inscriptions shown in italics, and some of their pages appear as figures illustrating the essays in this volume. The complete contents of the sketchbooks may be consulted on microfilm through the Archives of American Art of the Smithsonian Institution, Washington, D.C.

The location of works being shown as part of the exhibition is indicated at the end of each caption, as follows:

[A] Williams College Museum of Art, Williamstown, Massachusetts
[B] Peggy Guggenheim Collection, Venice
[C] The Museum of Fine Arts, Houston, Texas

OILS

30 (recto) (see p. 113)
Well, Venice, ca. 1898–99
Oil on panel
10½ × 13¾ in.
(26.7 × 34.9 cm)
London Family Collection

Cf. related monotype
Venetian Well (CR 1704).

30 (verso)
Sketches of head and pipe
Pencil
[ABC]

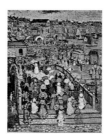

392
Ponte della Paglia,
ca. 1907–10;
repainted 1914–15
Oil on canvas
27⅞ × 23⅛ in.
(70.8 × 58.7 cm)
The Phillips Collection,
Washington, D.C.
Acquired 1922

WATERCOLORS

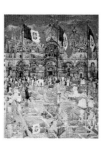

674 (see p. 33)
*Splash of Sunshine
and Rain,* 1899
Watercolor and pencil on paper
19⅜ × 14¼ in.
(49.2 × 36.2 cm)
Private Collection
Courtesy of Avery Galleries,
Bryn Mawr, Pennsylvania
[ABC]

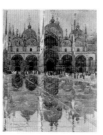

675
St. Mark's, Venice, 1898
Watercolor and pencil on paper
14⅞ × 11¾ in.
(37.8 × 29.8 cm), sight
Private Collection

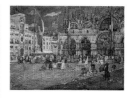

676 (see p. 35)
St. Mark's, Venice, 1898
(*The Piazza San Marco*)
Watercolor over graphite
on paper
14⅛ × 19⁷⁄₁₆ (35.9 × 49.4 cm)
National Gallery of Art,
Washington, D.C.
Gift of Eugenie Prendergast
(1984.63.1)
Image courtesy of the Board
of Trustees, National Gallery
of Art, Washington, D.C.
[A]

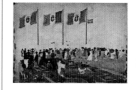

677 (see p. 37)
Piazza S. Marco, Venice,
ca. 1898–99
(*Piazza S. Marco, Venice:
Acqua Alta*)
Watercolor and pencil on paper
13⅛ × 19½ in.
(33.3 × 49.5 cm)
Collection of Roy and Cecily
Langdale Davis
[ABC]

1023 (verso) (see p. 37)
Flags in Piazza San Marco,
ca. 1898
Watercolor and pencil on paper
19¾ × 12½ in.
(48.9 × 31.7 cm)
Williams College Museum
of Art, Williamstown,
Massachusetts
Gift of Mrs. Charles
Prendergast (91.28.6)

1023 (recto)
Venice: The Zattere,
ca. 1911–12
Watercolor and pencil
[ABC]

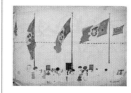

678 (recto) (see p. 34)
Venice, ca. 1898–99
Watercolor and pencil on paper
14⅛ × 20¾ in.
(35.9 × 52.7 cm)
Williams College Museum
of Art, Williamstown,
Massachusetts
Gift of Mrs. Charles
Prendergast (86.18.61)

View of the flags in front
of St. Mark's.

678 (verso)
Nude Bathers in a Landscape, ca. 1913–15
Pencil
[ABC]

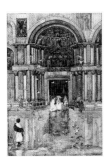

679 (see p. 43)
The Porch with the Old Mosaics, St. Mark's, Venice, ca. 1898–99
Watercolor and pencil on paper
16 × 11¼ in.
(40.6 × 28.6 cm)
Private Collection, St. Louis
[AC]

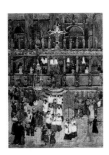

680 (see p. 43)
Easter Procession, St. Mark's, ca. 1898–99
Watercolor and pencil on paper
18 × 14 in.
(45.7 × 35.6 cm), sight
Collection of Joyce and Erving Wolf, New York City

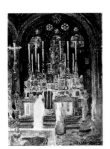

681
Interior of St. Marks, ca. 1898–99
Watercolor on paper
15 × 11 in. (38.1 × 27.9 cm)
Last known in Christie's sale, May 23, 1990
Photograph courtesy of Christie's Images

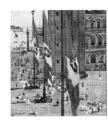

682 (see p. 36)
Piazza di San Marco, ca. 1898–99
Watercolor and graphite on off-white wove paper
16¹¹⁄₁₆ × 15⅜ in.
(42.4 × 39.1 cm)
The Metropolitan Museum of Art, New York
Gift of Estate of Mrs. Edward Robinson, 1952 (52.126.6)
Image © The Metropolitan Museum of Art, New York

View of the flags in St. Mark's Square and the campanile from the clock tower.
[C]

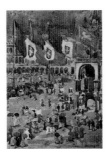

683
Piazza di San Marco, Venice, ca. 1898–99
Watercolor and pencil on paper
13¾ × 10 in.
(34.9 × 25.4 cm)
Collection of Jeptha H. Wade when destroyed in house fire, April 1929
Photograph courtesy of the Cleveland Museum of Art

View from the central balcony of the Doge's Palace.

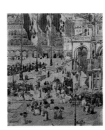

684 (see p. 32)
Piazza of St. Mark's, ca. 1898–99
Watercolor and pencil on paper
16⅛ × 14⅛ in. (41 × 36 cm)
Private Collection, New York

View from the central balcony of the Doge's Palace.
[A]

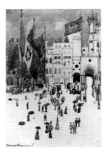

685
Flags in the Piazza San Marco, ca. 1898–99
Watercolor and pencil on paper
15 × 10½ in.
(38.1 × 26.7 cm), sight
Private Collection

View from the central balcony of the Doge's Palace.

686 (see p. 53)
Caffè Florian, Venice, ca. 1898–99
(Caffè Florian in Venice)
Watercolor and graphite on wove paper
11 × 15⅜ in. (27.9 × 39.1 cm)
National Gallery of Art, Washington, D.C.
Gift of Ernest Hillman, Jr., in memory of his friend John Davis Skilton, Jr. (2003.123.1)
Image courtesy of the Board of Trustees, National Gallery of Art, Washington, D.C.

Caffè Florian is on St. Mark's Square.
[AB]

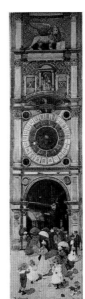

687 (see p. 163)
St. Mark's Square, Venice (The Clock Tower), ca. 1898–99
Watercolor and graphite on paper
23⅞ × 6⅛ in.
(60.6 × 15.6 cm)
Farnsworth Art Museum, Rockland, Maine
Museum Purchase, 1944; 44.316
Photo Credit: Melville D. McLean
[ABC]

688
Gray Day, Venice, 1899
Watercolor and pencil on paper
12¼ × 18 in.
(31.1 × 45.7 cm), sight
Mr. and Mrs. S. Roger Horchow

View of the Piazzetta and the Bacino from the Doge's Palace.

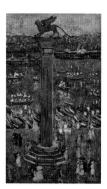

689 (see p. 45)
St. Mark's Lion, Venice,
ca. 1898–99
Watercolor and pencil on paper
18 × 10¾ in. (45.7 × 27.3 cm)
Private Collection, Texas

There is a preliminary sketch
for this watercolor on p. 39 of
one of Prendergast's Venetian
sketchbooks (CR 1479).
Although later dated 1902,
this watercolor was probably
begun during or just after
Prendergast's trip to Venice
of 1898–99.
[ABC]

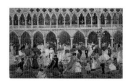

690 (see p. 40)
*Sunlight on the Piazzetta,
Venice,* ca. 1898–99
(Sunlight on the Piazzetta)
Watercolor over graphite pencil
on paper
12⅝ × 20⅝ in. (31.8 × 52.4 cm)
Museum of Fine Arts, Boston
Gift of Mr. and Mrs. William
T. Aldrich, 61.963

View of the Piazzetta with
the Doge's Palace in the
background.

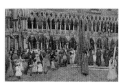

691 (see p. 41)
Festival Day, Venice,
ca. 1898–99
Watercolor and pencil on paper
12⅝ × 20 in. (32.1 × 50.9 cm)
Mount Holyoke College Art
Museum, South Hadley,
Massachusetts
Purchase with the Gertrude
Jewett Hunt Fund in memory
of Louise R. Jewett,
1951.167.1(b).PI

View of the Piazzetta with
the Doge's Palace in the
background.
[BC]

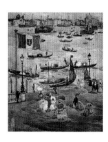

692 (see p. 56)
Canal, Venice, ca. 1898–99
Watercolor and pencil on paper
16 × 13½ in. (40.6 × 34.3 cm)
Abby and Alan D. Levy
Collection, Los Angeles

View from the Riva degli
Schiavoni across the Bacino,
showing the churches of the
Zitelle (to the left) and the
Redentore (to the right).
[ABC]

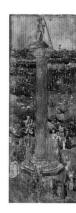

693 (see p. 44)
Column of St. Theodore,
ca. 1898–99
Watercolor and pencil on paper
15½ × 6 in. (39.4 × 15.2 cm)
Williams College Museum
of Art, Williamstown,
Massachusetts
Gift of Mrs. Charles
Prendergast (95.4.93)

Maurice Prendergast
mistakenly identified the
column of St. Theodore as
that of St. George.
[ABC]

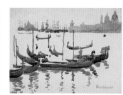

694 (recto) (see p. 53)
Gondolas, Venice,
ca. 1898–99
Watercolor and ink wash
on paper
10½ × 14¾ in.
(26.7 × 37.5 cm)
Private Collection

View across the entrance to
the Grand Canal, showing Santa
Maria della Salute (to the right)
and San Giorgio Maggiore
(to the left).

694 (verso)
*Sketch of the Façade
of S. Marco*
Pencil
[ABC]

1124 (verso)
Venice, ca. 1898–99
Watercolor and pencil on paper
21 × 14¼ in. (53.3 × 36.2 cm)
Williams College Museum
of Art, Williamstown,
Massachusetts
Gift of Mrs. Charles
Prendergast (95.4.6)

1124 (recto)
Narcissus, ca. 1910–13
Watercolor and pencil
[ABC]

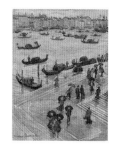

695 (see p. 62)
Rainy Day, Venice,
ca. 1898–99
Watercolor and pencil on paper
16¾ × 12½ in.
(42.5 × 31.7 cm)
Wichita Art Museum, Kansas
The Roland P. Murdock
Collection, M36.42

View of the steps of Santa
Maria della Salute from a
building above Ponte
dell'Abbazia.

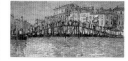

696 (see p. 48)
*The Bridge of Boats,
Venice,* ca. 1899
Watercolor and pencil on paper
9⅝ × 19⅛ in.
(24.4 × 48.6 cm), sight
Private Collection, New York

View of the temporary Bridge
of Boats constructed annually
(third Sunday of July) across
the Grand Canal. Sansovino's
Palazzo Corner is the large
building in the center. Because
Prendergast did not apply for a
passport until June 29, 1898,
it is likely that this is a scene
of the Festa del Redentore
of 1899.
[A]

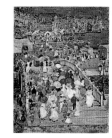

697 (see p. 51)
*Ponte della Paglia
(Marble Bridge),*
ca. 1898–99
Watercolor and pencil on paper
17¾ × 14⅛ in. (45.1 × 36 cm)
Private Collection

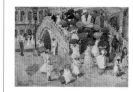

1780 (see p. 50)
Ponte della Paglia,
ca. 1898–99
Watercolor on paper
10¼ × 14¾ in. (26 × 37.5 cm)
Private Collection
[ABC]

698 (recto) (see p. 73)
Umbrellas in the Rain,
ca. 1898–99
Watercolor over graphite pencil
on paper
13¹⁵⁄₁₆ × 20⅞ in.
(35.4 × 53 cm)
Museum of Fine Arts, Boston
The Hayden Collection—
Charles Henry Hayden Fund,
59.57

View of Ponte della Paglia
with the Doge's Palace in
the background.

698 (verso)
*Sketch for Umbrellas in the
Rain (Sketch in Pencil and
Watercolor for Arcade and
Lamp Post)*
Watercolor over graphite pencil
on paper

French customs stamp appears
at upper right.
[AC]

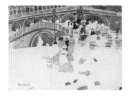

699 (see p. 54)
*Umbrellas in the Rain,
Venice*, ca. 1898–99
Watercolor and graphite on
off-white wove paper
10 × 13¾ in. (25.4 × 34.9 cm)
The Metropolitan Museum
of Art, New York
Bequest of Joan Whitney
Payson, 1975 (1976.201.4)
Image © The Metropolitan
Museum of Art, New York

View of Ponte della Paglia
with the Doge's Palace in
the background.
[B]

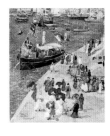

700 (see p. 16)
Riva San Biagio, Venice,
ca. 1898–99
Watercolor and pencil on paper
11⅞ × 10⅝ in. (30.2 × 27 cm)
Collection of Meredith and
Cornelia Long
[AC]

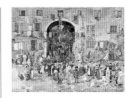

701 (recto)
The Quai, Venice,
ca. 1898–99
Watercolor and pencil on paper
15¾ × 13 in. (40 × 33 cm)
Private Collection

View of Riva San Biagio.

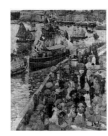

701 (verso)
Venetia Marina
Watercolor and pencil

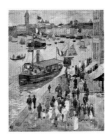

702 (see p. 61)
Riva San Biagio, Venice,
ca. 1898–99
Watercolor and pencil on paper
13⅛ × 10⅝ in. (33.3 × 27 cm)
Private Collection, New York
[A]

1028 (verso)
Boat with Flags,
ca. 1898–99
Watercolor and pencil on paper
13¾ × 19¾ in.
(34.9 × 50.2 cm)
Collection of Mr. and Mrs.
Alan I. Kay

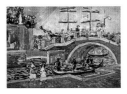

1028 (recto)
Ponte S. Vio, 1911–12
Watercolor and pencil

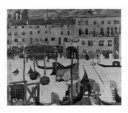

703
Riva degli Schiavoni,
ca. 1898–99
(*Riva degli Schiavoni,
Castello (Venecia)*)
Watercolor and pencil on paper
14½ × 19 in. (36.8 × 48.3 cm)
Museo Thyssen-Bornemisza,
Madrid

View of the end of the Riva
degli Schiavoni, now called
Riva dei Sette Martire, at the
old entrance to the Arsenale.
[B]

704
Riva degli Schiavoni,
ca. 1898–99
(*Riva degli Schiavoni,
Castello*)
Watercolor and pencil on paper
14 × 10½ in. (35.6 × 26.7 cm)
Collection of The Dixon Gallery
and Gardens, Memphis,
Tennessee
Museum Purchase from
Cornelia Ritchie made possible
by the Levy Family Fund,
2000.4.6

View of the end of the Riva
degli Schiavoni, now called
Riva dei Sette Martire, at the
old entrance to the Arsenale.
[ABC]

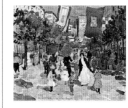

705 (see p. 46)
Via Garibaldi, ca. 1898–99
Watercolor and pencil on paper
11⅛ × 13⅞ in.
(28.3 × 35.2 cm)
Cheekwood Botanical Garden
and Museum of Art, Nashville,
Tennessee
Museum Purchase through
the Bequest of Anita Bevill
McMichael Stallworth
[ABC]

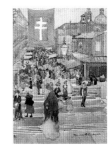

706 (see p. 38)
Market Place, Venice,
ca. 1898–99
Watercolor and pencil on paper
13⅝ × 10 in. (39.9 × 25.4 cm)
Private Collection

View from the steps of the Rialto
Bridge of the market below,
with San Giacomo di Rialto at
the right. There is a preliminary
sketch on p. 165 in a Venetian
sketchbook (CR 1479).

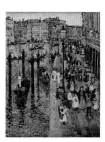

707 (see p. 59)
The Grand Canal, Venice,
ca. 1898–99
Watercolor and pencil on paper
17¾ x 13¾ in.
(44.1 x 34.9 cm)
Terra Foundation for American
Art, Chicago
Daniel J. Terra Collection,
1999.123

View of Riva del Vin
(Fondamenta del Vin) from
the foot of the Rialto Bridge.
[ABC]

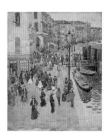

708 (see p. 58)
Venice, ca. 1898–99
Watercolor and pencil on paper
18¼ x 15 in. (46.4 x 38.1 cm)
Colby College Museum of Art,
The Lunder Collection,
Waterville, Maine
Photo Credit: Alan LaVallee

Although Prendergast inscribed
this work "Fondamenta del
Vin," it is a view of Riva del
Ferro (across the Grand Canal
from the Fondamenta del Vin)
from the foot of the Rialto
Bridge.
[ABC]

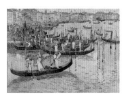

709
Venice: Traghetti-Battelli,
ca. 1898–99
Watercolor and pencil on paper
10⅞ x 15⅛ in.
(27.6 x 38.4 cm)
Private Collection

The buildings in the
background are along
the Riva degli Schiavoni.
[AC]

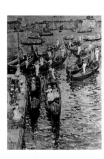

710
Summer in Venice,
ca. 1898–99
Watercolor and pencil on paper
20 x 14 in. (50.8 x 35.6 cm)
Private Collection

View from the Ponte della
Paglia, looking across the
Bacino to the Giudecca and
the church of the Zitelle
(to the right).

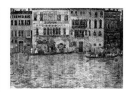

711 (see p. 57)
*Venetian Palaces on the
Grand Canal,* 1899
Watercolor and pencil on paper
14 x 20¾ in. (35.6 x 52.7 cm)
Karen and Kevin Kennedy
Collection

View of Ca' da Mosto, with
Palazzo Dolfin and Palazzo
Bolani on either side.
[ABC]

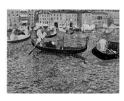

712
Grand Canal, Venice,
ca. 1898–99
Watercolor and pencil on paper
10 x 13⅞ in. (25.4 x 35.2 cm)
Williams College Museum
of Art, Williamstown,
Massachusetts
Gift of Mrs. Charles
Prendergast (91.18.6)

View from the steps of the
Dogana, along the Grand Canal,
showing the former Bucintoro
rowing club (to the right) and
buildings that are now hotels.
[ABC]

713 (see p. 42)
Festival, Venice,
ca. 1898–99
Watercolor and pencil on paper
18⅜ x 14⅜ in.
(46.6 x 36.4 cm)
The Museum of Modern Art,
New York
Gift of Abby Aldrich Rockefeller
(133.1935)
Digital Image © The Museum
of Modern Art/Licensed by
Scala/Art Resource, New York

View of Campo Sant' Aponal.
[ABC]

714
Lacemakers, Venice,
ca. 1898–99
Watercolor and pencil on paper
13½ x 9⅝ in.
(34.3 x 24.4 cm), sight
Private Collection

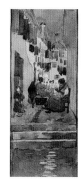

715
Italian Courtyard,
ca. 1898–99
Watercolor and pencil on paper
15 x 6 in. (38.1 x 15.2 cm)
Last known in Christie's sale,
November 29, 2000
Photograph courtesy of
Christie's Images

716
Campo San Cassiano,
ca. 1898–99
Watercolor on paper
10¾ x 15½ in.
(27.3 x 39.4 cm)
Boca Raton Museum of Art,
Florida
The Dr. and Mrs. John J. Mayers
Collection, Boca Raton, Florida
1989.140
[ABC]

717 (see p. 55)
Venetian Canal,
ca. 1898–99
Watercolor and pencil on paper
13⅞ x 9⅞ in.
(35.2 x 25.2 cm)
The Cleveland Museum of Art
Gift of Mrs. Herman L. Vail,
1968.356
[B]

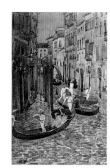

718
The Canal, Venice,
ca. 1898–99
Watercolor and pencil on paper
16⅞ x 11⅛ in.
(42.9 x 28.3 cm)
Private Collection, Maryland

View of Rio dei Greci from
Ponte della Pietà on the
Riva degli Schiavoni.

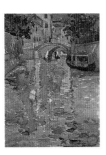

719
Side Canal, Venice,
ca. 1898–99
Watercolor over graphite
on paper
13⁷⁄₁₆ x 9¹⁵⁄₁₆ in.
(33.8 x 25.2 cm)
The Nelson-Atkins Museum
of Art, Kansas City, Missouri
Acquired through the
generosity of Mrs. George C.
Reuland through the W.J. Brace
Charitable Trust, F81-46
Photograph by Jamison Miller

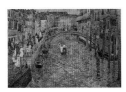

720 (see p. 60)
Venetian Canal Scene,
ca. 1898–99
Watercolor and pencil on paper
13⁷⁄₈ x 20³⁄₈ in.
(35.2 x 51.8 cm)
Private Collection, New York

View of the Ponte Lion from
the Ponte dei Greci, looking
down the Rio dei Greci
toward San Lorenzo.
[A]

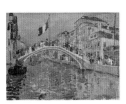

721
A Bridge in Venice,
ca. 1898–99
Watercolor and pencil on paper
11¼ x 14⁷⁄₈ in.
(28.6 x 37.8 cm)
The Cleveland Museum of Art
Gift of Mrs. A. Dean Perry in
memory of Mr. and Mrs.
Edward Belden Greene,
1960.164

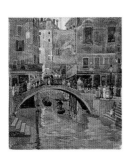

722 (recto) (see p. 39)
Venice, ca. 1898–99
Watercolor and graphite
on wove paper
17¼ x 15½ in.
(43.8 x 39.4 cm)
Addison Gallery of American
Art, Phillips Academy, Andover,
Massachusetts
Bequest of Lizzie P. Bliss,
1931.96

View of Ponte Apostoli from
Sotto Portico del Magazen.

722 (verso)
Sketch of Gondolas
Pencil

Too light to reproduce.

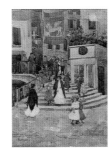

723
*Ponte Gianbattista-
Gallucioli*, ca. 1898–99
Watercolor and pencil on paper
15 x 11 in. (38.1 x 27.9 cm)
Collection of Adelaide Fuller
Biggs

Ponte de la Chiesa, on the
Campo San Cassiano.

724 (see p. 119)
Festa del Redentore,
ca. 1899
Watercolor and pencil on paper
11 x 17 in. (27.9 x 43.2 cm)
Williams College Museum
of Art, Williamstown,
Massachusetts
Gift of Mrs. Charles
Prendergast (91.18.5)

The Festa del Redentore takes
place on the Giudecca Canal
on the third Sunday of every
July. Because Prendergast did
not apply for a passport until
June 29, 1898, it is likely that
this is a scene of the Festa del
Redentore of 1899.
[ABC]

725 (see p. 119)
Fiesta Grand Canal, Venice,
ca. 1899
Glass and ceramic tiles in plaster
11 x 23 in. (27.9 x 58.4 cm)
Williams College Museum
of Art, Williamstown,
Massachusetts
Gift of Mrs. Charles
Prendergast (95.4.79)

This is not a watercolor, and
is the only work of its kind in
Maurice Prendergast's œuvre.
[ABC]

726
Festival, ca. 1899
Watercolor on paper
16⁵⁄₈ x 11⁷⁄₈ in.
(42.2 x 30.2 cm)
Private Collection

See note, CR 724.

727 (see p. 49)
Festival Night, Venice,
ca. 1899
Watercolor and pencil on paper
11 x 15 in. (27.9 x 38.1 cm)
The Samuel Courtauld Trust,
The Courtauld Gallery, London

See note, CR 724.
[AB]

728 (see p. 77)
The Lagoon, Venice, 1898
Watercolor and pencil on paper
11⅛ x 15⅜ in.
(28.3 x 39.1 cm)
Fayez Sarofim Collection
[ABC]

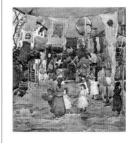

729 (see p. 47)
*Fiesta—Venice—S. Pietro
in Volta*, ca. 1898–99
Watercolor and pencil on paper
13³⁄₈ x 12½ in. (34 x 31.8 cm)
Williams College Museum
of Art, Williamstown,
Massachusetts
Gift of Mrs. Charles
Prendergast (86.18.76)
Photo Credit: Arthur Evans
[ABC]

730 [2366]
Fiesta, ca. 1899;
reworked ca. 1936 by
Charles Prendergast
Watercolor, pencil, and ink
on paper
12½ x 19½ in.
(31.8 x 49.5 cm)
Private Collection
Courtesy of Adelson Galleries,
New York

Rare watercolor showing the
work of both Charles and
Maurice Prendergast.

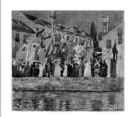

731
Procession, Venice, 1899
Watercolor and gouache
on paperboard
11 x 12¼ in. (28.5 x 32 cm)
High Museum of Art, Atlanta
Bequest of John Gardner
Greene in memory of his uncle
Howard Gardner Nichols, 75.2

Most likely of San Pietro
in Volta.
[AB]

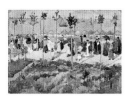

732 (see p. 64)
The Lido, Venice,
ca. 1898–99
Watercolor and pencil on paper
10½ × 15 in. (26.7 × 38.1 cm)
Private Collection
Courtesy of Guggenheim
Asher Associates
[ABC]

733
Venetian Scene,
ca. 1898–99
Watercolor and pencil on paper
8¼ × 10¾ in. (23.2 × 27.3 cm)
Last known in Christie's sale,
2005
Photograph courtesy
of Christie's Images

View of Corso del Popolo at
Chioggia from Piazzetta Vigo.

734
Italian Flower Market,
ca. 1898–99
Watercolor and pencil on paper
14½ × 10 in.
(36.8 × 25.4 cm), sight
Private Collection of Mrs. Irving
Levitt, Atlanta, Georgia

According to Charles Hovey
Pepper, this scene is in
Florence (see Mathews essay,
n. 47).

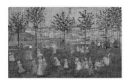

735
Siena, ca. 1898–99
Watercolor and graphite
on paper
12¼ × 20⅛ in. (31.1 × 51.1 cm)
Private Collection
Photograph courtesy
Spanierman Gallery, LLC,
New York

View from La Lizza, a public
park overlooking Siena.

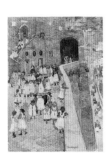

736 (recto) (see p. 67)
Courtyard Scene in Siena,
ca. 1898–99
Watercolor and pencil on paper
14 × 10¼ in. (35.6 × 26 cm)
Honolulu Academy of Arts
Gift of Mrs. Philip E. Spalding,
1940 (11,654)

It is likely that this is a view of
the former entrance to the
convent at San Dominico in
via Santa Caterina.

736 (verso)
*Verso of Courtyard Scene
in Siena*
Pencil

Too light to reproduce.
[ABC]

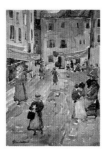

737
Siena, ca. 1898–99
Watercolor and pencil on paper
13⅞ × 10 in.
(35.2 × 25.4 cm)
Collection of James and
Barbara Palmer
[A]

738
Siena, 1899
Watercolor and pencil on paper
14¼ × 5⅞ in.
(36.2 × 14.9 cm)
Williams College Museum
of Art, Williamstown,
Massachusetts
Gift of Mrs. Charles
Prendergast (86.18.68)
[ABC]

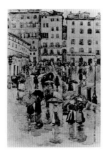

739
Rainy Day, Siena,
ca. 1898–99
Watercolor and pencil on paper
18¾ × 13 in. (47.6 × 33 cm)
Last known in Sotheby's sale,
1996

740
Siena, ca. 1898–99
Watercolor and pencil on paper
13¾ × 10 in. (34.9 × 25.4 cm)
Private Collection
Courtesy of Adelson Galleries,
New York

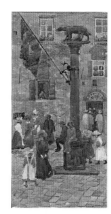

741 (see p. 66)
*Campo Vittorio Emanuele,
Siena,* ca. 1898–99
Watercolor and pencil on paper
11¼ × 13¾ in.
(28.6 × 34.9 cm)
Private Collection

742 (see p. 66)
Siena, Column of the Wolf,
ca. 1898–99
Watercolor and pencil on paper
19⅛ × 9½ in.
(48.6 × 24.1 cm)
A New England Collector

Located in Piazza Tolomei.
[ABC]

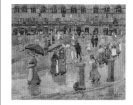

743
Assisi, ca. 1898–99
Watercolor and pencil on paper
15⅜ × 11 in. (39.1 × 28 cm)
Williams College Museum
of Art, Williamstown,
Massachusetts
Gift of Mrs. Charles
Prendergast (86.18.59)
[ABC]

744 (see p. 70)
Early Spring—Monte Pincio,
ca. 1898
Watercolor and pencil on paper
14½ × 10¾ in.
(36.8 × 27.3 cm)
Private Collection
Courtesy of Adelson Galleries,
New York

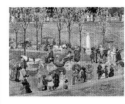

748 (see p. 122)
Pincian Hill, Rome, 1898
Watercolor over graphite pencil
under-drawing on thick,
medium-textured, off-white
watercolor paper
21 × 27 in. (53.3 × 68.5 cm)
The Phillips Collection,
Washington, D.C.
Acquired 1920
[C]

752 (see p. 68)
Capri, 1899
Watercolor and pencil on paper
14 × 10½ in.
(35.6 × 26.7 cm)
Norton Museum of Art,
West Palm Beach, Florida
Gift of Elsie and Marvin
Dekelboum, 2005.53
[AB]

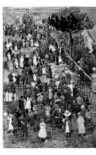

745 (recto) (see p. 123)
Afternoon Pincian Hill,
ca. 1898–99
Watercolor and pencil on paper
15⅛ × 10⅜ in.
(38.4 × 26.4 cm)
Honolulu Academy of Arts
Gift of Mrs. Philip E. Spalding,
1940 (11,653)

745 (verso)
Sketch of Venice
Pencil and watercolor

View along the Riva
degli Schiavoni, Venice.
[ABC]

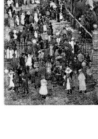

749 (see p. 71)
*Steps of Santa Maria
d'Aracoeli, Rome*,
ca. 1898–99
Watercolor and pencil on paper
20⅜ × 14⅛ in.
(51.8 × 35.9 cm)
Private Collection

753 (recto)
Capri, ca. 1898–99
Watercolor and pencil on paper
10⁷⁄₁₆ × 14¼ in.
(26.5 × 36.2 cm)
Iris & B. Gerald Cantor Center
for Visual Arts at Stanford
University, Palo Alto, California
Gift of Gordon M.
and Elizabeth R. Buck,
1983.67

View from a room
in the Hotel Capri.

753 (verso)
Sketch of Steamboat
Watercolor

750 (see p. 121)
Spanish Steps, Rome,
ca. 1898–99
Watercolor and pencil on paper
20¾ × 14¼ in.
(52.7 × 36.2 cm)
Collection Neuberger Museum
of Art, Purchase College,
State University of New York
Gift of Roy R. Neuberger,
1996.15.01
[ABC]

754
Capri, ca. 1898–99
Watercolor and pencil on paper
13⅞ × 20¼ in.
(35.2 × 51.4 cm)
Last known in Christie's sale,
December 2, 1988
Photograph courtesy
of Christie's Images

746 (see p. 123)
Monte Pincio, Rome,
ca. 1898–99
Watercolor and graphite
heightened with gum arabic on
ivory wove watercolor paper
15⁷⁄₁₆ × 19¾ in.
(39.4 × 50.2 cm)
Terra Foundation for American
Art, Chicago
Daniel J. Terra Collection,
1999.117
[ABC]

751
Capri, ca. 1898–99
Watercolor and pencil on paper
9 × 14¼ in. (22.9 × 36.2 cm)
Williams College Museum
of Art, Williamstown,
Massachusetts
Gift of Mrs. Charles
Prendergast (86.18.73)
[ABC]

747 (see p. 72)
*Borghese Garden, Rome,
Race Track*, ca. 1898–99
(*El hipódromo*;
or *Piazza Siena, Jardines
Borghese, Roma*)
Watercolor and pencil on paper
14 × 18⅛ in. (35.6 × 36 cm)
Museo Thyssen-Bornemisza,
Madrid
© Museo Thyssen-Bornemisza.
Madrid
[B]

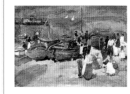

755 (recto) (see p. 69)
At the Shore (Capri),
ca. 1898–99
Watercolor and pencil on paper
10¼ × 14¾ in.
(26 × 37.5 cm), sight
Private Collection, New York

View of Marina Grande, Capri.

755 (verso)
View of St. Malo
Watercolor

View of Marina Grande, Capri,
incorrectly inscribed "St. Malo."
[A]

756
Capri, ca. 1898–99
Watercolor and pencil on paper
10½ × 12⅝ in.
(26.7 × 32.1 cm)
Collection of Judith H.
Dobrzynski

This work was originally
double-sided, but the paper
was split around 1966. The
former other side of this
watercolor is *St. Malo Sailboats*
(CR 870).
[AC]

870
St. Malo Sailboats,
ca. 1907
Watercolor and pencil on paper
10⅛ × 14⅛ in.
(25.7 × 38.9 cm)
Berry-Hill Galleries, New York

This work was originally
double-sided, but the paper
was split around 1966. The
former other side of this
watercolor is *Capri* (CR 756).

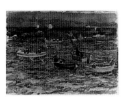

757
Along the Shore,
ca. 1898–99
(*Along the Shore, St. Malo*)
Watercolor and pencil on paper
11 × 15½ in. (27.9 × 39.4 cm)
Collection of William Marshall
Fuller

Although recently titled
St. Malo, this is likely to be a
view of Marina Grande, Capri.

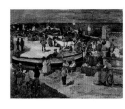

758 (recto) (see p. 69)
Grande Marina, Capri,
ca. 1898–99
Watercolor and pencil on paper
11 × 15⅜ in. (27.9 × 39.1 cm)
Private Collection

758 (verso)
*Sketch of Boats
and a Bridge*
Pencil on paper

759
Port Scene, ca. 1898–99
(*Port Scene at San Malo*;
or *Fisherman at San Malo*;
or *Fishing Scene in Brittany*)
Watercolor and pencil on paper
14⅜ × 10⅜ in.
(36.5 × 26.4 cm)
University of Iowa Museum
of Art, Iowa City
Gift of John J. Brady, Jr.
1992.19

View of the shore of
Marina Grande, Capri.
[ABC]

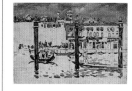

1009 (recto) (see p. 85)
Rialto Bridge, ca. 1911–12
(*Rialto Bridge (Covered
Bridge, Venice)*)
Watercolor and graphite
on off-white wove paper
15⅜ × 22¼ in.
(39.1 × 56.5 cm)
The Metropolitan Museum
of Art, New York
The Lesley and Emma Sheafer
Collection, Bequest of
Emma A. Sheafer, 1973
(1974.356.1recto)
Photograph © 2000
The Metropolitan Museum
of Art, New York

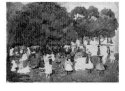

1009 (verso) (see p. 92)
Central Park Scene,
ca. 1900–03
(*Pedestrians in a Park*)
Watercolor and graphite
on off-white wove paper
The Metropolitan Museum
of Art, New York
The Lesley and Emma Sheafer
Collection, Bequest of
Emma A. Sheafer, 1973
(1974.356.1verso)
Image © The Metropolitan
Museum of Art, New York
[A]

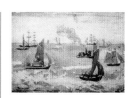

1010 (recto) (see p. 86)
Rialto, Venice,
ca. 1911–12
Watercolor and pencil on paper
14⅞ × 21⅞ in.
(38.1 × 55.9 cm)
Williams College Museum
of Art, Williamstown,
Massachusetts
Gift of Mrs. Charles
Prendergast (86.18.79)

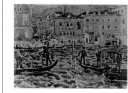

1010 (verso)
Rialto, Venice
Watercolor and pencil

View of the Grand Canal
from Riva del Carbon.
[ABC]

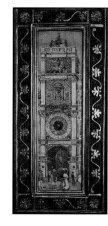

1011 (see p. 163)
*Clocktower, St. Mark's
Square, Venice*, 1911
Watercolor and pencil on paper
22⁷⁄₁₆ × 6¹⁄₁₆ in.
(57 × 15.4 cm)
Iris & B. Gerald Cantor Center
for Visual Arts at Stanford
University, Palo Alto, California
Gift of Janet Churchill Green,
1984.88

1012
Venetian Scene,
ca. 1911–12
Watercolor and pencil on paper
10⅞ × 14⅞ in.
(27.6 × 37.8 cm), sight
Last known in the collection
of Mrs. Morris Kantor, 1976

View of the Traghetto di
Pescheria from the foot of the
bridge going into the Pescheria,
looking across the Grand Canal.

1013 (see p. 82)
*Santa Maria Formosa,
Venice*, ca. 1911–12
Watercolor and graphite pencil
on paper
22 × 15¼ in.
(55.8 × 38.9 cm)
Museum of Fine Arts, Boston
The Hayden Collection—
Charles Henry Hayden Fund,
59.58
Photograph © 2009,
Museum of Fine Arts, Boston
[AC]

1014 (recto) (see p. 91)
*Campo San Samuele,
Venice*, ca. 1911–12
Watercolor and graphite
on laid paper
11¼ × 15⅜ in.
(28.6 × 39.1 cm)
Portland Museum of Art, Maine
Gift of William D. Hamill,
1991.9.1
Photo by Benjamin Magro

There is a preliminary sketch
in each of two Venetian
sketchbooks (CR 1499
and CR 1501).

1014 (verso)
San Samuele
Pencil

Too light to reproduce.
[A]

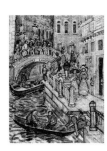

1015 (see p. 90)
Bridge and Steps, Venice,
ca. 1911–12
Watercolor, graphite, oil pastel,
gouache, and charcoal on
paper
20⁵⁄₁₆ × 15¼ in.
(51.6 × 38.7 cm)
Norton Museum of Art,
West Palm Beach, Florida
Bequest of R.H. Norton,
53.155
[AB]

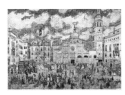

1016 (see p. 89)
*Campo Santa Maria
Formosa, Venice*,
ca. 1911–12
Watercolor and pencil on paper
12¾ × 18½ in.
(32.4 × 47 cm)
Fayez Sarofim Collection
[ABC]

1017
Venetian Bridge,
ca. 1911–12
Watercolor and pencil on paper
15¼ × 22 in.
(38.7 × 55.9 cm)
Last known in the collection
of Mr. and Mrs. Harris J. Klein,
1974

This is probably
Ponte de Conzafelzi.

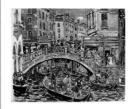

1018 (recto) (see p. 86)
Canal, ca. 1911–12
Transparent watercolor
over graphite on heavyweight
textured wove paper
15½ × 22¹⁄₁₆ in.
(39.4 × 56 cm),
overall—irregular
Munson-Williams-Proctor Arts
Institute, Museum of Art, Utica,
New York
Edward W. Root Bequest,
57.213B

View of Ponte Apostoli from
Sottoportico del Magazen.

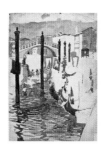

1018 (verso)
Rialto Bridge in Venice
Transparent watercolor
over graphite on heavyweight
textured wove paper
Munson-Williams-Proctor Arts
Institute, Museum of Art, Utica,
New York
Edward W. Root Bequest,
57.213A

1159 (verso) (see p. 94)
*Gondolas on the Grand
Canal, Venice*, ca. 1911–12
Pencil and watercolor on paper
11⅝ × 16⅛ in. (29.5 × 41 cm)
Williams College Museum
of Art, Williamstown,
Massachusetts
Gift of Mrs. Charles
Prendergast (86.18.47)

1159 (recto) (see p. 94)
Horseback Rider,
ca. 1912–15
Watercolor, pastel,
and pencil on paper
[ABC]

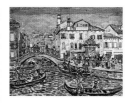

1019 (recto) (see p. 87)
Venice, ca. 1911–12
Watercolor, pencil, and pastel
on paper
17⅛ × 23⅛ in.
(43.8 × 58.7 cm)
Collection of the McNay Art
Museum, San Antonio
Bequest of Marion Koogler
McNay, 1950.116

View of Campo San Pantalon
(to the right).

1019 (verso)
Sketch for Venice
Watercolor and pencil

Too light to reproduce.
[AB]

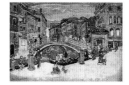

1020
Venice, the Little Bridge,
ca. 1911–12
Watercolor and pencil on paper
14¾ × 22 in.
(37.5 × 55.9 cm)
North Carolina School of
the Arts Foundation, Inc.,
Winston-Salem

View of Ponte del Mondo
Nuovo from Fondamenta Santa
Maria Formosa, just at the foot
of Ponte della Bande.

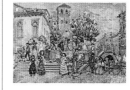

1021 (see p. 92)
Venice, ca. 1911–12
Watercolor and graphite
on paper
14⅜ × 21¼ in.
(37.5 × 54 cm)
Columbus Museum of Art, Ohio
Gift of Ferdinand Howald,
1931.251

View of Ponte Nicolo
Pasqualigo, showing the
campanile of San Felice in
the background.
[BC]

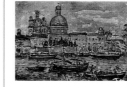

1022
Grand Canal, Venice, 1912
Watercolor and pencil on paper
13¾ × 19½ in.
(34.9 × 49.5 cm)
Last known with Charles Lock,
early 1960s

View of Santa Maria della
Salute from the Giudecca Canal.
There is a preliminary sketch
in a Venetian sketchbook
(CR 1498).

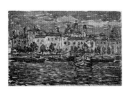

1023 (recto)
Venice: The Zattere,
ca. 1911–12
Watercolor and pencil on paper
12½ × 19¼ in.
(31.7 × 48.9 cm)
Williams College Museum
of Art, Williamstown,
Massachusetts
Gift of Mrs. Charles
Prendergast (91.28.6)

View of the Zattere, looking
across the Giudecca Canal with
Santa Maria della Salute in the
distance.

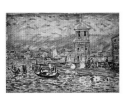

1023 (verso) (see p. 37)
Flags in Piazza San Marco,
ca. 1898–99
Watercolor and pencil
[ABC]

1024 (recto)
Venice, ca. 1911–12
Watercolor and pencil on paper
14½ × 20¾ in.
(36.8 × 52.7 cm)
Last known at Nardin Gallery,
New York, 2000

View of the old Customs House
at the tip of the Dorsoduro.

1024 (verso)
Study of Gondolas
Watercolor and pencil

Too light to reproduce.

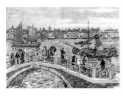

1025 (recto) (see p. 87)
*View of Venice
(Giudecca from the Zattere),*
ca. 1911–12
Watercolor and pencil on paper
15¼ × 22 in.
(38.7 × 55.9 cm)
Private Collection
Courtesy of Kodner Gallery,
St. Louis

This is a view of Ponte della
Calcina looking across the
Giudecca Canal from a room in
Pensione Seguso, just above
Campiello della Calcina.

1025 (verso)
View of Central Park,
ca. 1900–03
Watercolor and pencil
[ABC]

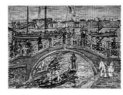

1026
Bridge at Venice,
ca. 1911–12
Watercolor and pencil on paper
14 × 20 in.
(35.6 × 50.8 cm), sight
Private Collection

View of Ponte della Calcina
looking across the Giudecca
Canal from a room in Pensione
Seguso, just above Campiello
della Calcina. Originally double-
sided, it was separated in
1978 from its former other
side, *Franklin Park, Boston*
(CR 615).

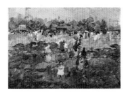

615
Franklin Park, Boston,
ca. 1896–97
Watercolor on paper
14 × 20 in.
(35.6 × 50.8 cm), sight
Private Collection

Separated in 1978 from its
former other side, *Bridge at
Venice* (CR 1026).

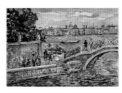

1027 (recto) (see p. 167)
Venice, ca. 1911–12
Watercolor over graphite on
moderately cream wove paper
15⁷⁄₁₆ × 21¹⁵⁄₁₆ in.
(38.6 × 55.7 cm)
Worcester Art Museum,
Worcester, Massachusetts
Museum Purchase. 1941.37

View of Ponte della Calcina
looking across the Giudecca
Canal from a room in Pensione
Seguso, just above Campiello
della Calcina.

1027 (verso)
*Untitled (Ponte della Paglia,
Sansovino's Library, and
the Columns of the Lion
and St. Theodore)*
Graphite on moderately cream
wove paper

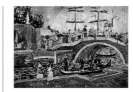

1028 (recto)
Ponte S. Vio, ca. 1911–12
Watercolor and pencil on paper
13¾ × 19¾ in.
(34.9 × 50.2 cm)
Collection of Mr. and Mrs.
Alan Kay

View of Ponte della Calcina
(over the Rio San Vio, which
may also have been the name
of the bridge) looking across
the Giudecca Canal from a
room in Pensione Seguso, just
above Campiello della Calcina.

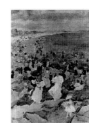

1028 (verso)
Boat with Flags,
ca. 1898–99
Watercolor and pencil

636 (verso)
Venetian Scene,
ca. 1911–12
Watercolor and pastel

View along Rio San Vio, just
across from Campiello della
Calcina.

636 (recto)
Nantasket Beach, Mass.,
ca. 1896–97
Watercolor and pencil on paper
18 × 13⅛ in.
(45.7 × 33.3 cm), sight
Private Collection

1029
Venice—Side Canal,
ca. 1911–12
Watercolor and pencil on paper
11¾ × 18 in.
(29.8 × 45.7 cm)
Emmanuel College, Boston
Gift of Mrs. Charles
Prendergast, June 1991, in
honor of Sister Ellen Glavin,
SND

View of Campo San Trovaso
from Fondamenta Nani along
Rio San Vio.
[ABC]

1030 (recto) (see p. 93)
Venice, ca. 1911–12
Watercolor and pencil on paper
13¼ × 19½ in.
(33.7 × 49.5 cm)
Private Collection
Courtesy of Owen Gallery,
New York

View of Rio San Vio from
Campiello della Calcina.

1030 (verso)
*Sketch—Figures on a
Beach*, ca. 1896–97
Watercolor and pencil on paper

1031
Venice, ca. 1911–12
Watercolor and pencil on paper
11¾ × 15¼ in.
(29.8 × 38.7 cm)
Last known in Sotheby's sale,
1989

View of Ponte San Trovaso
from Fondamenta Nani.

1032
Little Bridge, Venice,
ca. 1911–12
Watercolor and pencil on paper
15¼ × 19⅜ in.
(38.7 × 49.2 cm)
Last known in Sotheby's sale,
1992

View of Ponte delle Maravegie
over Rio San Trovaso.

1033 (see p. 86)
Scene of Venice,
ca. 1911–12
Watercolor and pencil on paper
15 × 20½ in.
(38.1 × 52.1 cm)
Collection of Ann and Gordon
Getty

View of Ponte Loredan, with
Campo San Vio to the right.

1034 (recto) (see p. 91)
Palazzo Dario,
ca. 1911–12
Watercolor and pencil on paper
11¼ × 15¼ in. (28.6 × 38.7 cm)
Collection of Donna Seldin Janis

This view is taken from
Fondamenta Ospedaletto, with
Campiello Barbaro to the right.

1034 (verso)
*Untitled (Ponte della Paglia,
Sansovino's Library, and the
Columns of the Lion and
St. Theodore)*
Pencil

Too light to reproduce.
[ABC]

DRAWINGS

1403 (see p. 116)
Festa del Redentore,
ca. 1899
Pencil on paper
3½ × 4½ in. (8.9 × 11.4 cm)
Last known in Sotheby's sale,
1987

The Festa del Redentore takes
place on the Giudecca Canal in
Venice on the third Sunday of
July. Because Prendergast did
not apply for a passport until
June 28, 1898, it is likely that
the scene is the Festa del
Redentore of 1899. Cf. related
monotype *Festa del Redentore*
(CR 1708).

SKETCHBOOKS

1479 *Sketchbook* ("Italian Sketchbook"), ca. 1898–99
(see pp. 31, 37, 38, 50, 63, 107, 111, 115, 124)
6¾ × 4½ in. (17.1 × 11.4 cm)
The Cleveland Museum of Art
Gift of Mrs. Charles Prendergast (51.422)

Ninety-one pages of pencil drawings, all done in Venice save
possibly three landscapes, with many studies of women, some of
men, canals, bridges, gondolas, gondoliers, portrait heads and a
seated portrait labeled "Seruk's Wife," a Byzantine reliquary with
several domes, frame studies, and flag and banner studies, some
of the above line-framed; *Rialto, St. Mark's, Casa Zabeo, San
Trovaso, Stella D'Oro (Pension), train from Venice to Bellrino, Naples
Museum / Ponte Sta. Margarita / I am bidding goodby to Italy this
week, I start for home next Thursday, November 16 [1899] . . . , it
has been the visit of my life. I have been here almost a year . . . and
I have seen so many beautiful things it almost makes me ashamed
of my profession today / Spreewald near Berlin, take Saturday train
from Berlin to Spreewald, stay at Burg, return by punt to the railroad.
Horseshoe Inn, N. Oxford St., and Tottenham Court Road, London.*
(Archives of American Art, Smithsonian Institution (hereafter AAA),
roll number 3583)
[ABC]

1480 *Sketchbook* ("Sketchbook 49,"
"Florence Sketchbook"), ca. 1898–99 (see p. 52)
7⅞ × 5¹¹⁄₁₆ in. (20 × 14.5 cm)
Museum of Fine Arts, Boston
Gift of Mrs. Charles Prendergast in honor of Perry T. Rathbone
(1972.1139)

Forty-two pencil drawings, several with Florentine references,
one line-framed scene of a piazza with flags and market scene,
numerous frame studies including four- and six-part polyptychs,
detailed view of Ponte Vecchio, Florence, line-framed tapestry
design, coats of arms with rampant lion, and line-framed half-length
of a saint (Dominic?); *Fra Angelico [six-part panel] / old Florentine
[frame] / tapestry / Carlo Crivelli / Adorazion dei Magi / under
glass / Vittore Carpaccio soggetto biblico.* (AAA 3587)

1481 *Sketchbook* ("Sketchbook of Frame Studies"),
ca. 1898–1903 (see p. 83)
6⅞ × 4 in. (17.5 × 10.2 cm)
Williams College Museum of Art, Williamstown, Massachusetts
Gift of Mrs. Charles Prendergast (85.26.9)

Ninety-five pages of pencil drawings, which may have been done
in Venice, mostly frame studies with more than the artist's usual
care for their descriptive quality, showing molding ornaments and
sections; there are also a few studies of horses in profile and four
or five human figures. (AAA 3583)
[ABC]

1498 *Sketchbook* ("Sketchbook 42"),
ca. 1911–12
6¹¹⁄₁₆ × 4⁹⁄₁₆ in. (17 × 11.5 cm)
Museum of Fine Arts, Boston
Gift of Mrs. Charles Prendergast in honor of Perry T. Rathbone
(1972.1132)

Thirty-eight pages of pencil drawings, including many studies
from paintings and details of frames, an elaborate study of
bathing nymphs with *intense blue mountains* in distance, another
of Perseus freeing Andromeda, and others, some line-framed,
including a view of Il Redentore, a view of the Salute as seen from
the Giudecca Island (seen from Casa Frollo, where Prendergast
stayed?), and an octagonal tower on top of which is a circular
roof supported on colonnettes. A shopping list includes pigments,
brushes, and a sketching box, and two books on art are cited:
O.M. Dalton, *Byzantine Art and Archaeology*, and E.C. Gardner,
Painters of the School of Ferrara. (AAA 3586)

1499 *Sketchbook* ("Sketchbook 74"),
ca. 1911–12 (see p. 84)
6⁵⁄₁₆ × 4⅛ in. (16 × 10.5 cm)
Museum of Fine Arts, Boston
Gift of Mrs. Charles Prendergast in honor of Perry T. Rathbone
(1972.1164)

Twenty-seven pages of pencil drawings, many views of Venice,
studies of gondoliers and gondolas, the Grand Canal with view
of San Samuele, Venetian buildings and columns in the Piazzetta,
women with children, also a seated nude figure, details of frames
(one very ornate frame inscribed "Cluny"?), and two landscapes
with trees and figures, one with balustrade in foreground;
*Fondamenta Sangiant [San Giantofetti, on the Dorsoduro, behind
the Accademia gallery] very fine, Ponte Trovaso afternoon 5.30,
afternoon late Ponte della Paglia / Rio dei Frari, opposite Browning*

Palace, late morning or early afternoon / Campo S. Safier [probably Santa Sofia, near the Ca' d'Oro], *Grand Canal Rialto, morning, Fondamenta Rio Marina, dei Frari, Campiello S. Giovanni all morning*; Prendergast also copied out a long poem, "A Cowboy's Prayer," by C.B. Clark, Jr. (AAA 3587)

1500 *Sketchbook* ("Sketchbook 68"),
ca. 1911–12
5¾ × 3³⁄₁₆ in. (14.5 × 9 cm)
Museum of Fine Arts, Boston
Gift of Mrs. Charles Prendergast (1972.1158)

One pencil drawing, a figure of a woman, the rest of the book being given over to many addresses (Boston area, Paris, Venice) and many quotations (notably from Nonnos, a late Classical writer who compiled quotations from now lost authors), and a list of the artist's own pictures, some with prices: *"The Bathers, No. 2," from 1000 without frame, "The Promenade No. 2," 800, "Landscape with Figures," 500, "Sunset," 800 without frame, "The Bathers," "Promenade," "Crepuscule," "Marblehead Rocks"*; also, *William Macbeth* [dealer], *450 Fifth Ave., New York, Mr. John Sloan* [artist], *155 E. 27th St., New York City.* (AAA 3587)

1501 *Sketchbook* ("Sketchbook 39"),
ca. 1911–12 (see p. 94)
7¹⁄₁₆ × 4⁵⁄₁₆ in. (18 × 11 cm)
Museum of Fine Arts, Boston
Gift of Mrs. Charles Prendergast in honor of Perry T. Rathbone (1972.1129)

Forty-five pages of pencil drawings done in Italy (Venice and elsewhere), of gondolas passing a church (San Samuele, Venice), figures in a landscape, monument on a pedestal with standing figure surrounded by four seated figures and town rising on hill behind with horse and carriage in foreground, bridge over river in a town, a dozen sketches of frame details, and many sketches, mostly line-framed, that appear to be after paintings of mythological subjects and landscapes; *Maurice B. Prendergast, American Express, Genoa.* (AAA 3586)

MONOTYPES

1697 (see p. 125)
Girl from Siena, 1898
Monotype on paper
Image: 9⅞ × 4⅞ in.
(25.1 × 12.4 cm)
Private Collection
Photo Credit: John Bigelow Taylor
[ABC]

1698 (see p. 124)
The Roman Campagna,
ca. 1898–99
Monotype on paper
Plate: 9⅛ × 12⅜ in.
(23.2 × 31.4 cm)
Des Moines Art Center, Iowa,
Permanent Collections
Purchased with funds in
memory of Truby Kelly Kirsch,
1953.21
[ABC]

1699 (see p. 105)
*Monte Pincio
(The Pincian Hill)*,
ca. 1898–99
Monotype with watercolor
on cream Japanese paper
Image: 7½ × 9⅜ in.
(19 × 23.8 cm)
Terra Foundation for American
Art, Chicago
Daniel J. Terra Collection,
1992.94
[ABC]

1700 (see p. 98)
Roma: Flower Stall,
ca. 1898–99
Monotype on paper
with pencil additions
Image: 9⅜ × 7½ in.
(23.8 × 19 cm)
Collection of the McNay Art
Museum, San Antonio
Gift of the Friends of the
McNay, 1976.5
[AB]

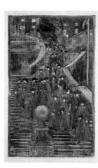

1701 (see p. 120)
The Spanish Steps,
ca. 1898–99
Monotype on paper
Image: 11¹¹⁄₁₆ × 7½ in.
(29.7 × 19.1 cm)
The Cleveland Museum of Art
Mr. and Mrs. Charles G. Prasse
Collection, 1982.167
[C]

1702 (see p. 102)
On the Corso, Rome,
ca. 1898–99
Monotype with graphite
on cream Japanese paper,
laid down on Japanese paper
Image: 11¾ × 7½ in.
(29.8 × 19 cm)
Terra Foundation for American
Art, Chicago
Daniel J. Terra Collection,
1992.96
[ABC]

1703 (see p. 103)
Bella Ragazza: Merceria,
ca. 1898–99
*(Bella Ragazza:
Merceria, Venice)*
Monotype on ivory
Japanese paper
Image: 6 × 7¹⁄₁₆ in.
(15.2 × 17.9 cm)
Terra Foundation for American
Art, Chicago
Daniel J. Terra Collection,
1992.71
[ABC]

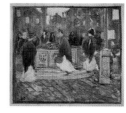

1704 (see p. 112)
Venetian Well,
ca. 1898–99
Monotype and graphite
on wove tissue paper
Image: 9 × 10³⁄₁₆ in.
(22.9 × 25.9 cm)
Addison Gallery of American
Art, Phillips Academy,
Andover, Massachusetts
Museum Purchase, 1939.5

Cf. related oil on panel
Well, Venice (CR 30).
[C]

1705 (see p. 114)
Venetian Well,
ca. 1898–99
Monotype with graphite
on cream Japanese paper
Image: 7½ × 5¾ in.
(19 × 14.6 cm)
Terra Foundation for American
Art, Chicago
Daniel J. Terra Collection,
1992.115

Venetian Well and *Venetian Court* (CR 1706) together form one composition. This image appears to be the second pull of the left side.
[ABC]

1706 (see p. 115)
Venetian Court,
ca. 1898–99
Monotype on grayish-ivory
China paper
Image: 7 7/16 × 5 15/16 in.
(18.9 × 15.1 cm)
Terra Foundation for American
Art, Chicago
Daniel J. Terra Collection,
1999.124

Venetian Well (CR 1705) and
Venetian Court form a single
composition. This image
appears to be a later pull
of the right side.
[ABC]

1707 (see p. 104)
Venice, ca. 1898–99
Monotype on cream
Japanese paper
Image: 10 × 7 7/8 in.
(25.4 × 20 cm)
Terra Foundation for American
Art, Chicago
Daniel J. Terra Collection,
1992.114
[ABC]

1708 (see p. 117)
Festa del Redentore,
ca. 1899
Monotype on cream
Japanese paper
Image: 12 1/4 × 7 7/16 in.
(31.1 × 18.9 cm)
Terra Foundation for American
Art, Chicago
Daniel J. Terra Collection,
1992.83

Cf. preliminary pencil sketch,
Festa del Redentore (CR 1403).
[ABC]

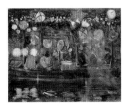

1709 (see p. 119)
Festa del Redentore, Venice,
ca. 1899
(*Festa del Redentore,
Venice*; or *Fiesta, Venice*)
Monotype on paper
7 1/2 × 9 3/8 in. (19.1 × 23.6 cm)
University of Iowa Museum
of Art, Iowa City
Gift of John J. Brady, Jr.,
1992.22
[ABC]

1710 (see p. 119)
Fiesta, Venice, ca. 1899
Monotype on paper
Image: 10 1/8 × 7 7/8 in.
(25.7 × 20 cm)
Museum of Art, Rhode Island
School of Design, Providence
Anonymous Gift 1990.141.1
Photograph by Erik Gould
[AC]

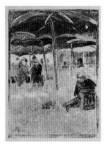

1711 (see p. 108)
Orange Market,
ca. 1898–99
Monotype on paper
with pencil additions
Image: 12 7/16 × 9 1/8 in.
(31.6 × 23.2 cm)
The Museum of Modern Art,
New York
Abby Aldrich Rockefeller Fund
(169.45)
Digital Image © The Museum
of Modern Art/Licensed by
Scala/Art Resource, New York
[ABC]

1712
Picnic with Red Umbrella,
ca. 1898–99
Monotype on paper
with pencil additions
Sheet: 9 1/4 × 7 1/2 in.
(23.5 × 19 cm)
Horatio Colony House Museum
and Nature Preserve, Keene,
New Hampshire
[ABC]

1713 (see p. 109)
Market Scene,
ca. 1898–99
Monotype on paper
with pencil additions
Image: 7 5/8 × 9 3/8 in.
(19.4 × 25.1 cm)
Collection of the Prints
and Photographs Division,
The Library of Congress,
Washington, D.C.
Pennell Fund (540031)
[ABC]

1858 Maurice Brazil Prendergast is born and baptized on October 10 in St. John's, Newfoundland (family Bible, Prendergast Archive and Study Center, Williams College Museum of Art; St. John's Basilica Baptism Records).

1863 Charles James Prendergast is born on May 27 and baptized on June 24 in St. John's, Newfoundland (family Bible, Prendergast Archive and Study Center, Williams College Museum of Art; St. John's Basilica Baptism Records).

1868 In November, the Prendergast family moves to Boston (US naturalization papers of Maurice Prendergast, Sr., 1881).

1886–87 Charles travels twice to England on a cattle boat, the second time with Maurice (Basso, "Profiles: A Glimpse of Heaven—II"; see Mathews essay, note 11).

1891–94 Maurice and Charles arrive in Paris by January 1891 (inscription, catalogue raisonné no. 517). Maurice studies at the Académie Julian (bill for classes, Prendergast Archive and Study Center, Williams College Museum of Art) and also at the Académie Colorassi, as does Charles (Charles's biographical data form for associate membership, National Academy of Design, New York, ca. 1939).

1894 Maurice returns to Boston on September 1 on the S.S. *Cephalonia* from Liverpool (passenger arrival list).

1895 First known inclusion of works by Maurice in an exhibition (*Fifty-Second Exhibition*, Boston Art Club, April 6–27, 1895).

1898 Maurice applies for a US passport on June 29.

1898–99 Maurice travels to Italy and stays for about eighteen months. As reconstructed by Charles Hovey Pepper, his itinerary includes Venice, Padua, Florence, Siena, Orvieto, Rome, Naples, and Capri (Pepper, "Is Drawing to Disappear in Artistic Individuality?"; see Mathews essay, note 47).

Photograph of Maurice Prendergast in his studio, ca. 1900–03
Prendergast Archive and Study Center, Williams College Museum of Art, Williamstown, Massachusetts
Photo Credit: Arthur Evans

Panorama della Piazetta, ca. 1898
Photograph
Prendergast Archive and Study Center, Williams College Museum of Art, Williamstown, Massachusetts
Photo Credit: Arthur Evans

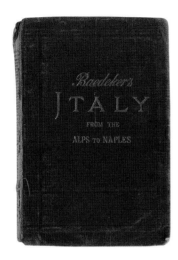

Cover, Karl Baedeker, *Italy from the Alps to Naples*, 2nd edn, Leipzig (Karl Baedeker) 1909
Prendergast Archive and Study Center, Williams College Museum of Art, Williamstown, Massachusetts
Photo Credit: Arthur Evans

1899 While he is still in Italy, sixteen of Maurice's Italian watercolors are shown at the Eastman Chase Gallery in Boston, possibly constituting his first solo exhibition (*Boston Evening Transcript*, April 6, 1899, p. 8).

1900 Maurice has his first major solo exhibition of watercolors and monotypes at the gallery of William Macbeth in New York, March 9–24.

1907 Maurice sails to France on May 19 and arrives in Le Havre on May 28. According to letters from Maurice to Charles (Prendergast Archive and Study Center, Williams College Museum of Art) and to Esther Baldwin Williams (Esther Baldwin Williams Papers, Archives of American Art), his itinerary is as follows: Paris, by May 31; Versailles, June 15; St. Malo, June 31 to the end of August; back to Paris in September. Maurice plans to return to Boston by boat on October 26 (letter from Maurice to Esther Baldwin Williams, October 10, 1907, Esther Baldwin Williams Papers, Archives of American Art).

1911 Charles travels to Italy from about June 15 through October; Maurice follows him in August. During the autumn, Maurice becomes ill and undergoes prostate surgery at the Cosmopolitan Hospital in Venice (letters from Maurice to Esther Baldwin Williams, Esther Baldwin Williams Papers, Archives of American Art, and to Charles, Prendergast Archive and Study Center, Williams College Museum of Art, September–December 1911).

1912 On January 31, Maurice sails home on White Star Line S.S. *Canopic*, which stops in Palermo (letter from Maurice to Charles, December 23, 1911, Prendergast Archive and Study Center, Williams College Museum of Art).

1913 Maurice exhibits seven works in the *International Exhibition of Modern Art*, commonly known as the "Armory Show," which runs in New York from February 17 to March 15.

1915 Maurice has his first career retrospective at the Carroll Galleries, New York, from February 15 to March 6. Works from both Italian trips are included.

1924 Maurice dies on February 1 in New York.

1927 Charles marries Eugénie Van Kemmel in May.

1948 Charles dies on August 20 in Norwalk, Connecticut.

STAFF AND BOARD LISTS

WILLIAMS COLLEGE MUSEUM OF ART

Staff
Michele Alice, Museum Security Officer
Joseph Congello, Museum Security Officer
Lisa G. Corrin, Class of 1956 Director and Lecturer in Art
Elizabeth Gallerani, Coordinator of Mellon Academic
 Programs
Diane Hart, Director of Museum Registration
Aimee Hirz, Public Relations Assistant
George Philip LeBourdais, Curatorial Assistant
Dorothy Lewis, Budget Administrator and Assistant
 to the Deputy Director
Christine Maher, Museum Shop Assistant
Nancy Mowll Mathews, Eugénie Prendergast Senior
 Curator of Nineteenth and Twentieth Century Art
 and Lecturer in Art
Michele Migdal, Museum Shop Manager
Elizabeth Milanesi, Office Assistant
Richard Miller, Preparator
Christine Naughton, Director of Museum Donor Relations
Hideyo Okamura, Manager of Exhibition Design
 and Planning/Chief Preparator
Vivian Patterson, Curator of Collections
Kathryn Price, Interim Associate Curator
Emily Schreiner, Coordinator of Education Programs
Edith V. Schwartz, Prendergast Assistant
Suzanne A. Silitch, Director of Communications
 and Strategy
Greg Smith, Preparator
John R. Stomberg, Deputy Director/Chief Curator
 and Lecturer in Art
Rachel Tassone, Associate Registrar
Amy Tatro, Assistant to the Director
Raymond Torrenti, Museum Membership
 and Special Events Manager
Jason Wandrei, Museum Security Officer
Cynthia Way, Director of Education and Visitor Experience
Terence White, Supervisor of Museum Security and Facility

Visiting Committee
George W. Ahl III, Chair
Brent R. Benjamin
Walter S. Bernheimer II
Stephen R. Birrell
John C. Botts
Hiram C. Butler
Michael B. Keating
John R. Lane
Shamim Momin
Jack Shear
Margaret Stone
Laurie J. Thomsen
Paul Tucker
David P. Tunick
Kristina Van Dyke
Laura Whitman

Advisory Members
Walter S. Bernheimer II, Chair, Fellows Council,
 Williams College Museum of Art
Thomas J. Branchick, Director and Conservator of
 Paintings, Williamstown Art Conservation Center
Michael Conforti, Director, Sterling and Francine Clark Art
 Institute, and Lecturer in the Graduate Program
 in Art History, Williams College
Marc Gotlieb, Director, Graduate Program
 in the History of Art, Williams College
Joseph C. Thompson, Director, MASS MoCA
Robert L. Volz, Custodian, Chapin Library of Rare Books,
 Williams College

Members Ex Officio
Stephen R. Birrell, Vice President for Alumni Relations
 and Development, Williams College
Lisa G. Corrin, Class of 1956 Director and Lecturer in Art,
 Williams College Museum of Art
Zirka Filipczak, Chair of Art Department and J. Kirk T.
 Varnedoe '67 Professor of Art, Williams College
Keith C. Finan, Associate Provost, Williams College
Christine Naughton, Director of Museum Donor Relations,
 Williams College Museum of Art
Morton Owen Schapiro, President and Professor
 of Economics, Williams College
John R. Stomberg, Deputy Director/Chief Curator
 and Lecturer in Art, Williams College Museum of Art

TERRA FOUNDATION FOR AMERICAN ART

Board of Directors
Mark A. Angelson
Gilda Buchbinder
Gerhard Casper
Ronald R. Davenport, Sr., Vice Chair and Treasurer
James R. Donnelley
Charles C. Eldredge
Marshall Field V, Chairman
Kathleen A. Foster, Secretary
Robert S. Hamada
Catharine C. Hamilton
David G. Kabiller
William A. Osborn
Michael E. Shapiro
Marilynn Thoma
Frederick Vogel III

Staff
Executive Staff
Elizabeth Glassman, President and Chief Executive Officer
Donald H. Ratner, Executive Vice President
 and Chief Financial Officer
Amy Zinck, Vice President

Foundation Headquarters, Chicago
Jessica Beck, Curatorial Intern
Leslie Buse, Executive Assistant
Carrie Haslett, Program Officer, Exhibitions
 and Academic Programs
Elaine Holzman, Director of Finance
Elizabeth Kennedy, Curator of Collection
Dennis Murphy, Building Engineer
Eleanore Neumann, Grants and Program Assistant
Catherine Ricciardelli, Registrar of Collection
Jennifer Siegenthaler, Program Officer, Education Programs
Elisabeth Smith, Grants and Communications Manager
Lynne Summers, Executive Assistant
Ariane Westin-McCaw, Collection and Programs Assistant

European Office, Paris
Ewa Bobrowska, Associate Program Officer, Research
Véronique Bossard, Residences Coordinator
Katherine Bourguignon, Associate Program Officer
 and Associate Curator
Miranda Fontaine, Program Coordinator
Sophie Lévy, Deputy Director, Curator
Francesca Rose, Head of Publications and Communication
Veerle Thielemans, Head of Academic Programs

INDEX

LIST OF CONTRIBUTORS

Nancy Mowll Mathews is Eugénie Prendergast Senior Curator of Nineteenth and Twentieth Century Art and Lecturer in Art at the Williams College Museum of Art, Williamstown, Massachusetts.

Elizabeth Kennedy is Curator of Collection at the Terra Foundation for American Art, Chicago.

Kimberly J. Nichols is Associate Paper Conservator in the Department of Prints and Drawings at the Art Institute of Chicago.

Olga Płaszczewska is Chair of Comparative Literature in the Faculty of Polish Studies at Jagiellonian University, Kraków, Poland.

Alessandro Del Puppo is a lecturer at the Università degli Studi di Udine, Italy.

Jan Andreas May is Assistant Curator at the Neue Nationalgalerie in Berlin, Germany.

Carol Clark is the William McCall Vickery 1957 Professor of the History of Art and American Studies at Amherst College, Massachusetts.